TURNER'S ENGLAND
1810–38

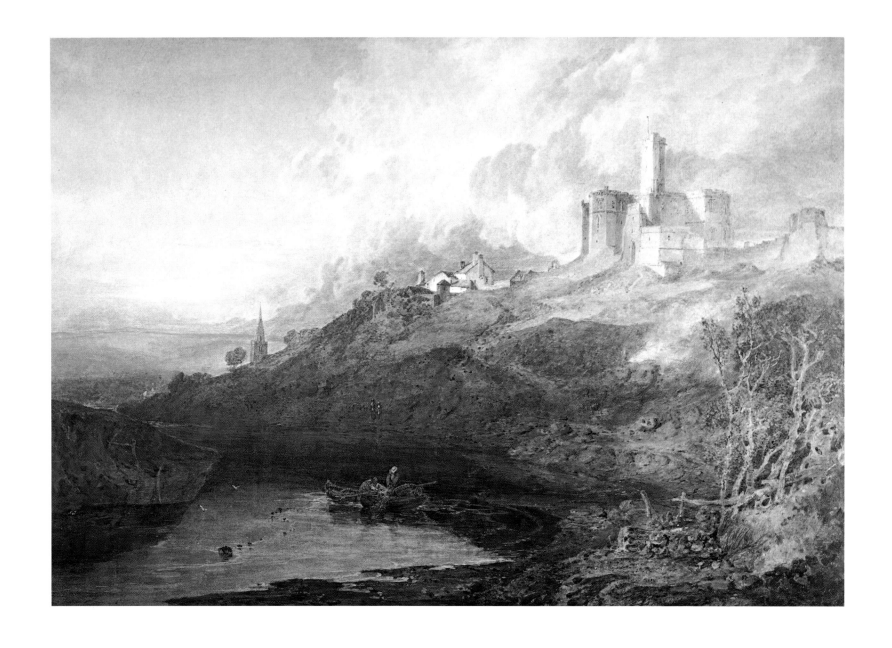

WARKWORTH CASTLE, NORTHUMBERLAND — THUNDER STORM APPROACHING AT SUN-SET

TURNER'S ENGLAND
1810-38

ERIC SHANES

CASSELL

Cassell
Villiers House
41–47 Strand
London WC2N 5JE

Conceived and produced by Breslich & Foss, London

Text © 1990 Eric Shanes
Typesetting and design © 1990 Breslich & Foss

British Library Cataloguing in Publication data
Turner, J. M. W. (Joseph Mallord William)
Turner's England.
1. English paintings, Turner, J. M. W. (Joseph Mallord William), 1775–1851
I. Title II. Shanes, Eric, 1944–
759.2

ISBN 0 304 31953–8

Edited by Judy Martin
Designed by Nigel Partridge
Film originated by Dot Gradations Ltd, Essex
Typeset by Chapterhouse, Liverpool
Printed and bound by Everbest Printing Co. Ltd., Hong Kong

Distributed in Australia by
Capricorn Link (Australia) Pty Limited,
PO Box 665, Lane Cove, NSW 2066

ACKNOWLEDGEMENTS

I should like to thank Evelyn Joll of Messrs Thos. Agnew and Sons, David Posnett of the Leger Galleries, and Desmond L. Corcoran of Alex Reid and Lefevre for helping to obtain colour photographs of works in private collections and permissions to reproduce them; Andrew Wilton, Curator of the Clore Gallery for the Turner Collection, and his staff, particularly Robert Upstone and Ian Warrell; Paul Goldman of the British Museum Department of Prints and Drawings; Kate Dinn of Falmouth Art Gallery; Mr Clifford G. Bloomfield for helping me understand the drainage systems of the Rye marshes; Karen Heaney; Prof. Luke Herrmann; Prof. Michael Kitson; Judy Martin; Edward Yardley; Stanley Warburton; and Jacky Darville for keeping me sane, or at least as sane as I will ever get to be.

E.S.

CONTENTS

FRONTISPIECE

This watercolour was engraved for 'The Rivers of England' series in 1826, although it dated from long before. Turner may have had it transcribed for the 'Rivers' series because the scheme included engravings after watercolours by his long-dead friend, Thomas Girtin. Turner certainly spent much time in proofing the Girtin prints,[1] and it may be that by including a much earlier Girtinesque image of his own in the 'Rivers' series,[2] he was attempting to ameliorate the slightly old-fashioned look that Girtin's images would have presented amid so many of his own recent designs.

The watercolour was exhibited at the Royal Academy in 1799, when its title in the Exhibition catalogue was accompanied by these amended verses drawn from James Thomson's poem, *The Seasons*:

> — Behold slow settling o'er the lurid grove,
> Unusual darkness broods; and growing, gains
> The full possession of the sky; and on yon baleful cloud
> A redd'ning gloom, a magazine of fate,
> Ferment

Clearly Turner employed these lines to widen the temporal scope of his design, for without them the anticipation of things to come would have been beyond its dramatic range.

We look north-eastwards across a loop in the river Coquet, and the pall of smoke indicates the strength of the wind; in the engraving Turner made another pall of smoke issue from a cottage beyond the castle.

1799 52.1 × 74.9 cm (20½ × 29½ in)
Victoria and Albert Museum, London

PREFACE

Turner created probably the most skilled and expressive watercolours in the history of the medium, and many of them were made to be subsequently reproduced as engravings in series, either with an accompanying letterpress or in book form, and often surveying the scenery of particular countries, regions or locales. Yet although these engravings did much to foster the appreciation of Turner's art, the public had little chance of ever seeing the original watercolours on which they were based, for the painter usually sold them off to the promoters of each engraving scheme (who in turn sold them on to collectors after each engraving was completed), or else he merely lent them to the engravers and did not subsequently exhibit them after they had been returned to him. As a result, the majority of the watercolours are now dispersed in public and private collections around the world. This has militated against widespread familiarity with these pictures, even though they are generally considered to be some of Turner's most beautiful works.

This book brings together all of the traceable watercolours of scenery in England (and a small number of subjects in Wales) that Turner made between 1810 and 1836 specifically for engraving in eleven series of topographical views. In addition, it includes several drawings that were made after 1810 which Turner subsequently allowed to be engraved at a later date. (A number of engravings were also made after 1810 of drawings created *before* that date, but for reasons of space they have all been omitted, with the exception of the frontispiece, which can represent them all.)

The series of watercolours made specifically for engraving include 'PICTURESQUE VIEWS ON THE SOUTHERN COAST OF ENGLAND', a group of drawings whose engravings did much to advance Turner's popularity with the general public; the watercolours that were made for an abortive attempt to follow the southern coast scheme with a similar survey of 'PICTURESQUE VIEWS ON THE EAST COAST OF ENGLAND'; the 'VIEWS IN SUSSEX' designs, as well as the 'VIEWS AT HASTINGS AND ITS VICINITY'; the 'RIVERS OF DEVON' drawings and engravings; the exquisite, tiny watercolours made for 'THE RIVERS OF ENGLAND' and 'THE HARBOURS OF ENGLAND' series; the watercolours and engravings created for another abortive project, the 'VIEWS IN LONDON' scheme; the 'HISTORY OF RICHMONDSHIRE' series; the 'MARINE VIEWS' scheme; and the 'PICTURESQUE VIEWS IN ENGLAND AND WALES' series of watercolours and engravings, a group of works that has rightly been called 'the central document in Turner's art'.[3]

In the introductory essay which follows, I have appended to the subtitle of each series the corresponding numbers of the colour plates of those works. Where drawings remain untraced, or are not available for colour reproduction, they are represented either in monochrome photographs (where these are available) or by the engravings made from them; such reproductions appear as a separate section of black and white plates following the colour plates, and the commentaries on them appear below each plate. The sequence of plates follows the sequence in which the prints made from the watercolours appeared, although in some cases the sequencing has had to be altered, so as to allow works to appear opposite one another. Unless stated otherwise, all works are in watercolour on white paper, with height preceding width in the sizes given. Where there is a difference between the title of the work as it was published in an exhibition catalogue during Turner's lifetime, and the title of the engraving, I have used the exhibition title, as presumably there was less interference with these than might have been the case with publishers of engravings, who were generally a law unto themselves and could alter Turner's intended titles at will. In the case of several works in the 'England and Wales' series especially, the painter's original titles throw much light upon his intended meanings in the drawings.

Much of the material in this book appeared in a somewhat more primitive guise in my two earlier books, *Turner's Picturesque Views in England and Wales*, which was first published in 1979, and *Turner's Rivers, Harbours and Coasts*, dating from 1981. I have taken the opportunity to incorporate new material on the financial side of the 'England and Wales' series that has been discovered since 1979, and I have also considerably revised most of the commentaries to the individual drawings (especially in the case of the 'England and Wales' series works), as well as expanded my brief to include many watercolours that were not covered in those books, or which have come to light since they were published. Finally, I must apologise to Welsh readers for omitting the words '. . . and Wales' from the title of this book, but it was felt that their employment might cause confusion with my first book, and in any case drawings of Welsh subjects form only a small proportion of the designs discussed here.

INTRODUCTION

THE ENGRAVINGS

In 1810 Joseph Mallord William Turner was thirty-five years old. He had already been a Royal Academician for eight years and was generally recognized as the leading British landscape and marine painter, if not even as an artist comparable with the great masters of the past. During the early spring of 1810 he was engaged by a Tory Member of Parliament for East Sussex, John Fuller (ill. 1), to visit his constituency and make four watercolours of views there.[4] Fuller hired the drawings for the huge sum of a hundred guineas so that they could be transcribed into prints which he could give to his friends and neighbours amongst the county gentry, although eventually he bought all four of the watercolours from Turner.

Fuller was very wealthy, his activities on his six thousand acre Sussex estates centring around the local iron-smelting industry. He also owned sugar plantations and rum distilleries in Jamaica where he was an important slave-owner. Fuller liked to be known as 'Honest Jack' because of his bluff ways, but more usually he was known as 'Mad Jack' because of his eccentricities. These included the building of a number of follies around Rosehill, his home in Brightling Park, and amongst them was a pyramid in the adjacent Brightling churchyard in which to be buried (where he was buried after he died in 1834). Occasionally, Fuller's 'honest' or 'mad' ways could even land him in trouble, as occurred in March 1810 when his outrageous behaviour during a Parliamentary debate on the abolition of slavery led him to be locked up by the Speaker of the House of Commons for two days. The embarrassment this caused subsequently cost him the backing of his party at the next election in 1812. But if Fuller was impervious to the ugliness of slavery, and indulged in both behavioural folly and architectural follies, he could also appeciate the beauties of Turner's art, and eventually he owned thirteen watercolours that the painter made for him after 1810, as well as two of his oil paintings, including a commissioned view of Rosehill that was completed in 1811.[5]

THE 1810 SUSSEX VIEWS (1–4)

Turner travelled down to Sussex in the early summer of 1810 and made a considerable number of sketches from which to develop the initial four Sussex watercolours and the oil painting of Rosehill. The watercolours are relatively large works, and in common with a number of the later Sussex scenes made for

Fuller, the painter employed the colour green quite freely in them, which was unusual for him as it is a colour he did not normally much care for. At Fuller's expense, these drawings were reproduced as aquatints by the engraver J. C. Stadler.[6] Fuller also toyed with the idea of having Stadler reproduce the oil painting, but nothing came of it.[7]

Turner's delivery of the painting was often fondly recalled by Fuller. He had invited Turner to breakfast at his London residence in Devonshire Place and told him to bring the work with him, when it would be paid for.

To this Turner consented. He took the picture in a Hackney coach, breakfasted, received the cheque, thanked the purchaser and left. He had not gone above five minutes, when a knock was heard at the door. The painter was back – 'I must see Mr Fuller.' He was shown in. 'Oh, I'd forgotten; there is three shillings for the hackney coach.' The sum was paid. Fuller, who was laughing all the while, loved to relate this story to his friends.[8]

The watercolours and paintings were proudly displayed at Rosehill and at Devonshire Place where they were seen by a friend of Fuller's who recorded ' . . . A dinner . . . of taste and magnificence, a superb service of plate, a pack of lacquays in rich liveries, a French cook of £150 wages, a splendid dessert, pictures of the Sussex Domains by Turner, some . . . [he] . . . must have been paid £500 for'.[9] Indeed, Fuller spent a lot of money on Turner's work over the years, and in 1811 alone the artist recorded payments from Fuller of some £417.[10]

By 1811, however, Turner had also made the acquaintance of two men who were to be responsible for commissioning a much greater amount of work from him. These were the brothers William Bernard Cooke and George Cooke, enormously experienced engravers who had long wanted to work with Turner. Indeed, they ' . . . seldom met without discussing their favourite topic, and many a scheme was formed and abandoned, before their wishes could be achieved.'[11] By 1811 they were ready.

PICTURESQUE VIEWS ON THE SOUTHERN COAST OF ENGLAND 1811–26 (19–47, 231–39)

The Cooke brothers invited Turner to contribute twenty-four drawings to a publication entitled

1 Henry Singleton, JOHN FULLER, M.P., signed and dated 10 June 1806, oil on canvas, Royal Institution, London.

'Picturesque Views on the Southern Coast of England', and it was envisaged that eventually this would form part of an even larger scheme to depict the entire coastline of mainland Britain.[12] Other artists were also to make works for the series, including Peter De Wint, William Owen and Richard Westall. Turner was to receive £7.10s for his watercolours and the Cooke brothers paid themselves twenty-five guineas for line-engraving each design on copper plates and printing them (line-engraving being the form of engraving that was employed to transcribe most of the watercolours discussed in this book, whereby images are reproduced by means of incised lines on metal plates). W. B. Cooke put up the entire initial capital, and a syndicate was formed with the publisher John Murray as the principal shareholder to advertise and distribute the work.[13] Although by 1811 there had been countless schemes devoted to illustrating inland scenery, the idea of producing a series of views of the English coast was an original one, and obviously the backers therefore thought they were onto a good thing. The work was to be published in sixteen parts, the parts to appear six times a year, each containing three quarto plates and two vignettes.

Turner was unusually receptive to the idea of making series of watercolours for line-engraving in 1811, for although his works had been translated into such prints from the mid-1790s onwards, he had not become convinced of the creative potentialities of the medium until late in 1810 when the engraver, John Pye (aided in the engraving of the figures by Charles Heath, whom we shall encounter again) produced a beautiful print of the 1808 oil painting *Pope's Villa at Twickenham*.[14] Turner was so delighted by the delicacy of Pye's work in rendering his subtle light effects that he is reputed to have said 'you can see the lights; had I known there was a man who could do that, I would have had it done before'.[15] The invitation from the Cooke brothers therefore could not have come at a better time.

Turner wasted no time in finding subjects for the watercolours, setting off on a tour of the West Country in mid-July 1811. Before leaving, he did some homework on things to see, noting down in a sketchbook such facts as the market days in Melcombe Regis, the height of Portland lighthouse, the chemical constituents of the waters at Nottington Spring and the date of King William III's landing at Brixham.[16] He travelled via Salisbury to Poole in Dorset and thence made his way along the coast westwards to Land's End before traversing the north coast of Cornwall and Devon into Somerset. He was back in London by mid-September, and it was a very productive journey, for over forty works would eventually be developed from sketches made on it. The first batch of 'Southern Coast' watercolours was probably made in the winter of 1811–12 (18–24, 231–32), although two more years elapsed before the engravings that were transcribed from them were published, partly because Turner himself was frantically busy in these years, and partly because W. B. Cooke was unwell in 1812–13.[17]

In 1813 Turner again travelled westwards to gain material for the 'Southern Coast' designs. This time he based himself in Plymouth, staying for the last week in August and the first two weeks in September principally with a young journalist, Cyrus Redding (whom he had first met in London the previous year), as well as with John Collier and Ambrose Johns, a local artist. Both Redding and Collier would go on to public eminence later in life, Redding as the leading Victorian writer on wine[18] and Collier as the Member of Parliament for Plymouth between 1832 and 1841, whilst among the further acquaintances Turner made in Plymouth in 1813 was Charles Lock Eastlake, a painter who would later become director of the National Gallery and a President of the Royal Academy. From Plymouth, Turner and his friends made numerous excursions into the surrounding countryside, and on some of the trips the artist painted in oils directly from nature, which was unusual for him. He visited Saltram and Cothele, Saltash and Trematon Castle, and enjoyed picnics in the famous park on Mount Edgcumbe. He also took a boat trip through rough seas down the coast to Burgh Island in Bigbury Bay, and demonstrated that he had excellent sea-legs (unlike his companions, who were violently seasick), studying the movement of the waves with intense concentration and muttering 'that's fine – fine'.[19] In all, Turner spent three weeks in Plymouth, and he was so inspired by the town and its sur-roundings that he may have returned there the following year, although virtually nothing is known of that visit.[20]

On his return to London in 1813 Turner completed further watercolours for the 'Southern Coast' series and spent much time supervising the engravings. However, because of the delay in publishing the prints, the 'Southern Coast' scheme was no longer alone in proposing to illustrate the British coastline; competition had been announced in the form of William Daniell's 'Voyage around Great Britain', a part-work similar to the Cooke brothers' venture that was to be illustrated, moreover, with coloured plates. William Cooke (who by now was responsible for the business affairs of both brothers) attempted to hurry Turner along[21] in supervising the engravings so that the first part of the 'Southern Coast' series could appear on 10 December 1813, the same publication date as Daniell's scheme, but this did not prove possible, and the Cooke venture did not make its debut until 1 January 1814.

Originally the Cooke brothers had asked John Landseer to write an accompanying text for the engravings, but he had declined the commission,[22] so Turner offered to write the letterpress for the 'Southern Coast' series instead. When he supplied W. B. Cooke with his literary accompaniment in 1813 it turned out to be in the form of a poem. This is still extant in draft form,[23] and although it demonstrates the extent to which the painter troubled himself with the histories of the places he recorded and his highly moral view of those landscapes, unfortunately it also proved somewhat in-comprehensible to Cooke who understandably rejected it. Eventually a conventional (and very dull) text to each part of the scheme was written by William Combe,[24] and after his death in 1823, by Barbara Hofland. Yet if Turner's verbal poetry proved in-digestible, it quickly became apparent that his highly poetic images were largely re-sponsible for making the 'Southern Coast' series attractive to the public. As a result, in December 1814 W. B. Cooke invited the painter to create even more works for the project, whilst also offering him more money to do so. Now he was to make a total of forty watercolours for engraving and receive ten guineas per watercolour instead of the seven and half pounds paid formerly. At the same time the Cooke brothers took the opportunity to ask for, and get, more money from the supporting syndicate for engraving the plates.[25]

By 1814 Turner was also showing an involvement in the processes of engraving that greatly improved the 'Southern Coast' series images, supervising every stage of the preparation and printing of the plates. W. B. Cooke recorded in 1814 how the painter corrected (or 'touched') a proof of the 'Southern Coast' print of *Lyme Regis, Dorsetshire* (ill. 2):

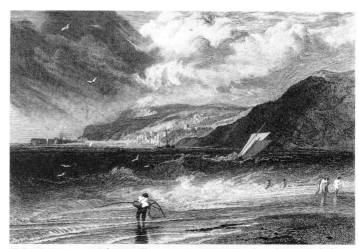

2 *Touched proof of the engraving by W. B. Cooke of* LYME REGIS, DORSETSHIRE, *1814, British Museum, London.*

On receiving this proof Turner expressed himself highly gratified – he took a piece of *white* chalk and a piece of *black* giving me the option as to which he should touch it with. I chose the white – he then threw the black chalk to some distance from him. When done, I requested that he would touch another proof in *black*. – 'No', said he, 'you have had your choice and must abide by it' – how much the comparison would have gratified the admirers of the genius of this *great and extraordinary Artist*.

Turner's involvement may be seen in the new richness and depth of tone that the engravings enjoyed. Rather than accept line-engraving as a poor substitute for his original images, the artist was increasingly exploring the medium as a means of expression in its own right. The result was to afford him an entirely new creative dimension. The engravings reached a much larger public than the original designs ever could, and Turner undoubtedly welcomed both this widening of his audience and the ensuing furtherance of his reputation. (Indeed, as we shall discover below, he later chose to earn less from having his works engraved than he could have earned by selling them outright.)

THE RIVERS OF DEVON 1815–23 (15–17, 228, 229)
Because of the vital contribution that Turner's images were making towards the success of the 'Southern Coast' scheme, in 1815 W. B. Cooke invited the painter to create another series of watercolours for engraving, a publication to be called 'The Rivers of Devon'. Turner furnished him with four watercolours, views of Plymouth Sound (228, 229), Ivybridge (15) and a multiple river-source in north Devon (16), while another Devon river scene may also be connected with the project (17).[26] Because W. B. Cooke was overworked, in the end 'The Rivers of Devon' series never actually appeared as such, and Cooke brought out three of the engravings separately. *Ivy Bridge, Devonshire* was published in 1821, after the plate had been worked on for over five

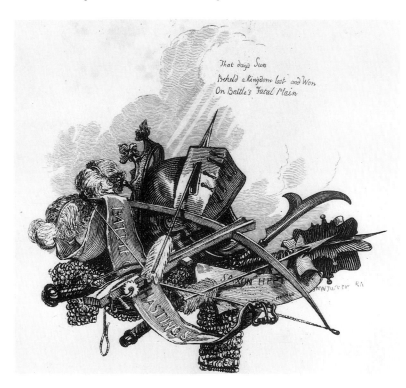

3 EMBLEMATIC FRONTISPIECE ON THE COVER OF THE 'VIEWS IN SUSSEX', 1819. *This design was engraved by Turner with assistance from J. C. Allen, whose help was acknowledged by the artist in a letter now in the Fitzwilliam Museum, Cambridge.*

years, and the two views of Plymouth Sound appeared as a pair of prints in 1824 under the title of 'Two Views in Plymouth'. Of the other two drawings that were definitely or putatively made for 'The Rivers of Devon' series, respectively one was published as a line-engraving in 1850, and the other as a chromo-lithograph in 1852.

By the mid-1810s both the Cooke brothers were increasingly over-burdened with work, as the endless delays over the appearance of the various parts of the 'Southern Coast' scheme make clear. Originally it had been planned that the final set of prints would have been published by mid-1816, but in fact they did not appear until nine and half years later. Yet the pressures of work and ensuing delays did not curb W. B. Cooke's ambitiousness. Indeed, in 1815 he committed himself to producing yet another engraved partwork from watercolours of English scenery by Turner.

VIEWS IN SUSSEX AND RELATED DRAWINGS 1810–23 (5–14, 230)
In 1815 Jack Fuller agreed to finance the line-engraving of some of the further watercolours depicting Sussex scenery that he had bought from Turner, in addition to the four drawings that had been reproduced as coloured aquatints around 1812.[27] The work was to appear in three parts, the first of which (consisting of five engravings plus an emblematic frontispiece designed by Turner for the cover, ill. 3) was published in 1820 under the title of 'Views in Sussex'. A sequel was subsequently planned, to be called 'Views at Hastings and its vicinity', but this never appeared. Originally John Murray had agreed to publish the 'Views in Sussex' but because of W. B. Cooke's tardiness in producing the 'Southern Coast' prints on time, in 1819 he withdrew his support from that project and the distribution of the 'Views in Sussex' suffered in consequence, with Cooke forced to try and distribute the prints himself.[28] He was unsuccessful in doing so and eventually three engravings for the second part of the scheme were left uncompleted. One of them was of a drawing of *Winchelsea* (11) that Cooke had obviously diverted from the 'Southern Coast' series.

LOIDIS AND ELMETE, 1816–20 (52–54, 242–43)
A number of other watercolours of English scenes by Turner were engraved for topographical works during this period as well. In 1812 an impressive watercolour of Fountains Abbey dating from 1798[29] was engraved to embellish the second edition of a 'History and Antiquities of Craven in the County of York' written by the Rev. Thomas Dunham Whitaker (1759–1821) of Holme, in Cliviger, Lancashire,[30] and in 1816 Whitaker called upon Turner's services again.

Whitaker was the vicar and rector of various parishes in Lancashire, including Whalley, Heysham and Blackburn, and he was the author of antiquarian histories of various parts of the north of England. Engravings from designs by Turner had also appeared in his first publication, a history of Whalley which appeared in 1801, and 1816 saw the commencement of publication of another historical partwork written by him, namely 'Loidis and Elmete' or 'an attempt to illustrate the district described by Bede, and supposed to embrace the lower portions of the Airedale and Wharfedale, together with the entire Vale of Calder in the County of York' (to quote its subtitle). This covered the area around Leeds, as well as the burgeoning town itself, and it included five engravings after designs by Turner. All of the embellishments were line-engravings, three in the form of etchings, and one of them was taken from a drawing of Harewood House made in 1798.[31]

Whitaker did not use any new designs from Turner for 'Loidis and Elmete', being content that engravings made from old or recent drawings should adorn his text. Moreover, the printing of those engravings was paid for by the owners of the places represented in them. But with his next project the antiquarian called upon Turner as never before to supply new watercolours for subsequent engraving, while payment was to be made to the artist by a single publisher.

THE HISTORY OF RICHMONDSHIRE 1816–23 (55–73, 248, 249)
By 1816 Whitaker had formed the idea that the 'History of Craven' and 'Loidis and Elmete' should eventually contribute towards the formation of a grandiose 'General History of the County of York'. To advance that scheme he therefore proposed to write further volumes for the work, including a 'History of Richmondshire', a survey

of the region around Richmond, Yorkshire, extending into Lancashire which had formed a county in Anglo-Saxon and Norman times. The exploration of Richmondshire was to be coupled with a survey of Lonsdale, the area around the river Lune in Lancashire. Like most of the other engraving schemes discussed in this book, the 'History of Richmondshire' was published in parts on subscription, and the parts could either be obtained separately or as a complete set in book form when all of them had appeared. It was planned that later sections of the 'County of York' would deal with most of the East Riding, all of the North Riding and the area around Sheffield known as Hallamshire, as well as lower Swaledale, Nidderdale and the city and environs of York itself.

The London publisher Longman undertook to publish the work, and in May 1816 Turner was invited to make 120 new watercolour designs for subsequent transcription into engravings for the scheme, for which he was to receive in total the immense sum of 3000 guineas (i.e. 25 guineas per drawing).[32] The artist already had sketches of many places of suitable antiquarian and/or natural interest in his possession, but he undertook another tour of the north of England in order to obtain more material for the large number of drawings that were now required. The places he should visit, and the subjects he should paint, were decided in advance by a committee of four local worthies (including Whitaker) who travelled round the region ahead of him.

Turner set out on his tour in July 1816. He could not have chosen a worse year in which to explore the English countryside. Unbeknown to him, in the previous year Mount Tambora in the South Seas had exploded in the largest volcanic eruption ever recorded, and it caused adverse global weather conditions for several years afterwards. 1816 was known as 'Eighteen Hundred and Freeze to Death' or 'the year without a summer', for in India it snowed in mid-July, while in England it rained virtually non-stop, although the volcanic debris dispersed in the atmosphere did produce many wonderful sunsets. The abnormally wet conditions can be seen in several of the 'Richmondshire' drawings such as *Weathercote Cave when half filled with water* (72). Turner stayed initially with his great friend Walter Fawkes, at Farnley Hall, midway between Leeds and Bradford, from where he later wrote to a friend, James Holworthy: 'Rain, Rain, Rain, day after day. Italy deluged, Switzerland a wash-pot, Neufchatel, Bienne and Morat lakes all in *one*' (presumably he had read newspaper reports of this bad weather).[33] With members of the Fawkes family, Turner made excursions to see Malham Cove and Gordale Scar before going off on his own to traverse Wharfedale, Wensleydale, Mossdale and Swaledale to Richmond, from whence he reported to Holworthy, 'Weather miserably bad. I shall be web-foot, like a Drake.'[34]

After leaving Richmond he travelled north to Barnard Castle, and thereafter followed the river Tees to High Force and Cauldron Snout, later describing this final part of the journey as 'a most confounded fagg, tho on Horseback. Still, the passage out of Teesdale leaves everything behind for difficulty – bogged most compleatly Horse and its Rider, and nine hours making 11 miles'.[35] From Teesdale he crossed into Westmoreland and thence into Lancashire, descending via Appleby to Kendal and travelling over Morecambe Bay at low tide to Lancaster. He then explored the Lune valley and made his way up the Greta and Dee valleys to Chapel le Dale before returning to Farnley Hall for the start of the shooting season on 12 August. Although Turner could rarely (if ever) have seen the sun on this trip, he did not let such an absence deter his imagination, and the watercolours he made back in London between 1816 and 1818 display a wonderful variety of lighting conditions, including much brilliant sunshine.

Unfortunately, even before the first part of the 'History of Richmondshire' had appeared, it became very apparent to Longman's that the whole scheme was going to be an immensely expensive affair, and that it might prove a failure with the public. By early 1818 they were already looking for ways to pull out of publishing it, while in February 1819 they sought legal advice as to how they could break their agreement with Turner to supply them with 120 drawings. And when the 'History of Richmondshire' did begin to appear in March 1819 their fears regarding its public reception were quickly confirmed, for despite Turner's superb images, the work did not sell in quantities that would have guaranteed the success of the scheme, Whitaker's highly pedantic antiquarianism obviously proving too specialized for widespread public appeal. As a result of Longman's growing disenchantment with the

project, there were long publishing delays, and these further fuelled public indifference to the scheme. But the death of Whitaker in December 1821 meant that Longman could withdraw gracefully from the project, and after they had published the final parts of the 'History of Richmondshire' in June 1823, the 'General History of the County of York' was terminated. Twenty of Turner's designs had been engraved, and the artist was undoubtedly left with one or two unengraved drawings (73).

THE HISTORY OF DURHAM 1816–20 (74–76, 241)
Nor was the 'History of Richmondshire' the only antiquarian work to involve Turner during these years. Robert Surtees (1779–1834) of Mainsforth, County Durham, was a fanatical local historian who used to drive around carefully examining every last architectural remnant in the county, and he quite exhausted his groom in the process; as the poor man complained, 'we could never get past an old beelding' without stopping.[36] Surtees published his findings in a *magnum opus* entitled 'The History and Antiquities of the County Palatine of Durham', the first volume of which appeared in 1816, with illustrations paid for by its subscribers. Those engravings had not included portrayals of the various 'castles and other residences of gentlemen' who financially supported the scheme.[37] Accordingly, for the second volume of the tome, which was published in 1820, the Earl of Strathmore commissioned Turner to supply watercolours for engraving (74–76) of two of his residences, Hylton Castle, near Sunderland, and Gibside, near Gateshead (of which Turner made two views but only one of them was engraved). At the same time the third Earl of Darlington, who had commissioned an oil painting from Turner of his magnificent country seat, Raby Castle, also ordered a watercolour of the building to adorn the 'History of Durham', as well as paying for its engraving (241).

Yet while Turner was preoccupied with making the 'Richmondshire' and 'Durham' designs, W. B. Cooke had not been idle. Indeed, his demand for watercolours that could be copied as engravings was still on the increase.

VIEWS IN LONDON AND ITS ENVIRONS, 1820–27 (100–01, 246–47)
In July 1820 W. B. Cooke commissioned a partwork on London, to be engraved by Edward Goodall from designs by Turner, Alexander Wall Callcott, William Westall, Frederick Nash and Frederick Mackenzie, although Turner does not appear to have made any watercolours for the series at this time.[38] Just over a year later Goodall withdrew from the proposed scheme, while in 1822 Turner wrote to Cooke advising him that Callcott had also had second thoughts about the venture.[39] Only in August 1824 was there a public announcement about the series, when it was stated in *The Repository of Arts* that a work entitled 'Views in London and its environs' would appear three times a year and feature engravings by J. C. Allen after designs by Turner, Callcott, Nash and Westall.

Unfortunately, Cooke was beaten to the draw yet again, for just as Allen must have been starting work on the engravings, a rival publication at a more advanced stage of preparation was announced, with the nearly identical title of 'Picturesque Views in London and its environs'. This was published by Hurst and Robinson, with engravings by Charles Heath (who was already beginning to figure largely in Turner's life by this time anyway) from designs by Peter De Wint, Westall and Mackenzie. Obviously the advanced state of Heath's project discouraged Allen and Cooke from proceeding too quickly with their London partwork, and not until 1827 did they publish any engravings of Turner's designs, when they brought out a print of *The Custom House* (100). Later that year another of Turner's views (101) that had also originally been intended for the scheme appeared as a print, although from another publisher, while a third design (247) did not appear in engraved form until 1831 when it adorned an 'annual' published by Alaric Watts. A fourth drawing (246), made like the others between 1824 and 1825, was never engraved.

THE RIVERS OF ENGLAND 1822–26 (77–93)
It is not surprising that W. B. Cooke proved somewhat lackadaisical in advancing the London scheme, for by the early 1820s he was frantically busy with all his other plans involving Turner. One of them concerned yet another venture. At the time, Cooke

was employing Thomas Goff Lupton, an engraver and pioneer in the use of steel for mezzotint engraving who had worked with Turner in the late 1810s. Until Lupton's breakthrough around 1820, mezzotint plates had been made of copper, which wore down very quickly, thus rendering them relatively uneconomic. Steel being a lot harder, it could produce an almost infinite number of impressions without any loss of quality, and the prints could therefore be sold much more cheaply. For this technical invention, Lupton was awarded the gold medal of the Society of Arts in 1822.

As steel-faced mezzotint engraving was clearly 'the coming thing', Cooke agreed with Turner on the inception of a further series, a work to be entitled 'The Rivers of England'. Designs by the late Thomas Girtin and William Collins were also to be reproduced in the series, and to keep the somewhat old-fashioned images by Girtin company, Turner had an early Girtinesque drawing of his own engraved in the scheme (Frontispiece). Between 1822 and 1825 Turner produced seventeen or more drawings for 'The Rivers of England', two of which are predominantly canal scenes (79, 89). He did not sell them to Cooke but merely charged him eight guineas for their loan while they were being engraved.

Out of loyalty to Girtin, Turner spent much time 'touching' the proofs of the prints made from his late friend's watercolours, saying

' . . . I'll touch them for Poor Tom. Poor Tom!' and he continued repeating the words, 'Poor Tom' as if to himself. Cooke took the proofs to him, and [Turner] worked upon them for a long time, bestowing great care and 'making them' as Cooke said, 'quite his own'; and, at last, after holding them individually at arm's length, throwing them on the floor, turning them upside down, and flinging them in every direction, he said, 'There, Poor Tom! That will do. Poor Tom!' and Cooke was about to take the impressions away, when Turner, clapping his arm upon them, exclaimed – 'Stop! You must pay me two guineas a piece first.'[40]

Obviously because of Turner's involvement, the Girtin plates in the 'Rivers' series are amongst the best prints in the work.[41]

Yet despite having commissioned so many new images from Turner for 'The Rivers of England' series, as well as all his other schemes (such as the 'Picturesque Views on the Southern Coast' which still continued to appear), W. B. Cooke did not curb his ambitions to collaborate with the artist; on the contrary, he commissioned even more work from him, and on a bigger scale than ever before.

MARINE VIEWS 1822–24 (94–99, 245)

Since 1817 Cooke had owned a very large drawing of the Eddystone lighthouse which originally he had intended to have (somewhat inappropriately) engraved in the 'Rivers of Devon' scheme (240). In 1822 he was also endeavouring to engrave the large drawing of *Hastings* (13) for the second part of the Sussex work. This drawing possibly inspired him to propose that Turner should create a series of similarly large watercolours which would be reproduced in mezzotint and published under the title of 'Marine Views'; to such a scheme the Eddystone drawing could be allocated (as it was). Turner made six major drawings expressly for the 'Marine Views' series between 1822 and 1824, and they constitute some of his finest marine watercolours,[42] although only two of them were published as mezzotint engravings, the first of them accompanied by a vignette engraving of *Neptune's Trident* designed by Turner (ill. 4) which was intended to act as the frontispiece for both the parts and the later, bound copies of the whole set of prints. A third mezzotint was left uncompleted by the rupture between Turner and Lupton in 1826.[43] Turner was almost certainly paid sixty guineas for all of the large drawings.[44] The vignette watercolour frontispiece for the 'Marine Views' series was to be the source of a later dispute between Turner and Cooke as the latter was under the impression he had been given the drawing by the artist, and as a result he had presented it to his wife; ultimately he was forced to return it.[45]

In 1823 and 1824 several of the 'Marine Views' watercolours featured prominently in exhibitions that W. B. Cooke held in the three-roomed picture gallery he had installed above his newly modernized print-shop in Soho Square.[46] The first of these

shows had been mounted in 1821 but it had only comprised engravings (thirty-one after designs by Turner),[47] while in the following year Cooke displayed twenty-three Turner watercolours alongside works by Rembrandt, Watteau, Giorgione and Michelangelo. The 1823 exhibition included nine watercolours by Turner, one of them the impressive *Dover Castle* (96) that had only just been made for the 'Marine Views' series. Two more large watercolours created for engraving in the same scheme were subsequently put on display in Cooke's gallery during the course of 1823, one of them (98) immediately after it had been completed.[48] In 1824 Cooke displayed seventeen more watercolours by Turner amid the collection of 272 works by Titian, Poussin, Claude, Gainsborough and others on view, and these included two more watercolours that Turner had recently made for the 'Marine Views' series.[49]

A notion of how much pressure Cooke was putting on Turner at about this time can be gauged from the following anecdote:

. . . it was his habit, Mr Munro told me, to visit Turner on Sunday afternoons, when the painter was often at leisure. In the course of a pleasant chat . . . their social privacy was invaded by the irruption of Cooke, who, with all the air of a bullying tailor come to look after a poor sweating journeyman, wanted to know if those drawings of his were never to be finished. When the door presently closed behind him, the big salt tears came into Turner's eyes, and he murmured something about 'no holiday ever for me'.[50]

Turner was an extremely sensitive man, and therefore emotionally very vulnerable, but his tearfulness was clearly caused by Cooke's hectoring manner, not by any self-pity at

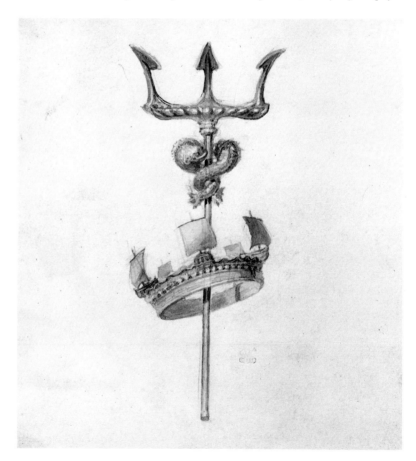

4 NEPTUNE'S TRIDENT. *Original design in watercolour for the wrapper vignette for the 'Marine Views' series. The drawing remained in the Turner Bequest (*CLXVIII-C*). It was probably engraved by W. B. Cooke. British Museum, London.*

having to work so hard, for rather than cutting down on his commitments to engravers, during the 1820s the painter constantly increased them.

By the summer of 1824 the end of the southern part of the 'Coast' scheme was well in sight and Turner gave some thought to its continuation up the eastern seaboard. He toured Sussex and Kent (to obtain material for the final 'Southern Coast' watercolours), as well as East Anglia, visiting Colchester and the coast from Aldeburgh to Yarmouth. In the late autumn he also stayed at Farnley Hall, the last time he was ever to go there, for Walter Fawkes was to die the following year and Turner never re-visited Farnley Hall thereafter, so potent were the memories it held for him.[51] And sometime towards the end of 1824 Turner embarked upon yet another scheme to reproduce his watercolours via engravings. This project matched the 'Richmondshire' series in scope, for it also required 120 watercolours that could be turned into engravings. Yet unlike the earlier, ill-fated partwork, this new scheme did almost succeed in bringing forth such a huge number of watercolours and engravings from the artist.

PICTURESQUE VIEWS IN ENGLAND AND WALES 1825–38 (133–225, 250–57)
Turner had known the engraver Charles Heath (ill. 5) for many years and had collaborated with him on a number of prints after his pictures.[52] On 19 February 1825, Heath wrote to a mutual friend:

> I have just begun a most splendid work from Turner the Academician. he is making me 120 Drawings of England and Wales – I have just got four and they are the finest things I ever saw they cost me 30 Gins each and I have been offered 50 Gins each by two or three different Gentlemen. The Drawings, what is very unusual they will yield a Profit as much as the Plates, they will be engraved the size of the coast work of Cookes,[53] any one who has seen them says it will be the best and most lucrative speculation ever executed of that description. I mean to have them engraved by all the first Artists. Messrs Hurst & Robinson are to have half the work on condition they find all the capital necessary[54] – so that I have half the Drawings and half the Profits at no risk – I shall send you fine Proofs of course of the whole work. The Art of Engraving never flourished as it now does – there is so much doing that every Engraver is full . . .[55]

This letter makes it clear that Turner had more than financial reasons for committing himself to producing so many watercolours for engraving: if he had *only* been interested in making money, he could easily have obtained more for his watercolours by bypassing Heath and selling them directly to the collectors who were queuing up for them. Instead, he kept the collectors at one remove, because obviously he wanted to disseminate his images through the engravings and was prepared to accept less money for doing so.

The engraving of the 120 watercolours, on copper plates, was to be carried out by a number of engravers working under Heath's supervision, and there were no restrictions on the exact size of Turner's watercolours; all of them would be scaled down for the engravings. Unfortunately Heath does not tell us which four watercolours were with him by February 1825, although they may have included the *Saltash* (the only dated drawing in the entire 'England and Wales' series, dated '1825' (133)), *Knaresborough* (151) and *Bolton Abbey* (136).[56] But work on engraving the designs initially seems to have proceeded apace, for by April 1825 Heath was writing that he hoped to have the first print ready by the following July.[57] In the event, none of the engravings appeared that year – perhaps Turner was more demanding than Heath had anticipated over the quality of the prints – and in fact the first of the 'England and Wales' series engravings would only be published in March 1827.

An undoubted reason for the further delay was the bankruptcy of the printsellers and publishers Hurst and Robinson in January 1826 as a result of the huge economic crash of the preceding month.[58] Turner himself did not escape financial loss from that crash,[59] and Heath equally worried about how to finance the 'England and Wales' series because of it,[60] but his own fortunes were very buoyant at the time because of his publication of a series of immensely successful 'Annuals', illustrated gift books such as *The Keepsake* (to which Turner also contributed designs – see 132, 227 and 258) and

5 *Henry Courbauld after Mrs Dawson Turner,* CHARLES HEATH, *engraving, 1822.*

The Amulet. This success undoubtedly attracted financial support to his other schemes, and Heath soon found another firm, Robert Jennings and Company, who were prepared to market and distribute the 'England and Wales' series. However, it is clear that unlike the unfortunate Hurst and Robinson who had been prepared to put up *all* the capital for the venture, Robert Jennings only accepted responsibility for half the financing, Heath being responsible for the other half; this would have unhappy consequences later, when Heath's finances became generally over-extended and he found himself incapable of supplying his half of the money for the venture.[61]

By the middle of 1825 three parts of 'The Rivers of England' had appeared and the fourth part was well in hand. Encouraged by this, Thomas Lupton also conceived the idea of publishing a partwork with Turner, rather than just acting as a journeyman-engraver for W. B. Cooke.

THE PORTS OF ENGLAND 1825–28 (102–113)
Lupton proposed yet another set of marine subjects, originally to be called 'The Harbours of England' (the title was changed when the work was published). This was to appear in twelve parts with two prints per part, and Turner eventually made some fifteen or sixteen of the twenty-five commissioned watercolours for the scheme (including the wrapper vignette, ill. 6). Lupton sought and received permission to dedicate the work to George IV and issued a patriotically worded prospectus announcing the series.

The first part of 'The Ports of England' appeared in May 1826, as did the final part of the 'Southern Coast' scheme. Originally the Cookes had intended to engrave the entire 'Southern Coast' series themselves but eventually they were forced to call upon other engravers to assist them, and had they not done so it seems unlikely that they would ever have completed the work. After the publication of the final part W. B. Cooke then had the letterpress and all the prints bound (in a sequence corresponding to their topographical order, from Whitstable in the east to Watchet in the west) and re-published the work in book form.

The discussions between Turner and the Cooke brothers about the continuation of the 'Coast' work up the eastern seaboard led to violent quarrels in the autumn of 1826. The Cookes had hoped that Turner would make a further forty designs for the east coast scheme (as well as ultimately another forty for each of the north and west coasts,

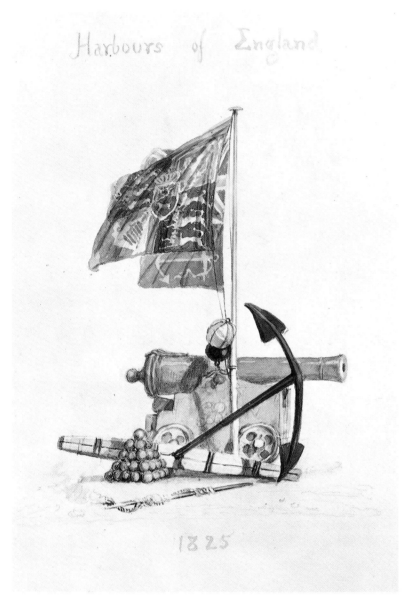

6 VIGNETTE FOR THE DESIGN ON THE WRAPPER OF 'THE PORTS OF ENGLAND', *indian ink and grey wash on paper, 30 × 21.1 cm (11⅞ × 8¼ in), Fitzwilliam Museum, Cambridge. As can be seen, Turner's original title for this series was 'Harbours' rather than 'Ports of England'. However, when the vignette was engraved in 1826 it did not include a title and when the series was published it was known as 'The Ports of England'. The publisher reverted to the use of 'Harbours' in the title when the series was reprinted in 1856. The engraver of this design is unknown but a proof in the British Museum includes pencil instructions by Turner, so it was probably Thomas Lupton, who was responsible for engraving the rest of the series.*

for the 'Southern Coast' drawings, a sum that would have totalled one hundred and six pounds. W. B. Cooke could not accept this.

But far more serious for Cooke, however, was Turner's demand that he should be supplied with twenty-five of the finest India-paper proofs of each print. This put the engraver in a financially impossible position, since the number of good (and therefore saleable) impressions produced from copper plates was severely limited by the softness of the metal: each plate would probably only produce about two hundred impressions before it would have to be re-worked, and if Turner was to siphon off the best prints, then Cooke's profits would have been seriously reduced. Turner's demand for the retroactive payment of increased fees was not totally unreasonable, as Cooke had obviously made a fair amount of money out of him over the years (although he also took the risks), and in any case, Charles Heath was simultaneously paying Turner thirty guineas for each, admittedly larger drawing for the 'England and Wales' series. Moreover, Heath had had no objection to supplying Turner with thirty proofs.[64] But in this respect W. B. Cooke proved himself to have been a better businessman than Heath, for unlike the latter he never ruined himself.

Both Turner and William Cooke refused to make concessions and relations were acrimoniously broken off. It was probably also at about this time that Turner argued publicly with George Cooke over the proofs of an engraving[65] made for the 'Southern Coast' by Edward Goodall:

[Turner] caught sight of George Cooke . . . and immediately began a very heated argument with him, claiming his right to the touched proofs. This claim George Cooke stoutly refused to concede.
'How can you justify such a demand? Tell me frankly why you asked for them?'
'Oh' said Turner, 'supposing it be only a whim?'
'I will humour no man in his whims,' answered George Cooke.
'Then, sir,' retorted Turner, 'you shall have no work of mine to engrave.'
Hotter and hotter grew the dispute, till George Cooke gave it its finishing touches.
'Sir' quoth he, 'I'll not engrave another of your pictures as long as I live.'
Turner flounced out of the room in a great passion . . .[66]

George Cooke then approached Goodall and told him not to give in to Turner's demands. However, Goodall had to visit Turner the very next day about another plate he was engraving[67] and he and Turner also quarrelled about the proofs:

Goodall refused to give them up and even half thrust them into the fire when the blaze caught them. Turner, whose chimney was never swept, ran with shovel and tongs to save the house, exclaiming, 'Good God! You'll set the house on fire'.[68]

These quarrels were to have a further repercussion, for clearly Turner then decided to publish the continuation of the 'Coast' scheme himself.

PICTURESQUE VIEWS ON THE EAST COAST OF ENGLAND *circa* 1827 (121–130)
Turner made four vignettes and six rectangular drawings for this series, all in bodycolour on blue paper. Three each of the vignettes and the rectangular drawings were engraved by J. C. Allen but two more plates were left unfinished. Contrary to his declarations to Cooke, Turner obviously did not have the time or the inclination to act as his own publisher any more.

Turner also quarrelled with Lupton; as Ruskin tells us, 'they petted each other with reciprocal indulgence of delay'.[69] In the end the painter refused to collaborate with Lupton any further. As a result of their break, Lupton was also unable to continue a mezzotint for the 'Marine Views' series of the 1824 *Twilight – Smugglers off Folkestone* (245) and the further publication of 'The Ports of England' series became impossible. By 1828 six works for this series and the title-page vignette had been completed. Lupton printed the plates he had in hand and sold most of the impressions,[70] as well as keeping the plates and reprinting from them in 1856 after Turner's death. At that time he also printed the other six uncompleted plates exactly as he had abandoned them in

thus totalling some 160 watercolours for the entire coast project[62]). Turner wanted more money for the new drawings, asking the engraver 'do you imagine that I shall go to John O'Groats's House [i.e. continue up the east coast to the north of Scotland] for the same sum I received for the Southern part?'[63] Cooke had therefore offered Turner twelve and a half guineas for each design made for the new series, an increase of two and a half guineas over the sum received by the painter for works in the 'Southern Coast' scheme. However, Turner wanted this difference to be paid to him retroactively

1828. The reprint was produced in collaboration with Ruskin who wrote a commentary for it, reverting to Turner's original title for the scheme, the 'Harbours' (rather than the 'Ports') of England'. In the mid-1830s Turner and Lupton apparently patched up their differences.[71]

Naturally, with the cessation of relations between Turner and the Cooke brothers in 1827, Turner's participation in the 'Rivers' series also came to an end. W. B. Cooke bound together all the unsold prints that had already been produced, and published them in 1827 under the collective title of 'The River Scenery of England'. By then the work included fifteen engravings after watercolours by Turner, and three additional plates were either uncompleted or cancelled due to imperfections in the metal. Immediately after the break with Turner, W. B. Cooke attempted to float the idea of an east coast venture without the painter's participation and advertised the scheme in the *Examiner*,[72] but it quickly became apparent that unless Turner contributed to the venture it had little chance of public success and the idea was soon dropped.[73]

Thus Turner's sixteen-year-long relationship with the Cooke brothers came to its sorry end. Between them, William Bernard Cooke and George Cooke had commissioned and directly engraved some forty-nine designs by Turner, and had additionally commissioned and been responsible for the engraving (by others) of upwards of another forty of his works. It was perhaps inevitable that their collaboration should terminate so badly. W. B. Cooke was both unreliable and over-ambitious, while Turner's growing preoccupation with money and his desire to amass large numbers of the proofs of his engravings made working with him very difficult. Yet all was not loss. Even if their joint venture did conclude on a sour note, their work together had enabled Turner to concentrate his range and produce important groups of drawings that display a greater continuity of ideas and certainty of purpose than had his previous watercolours. Moreover, in 1811 Turner had only just begun to take an interest in the creative potential of line engraving. By 1827 he had mastered its techniques and imbued the medium with a richness of expression hitherto absent from landscape subjects. The 'England and Wales' series was already enjoying the full benefits of such an involvement, as would the many other series of prints that Turner was to be concerned with until the 1840s. By affording the painter the chance to test different forms of engraving, and by constantly pressing him to produce new works on their behalf, the Cooke brothers had both advanced the art of landscape engraving and indirectly made a significant contribution to Turner's development as a watercolourist.

Of course, not all of Turner's relations with print-publishers and engravers were stretched beyond breaking point by 1827. Thus his relationship with Charles Heath appears to have been very healthy at this time, and in 1827 the first parts of the 'England and Wales' series began to appear fairly regularly three times a year, each part consisting of four engravings, the prices of which varied from a guinea and a half per part for proofs on India paper, to fourteen shillings per part for ordinary proofs. Nineteen engravers were eventually employed in producing the prints, and some cut as many as thirteen or fourteen plates each. Although the engravers were paid an average of one hundred pounds per plate, the job might take up to two years, and the work was tiring and tedious; as a vivid description of the common lot of Turner's engravers tells us: 'few have lived more solitary or more laborious lives. Bending double all through a bright, sunny day, in an attic or close work-room, over a large plate, with a powerful magnifying glass in constant use; carefully picking and cutting out bits of metal from the plate, and giving the painfully formed lines the ultimate form of some of Turner's most brilliant conceptions; working for twelve or fourteen hours daily, taking exercise rarely, in early morning or late at night; ''proving'' a plate, only to find days of labour have been mistaken, and have to be effaced and done over again . . . such is too commonly the life of an engraver.'[74]

In order to stimulate the sales of the 'England and Wales' engravings, in early June 1829 Charles Heath rented the Large Gallery in the Egyptian Hall, Piccadilly (ill. 7) and mounted an impressive display of all the prints to date, along with many of the watercolours from which they had been made. Some thirty-five 'England and Wales' watercolours were on show and the surviving handlist of exhibits[75] demonstrates that sometimes they were made long before they were copied as engravings, for two of them – *Plymouth* (180) and *Richmond Hill and Bridge* (176) – were not to appear in

engraved form for another three years. Unsigned reviews of the exhibition appeared in *The Examiner* (14 June), *The Atlas* (7 June), and *The Athenaeum and Literary Chronicle* (3 and 10 June). In the second of its linked reviews, the latter paper was sympathetic to Turner's elevation of imaginative (or 'poetic') reality over mundane appearances, and the review also affords us a helpful insight into Heath's power of veto as to which works would be engraved in the 'England and Wales' series:

> The proprietor of [*Stonehenge, 157*], Mr H. Charles Heath relates a pleasant story respecting it. Mr Turner . . . asked him if he would take it for one of the views of England. 'Stonehenge! such a subject!' 'But you may as well see it.' 'It would be of no use; the subject would never do.' Other drawings were proceeded with; on the back of one of these, Mr Heath happened one day to cast his eye on the 'Stonehenge'; but he no longer objected to the subject, bad as he had deemed it. He eagerly purchased the drawing; and few, we are assured, are they who will condemn this change of resolution. The subject all will own was an ungracious one; but this very defect has served to display the talent of Mr Turner.

By the summer of 1830 some thirty-six of the engravings had appeared and it has been suggested that Turner had completed the first fifty watercolours.[76] Originally the painter may have planned to visit the Continent that year, as in previous years, but revolution broke out in Paris on 27 July and in Belgium (against the Dutch) on 25 August, so prudently he decided to tour the Midlands instead, probably starting out in late August, after the General Election, and returning to London sometime in October (we know he was back in London on 1 November). Amongst other places he visited Oxford, Kenilworth, Dudley, Worcester, Chatsworth and Northampton, obtaining material for a further fourteen 'England and Wales' series watercolours.[77]

In the next few years Charles Heath made other attempts to promote the sales of the engravings. Thus in January 1831 he displayed a selection of the prints and drawings at an 'Artists' and Amateurs' Conversazione' at the Freemason's Tavern. But far more ambitious was the show he mounted of 'England and Wales' series watercolours and prints two and a half years later. This took place at the Moon, Boys and Graves Gallery at 6 Pall Mall in June and July 1833, and with sixty-six drawings on display it must have looked dazzling. The show opened on 8 June 1833, and in the gallery was an open subscription book for the engravings, which finally listed 100 subscribers (most of whom unfortunately later failed to take up their subscriptions).[78] Turner was second on the list, committing himself to purchasing '2 Columbier Folios before letters', doubtless to help get the ball rolling. Others who put their names down included John

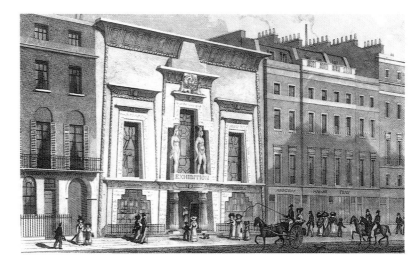

7 The Egyptian Hall, Piccadilly, the venue of the 1829 exhibition. It was demolished in 1905. British Museum, London.

Martin, the painter, Cyrus Redding and George Cooke (who perhaps had become reconciled with Turner by now). Towards the end of the exhibition an informal 'conversazione' was held in the gallery, on Wednesday, 3 July, at 8.30 pm, and *The Times* of two days later tells us that the rooms were brilliantly lit and that nearly 'two hundred artists and literati' attended. A later memoir also informs us that 'Turner himself was there, his coarse, stout person, heavy look and homely manners contrasting strangely with the marvellous beauty and grace of the surrounding creations of his pencil'.[79]

The exhibition was reviewed by the Press, although the *Observer* (16 June) did not care for it much, mentioning the tedium of seeing too many Turners together: 'the general effect is "terribly tropical", *hot, hot, all hot* and though full of talent and fine effects, very unlike the hue and truth of nature'. But other reviewers were kinder. For example, *The Athenaeum* (15 June) said of the show '. . . these drawings are of a beauty for which we can find no parallels', while *The Atlas* (16 June), *The Sunday Times* (23 June) and *Arnold's Magazine* (August) also mentioned the show sympathetically.

Yet despite the overall critical success of the exhibition, the engravings were by now only appearing in two parts per year and the whole business was becoming increasingly unprofitable. Indeed, the failure of the venture had started to become apparent even before 1833. In 1831 Robert Jennings (who had gone into partnership with William Chaplin) had sold out his half-share in the scheme to the Moon, Boys and Graves Gallery (hence the 1833 show there), while at about the same time most of Heath's commitments regarding *The Keepsake* and his other 'Annuals' were taken over by Longman who became responsible for supplying all the capital that was needed to produce them. This became necessary because Heath was caught in a financial vicious circle with the 'England and Wales' series: as a result of the low sales of the prints, he was starved of the cash he needed to keep the engravers going, and thus there were endless delays in production and a consequent further loss of sales. All this had diverted Heath's finances from supporting the production of the 'Annuals' and necessitated the takeover by Longman. In order to try and break this cycle, on 27 February 1834 Heath attempted to borrow £1500 to move things along more rapidly but only succeeded in raising £600.[80] Nor was he helped by problems amongst his partners in the scheme. At the beginning of 1835 Sir Francis Moon split with Boys and Graves, his place being taken by Richard Hodgson. Within a few months Hodgson and Graves quarrelled,[81] Graves departed and in May 1835 Hodgson sold off the gallery's half-share in the 'England and Wales' enterprise to Longman.[82] Doubtless it was the continuing profitability of the 'Annuals' that persuaded them to invest in the 'England and Wales' series, but even their involvement did not prevent the failure of the scheme.

A principal reason for the failure was Turner's insistence upon using copper plates for printing the engravings, rather than steel plates. (It will be remembered that copper wears down much more quickly and therefore produces fewer, and necessarily more expensive impressions than steel plates.) As a result, the engravings could not compete in price with the many cheaper cuts being printed off steel plates that were now flooding the market. Moreover, the public often only received the poorer later impressions of the prints, Turner having creamed off the best early proofs in large numbers. And ironically, Turner was also the victim of his own earlier success with the 'Southern Coast' and other series, for by the mid-1830s the public were becoming surfeited with topographical engravings. By mid-1836 Heath decided to lessen the number of prints to be produced – now there were to be ninety-six rather than the original one hundred and twenty – although because of his continuing cash difficulties, even then it took two more years to publish the final parts of the 'England and Wales' series. By 1836 Turner had created about a hundred 'England and Wales' drawings, including some that were never engraved, works like *Merton College, Oxford* (224), *The Burning of the Houses of Parliament* (209) and *Northampton* (190) which was exhibited in the 1833 show.

In 1832 Moon, Boys and Graves had collected the initial sixty engravings together (i.e., the projected first half of the scheme as originally envisaged) in book form and issued them with their letterpress which had been penned by H. E. Lloyd, a prolific travel writer and translator who also wrote the catalogue entries for the 1833 exhibition.[83] In 1838, after the final part of the scheme appeared, Longman had the ninety-six engravings re-bound into two volumes with the additional letterpress by Lloyd. The response was negligible, and this was the end of the 'Picturesque Views in England and Wales' series. Heath was financially ruined, although he was not formally declared bankrupt,[84] and probably came to an agreement with his creditors to pay off his debts gradually. Principal amongst those creditors was Longman who took a tolerant attitude towards Heath as his other publications, such as *The Keepsake*, were still highly profitable, and he went on working for them almost up until his death in 1848. In April 1840 Heath sold off his own sets of proofs of the engravings at Sotheby's.[85]

In order to recoup their losses, Longman tried to sell off the entire 'England and Wales' property to H. G. Bohn, a dealer in publisher's remainders and cheap offprints, for £3000. He offered only £2800, so they put the stock up for bidding at Southgate's auction rooms in Fleet Street on 18 June 1839. Included in the sale were several hundred copies of the bound sets of prints and the ninety-six copper plates:

> . . . after extensive advertising, the day and hour of sale arrived, when, just at the moment the auctioneer was about to mount the rostrum, Turner stepped in and bought it privately at the reserved price of three thousand pounds,[86] much to the vexation of many who had come prepared to buy portions of it. Immediately after the purchase, Mr Turner walked up to Bohn, with whom he was very well acquainted, and said to him: 'So, sir, you were going to buy my 'England and Wales', to sell cheap, I suppose – make umbrella prints of them, eh? – but I have taken care of that. No more of my plates shall be worn to shadows.' Upon Mr Bohn's reply that his object was the printed stock (which was very large) rather than the copper plates, he said: 'Oh! Very well, I don't want the stock. I only want to keep the coppers out of your clutches. So if you like to buy the stock, come and breakfast with me tomorrow, and we will see if we can deal.'
>
> When Mr Bohn presented himself at nine o'clock the next morning, the artist, giving no thought to the breakfast to which he had invited, unceremoniously enquired: 'Well, sir, what have you to say?'
>
> 'I have come to treat with you for the stock of your "England and Wales" ', was the answer.
>
> 'Well, what will you give?' was the sternly definite demand. It was then explained that in the course of the previous negotiation the coppers and copyright had been valued at £500; so that £2500, the balance remaining after deduction of that sum, would be the amount to be handed over to the painter. 'Pooh,' was the contemptuous reply; 'I must have my £3000 and keep my coppers; else good morning to you;' and thus the interview closed.[87]

The engravings and plates mouldered for many years in Turner's house in Queen Anne Street, and eventually they were auctioned off long after his death, at Christie's on 24 May 1874, when the plates were destroyed to preserve the value of the prints. Turner's wish to prevent the plates from being further printed until they were 'worn to shadows' was highly ironic, given that most of them were already worn out completely by the time they came into his hands.[88] The total cost of the venture may be estimated at somewhere between £15,660.50 and £17,700.[89] It is unlikely that it broke even[90] and Turner apparently only made a paltry £55.10s out of the scheme, the £3055.10s he had been paid over the years at 30 guineas each for ninety-seven drawings (including the unengraved *Northampton*[91]) being almost matched by the £3000 he paid to buy back the prints and plates at auction.[92]

Thus ended Turner's last attempt to disseminate his work in such a comprehensive way. Like all his other ambitious engraved partworks, such as the 'Richmondshire' series and the 'Southern Coast' scheme, the project ended in financial disaster for its publisher. But if the 'Southern Coast', 'Richmondshire', 'England and Wales' and other series discussed above were all to some extent financial failures, in every other respect they were successful, for they brought into being not only sets of landscape engravings that remain unequalled; they also called forth watercolours that are unsurpassed in their range and power.

THE WATERCOLOURS

The years between 1810 and 1836 formed the central phase of Turner's life, and the watercolours discussed in these pages played a vital role in the artist's development during that period. They certainly gain much from being seen together, for over the 1810–36 period we can witness a profound deepening of Turner's understanding of what he painted, and a growing inventiveness in the way he articulated that comprehension. The enhanced understanding is apparent in the increasingly idealized depictions of the constituent elements of landscapes and seascapes, such as trees, cloud forms and waves, while the greater inventiveness can be seen both in the painter's responsiveness to colour, tone and paint-handling, and in the increasingly subtle ways in which he elaborated the underlying truths of place, those social, cultural and economic factors that governed their existence. But before we go on to examine some of the main currents running through the works, it may be worth briefly outlining Turner's career during the years in which he made them.

The five or so years after 1810, from whence date the earliest of the Sussex drawings and the 'Southern Coast' series watercolours, saw Turner progress from strength to strength in paintings such as *Hannibal crossing the Alps* of 1812, *Frosty Morning* of 1813 and the superb *Crossing the Brook* of 1815. With *Dido building Carthage* of the same year, Turner arrived at complete maturity. He regarded the picture as his 'chef d'oeuvre' and always refused to sell it, even at one time requesting that it should be used as his winding sheet upon his death (fortunately he was later persuaded to change his mind, and instead willed the work to the National Gallery, to hang alongside a seaport scene by Claude).

In 1817 Turner travelled abroad for the first time in fifteen years, and in the 1818 Royal Academy show he exhibited the most impressive products of that trip, *The Field of Waterloo* and the beautiful, Cuyp-inspired *Dort Packet-Boat from Rotterdam becalmed*. In 1819 he exhibited the magnificent *England: Richmond Hill* in which he paid homage to two of his favourite painters, Claude Lorrain and Watteau, and in that same year he visited Italy for the first time. The 1820s saw him assimilating and building upon the Italian experience in pictures such as *Rome from the Vatican* of 1820, *The Bay of Baiæ* of 1823 and the *Forum Romanum* of 1826. Much of 1823–24 was spent working upon the largest of all his pictures, *The Battle of Trafalgar*, one of the most stupendous battle scenes ever painted. This generally optimistic phase of Turner's life came to an end in the autumn of 1825 with the death of Walter Fawkes, who was only six years older than the painter himself.

Other deaths in Turner's immediate circle followed, including that of his father in September 1829. Yet although death frequently raised its head in Turner's pictures after that time (as it had done earlier as well), the artist was generally too resilient to be downcast or pessimistic for long, and during the 1820s and '30s he produced some of his most brilliant, life-enhancing works, pictures like the views of Mortlake terrace, Dieppe and Cologne of the mid-1820s, as well as the painting that Ruskin saw as 'the central picture in Turner's career', namely *Ulysses deriding Polyphemus* of 1829. During the 1830s Turner publicly demonstrated his virtuosity by painting works in front of his fellow-artists at the Royal Academy and British Institution exhibitions, and in 1833 he displayed the first of his many oil paintings of Venice, a city that increasingly came to dominate his later responses to Italy. And throughout the entire decade he painted masterpiece after masterpiece. These include pictures of every type of scenery and subject, from remote Scottish caves to the burning of the Houses of Parliament, and from illustrations of poetry and the landscapes of the Bible to violent storm scenes. Perhaps the supreme masterpiece of the decade was his best-known and best-loved work, *The Fighting 'Temeraire'* of 1839.

It was within such a broad context that Turner made the many series of topographical watercolours surveyed here (along with several others treating of Scottish and Continental scenery). Clearly he liked the idea of making images in series, for designs that were linked together by some unifying title gave him not only a sense of dramatic purpose but also a means of demonstrating his immense range, if not even a way of expanding that capacity. Conversely, public comprehension of that range

necessarily disappears if the works are not considered serially, and such a consideration perhaps explains why Turner placed so much store on reproducing his works through series of engravings: even if the groups of watercolours were broken up, as they mostly were, nonetheless their creator could still demonstrate his immensity of vision through the sets of prints.

The 'Southern Coast', 'Ports of England', 'Marine Views' and 'East Coast' watercolours are, of course, predominantly sets of seascapes, and marine subjects also appear frequently in 'The Rivers of England', 'Rivers of Devon' and 'Picturesque Views in England and Wales' series. Indeed, the latter series contains some of Turner's very greatest portrayals of the sea, watercolours such as the immensely powerful and bleak *Longships Lighthouse, Lands End* (208) and *Lowestoffe* (213) which date from the mid-1830s. Between 1810 and 1823, however, Turner's response to the sea was generally optimistic, a reflection, indeed, of his wider outlook on life. Conspicuously absent during that period was the concern with shipwrecks that had earlier contributed so much to the growth of his reputation: after painting *The Wreck of a Transport Ship* around 1810, nine or so years were to pass before he exhibited another painting of a shipwreck and that picture merely displays the results of poor seamanship, its crew being in little danger. A drawing such as the *Loss of a man-of-war* of around 1818 is exceptional, while only one watercolour in the 'Southern Coast' series depicts a shipwreck, and that relegates suffering humanity to the distance (*Ilfracombe*, 233). There is, of course, plenty of stormy water around but during the 1810s Turner preferred to take a more hopeful view of things, his ships either sailing past dangerous rocks with relative equanimity (*The Mew Stone*, 25) or being warped into the safety of harbour (*Boscastle*, 44 or *Bridport*, 33). Only in 1823 did the painter again represent mankind being overwhelmed by the sea, in *A Storm (Shipwreck)* (98), and there he gave us savagery with a vengeance, the sea swirling with a quite cataclysmic power. Further stormy seas that either threaten to engulf mankind or have done so followed in the 'East Coast' and 'England and Wales' series, and by the mid-1820s such subjects once again resumed the normal, regular frequency of appearance that they had enjoyed in Turner's art during the early 1800s.

It is perhaps not surprising that Turner should have been attracted to making series of 'picturesque' views, for perhaps his earliest encounter with the representation of landscape had been through a set of such images. When he was merely eleven or twelve years old he was paid twopence a time by a Brentford distillery foreman, John Lees, to colour the engraved plates in a new topographical work entitled *Picturesque Views of the Antiquities of England and Wales* by Henry Boswell, published in 1786. This book contained a letterpress and a large number of engravings, by various artists, of 'picturesque' scenes.[93] Turner hand-tinted seventy of them, often to imaginative effect, especially in the skies, and fifty-eight of those tintings are of *exactly* the same subjects as may be found in his own later 'Picturesque Views in England and Wales' series. The similarity of the two titles is obvious, and given Turner's prodigious memory, it seems very possible that he remembered Boswell's tome when he came to make his own work.[94] But certainly the comprehensiveness of Boswell's book was matched by Turner's comprehensiveness in his own later collection of topographical designs.

Series of drawings made for engraving also clearly afforded Turner a means of extending himself, for he always imbued such groups of watercolours with separate sets of characteristics. Thus he painted the 'East Coast' works in gouache on blue paper, even though the preceding 'Southern Coast' drawings had been made in transparent watercolour on white paper. This typical change of medium and support was obviously a useful way of distinguishing each group of works, but another important rationale may be discerned in it. Differing types of paint or paper posed different technical problems; facing those challenges opened up new expressive and intellectual horizons, which simultaneously prevented Turner from becoming stale.

The responsiveness to challenge could equally determine questions of size, although such considerations usually also reflected the purpose for which works had been made. For example, Turner made consistently large watercolours for Jack Fuller. Their

dimensions partially derived from what Fuller was prepared to pay for them, partially from the requirement that the aquatints of the initial group should be large (they are almost identical in size to their watercolours[95]) and partially from the fact that the wide Sussex vistas they represent demanded such a size to accommodate them; to make those landscapes seem even larger, Turner only sparsely populated them. Likewise, the 'Southern Coast', 'Rivers' and 'Ports' watercolours were all geared in size to the specific needs of the engraver and reflected the fact that the engravings from them were all to be extremely small; to save the engravers trouble in scaling the images down, Turner made them to the correct dimensions (although again, what the Cookes or Lupton were willing to pay for them undoubtedly also determined their size). The special miracle of the later 'Southern Coast' drawings, and of all the watercolours in the 'Rivers' and 'Ports' series, is that they pack a huge sense of scale and an immense and exquisitely wrought amount of detail into each tiny space. To an artist who throughout his life demonstrated an avidity for challenge, these problems of technique, size and characterization must have seemed welcome. Landscape subjects had to be selected and tailored to fit each confine, and every series had to be imbued with its own set of formal identifications and qualities. Finding this identity engendered a continuous process of creative renewal.

As he matured, Turner also imbued each series of designs with a greater beauty of line, a more complex sense of structure, a growing richness of colour and an enhanced depth of meaning. To take the first, the beauteousness of Turner's line markedly increased during the 1810–15 period and this intensification may have derived from the painter's reading at a slightly earlier date of William Hogarth's book, *The Analysis of Beauty*, wherein is set out the notion that serpentine lines are a major psychological source of our experience of beauty.[96]

Depending on the purposes to which he put his lines, from the early 1810s onwards subtle undulations invest Turner's pictures with increasing gracefulness or energy. Thus in the 'Southern Coast' drawing of *Plymouth Dock* of around 1813, there is a new-found grace of line in the shapes of the trees on the left, while in *Rye* (38), made for the 'Southern Coast' series around 1823, the lines charge the inrushing flood tide with a powerful sensation of ebb and flow. Turner's beauty of line is seen most often, of course, in the rhythmic movement of water, but it is also encountered in the patterns of smoke, the shapes of trees and sails, and the curves of clouds or rocks.

Coupled with this increasing inventiveness of line was the growing contribution that lines make to the enforcement of structural unity, as well as to the expression of meaning (we shall examine the latter contribution below). Throughout the 1810s Turner explored the role that lines can play in tying works together,[97] and he was particularly inventive with such underpinnings in the 'England and Wales' series drawings – indeed, he appears to have made them a particular feature of those watercolours. The devices include a unifying V-line, to be seen in *Lancaster Sands* (150), *Walton Bridge* (170), *Tamworth Castle* (186), *Longships Lighthouse* (208), and *Prudhoe Castle* (143), with its overlapping inverted repetition of them. There is also the widespread employment of an X-device, as in *Barnard Castle* (142), *Dartmouth Cove* (137) or *Eton* (178). And equally forceful are the arabesques that lend both cohesion and dynamism to Turner's landscapes, as in *Launceston* (141), where our experience of the immense central void of the image is clearly created by the encompassing form.

Turner's sense of colour also continuously developed during the 1810–36 period. For example, the 1810 group of Sussex watercolours (1–4) demonstrates a limited palette of hot earth colours such as raw umber and burnt sienna, as well as green and Prussian blue. The overall effect is slightly crude and unintentionally suggests heat. By 1816 however, when Turner drew *Pendennis Castle* (29), we can see how far he had developed in a very short time. By now the painter avoided the earth colours, and instead set off the cool blues and greys of the distance by filling the foreground with their complementaries, some of the hottest colours in the spectrum: gold-yellows, reds and pinks. Yet those colours do not evoke heat at all; rather, the greater purity and better balance of colours precisely evokes the sense of cold air coming off the sea. Moreover, during the 1820s Turner achieved a far greater balancing of polarities, so as to obtain a maximum contrast within a small space. Such a balance gives his watercolours an extraordinary, almost jewel-like brilliance, especially the 'Rivers' and

'Ports' drawings, works including *Norham Castle* (81) and *Dartmouth* (82). The wealth of colour in such designs is also often enhanced by a constant optical flux of minute stipplings across the surface, an effect Turner may have appropriated from portrait-miniature painting. By the mid-1830s, when he made watercolours like *Kidwelly Castle* (214) for the 'England and Wales' series, the artist was capable of creating quite unearthly conjunctions of colour. And also inextricably linked to the development of colour was the development of tone. As Turner's range as a colourist grew, so too did his need to control tone with the utmost exactitude, and he was undoubtedly influenced in this by his collaboration with the Cookes and other engravers, for the absence of colour in the engravings demanded a compensatory emphasis on tone that eventually broadened the tonal range of both his watercolours and oils.

Yet in addition to constantly enriching his works with enhanced formal and colouristic qualities, Turner also imbued his images with a greater richness of meaning, and it is here that we come to the most profound but subtle area of his development during the 1810–36 period.

Turner is frequently celebrated as a precursor of French Impressionism, which he was, and by a small step of false logic, as an Impressionist himself, which he was not. His attitude towards landscape painting differed totally from that of the French Impressionists, even if it did lead him to visual conclusions superficially similar to those of their pictures. Instead, Turner was wholly an academic idealist and, indeed, he was one of the great idealists of Western art. The effects of that idealism can be seen throughout his art.

The painter had been affected by artistic idealism from the time of his studentship at the Royal Academy Schools in the early 1790s, but in the years leading up to 1811 that idealism received fresh impetus, for just as he was making the first of his watercolours for Fuller and the Cookes, he was also simultaneously bringing to fruition his most concentrated period of thinking about artistic idealism to date. At the end of 1807 Turner had been appointed Professor of Perspective at the Royal Academy, and over the following three years before he delivered his first set of lectures in the R. A. Schools, he undertook an intense study of aesthetics and art history. The lectures that commenced in January 1811 and which he gave most years until 1828 (although he did not resign the professorship until ten years later), were not a huge success with his audiences, as Turner was not a good speaker, and in any case he did not limit himself to the study of perspective. Instead, he ranged over a wealth of subjects from aesthetics to optics, and from the mechanisms of poetry to the specifics of how past masters had used landscape (and thus perspective) in the backgrounds of their works. Understandably, his audiences were for the most part mystified, given that they had presumably attended in order to learn of the workings of perspective. Yet the lecture manuscripts (now in the British Library) afford a matchless insight into Turner's thinking about the nature and purpose of art, for despite the opacity of his language, what he was attempting to say is abundantly clear.

Idealism was the aesthetic keynote of Turner's lectures, for he followed his great mentor, Sir Joshua Reynolds, in fully embracing the academic theory of poetic painting. Essentially this held that on its highest level painting is akin to poetry; that like epic poetry, painting should be concerned with the doings of mankind, not only demonstrating our actions but, more importantly, exploring our motives; and, above all, that painting should deal not with mundane appearances but with the immutable, essential truths of things, the concepts of truth, beauty and the ideal all being considered synonymous. Reynolds gave landscape painting a fairly low place in his artistic scheme of things because for him a landscapist merely viewed and represented a scene under arbitrarily determined conditions of light and weather, what he called the 'Accidents of Nature'. Although he conceded that Claude Lorrain had created an ideal landscape art, he did not think the genre capable of much complexity, and certainly not those dimensions of humanistic meaning that the 'higher' forms of art, such as history painting, could express. Turner proved him wrong by imbuing landscape painting and marine painting with all the degrees of human motivation, intellectual complexity and idealism that poetry possesses. And obviously because he had been thinking in such a concentrated manner about idealism between 1807–11, in the half-decade after 1810 Turner began to express that idealism with renewed intensity.

Idealism is certainly apparent in the pictures that Turner made before 1810, for even in the 1790s he had given deep consideration to expressing what he variously described as the 'Ideal beauties' and 'qualities and causes' of things.[98] This meant articulating the underlying dynamics of wind and wave motion, the structures of rocks and clouds and what had shaped them, and the fundamental constants of human behaviour as determined by geographical, cultural and historical considerations. As far as the representation of the sea is concerned, even by 1801, when he painted his first truly great marine picture, the so-called 'Bridgewater Seapiece', Turner had expressed his apprehension of the fundamental dynamics of wave motion. His perception of geological fundamentals equally matured around the same time, fed by an already mature comprehension of the fundamentals of human architecture and augmented by his opportunities to analyse complex rock formations in Wales, Scotland and Switzerland, which he visited respectively during the 1790s, 1801 and 1802. Throughout the late 1790s Turner's comprehension of the 'qualities and causes' of cloud structures also matured, so that any mannerism in his representations of clouds had generally disappeared by about 1802. Only his tree forms remained fairly mannered throughout the 1800s, but around 1810 those too began to change, now being imbued with a greater understanding of the fundamental mechanics of arboreal form.

For example, in the four Sussex landscapes of 1810 (1–4) the trees are finely rendered but nothing of their inner life is conveyed. Thus the oak tree in the foreground of the 1810 *Beauport* (3) still manifests a mannered, eighteenth century stylization, the branches displaying those little curlicues and slight exaggerations that one sees throughout late eighteenth-century tree painting and in Turner's early work particularly. There is also a dichotomy between the form of the tree and its foliage; the one seems imposed upon the other. Only a few years later, however, this dichotomy had been resolved: by 1816, when Turner made *The Vale of Ashburnham* (10), he had found a way of marrying trunks, boughs and foliage with a new-found interdependency. And by imbuing the trees with an enhanced sinuousness of line and through more clearly differentiating internal shapes, he now became capable of also strongly suggesting their inner processes of growth, the truth of form or ideal beauty of each tree. By the time he came to make *Kirkby Lonsdale Churchyard* (70) around 1817, or *Bolton Abbey* (136) around 1825, Turner's tree forms had come to seem consummately ideal, and because they are often the dominant objects in the designs, they equally impart the sense that we are looking at an ideal world around them.

Naturally, Turner could never have arrived at such universals of form without having studied particulars with the utmost intensity. There are upwards of 10,000 sketches in around 300 sketchbooks in the Turner Bequest in London, and the artist's lifelong habit of drawing everything and anything served him well, providing him with a massive library of source material. But the act of drawing also fulfilled a secondary function, namely the training of memory. Turner had an unusually retentive memory (which he kept honed by constant sketching) and it provided an especially useful means through which he could arrive at the ideal, for of course memory constantly sifts the essential from the inessential, the important from the accidental. Thus Turner's works are full of weather and lighting effects that probably in reality he witnessed far away from the places in which they end up in his pictures; there was no better way of transcending the 'Accidents of Nature' or arbitrariness of experience than to redeploy such effects, and it was a method that had been practised by Claude and recommended by Reynolds. Turner's reliance upon memory can be seen at its most outstanding in works like *Louth* (160) where all the considerable staffage was added from memory to a topographical layout taken from a bare outline sketch made over thirty years earlier. The use of memory to supply staffage also explains why in many of the watercolours of ports and harbours made during the mid-to-late 1820s we see the military personnel and shipping Turner could only have witnessed when he had visited those towns during the Napoleonic wars over ten years earlier. And memory certainly did the artist proud with the 'Richmondshire' drawings, for although he mostly portrayed scenes in which the sun shines (sometimes to glorious effect, as in *Kirkby Lonsdale Churchyard*, 70, and *Wycliffe, near Rokeby*, 62), he can rarely have seen the sun on much of his dismal, soggy tour of 1816. Here, as elsewhere, Turner represented things not as they were but as he wanted them to be, ideal worlds indeed.

Turner's method of making watercolours stemmed wholly from his idealism. The artist rarely painted out-of-doors, for in the time it took him to create one watercolour in the open-air he could make several in his studio. Usually he would select a line drawing of a subject that he might have made in one of his sketchbooks many years before, a sketch or study that almost invariably contained no indications of lighting, weather or staffage, thus leaving his imagination to invent such details or supply them from memory. Turner would then delicately transfer some of the outlines to the watercolour sheet before starting work:

> There were four drawing boards, each of which had a handle screwed to the back. Turner, after sketching the subject in a fluent manner, grasped the handle and plunged the whole drawing into a pail of water by his side. Then quickly he washed in the principal hues that he required, flowing tint into tint, until this stage of the work was complete. Leaving this drawing to dry, he took a second board and repeated the operation. By the time the fourth drawing was laid in, the first would be ready for the finishing touches.[99]

A further account of Turner's watercolour method has indirectly come down to us from the same witness:

> . . . [Turner] stretched the paper on boards and after plunging them into water, he dropped the colours onto the paper while it was wet, making *marblings* and gradations throughout the work. His completing process was marvellously rapid, for he indicated his masses and incidents, took out half-lights, scraped out highlights and dragged, hatched and stippled until the design was finished. This swiftness, grounded on the scale practice in early life, enabled Turner to preserve the purity and luminosity of his work, and to paint at a prodigiously rapid rate.[100]

This witness also recorded that the daughters of Walter Fawkes had seen cords stretched across Turner's bedroom at Farnley Hall with 'papers tinted with pink, blue and yellow hanging on them to dry'.[101] Those tints are of course the primary colours, and therefore the basics of colour. That Turner should have used them to underpin his works indicates yet another aspect of his concern with essentials, namely his desire to arrive at an idealism of colour, just as he aimed to express the ideals of form.[102]

Turner's idealism led him not only to perfect appearances of forms and phenomena, and to employ a synthesizing or sifting method, as well as an idealizing palette, with which to do so. Another, more subtle kind of idealism was also stated with renewed vigour after 1810. This was his response to the truth of place, which was inextricably linked to fundamentals of human behaviour and history. The inherant demands of topographical watercolours made for engraving had much to do with this type of statement, for such designs were anyway expected to include visual expositions of the human activity in the places depicted, references that could be augmented by an accompanying letterpress. Turner had celebrated the economic bases of life in the places he represented even in his very earliest topographical works, but during the 1810s he began to find far more subtle ways of expressing those truths, as well as the historic, economic and social essentials of place, drawing upon his already vast experience of inventing meanings in his more ambitious poetic and historical oil paintings in order to enrich the imagery of his watercolours and meet the demands of poetic idealism.

A good example is the drawing of *Battle Abbey* (4) made for Jack Fuller in 1810. Ostensibly we are simply looking at a landscape beyond two boys stoning a snake that is slithering towards a hole through which it clearly aims to escape. But Turner was well aware that Senlac Hill (upon which the Battle of Hastings was fought in 1066 and where the Abbey may be seen in the distance) was no ordinary hill, and he set out to elaborate what had determined events there and thus given the place its meaning. The associations of a repulsive creature approaching a hole, the confrontation between the boys and the snake, the similarities of the circular, flattened top of a tree-trunk to that of an eye, and of a forked tree-trunk to the V-shaped head of an arrow, were all surely intended to remind us of the fact that the whole course of British history had been decided by a violent confrontation on this very spot, and essentially by something V-shaped horribly entering King Harold's eye.

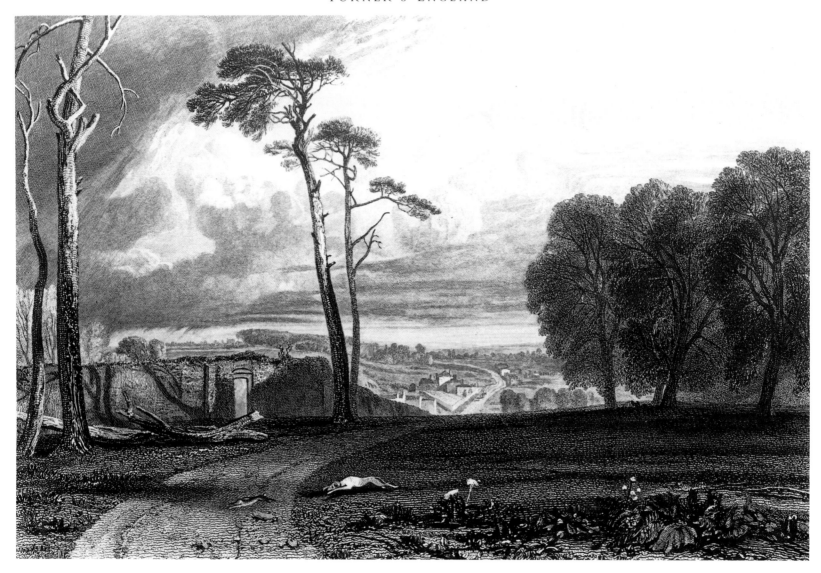

8 *W. B. Cooke after J. M. W. Turner*, BATTLE ABBEY, THE SPOT WHERE HAROLD FELL, *engraving, 1819.*

Such an interpretation is completely supported by the verbal insight that Turner himself later gave us into the meaning of another, closer view of the same location. This is *Battle Abbey, the spot where Harold fell*, a watercolour made for the 'Views in Sussex' scheme around 1815 that has now disappeared and is therefore represented here by W. B. Cooke's engraving made from it (ill. 8).[103] Battle Abbey was built on the site of the Battle of Hastings by William the Conqueror to celebrate his victory and the altar of its church supposedly stood on the spot where Harold was killed; it was demolished during the Reformation. At some point (probably in 1831) the watercolour was in Edinburgh when Turner visited the city, and his cockney accent was thought to be so amusing that it was recorded in an anecdote that also explains the underlying meaning of the design:

> Thomson[104] was examining this drawing with admiration when Turner called out, 'Ah! I see you want to know why I have introodooced that 'are. It is a bit of sentiment, sir! for that's the spot where 'Arold 'Arefoot fell, and you see I have made an 'ound a-chasing an 'are!'[105]

Turner amplified the associations of the impending death of the ''are' throughout the design.[106] In parallel with the direction taken by the animals, from right to left the trees

demonstrate the stages of death, being respectively in full leaf, semi-leafage and complete leaflessness through having been struck dead by lightning, while upon the most prominent of the dead trees Turner introduced a specific association of the manner of King Harold's death, for 'the blasted trunk on the left, takes, where its boughs first separate, the shape of the head of an arrow',[107] a visual pun that is reinforced by the great many forked branches on the left. And light adds to the 'powerful impression of melancholy and sadness'[108] in the scene, for a storm approaches beyond the long shadows being cast by the setting sun. This storm bears both its own poetic connotations of 'the storms of war' and brings darkness with it, for it will shortly blot out the light, just as the light of the hare will soon be blotted out forever.

Battle Abbey, the spot where Harold fell is not the only work discussed in this book where Turner vouchsafed us an insight into the typical thought processes that lay behind the metaphorical or punning deployment of his staffage and weather effects. He also admitted to using animals and light effects associatively to express the essential meaning of place in *Wycliffe, near Rokeby* (62), made for the 'Richmondshire' series

around 1817, where in a view of the supposed birthplace of John Wyclif he created an allegory of the birth of English religious and political liberty. But armed with the insights that the artist did verbally provide for these designs, we can confidently probe for covert levels of significance in a great many other images that furnish the requisite clues for believing that they contain such meanings, such as anomalies within the imagery, questions of motive in the staffage, and coincidences between details of that staffage and the historical background of the places depicted, as in *Battle Abbey, the spot where Harold fell* and *Wycliffe, near Rokeby*.[109] Turner was completely steeped in the techniques of poetic and historical painting, with its deployment of all kinds of visual puns (such as making a forked tree also stand for an arrowhead that is not visibly present), its use of similes or similarities between very different kinds of objects that are set before us, and its recourse to visual metaphors or allegories, where a meaning exists behind what we actually see.

Moreover, Turner also possessed a rich sense of narrative invention that can be encountered in many of the watercolours discussed in this book, works in which the painter often created a 'story-line' that is immensely complex. It was by the employment of visual puns, similes, metaphors and narratives, in addition to visual harmoniousness, that painting could most truly become poetic, and Turner was certainly aware of how verbal poetics and visual metaphors function, for he analysed the imaginative mechanisms of both poetry and painting in his perspective lectures.[110] By the time he came to make the 'England and Wales' drawings from the mid-1820s onwards, his work was full of these types of associative, imaginative and narrative meanings. But they were never 'imposed' on his imagery; instead, they determined it, and were often used to express the fundamental truths of place. The proof of this assertion is the fact that in addition to the devices cited above, Turner also employed pictorial structure to further the communication of meanings. Thus in *Walton Bridge* in the 'England and Wales' series (170), he employed linear divergence to express the effort of animals towing barges along the Thames, or in the watercolour of *Eton* in the same series (178) a basic X-structure serves to underpin the essential dramatic contrast of the design, that of work and learning. These structures were fundamental to the images, being blocked in from the very start, and their integrality demonstrates how crucial was the expression of meaning for their creator.

Another, wholly related aspect of Turner's idealism was his moralism. The artist not only believed painting and poetry to be 'sister arts' but he also held that it was the duty of poetry (and therefore of painting) to be prophetic.[111] In a number of his major views of Greece, Rome, Carthage and Venice exhibited at the Royal Academy and elsewhere from the early 1810s right up until 1850, Turner warned of the dangers to such civilizations of human vanity, if and when individuals put their own interests above those of their fellow citizens. The concept of human vanity, and the fallacious hopes it breeds, was central to Turner's whole thinking about life and art, and naturally it was therefore expressed in the watercolours made between 1810 and 1836. For example, in almost all of the representations of lighthouses seen in these pages, the buildings have ironically failed to prevent shipwreck (127, 128, 173, 208, 213). Similarly, we encounter the juxtaposition of ruined castles with shipwrecks; the conjunction of ancient ruin with the more recent ruin of human hopes and aspirations was intended to look both romantic and act as a warning (161).

Turner's moralism also governed his representation of the human figure. Here he stood one of the central tenets of academic idealism on its head. It was held by theorists of the concept of poetic painting that all things are imperfect 'imitations' of perfect archetypes, and that it is the duty of the artist to try and arrive at forms which are equivalent to those archetypes by synthesizing the most beautiful features of several models into idealized unities, thus effecting a transcendence of particularities and arriving at universals. Turner certainly followed this course of action as far as the representation of forms and phenomena outside of man are concerned. But rather than make his people look perfect, the painter instead created an inverted archetype to stand for humanity. By drawing upon the types of 'low' representations of people as seen in the works of artists such as Rembrandt,[112] David Teniers the younger, Hogarth and P. J. de Loutherbourg, he evolved a caricatural model of humankind, making us look as coarse as possible. He did so not only because that was how he perceived most people in an age of little education and great social deprivation, but also because by means of such crudity he could maximize the contrast between the perfection of external nature and the imperfection of man, a moral contrast that is the basic dramatic statement of his entire art: the world around us constantly renews itself, it is immense, immeasurably beautiful and hostile, yet we try to pit ourselves against it and even try to lord it over that surround – what vanity! The seeming vacancies and doll-like features of Turner's figures were not supplied by any human or painterly deficiency on his part, but by a conscious and wholly moralistic desire to create a direct metaphor for something essential to human nature, namely our hubris and its tragi-comic implications.

Turner's idealism therefore addressed all manner of essentials. But his ultimate perspective on our existence did not lead him to turn his back on human life. Instead, he embraced all that went on around him, for he was as passionately interested in social realities as he was in the settings in which he lived. Indeed, it seems valid to claim that Turner was the greatest social observer of the nineteenth century, just as he was foremost in so much else. Thus he gave us the full range of society, from the genteel elegance of the aristocratic and bourgeois leisure-classes to the bawdiness of shore leave for the lower decks, and from the difficulties of economic survival for the coastal poor to the pains and pleasures of rural existence. There is even a hidden sequence of works that crosses from one engraving scheme to another, watercolours made for the 'Southern Coast', 'Marine Views' and 'England and Wales' projects that chart the entire progress of a smuggling operation, including its detection by law-enforcement officers (95, 45, 245, 172). And with the exception of the railways, every aspect of the technological and social advance of Turner's epoch is represented in these pages: the increase of urban growth and its infringement on the countryside; the decline of established institutions such as the Church and the landed aristocracy; the pressure for political change during the crisis years of 1829–32, the period of parliamentary reform and its successful outcome; the rise of industry and the decline of agriculture; the demand for religious tolerance and education, exemplified in depictions of schools and universities; the establishment of the regular army, coastguard and navy; hunting, shooting and fishing (both as recreation and industry); the country market and fair; the canal, the stagecoach, river traffic and ocean-going shipping; smuggling and coastal plunder; and always wreck and ruin and the vain attempt of man to achieve some measure of permanence in a beautiful but indifferent universe. In sum, these images hold up a unique and vivid mirror to an age, a time of immense change in which Britain evolved from a predominantly rural society into the world's major industrial power.

The series of watercolours and engravings discussed in this book constitute a significant part of Turner's artistic achievement in the three decades after 1810 and indeed, the engravings constituted the painter's most widely disseminated statements in the public realm between 1810 and 1836. The 'Southern Coast' series was, moreover, the longest-lasting of the many schemes for engraving that Turner was ever to be involved in, while the 'England and Wales' series took nearly as long. When seen together, as Turner undoubtedly wanted them to be perceived,[113] the watercolours and engravings represented in these pages project a phenomenally exhaustive view of the land in which they were made. Each work attests to Turner's extraordinary powers of observation, memory and imagination and every one of them is endowed with superb technical mastery and a unique sense of character. Among them are some of Turner's finest masterpieces. We are indeed fortunate that an unstable slave owner, a couple of provincial antiquarians and some ambitious engravers called them into being.

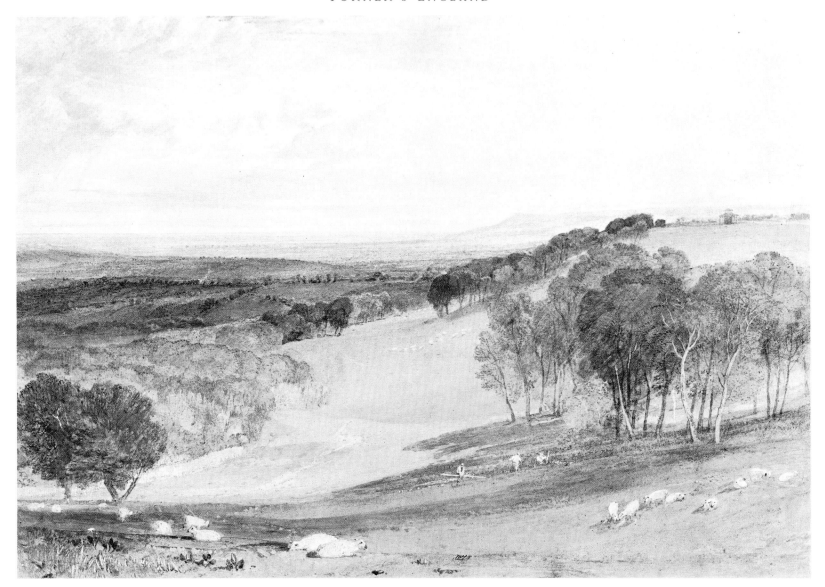

1 ROSEHILL

This drawing was clearly intended to complement a distant view of Rosehill House that Turner was painting in oils for Jack Fuller at the time.[1] Doubtless with his patron's tastes in mind, Turner quite naturally took as his subject the fine view from the rear of Rosehill House itself. In the distance is Beachy Head, with a number of Martello towers ranged along Pevensey Bay on the left. On the right is the rotunda designed for Fuller by Robert Smirke, later to be the architect of the British Museum. Turner was content here simply to record the beauty of the landscape, and the labourers scarcely disturb the late afternoon tranquillity.

1810 39.4 × 56.5 cm (15½ × 22⅛ in)
Fitzwilliam Museum, Cambridge, U.K.

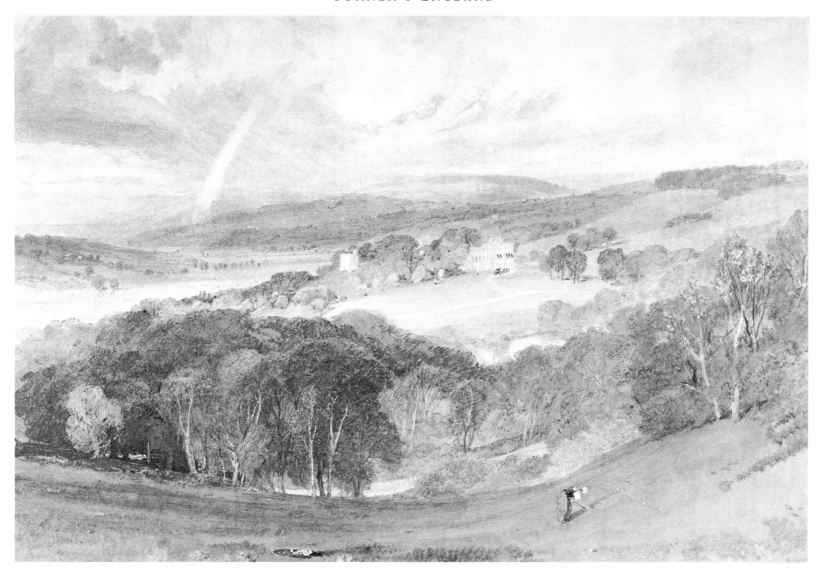

2 *ASHBURNHAM*

Ashburnham Place was the country seat of Fuller's next-door-neighbours, the Ashburnham family, and Turner later drew the mansion from the hillside that appears beyond it (see 10). A carriage is standing in front of the house where the canopies are drawn to keep out the summer afternoon sunlight. A small expanse of Broad Water can be seen in front of the house, while to the left of it is the Perpendicular tower of St Peter's Church. On the distant skyline at the extreme left is a tiny highlight which represents Brightling Observatory on Jack Fuller's estate (it is much clearer in the aquatint); this building was also to be the subject of another design by Turner (230). In reality, Rosehill itself would be located to the right of the rainbow.

1810 36.2 × 55 cm (14⅛ × 21½ in)
University of Liverpool, U.K.

3 BEAUPORT

Beauport House, near Hastings, was built by General James Murray who named it after Beauport in Canada where he had been the colonial governor between 1763 and 1767. The house was destroyed by fire in 1923 but it was later rebuilt and is now a hotel. The property is immediately adjacent to Crowhurst Park (see 6).

In the distance the coastline stretches away to Dungeness, while in the foreground a traveller has just missed the Hastings coach.

1810 37.8×54.6 cm ($14\frac{7}{8} \times 21\frac{1}{2}$ in)
Fogg Art Museum, University of Harvard, U.S.A.

4 BATTLE ABBEY

In the distance is Battle Abbey, built on the site of the Battle of Hastings by William the Conqueror to celebrate his victory in 1066. Like the later design of the same subject made for Jack Fuller (see Introduction, ill. 8) the drawing operates on both naturalistic and associative levels, and an analysis of the latter dimension to this work appears on page 19. However, it is also worth observing that between the boys and the snake is a tree trunk whose circular, flat top strongly resembles the pupil and iris of an eye, while immediately to the right of the trunk is another circular cut-down trunk. Similarly, the snake is slithering towards two rabbit burrows that are placed in a side-by-side manner reminiscent of the pairing of eyes. The snake is therefore approaching the *leftmost* tree trunk and rabbit hole of each paired form. This may be a reference to the belief that it was in his right eye (i.e. the left eye as it faces us) that King Harold was fatally wounded in 1066. It seems equally likely that the V-shape of the tree trunk on the right was intended to allude to the arrow which caused that death.

The sky was drawn with great confidence, the blues having been floated onto very damp paper. The oak was overpainted, judging by its transparency. The detailing of the bank of the road is very fine, and one can easily identify foxglove and yarrow among the wayside plants.

1810 37.5 × 55.2 cm (14¾ × 21¾ in)
Private Collection, U.K.

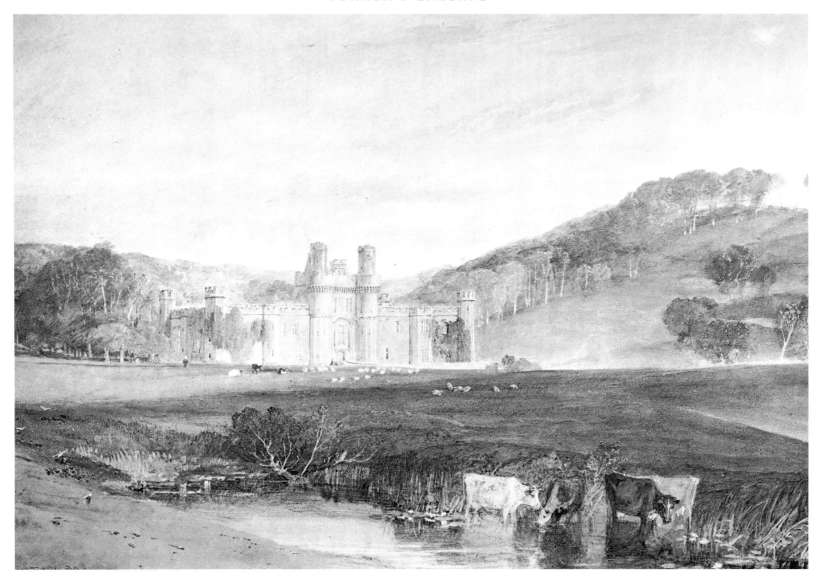

5 HURSTMONCEUX CASTLE, SUSSEX

Turner doubtless kept in touch with Jack Fuller between 1810 and 1815, when he is known to have revisited Rosehill, and this drawing appears stylistically to date from about 1813.

Hurstmonceux Castle stands about six miles from Rosehill. It was built in the fifteenth century and in recent years it has housed the Royal Greenwich Observatory. When Turner sketched the building in 1810 it was uninhabited, the interior having been entirely gutted by its owner in 1777 (it was restored in 1913). The drawing is now somewhat faded, although the series of diagonals running up the right hand side of the design still imparts a subtle dynamism to the scene.

c. 1813, signed 38.1 × 55.9 cm (15 × 22 in)
Private Collection, U.K.

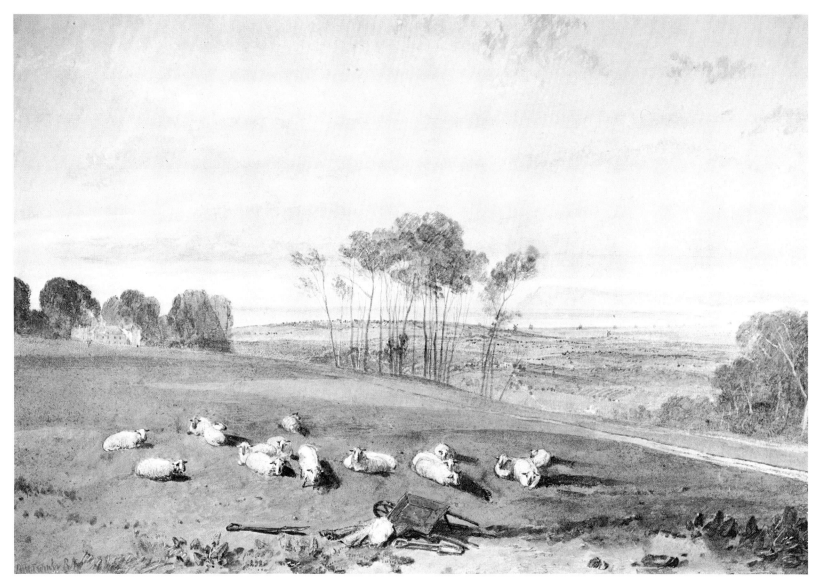

6 PEVENSEY BAY, FROM CROWHURST PARK

The increased richness of colour, quality of line and detailing of this watercolour suggests that it dates from around 1813.

Crowhurst Park was the country residence of the Pelham family, to whom Jack Fuller was a close neighbour, and one of the Pelhams is known to have bought a painting from Turner at around the time this work was made.[2] The house itself can be seen on the extreme left. Bexhill is visible beyond the central coppice of ash trees, and a great number of Martello towers are dotted around Pevensey Bay towards Beachy Head. The summer morning sunlight is strong and warm, and Turner added to the sense of repose by making all the sheep recline in the heat. The abandoned agricultural implements increase the mood of restfulness, for doubtless their users have gone to their breakfast.

c. 1813
Private Collection, U.K.

36.9 × 55.9 cm (14½ × 22 in)

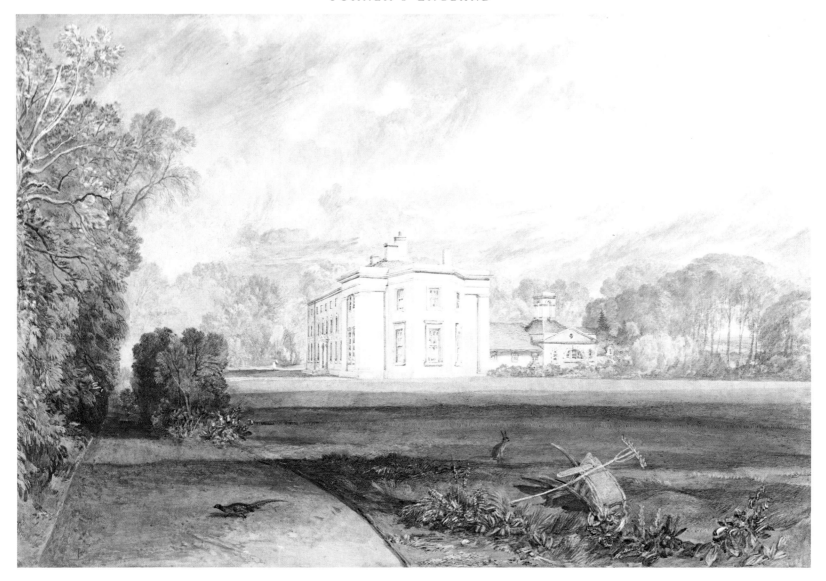

7 ROSEHILL, SUSSEX

Rosehill (now known as Brightling Park) was built by Jack Fuller's great-uncle who named it after his wife's home at Rose Hill, Jamaica. It dates from the seventeenth century and by Turner's day had been extensively altered. It is still standing but has been further rebuilt and looks very different today.

It seems natural that Jack Fuller should have wanted a view of his residence to augment the various depictions that Turner was making for him of the houses, abbeys, estates and castles belonging to his neighbours and acquaintances. In his 1810 oil painting the artist had already depicted the house from an extremely distant vantage point, so perhaps this unassuming architectural elevation was required to supply the close detail missing from that view.[3]

The complexity of the foliage on the left suggests a date of around 1815 for the work. Rosehill looks very beautiful, and the pheasant and hare seem to feel very safe in such pleasant surroundings.

c. 1815
British Museum, London

37.9×55.6 cm ($14\frac{7}{8} \times 21\frac{7}{8}$ in)

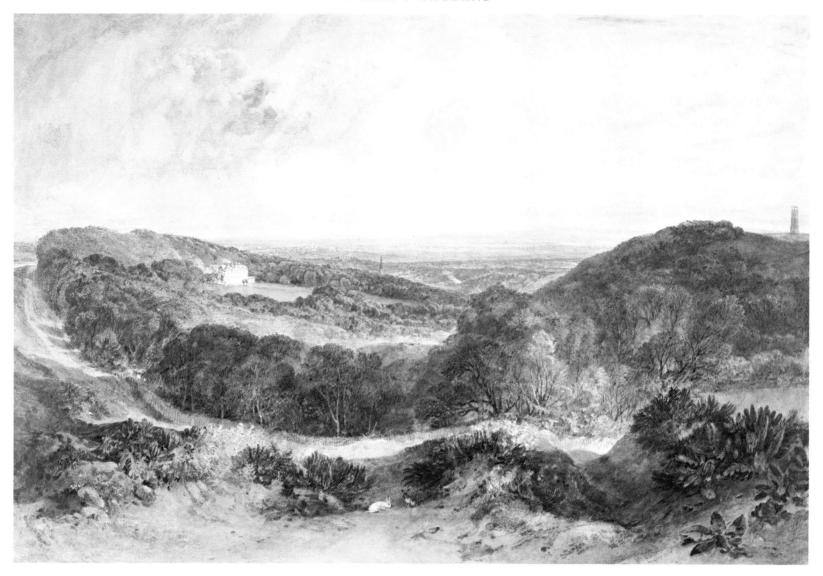

8 THE VALE OF HEATHFIELD

This splendid drawing represents the view looking across Heathfield Park towards Heathfield House and Church, the Heathfield-to-Hailsham road, and Beachy Head in the distance.

Heathfield House and Park were renowned in Turner's day as the former home of George Augustus Elliot whose heroic defence of Gibraltar during the Spanish siege of 1779–82 had led to his ennoblement as Lord Heathfield in 1787.[4] In memory of the gallant general the subsequent owner of the property built the tower on the hillside on the right. Jack Fuller was distantly related to Lord Heathfield.[5] The richness of the cultivated estate is clearly contrasted with the empty heath and wild heathplants in the foreground, where Turner introduced the only occupants of the entire vista. As the letterpress accompanying the engraving of this design commented, 'the rabbits mark the quiet of the scene, and express a wildness scarcely anything else could so well represent.'[6]

The drawing enjoys a wealth of tonal contrasts, juxtapositions of light and dark that add much to the rhythmic flow and unity of the design. Such a flow is augmented by the sharp linear definition of the estate, while the house, gateway to the estate (to be seen on the left in the middle-distance), church spire and considerably heightened Gibraltar tower fittingly act as the four principal focal points of the work.

c. 1815

British Museum, London

37.9 × 56.2 cm (14$\frac{7}{8}$ × 22 in)

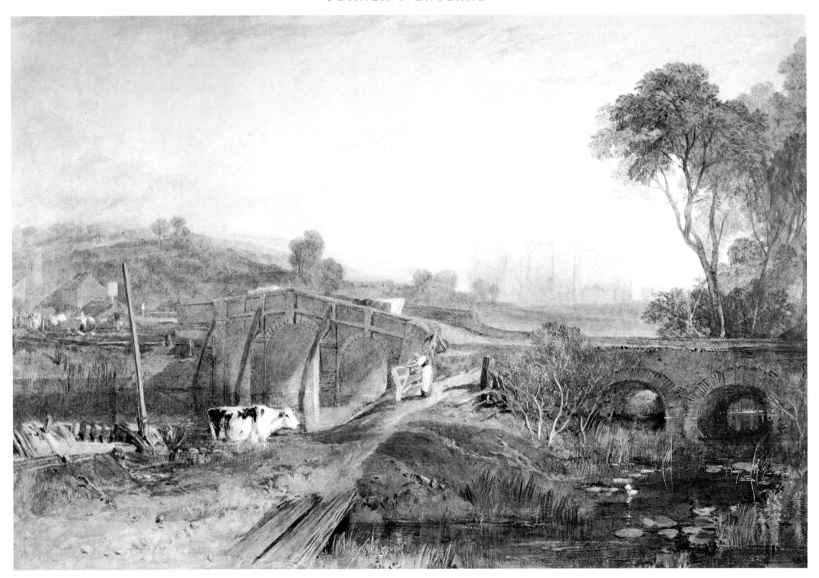

9 *BODIHAM CASTLE, SUSSEX*

Bodiham Castle is situated about six miles from Rosehill and it dates from 1385. Jack Fuller bought it in 1828 to prevent its demolition and it was finally restored in 1919.

 Turner portrayed the building from across the river Rother. On the left is the Red Lion inn (now The Castle) which dates from the fifteenth century; some women are drying its laundry in the sun. The work is subtly unified by the timber supports of the bridge and the parallel line running up into the distance from the timbers in the foreground, via the gatepost to the right of the bridge, while the mast on the left parallels the principal tree trunk on the right. The drawing has a wonderful richness of tone and colour, and the castle seems very dreamlike in the early morning haze.

c. 1816 38.1 × 55.9 cm (15 × 22 in)
Private Collection, U.K.

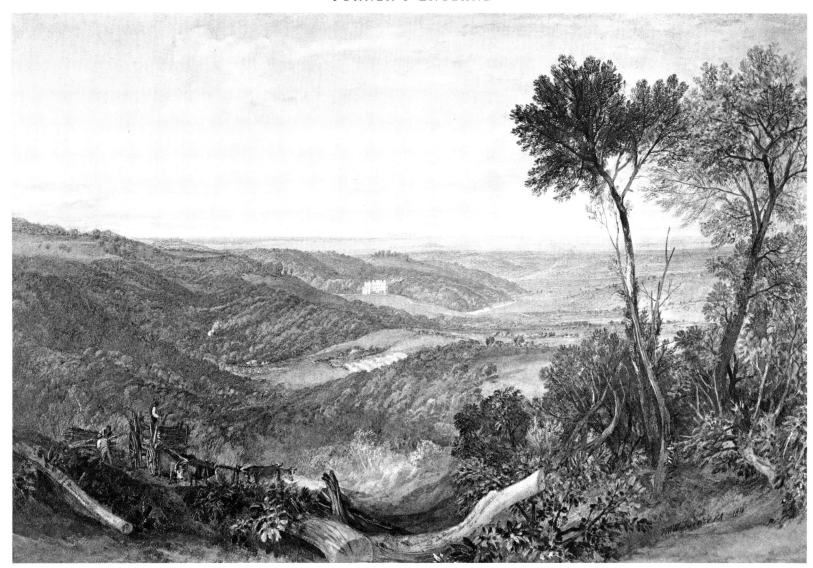

10 THE VALE OF ASHBURNHAM

This drawing epitomizes Turner's genius for organizing a design around the truth of place, his awareness of the historical and social background of a *locus*. In front of the distant Martello towers running around Pevensey Bay to Beachy Head is Ashburnham Place, the home of the Ashburnham family. Historically, the Ashburnhams had been extensively engaged in the manufacture of iron and, like other important ironmasters (including the Fullers), they had therefore been responsible for the destruction of vast expanses of East Sussex woodland because the iron-smelting required a great deal of charcoal to fuel the furnaces. By 1810, when Turner stayed at Rosehill, the wood was becoming very scarce and the after-dinner conversation might very well have centred on the local energy crisis.

Just behind the trees on the right was Ashburnham Forge, the actual site of the iron-smelting works, and Turner must have been aware of that forge in 1810 when he made the sketch[7] upon which this watercolour was later based. A subtle line runs down the leading ash tree on the right and around to the felled timber in the centre, passes up to the men loading the wood onto the cart at the left (a cart that faces towards the forge) and thence leads the eye to the distant pall of smoke beyond, before finally arriving at the great house itself. By this means Ashburnham Place is ingeniously framed with the very process that formed the basis of the Ashburnham family fortunes.

1816, signed and dated
British Museum, London

37.9×56.3 cm ($14\frac{7}{8} \times 22$ in)

11 WINCHELSEA, SUSSEX, AND THE MILITARY CANAL

Unlike *Hurstmonceux Castle* (5) and *Bodiham Castle* (9), which were also intended for the sequel to the 'Views in Sussex', this watercolour was not owned by Jack Fuller and its dimensions greatly differ from those of his other drawings. Its size and subject suggest that it was originally made for the 'Southern Coast' series and diverted to the 'Hastings' scheme by W. B. Cooke, who was responsible for engraving it. The engraving was never completed. Although in a previous book I dated the work to 1817, I now think it looks to be from much earlier.[8]

During the Napoleonic Wars, a defensive system comprising a canal and a road was built to prevent the invasion of Romney Marsh and the flatlands to the west. Turner may well have seen the canal and road being constructed at Winchelsea around 1805–07, for thereafter he always associated the town with the military.[9] For most of its route between Rye and Winchelsea the road runs parallel with the river Brede, which substitutes for the Royal Military Canal along this stretch of the defence

system, but towards Winchelsea the military road and the river separate. Here we look westwards along that section of the road, with some of the Martello towers that also guarded this part of the coast visible in the distance on the left. On either side of the road are drainage ditches, while beyond the coach in the centre are the Bridge Inn and the toll cottage which was demolished in the 1950s. Up to the left is the Strand Gate at Winchelsea, which is also visible in the 'England and Wales' series view of the town (167). In the later drawing, soldiers approach a tempestuous sky that evokes the 'storms of war'. Here the sky is calmer, with dark rain-clouds passing away to the right and soldiers following the storm.

c. 1813 12.7 × 20.3 cm (5 × 8 in)
Private Collection, U.K.

12 ERIDGE CASTLE, EAST SUSSEX

Although this drawing was not bought by Jack Fuller it may have been intended for him. It is the same size as the other East Sussex drawings he commissioned, and its approximate date supports this contention. Moreover, Jack Fuller was a friend of the owner of Eridge Castle, the second Earl of Abergavenny, another of the principal land-owners in the county.

Eridge Castle was not a castle at all, but a house that dated from before Elizabethan times. By the end of the eighteenth century it had fallen into considerable disrepair and was eventually used as a farmhouse. When Lord Abergavenny took over the property in 1787 he spent a fortune rebuilding it in the fashionable Gothic style. It was reputed to embody the worst possible taste and was demolished in 1939.

In the foreground a shepherdess picks herself up from the ground. Her unusual action may embody an allusion to the pick-me-up given to Eridge Castle by Lord Abergavenny, a fact surely known to Turner. The light is hot and brilliant, and it suggests that a storm is brewing.

c. 1815–20
Whitworth Art Gallery, Manchester, U.K.

36.9 × 54.3 cm (14½ × 21⅜ in)

VIEWS AT HASTINGS

13 HASTINGS FROM THE SEA

This watercolour was finished in July or August 1818, for an untraced letter of 21 July 1818 from Turner to W. B. Cooke informed the engraver that the work was nearing completion and asked when it would be paid for.[10] The fact that Turner informed Cooke of its progress suggests that he was taking a long time over making it, which is not at all surprising, given its size and visual complexity. On 31 August 1818 Cooke recorded payment to Turner of £42 (40 guineas) for the drawing, so it must have been completed by then.

In recent years the watercolour has been known as 'Hastings: deep-sea fishing',[11] a spurious title that ignores Turner's own name for the work that was printed in the catalogue of the exhibition held at W. B. Cooke's Gallery in 1822, in which the drawing appeared.[12] The inclusion of 'deep-sea fishing' in the title is also factually

inaccurate, for the design clearly depicts inshore fishing, and in any case the waters around Hastings are technically considered shallow, at no point being more than twenty fathoms deep. Moreover, none of the fishing boats depicted are large enough to carry deep-sea tackle.

In the catalogue of the 1822 exhibition, W. B. Cooke announced his intention to engrave the design in the sequel to the 'Views in Sussex' (the 'Views at Hastings and its vicinity') and he restated that aim in his 1824 exhibition catalogue. However, he never published the engraving. This failure may have been due to the subsequent financial failure of the Sussex project, or to the fact that he was already over-burdened by work, or simply because he delayed engraving the design for far too long and was unable to do so after he and Turner broke off relations in 1827. In any event the drawing subsequently passed to the art dealer Gambart, who had it engraved[13] by Robert Wallis in 1851. Turner approved that print, but died before he was able to 'touch' the proofs.

The composition is intricately structured and contains a wealth of foreground incident. A series of shallow V-lines are counterpoised over an underlying figure-of-eight pattern, and the tip of the predominant V-line meets at the helmsman of the boat in the foreground, while beyond him the V-lines are repeated by the lines of the hills which seem to recede infinitely into the distance. The cliffs enjoy an alpine sense of scale. From left to right in front of them we can perceive a pall of smoke which indicates a strong westerly wind and approaching storm; a cutter with her sails 'goose-winged', sailing straight down the wind; a fishing smack at work; and in the centre a yawl that has just arrived on the scene. The crew have dropped its head-mast and boom-mast, the top and bottom masts of the mainsail, and the falling sail can be seen at the base of the mast, while next to the mizzenmast is a small 'tabernacle' which supports the mainsail head and boom-masts when they are lowered. (The mizzenmast of this boat is impossibly situated, for it would completely obstruct the turning of the tiller to starboard.) The men on the yawl are about to tie up at a buoy in order to begin fishing, while at the prow a man prepares to grab the buoy with a boathook. Hanging from the boat is a rope which will be used to attach the boat to the buoy. The helmsman is bringing the boat round into the wind and when she is secured to the buoy, another man in the bow will drop the anchor.

Beyond the yawl a hoy is fast approaching, tacking into the wind, and its shape acts as the keystone of the pictorial architecture. To the right of the yawl is another smack, with lowered masts, in which men are busy fishing, while beyond it is a brig exchanging cargo with smaller boats, as it is unable to berth any closer inshore due to its size. Finally, a seagull is poised above a piece of jetsam, immediately below the brig. This juxtaposition exactly balances the juxtaposition of the boathook poised to snag the buoy on the left, a balance which suggests that boathook and bird are each just about to make contact. Turner again similarly suggested an impending dual contact in the 'England and Wales' drawing of *Gosport* (174).

When this work was exhibited in 1822, *The Repository of the Arts* for 1 March (pp. 172–74) singled it out as being very fine and displaying 'great power and truth', while *The Examiner* for 4 February (p. 75) called it 'as perfect a proof we have ever seen of the power of the pencil to characterize the motion of clouds and water'. Similarly, the reviewer in *The Englishman* of 24 February (p. 4) stated that 'Mr Turner has displayed to an astonishing degree the varied powers of his pencil', although he or she complained also that 'the picture might still be improved by a little less redundant composition in the sky, where the large masses interfere too much with the principal object of attention'. But it is easy to ignore such a complaint, for the work is one of Turner's greatest portrayals of the natural world, fully communicating the 'Ideal beauties' of sea, land and sky through perfected forms that express both their intrinsic underlying dynamics and a sense of how they should look in an ideal world.

1818, signed and dated
British Museum, London

39.8×59.1 cm ($15\frac{5}{8} \times 23\frac{1}{4}$ in)

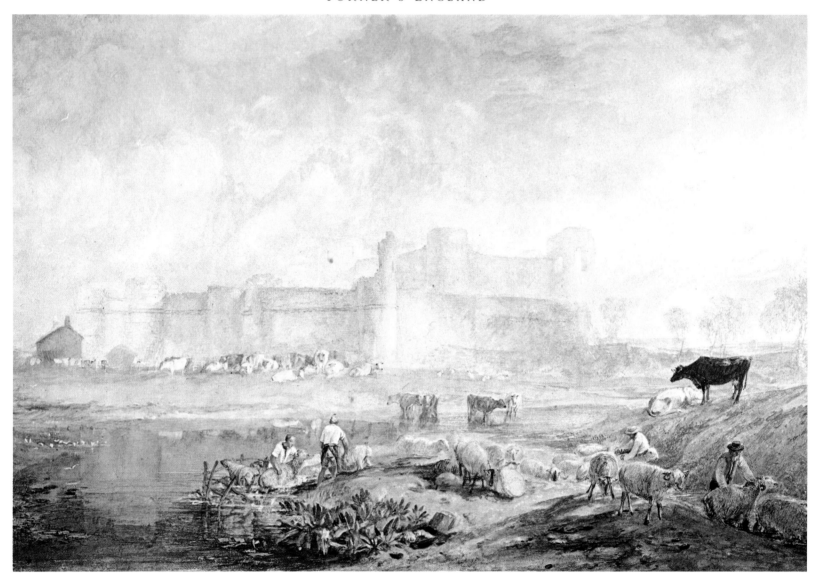

VIEWS AT HASTINGS
14 PEVENSEY CASTLE, SUSSEX

Pevensey Castle was built by the Normans inside the walls of a Roman fortress dating from the third century AD and it is located about ten miles from Jack Fuller's residence at Brightling Park. The watercolour looks as if it dates from later than any of Fuller's other Turner drawings and it was shown in the Cooke Gallery exhibition in 1823, when the catalogue (No. 15) stated that the work was 'Now being engraved for the Views in [*sic*] Hastings and its vicinity'. However, there is no indication that Cooke ever actually began engraving the work.

In the foreground some men are dipping sheep, and Turner has captured the exact stance of the animals as they shake themselves dry. The castle appears ethereal in the stormy, late afternoon light, and its immense tonal delicacy is both subtly modulated by the building to the left of it and greatly heightened by the extreme contrast of the black cow on the right.

c. 1820–23
Private Collection, U.K.

37.5 × 55.9 cm (14¾ × 22 in)

15 IVY BRIDGE, DEVONSHIRE

Turner visited Ivybridge, a small town about nine miles east of Plymouth, on his first West Country tour in 1811, and he exhibited an oil painting of Ivybridge mill at the Royal Academy in 1812. This watercolour derived from sketches made on a second trip there in 1813.[14]

The drawing exemplifies the way that by 1813 Turner was beginning to differentiate large masses of foliage with a new-found clarity, while also imbuing those arboreal forms with a sense of their inner life. The river Erme flows gently over the rocks beyond the bridge and then eddies more calmly to the foreground. Only the figure running across Ivy Bridge to catch the waiting Plymouth coach imparts a touch of urgency to the otherwise peaceful afternoon scene.

c. 1813 28 × 40.9 cm (11 × 16 in)
Clore Gallery for the Turner Collection, London (T.B. CCVIII-X)

16 SOURCE OF THE TAMAR AND TORRIDGE

The area about four miles south of the Hartland peninsula in north-west Devon forms
an important watershed, for three rivers rise there: the Marsland, which runs west; the
Tamar, which flows south through Devon down to Plymouth, where it enters the sea;
and the Torridge, which progresses east and then turns north to enter the sea at
Bideford.

Here Turner depicted the source of the latter two rivers. The painter's attention was
drawn to the spot by a map of Devonshire by John Carey that he carried with him on
his first West Country tour in 1811 and which clearly shows the 'Head of the Torridge

9 W. B. Cooke after J. M. W. Turner, SOURCE OF THE TAMAR AND TORRIDGE, *engraving, 1816–50.*

and Tamar Rivers'.[15] The precise source of the two rivers is indicated by the kneeling figure who looks into the water.

The Tamar and Torridge rivers rise at a point about a mile east of the Woolley Barrows, some neolithic grave-mounds which can be seen in the distance on the left. These tumuli were subsequently rendered more visible in the engraving of the work (ill. 9) that was started by W. B. Cooke in 1816 but not published until 1850.[16] In the print Turner also added another figure to the middle-distance, a man standing next to the dog. This man augments the implied line which runs through the rock, the kneeling figure, and the woman (and child), thus leading the eye into the distance.

On the hillside two bonfires give off clouds of smoke whose opposed dark and light tones and differing directions respectively denote and parallel the rising and divergence

of the two rivers. Below these clouds the Tamar winds away to the left, a course that is amplified by the left-hand pall of smoke, while the Torridge passes out of the front of the image in the direction repeated by the white smoke.

There are no known sketches for this work, which probably dates from 1811, judging by its style. The design again indicates Turner's fondness for green around the early 1810s, for at other times the painter did not much care for the colour. The handling is extremely spontaneous, with evidence of scumbling and extensive scratching and scraping-out of the highlights.

c. 1811–13 20 × 31.9 cm (7⅞ × 12½ in)
Yale Center for British Art, Paul Mellon Collection, U.S.A.

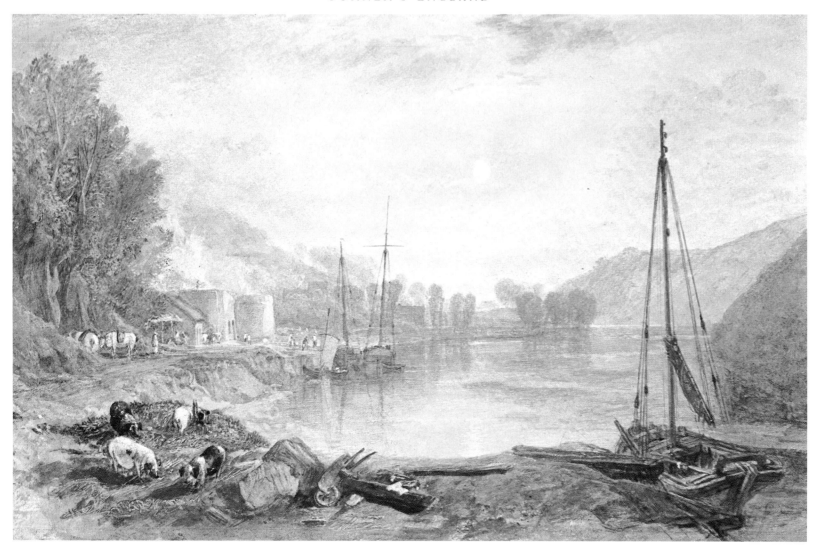

17 RIVER TAVEY, DEVONSHIRE

Although there is no known documentary link between this drawing and 'The Rivers of Devon' series, its size, subject and probable date strongly suggest that it was made for the scheme.

The title and topographical location of the design present problems. The watercolour first belonged to the dealer Gambart, who had it reproduced in 1855 as a chromo-lithograph which he published under the title of *The Banks of the Tavey*.[17] When Ruskin subsequently bought the drawing, the first title he gave it was *Pigs in Sunshine. Scene on the Tavey, Devonshire* but later he inexplicably altered that name to *Sunshine on the Tamar* and the work has ever since been identified as a scene on that river (both rivers converge above Plymouth). Yet Gambart's title and Ruskin's first identification both support the view that this is the watercolour exhibited in the 1829

Egyptian Hall, Piccadilly exhibition (No. 21) as *River Tavey, Devonshire*. No other known work by Turner offers itself as a candidate for consideration as that drawing.

Turner sketched the scene during his 1813 stay in Plymouth[18] but attempts to identify the precise location of the view have not proven successful. On the left is a limekiln with pigs in front of it. Ruskin wrote of these animals that Turner '. . . could draw *pigs* better than any other animal Sunshine, and rivers, and sweet hills; yes, and who is there to see or care for them? – only the pigs!'[19] In fact, the pigs naturally take little interest in their lovely surroundings.

c. 1813
Ashmolean Museum, Oxford, U.K.

21.7 × 36.7 cm (8½ × 14½ in)

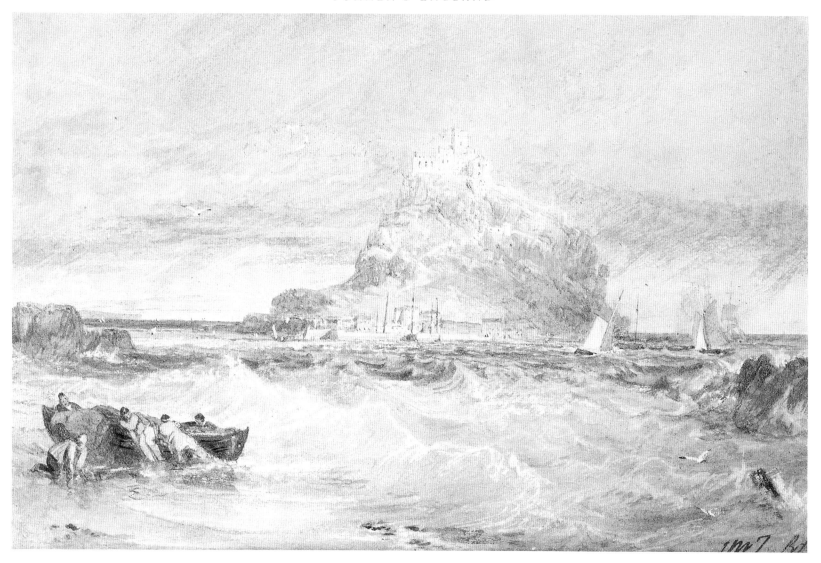

18 ST MICHAEL'S MOUNT, CORNWALL

St Michael's Mount was originally the site of a Benedictine abbey dating from the twelfth century. At the Reformation it became Crown property, and in 1657 it passed into private hands. The pinnacle is surmounted by a church that mainly dates from the fourteenth and fifteenth centuries. Quite naturally, Turner made the upper part of the Mount the focal point of the design, although because of the severe fading of the watercolour, probably due to the use of indigo, the building is not now thrown into much relief by the clouds beyond, whereas in the engraving that contrast is quite pronounced.

On the right are Mount's Bay drifters trawling for mackerel, and on the left a pilchard boat is being hauled ashore, its pilchard seine-net clearly visible.

c. 1811, signed 'JWT.RA' 14.6 × 22.2 cm (5¾ × 8¾ in)
Private Collection, U.S.A.

41

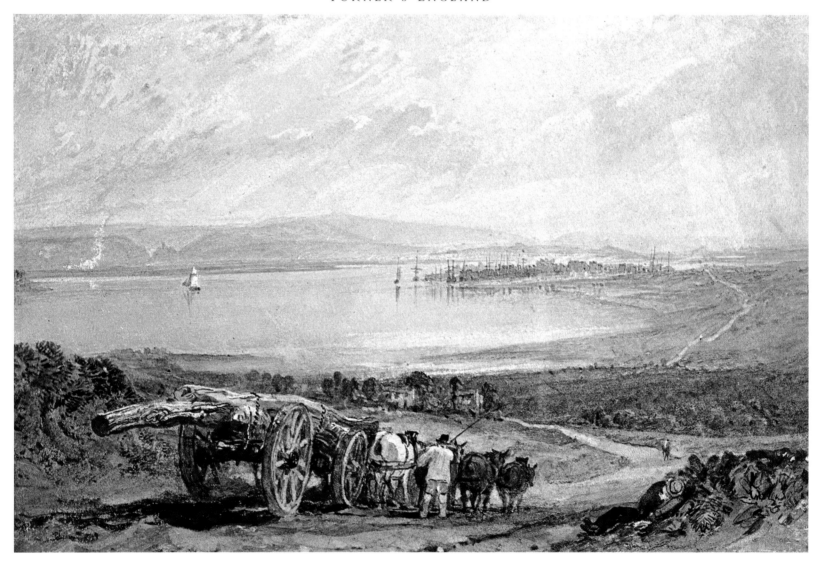

SOUTHERN COAST

19 POOLE, AND DISTANT VIEW OF CORFE CASTLE, DORSETSHIRE

In his unused poetic letterpress for the 'Southern Coast' series, Turner declared Poole to be a sad place whose reality did not live up to its pretensions. He also mentioned a 'deep-worn road' that 'Deny'd the groaning waggon's ponderous load', both of which he included in the drawing.[20] The waggon's 'ponderous load' of timber makes the vehicle and cargo look extremely like a field-gun. A dark circle at the tip of the protruding timber augments the association, as does the pall of smoke in the distance above it. The resemblance to a gun seems apposite to the portrayal of Corfe Castle, for that building had been destroyed after a siege during the Civil War.

The curvature of the bay leading around to Poole itself is exactly repeated by the curve of the road leading down the hill in the foreground, while to accentuate the

repetition Turner placed a distant figure on the bend, at 'the point of Thule' also mentioned in the poetic letterpress. In the foreground on the right a reclining figure suggests the languidness of the afternoon; perhaps the painter wanted us to connect this sleepiness with Poole itself. The sky, with its descending beams of light, is extremely similarly rendered in other drawings made of Dorset subjects, such as *Weymouth* (20) or *Bow and Arrow Castle* (30).

c. 1811
Private Collection, U.K.

13.9 × 21.9 cm (5½ × 8⅝ in)

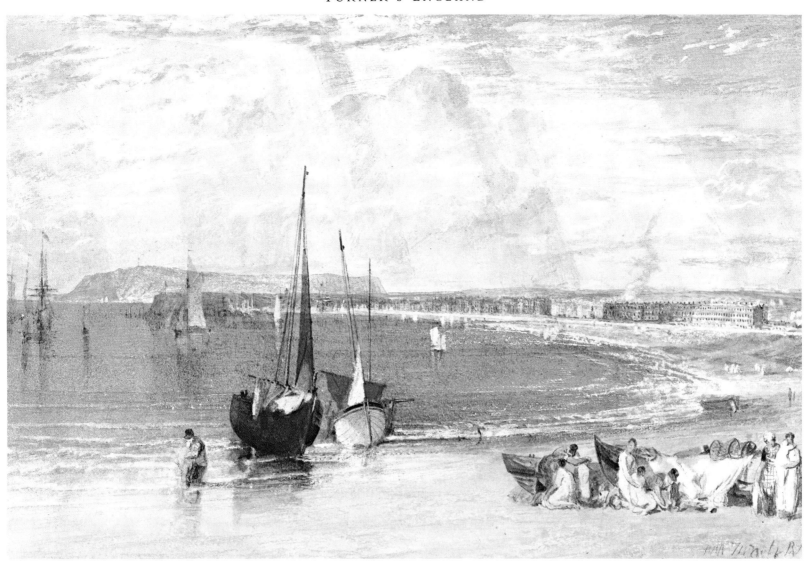

SOUTHERN COAST

20 WEYMOUTH, DORSETSHIRE

By 1811 Weymouth was well established as a fashionable holiday resort, for its long bathing-beaches were considered to be among the finest in Britain. In the foreground some bathers are being towelled dry as two washerwomen look on. On the nearby boats lobster pots are used as weights to hold down the washing.

The drawing sparkles with a multitude of tiny scratched highlights, and the areas of light and shade in the sky are superbly painted. Turner obtained such effects by tonal washes, with areas of white either stopped out previously with removable varnish or scratched out and added with a little bodycolour after the overpainting was completed.

The topsail of the cutter passing in front of the Portland peninsula was overpainted, judging by its transparency, while immediately below the cutter Turner created a linked vertical accent, a man who moves in the same direction as the boat.

c. 1811, signed 14 × 21.3 cm (5½ × 8⅜ in)
Yale Center for British Art, Paul Mellon Collection, U.S.A.

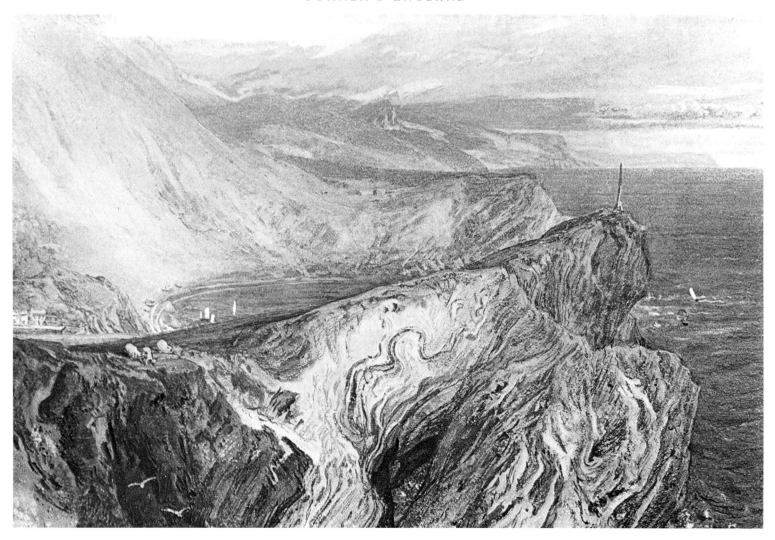

21 LULWORTH COVE, DORSETSHIRE

This drawing was sold at Christie's on 14 December 1928. It was bought by Agnew but is now untraced. Fortunately, it was reproduced in colour in *The Watercolours of J. M. W. Turner* by W. G. Rawlinson and A. J. Finberg, published in 1909. That colour reproduction is itself reproduced here.

Lulworth Cove is a natural harbour on the south Dorset coast and Turner noted in a sketchbook that it contained 'water for 80 ton burthen'.[21] The cove was then the property of Thomas Weld who was known to the painter (see *Lulworth Castle*, 34).

In the view we see St Alban's Head in the distance, with a public house and some cottages on the left. Turner was obviously impressed by the silent grandeur of the setting and he emphasized its lonely, vast scale by populating it merely with a few sheep, a couple of seagulls and some distant fishing boats. In the foreground the strata of shelly limestone, with their labyrinthine seams of chert, afforded him the opportunity to create superbly complex rhythms. The most prominent of the seams is vertically aligned both with an outcrop of the Purbeck hills in the distance and with a fissure in the rock beneath it.

c. 1811
Present whereabouts unknown

14.7 × 20.3 cm (5¾ × 8 in)

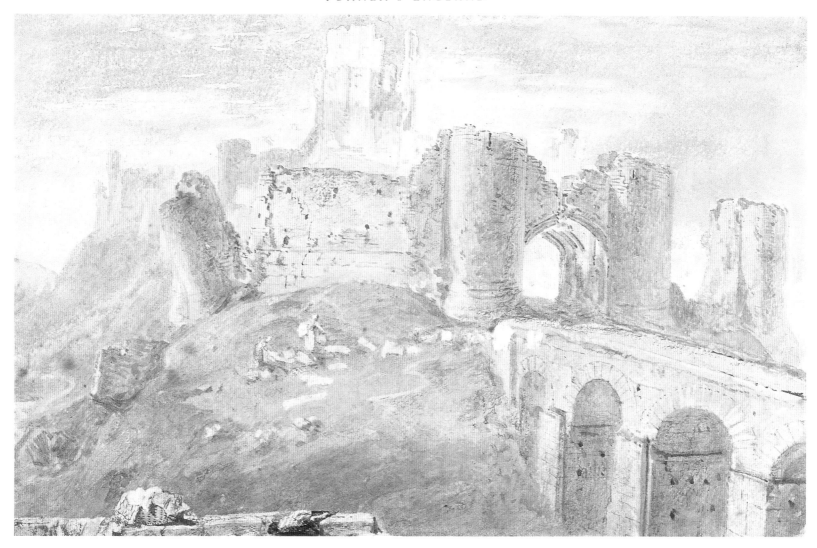

SOUTHERN COAST

22 CORFE CASTLE, DORSETSHIRE

Corfe Castle was a Norman fortification that became a Royalist stronghold during the Civil War. After a siege which lasted for two years, in 1646 it fell to Parliamentary forces who then blew it up.

Turner visited the castle in 1811 and sketched it exactly as it appears here.[22] The painter's draft letterpress for the engraving makes clear his feelings about the ruin:

> The arched causeway towering keep
> And yet deep fosse, scarce feed the straggling sheep,
> While overhanging walls, and gateway's nod,
> Proclaim the power of force and Time's keen rod[23]

The building does indeed look prey to the ravages of 'Time's keen rod'. Only the women enliven the scene as they lay out their washing to dry in the warm afternoon sun, and the bright, contrasted tones of the washing lead the eye from the bundle at bottom left up to the castle gateway.

c. 1811 13.8 × 22.3 cm (5½ × 8¾ in)
Fogg Art Museum, University of Harvard, U.S.A.

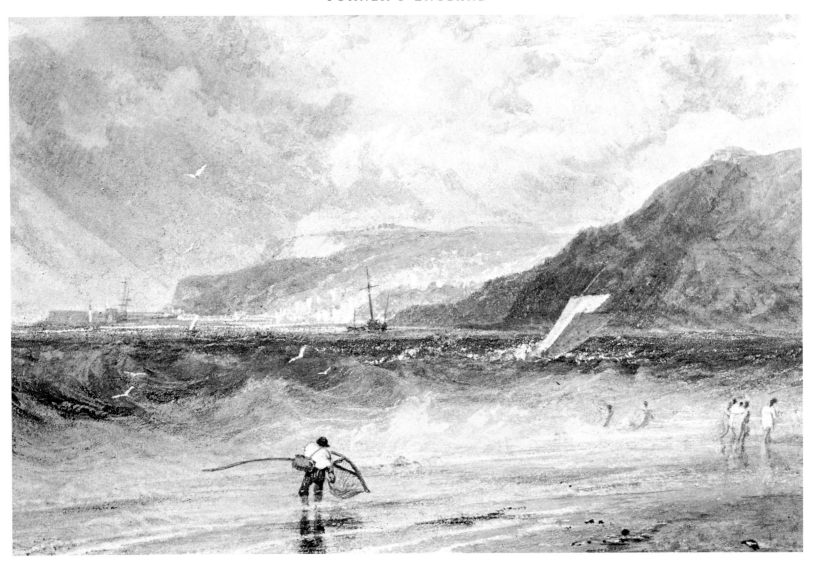

23 LYME REGIS, DORSETSHIRE: A SQUALL

This drawing was given the title that appears above when it was first exhibited in
W. B. Cooke's Gallery in 1822. We see the view from Charmouth looking towards
Lyme Regis in the distance, with the Cobb, a large breakwater that had only been
completed in 1795, to the left of the town. The watercolour completely captures the
fresh morning light and sudden fierce onset of the squall indicated in the title. The
strength of this wind is also clearly indicated by the angle of the lugger's masts and by
the slight sense of alarm manifested by the bathers. Even the shrimper is having trouble
controlling his net.

In 1814 W. B. Cooke recorded an extremely illuminating anecdote of Turner's
working method when proofing the print of this watercolour (see Introduction,
p. 10).

c. 1811 15.3 × 21.7 cm (6 × 8½ in)
Art Gallery and Museum, Glasgow, U.K.

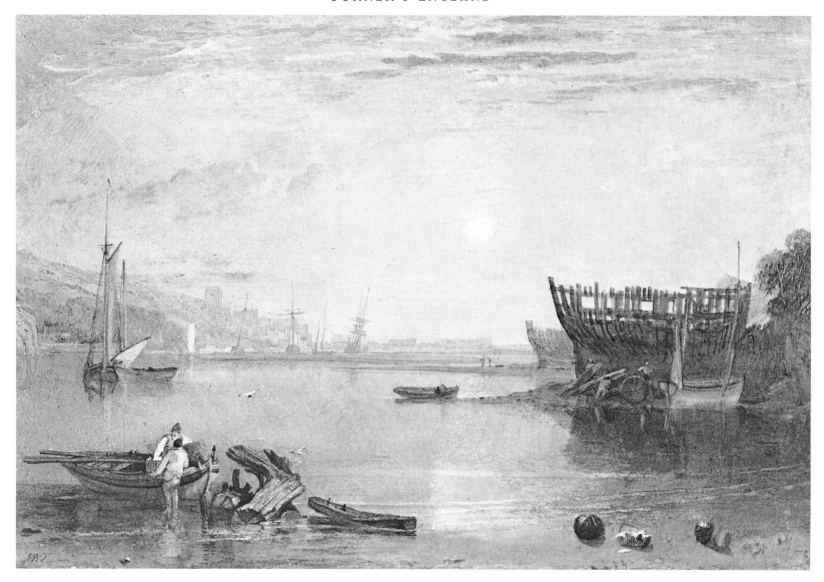

24 TEIGNMOUTH, DEVONSHIRE

Turner visited Teignmouth on his 1811 West Country tour and made several sketches of the place[24] from which he developed an oil painting now at Petworth, as well as this very similar watercolour. Both works depict virtually the same effect of dawn sunlight, with boats being dismantled for their timbers on the right. In the oil Turner somewhat idealized the view and placed a girl herding some cows on the left; here we see some fishermen unloading their catch.

Judging by the sketches, in this watercolour Turner depicted the scene much as he had originally witnessed it. Two far-off figures standing on the edge of the Teign mudflats act as tiny accents that heighten the effect of distance, and their dark tones also increase the brilliance of the light by contrast. When the work was engraved Turner deprecated George Cooke's rendition of these figures as 'One . . . too much a Falstaff, the other Master Slender'.[25] They were adjusted accordingly.

c. 1811 15.1 × 22.2 cm (6 × 8¾ in)
Yale Center for British Art, Paul Mellon Collection, U.S.A.

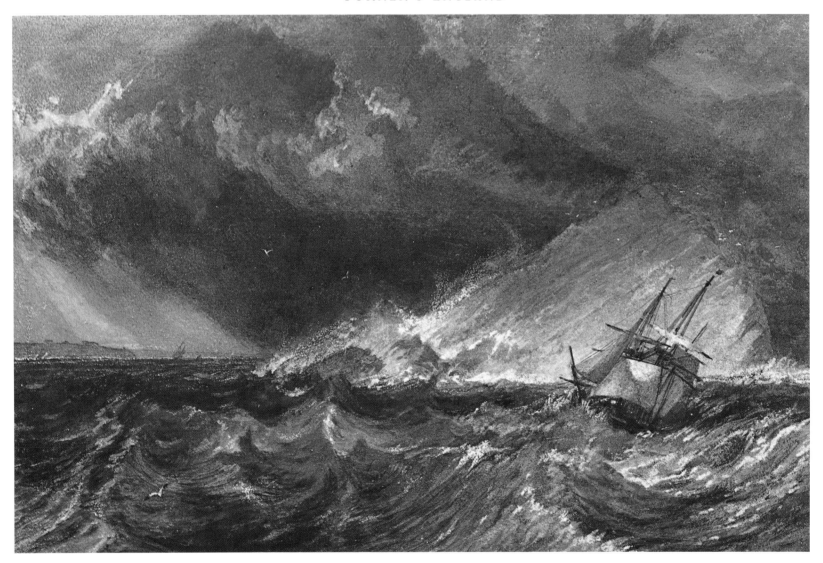

SOUTHERN COAST

25 THE MEW STONE AT THE ENTRANCE OF PLYMOUTH SOUND

In the ... 'Mewstone' there were some strange, weird clouds introduced which had a demonaical air about them; insomuch that Mr Stokes [the owner of the drawing] was struck by them, and asked Turner if he did not mean them for the demons and angels of the storm. Turner confessed the intention.[26]

The Great Mewstone (named after the seagulls which inhabit it) stands at the eastern entrance to Plymouth Sound. Turner must have sailed directly past the rock on his 1813 trip to Burgh Island (see p. 9) and it seems likely that he elaborated this watercolour from his memories of it on that outing, although distant sketches of the Mewstone do exist.

Immediately above the rock are the wisps of cirrus cloud that so reminded Stokes of 'angels'. Given that the Mewstone has no religious associations, Turner is unlikely to have intended any resemblance to demons and angels – he was probably just agreeing to the imaginative apprehension of such 'poetic' associations by 'confessing the intention'.

The drawing has a magnificent tonal range, and the racing movement of both the clouds and the tide is readily apparent. The small merchantman is in no danger, however. She has reefed her topsails to lower her centre of gravity in the strong wind, and will soon sail into the calmer waters of Plymouth Sound.

c. 1814 15.6 × 23.7 cm (6⅛ × 9⅜ in)
National Gallery of Ireland, Dublin

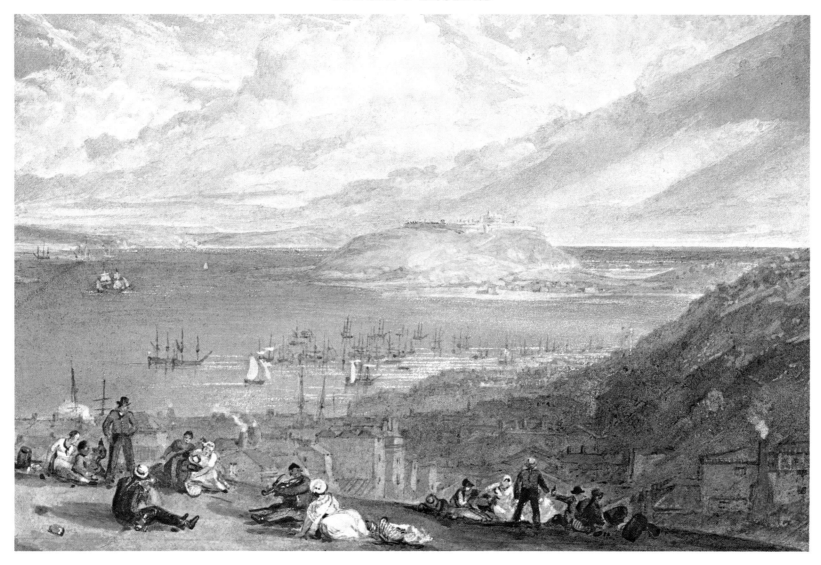

26 FALMOUTH HARBOUR, CORNWALL

Falmouth harbour is filled with both civilian and military shipping, a reminder that the war with France was still in progress when this drawing was made. In the centre, across Carrick Roads, is Pendennis Castle, with St Mawes in the distance on the left. The sky and rippling waters of Falmouth harbour are particularly well drawn.

In the foreground sailors and their women celebrate a rare spell of shore leave by holding a drunken debauch to music provided by a one-legged fiddler. The doll-like faces and clumsy limbs of these figures effect a complete congruence between the rough, outer guise of humanity and our inner life. The smoking chimney on the right repeats and amplifies the shape of various bottles. The resemblances of such objects to phalluses were commonly exploited in the satirical art of Turner's time, as the painter was surely aware, and they are not inappropriate here.

c. 1812–13 15.2 × 22.9 cm (6 × 9 in)
Lady Lever Art Gallery, Port Sunlight, U.K.

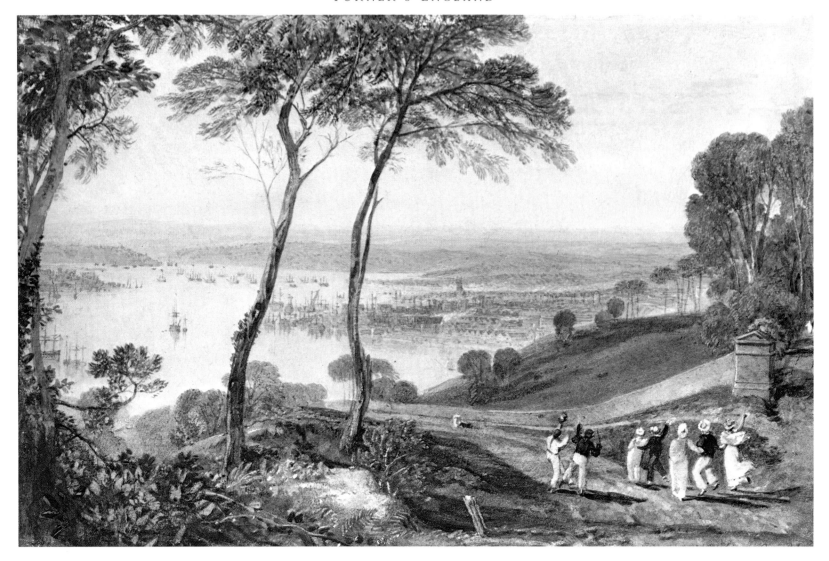

SOUTHERN COAST

27 PLYMOUTH DOCK, FROM NEAR MOUNT EDGECUMBE

Plymouth Dock was the largest town in Devon at the time Turner made this drawing; in 1823 the inhabitants petitioned George IV for it to be separately established from adjacent Plymouth and it was therefore renamed Devonport in 1824.

We look north-eastwards, with Mount Edgcumbe on the right. Mount Wise and Plymouth Dock can be seen across the intervening channel. In the dockyard are numerous ships, hulls under construction and sheer-hulks. A mass of shipping is lying in the major fleet anchorage of the Hamoaze. Much of it would have housed French prisoners of war when Turner visited Plymouth in 1811 and 1813. On the left is the village of Torpoint and beyond it in the distance is Saltash, a town that Turner would later depict in the 'England and Wales' series (133), again with marine personnel.

Almost imperceptible is Bren Tor, on Dartmoor, some nineteen miles away (but see ill. 10), and the tor is vertically aligned with the tower of the parish church of Stoke Damerel, the sails of a small boat, a figure on the road and a stake in the foreground.

Cyrus Redding, with whom Turner stayed in Plymouth in 1813, recalled being told by the painter that

he had never seen so many natural beauties in so limited an extent of country as he saw in the vicinity of Plymouth. Some of the scenes hardly appeared to belong to this island. Mount Edgcumbe particularly delighted him; and he visited it three or four times.[27]

Redding also tells of a picnic in Mount Edgcumbe Park to which Turner treated his friends in 1813:

There were eight or nine of the party, including some ladies. We repaired to the heights of Mount Edgcumbe at the appointed hour. Turner, with an ample supply of cold meats, shell-fish, and wines, was there before us. In that delightful spot we spent the best part of a beautiful summer's day. Never was there more social pleasure partaken by any party in that English Eden. Turner was exceedingly agreeable....The wine circulated freely, and the remembrance was not obliterated from Turner's mind long years afterwards.[28]

Here Turner replaced his friends with some sailors and their women. They are accompanied by a fiddler with a peg-leg and are waving to a couple making their way up the drive on the right, doubtless to enjoy each other's company in the privacy of the woods. The carousing men and women seem well matched by the equally rhythmic beech trees. In the engraving Turner made some adjustments to the image, giving a slightly more abandoned emphasis to the waving gestures of the figures.

c. 1813, signed
Private collection, U.K.

15.6 × 24.1 cm (6⅛ × 9½ in)

10 W. B. Cooke after J. M. W. Turner, PLYMOUTH DOCK SEEN FROM MOUNT EDGECOMB, DEVONSHIRE, *engraving 1816. British Museum, London.*

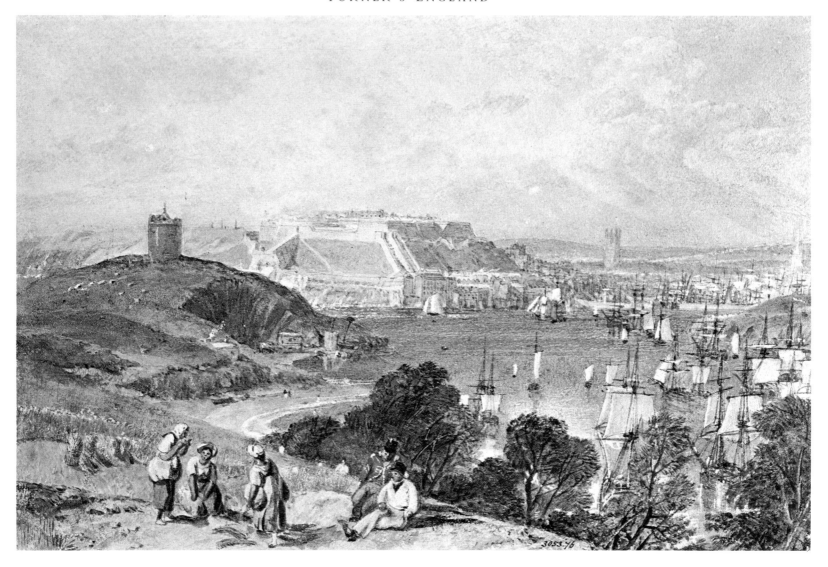

28 PLYMOUTH, WITH MOUNT BATTEN

This peaceful harbour scene takes in the view across Cattewater from Turnchapel, with the huge citadel in the distance, the small fort on Mount Batten Point to the left, and Plymouth on the right.

In the foreground are projected both the civilian and military associations of the town. Some women seem to be discussing the quality of the corn while a marine and a sailor recline nearby to watch them in the hot afternoon sunshine. The standing woman reinforces the vertical emphasis of the fort above her, a typical Turnerian stress. For an extremely different rendering of the same view, see *Plymouth* in the 'Ports of England' series (111).

c. 1814

14.6 × 23.5 cm (5¾ × 9¼ in)

Victoria and Albert Museum, London

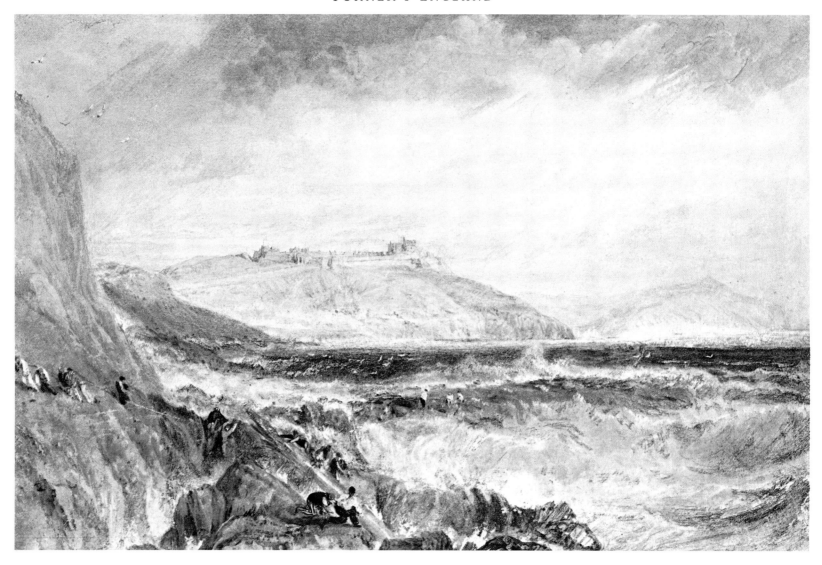

29 PENDENNIS CASTLE, CORNWALL; SCENE AFTER A WRECK

We look from Pennance Point across Falmouth Bay towards Pendennis Castle which
was erected by Henry VIII as part of a chain of forts to deter French invasion. The
castle dominates the Fal estuary and appears in several other watercolours reproduced
in this book (26, 40 and 113).

The morning scene is immensely rich and vigorous, with a strong wind blowing off
the sea and the reds, pinks and golds of the foreground effectively throwing back the
cooler tones of the distance.

c. 1816 15.5 × 23.5 cm (6⅛ × 9¼ in)
Private Collection, U.K.

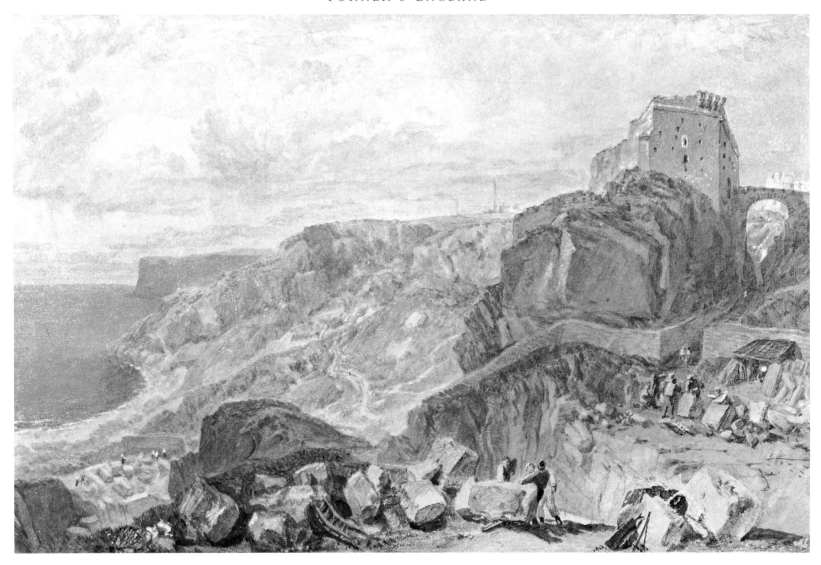

30 BOW AND ARROW CASTLE, ISLAND OF PORTLAND

In the distance is Portland Bill, with the twelfth-century Rufus Castle dominating the scene on the right. The castle received its nickname of 'Bow and Arrow' from its windows designed for use by archers. Most of it has now fallen into the sea and this process of erosion is clearly visible in the design.

The foreground is filled with quarrymen at work, for Portland is famous for its excellent white limestone, and the peninsula is covered with quarries; Turner could have found no better way of exemplifying the economic basis of life there. The hot morning sunlight filters through the clouds in a way that is reminiscent of Turner's earlier drawing of nearby Weymouth (20).

c. 1815 15.2 × 23 cm (6 × 9 in)
University of Liverpool, U.K.

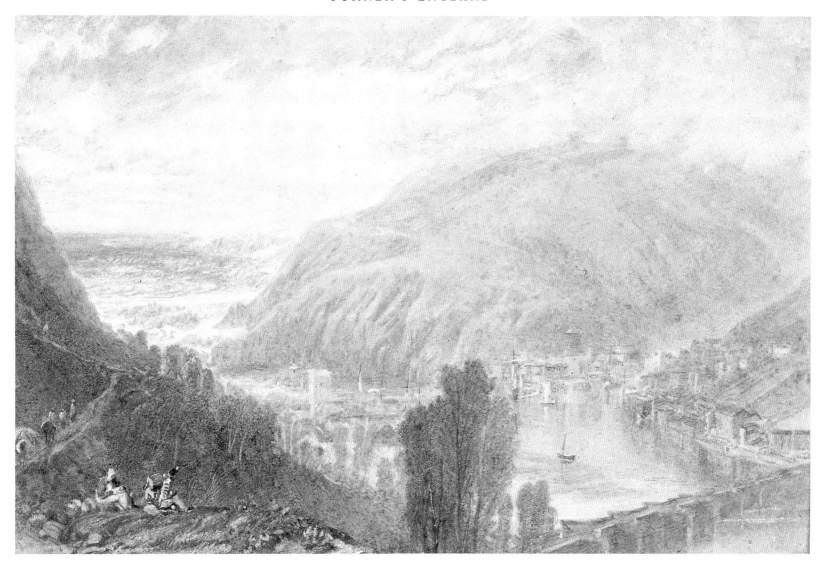

SOUTHERN COAST

31 EAST AND WEST LOOE, CORNWALL

Unfortunately this drawing has somewhat faded due to over-exposure to light. This is apparent in the upper reaches of the far hillside where the indigo used to supply the darker tones has faded, thus making those hills recede tonally, while the rain-cloud at the top right-hand corner is now almost completely bleached out (we can gauge how much the drawing has lost by comparing it with the engraving made from it, while for an even worse example of fading due to the use of indigo see *Bridport*, 33). Turner only realized the perils of using indigo relatively late in his career,[29] but fading can easily be avoided, providing the drawings are sheltered from strong light.

We look from the hillside above East Looe towards the narrow thirteen-arched bridge, dating from 1418, which linked the two halves of the town; it was demolished in 1853. In the distance the coast stretches around to Hannafore Point.

c. 1815 15.9 × 24.1 cm (6¼ × 9½ in)
City Art Gallery, Manchester, U.K.

55

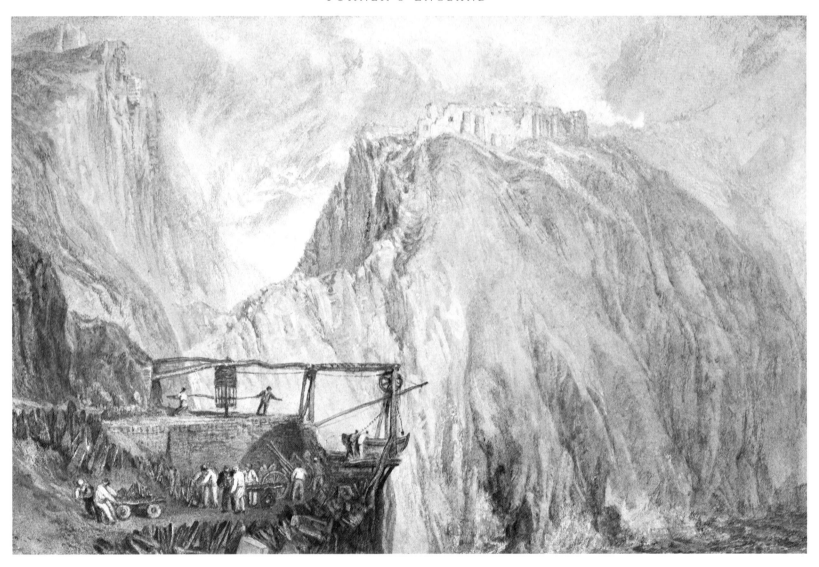

SOUTHERN COAST

32 TINTAGEL CASTLE, CORNWALL

Tintagel Castle dates from the twelfth century and is situated about 76 metres (250 feet) above sea level. A series of flowing lines defines the swirling ridges and fissures of the cliffs, which Turner has doubled or even possibly trebled in height, judging by the relative size of the men in the foreground who stack slate in readiness for shipping. On the projecting wooden platform at the left is a boat about to be lowered by a pulley controlled by a capstan which is vertically aligned with the lowest point of the ridge of cliff beyond it, thus reinforcing our awareness of the declivity.[30] The colouring is warm and amply communicates the afternoon heat, although the cooler tones on the right and the stormy sky both suggest that rain is on its way. The engraving made of this design by George Cooke in 1818 is an even more spectacular affair, for its linearity and wider tonal range further enhance the drama of the image.

c. 1815

15.6 × 23.7 cm (6⅛ × 9⅜ in)

Museum of Fine Arts, Boston, U.S.A.

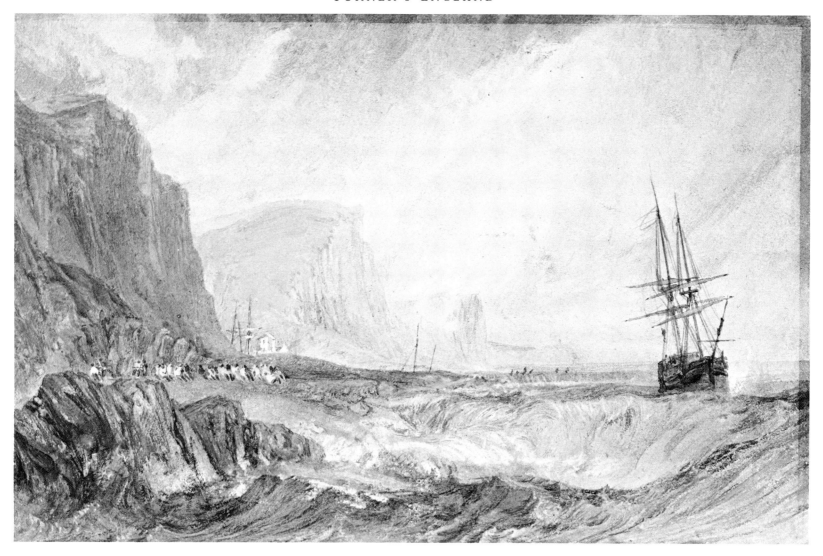

33 BRIDPORT, DORSETSHIRE

In Turner's time Bridport was famous for the manufacture of rope, and parts of it were even laid out to facilitate the twining of the cord. Due to its location midway between Plymouth and Portsmouth, the town was also ideally situated to supply the navy with rope and, indeed, it virtually monopolized the supply of cordage to the fleet. Turner was undoubtedly aware of this, for as he wrote in the unused poetic text drafted to accompany the engraving:

> . . . the low-sunk town
> Whose trade has flourished from early time
> Remarkable for thread called Bridport twine.[31]

What little we can see of Bridport therefore appears beyond the major product of the town, for a group of men in the middle-distance are pulling on a rope in order to warp a brig onto the beach. When the work was engraved, Turner added another figure running along the beach at the extreme left, perhaps to add to the impetus of the group.

Unfortunately, large areas of the sea and sky in this watercolour have faded badly due to its over-exposure to strong light, and the fading may have been exacerbated by the use of indigo. A measure of how much has been lost can be seen around the edges where strips of the drawing were masked by the picture frame for many years.

c. 1813–17 15.2 × 23.5 cm (6 × 9¼ in)
Bury Art Gallery, Bury, U.K.

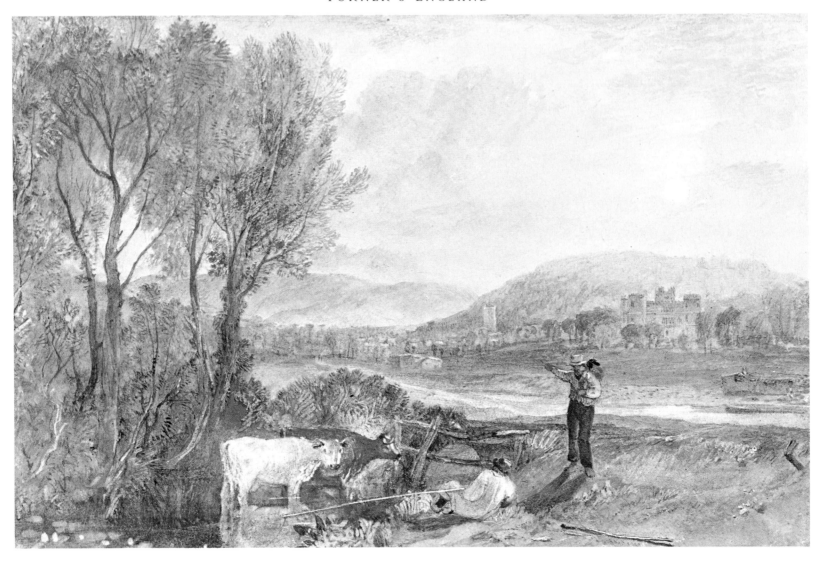

34 LULWORTH CASTLE, DORSETSHIRE

Turner visited Lulworth Castle and Cove in 1811 (see *Lulworth Cove*, 21). They were owned by a prominent Roman Catholic, Thomas Weld, to whom Turner had dedicated an engraving of Stonyhurst College, Lancashire in 1801 (Weld had recently given the building to the Jesuits to found a seminary). Nine years after making this drawing Turner again depicted the college, in an elaborate allegory of Roman Catholic emancipation made for the 'England and Wales' series (168).

In the foreground a shoeless itinerant ostensibly asks the way of a fishing yokel.[32] In the distance may be seen the castle, which was built in 1608 and destroyed in 1929. To the left is the village of East Lulworth, with the Purbeck hills beyond. Golden morning sunlight fills the scene with a wealth of brilliant colours, and Turner's mixing of gum with his pigment is apparent in the water lilies on the stream, while scraping out is evident throughout the foliage.

c. 1820 15.5 × 23.5 cm (6⅛ × 9¼ in)
Yale Center for British Art, Paul Mellon Collection, U.S.A.

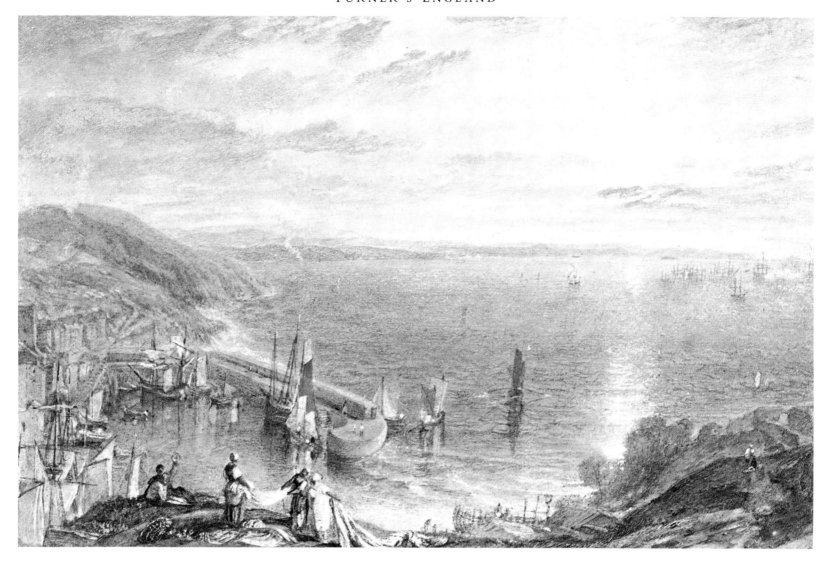

35 TORBAY, SEEN FROM BRIXHAM, DEVONSHIRE

Throughout the nineteenth century Brixham was considered to be the mother port of English Channel trawling. In this brilliant dawn scene we look towards Paignton and Torquay across Torbay, and the sun is therefore rising in the north-west. Turner had to compress a wide vista into a narrow space here, and in order to do so he was obliged to distort the topography of the scene, which included moving the sun to the left (and thus northwards). The work is based on a sketch on page 48 of the 1811 *Corfe to Dartmouth* sketchbook (T.B. CXXIV) which contains much of the detail included here but excludes both the figures and any indications of lighting.

A typical Brixham Mumble-Bee (a ketch-rigged trawler) can be seen docked at the quayside immediately above the two women slightly to the left of centre, and many more of these boats can be seen at work far out in Torbay. In the foreground a seated man waves at some women who are folding washing nearby. The phallic shape formed by his hat and arm can be seen in more bawdy contexts in other works such as *Plymouth Dock* (27) or *Dartmouth Cove, with Sailor's Wedding* (137).

c. 1816–17

15.8 × 24 cm (6¼ × 9½ in)

Fitzwilliam Museum, Cambridge, U.K.

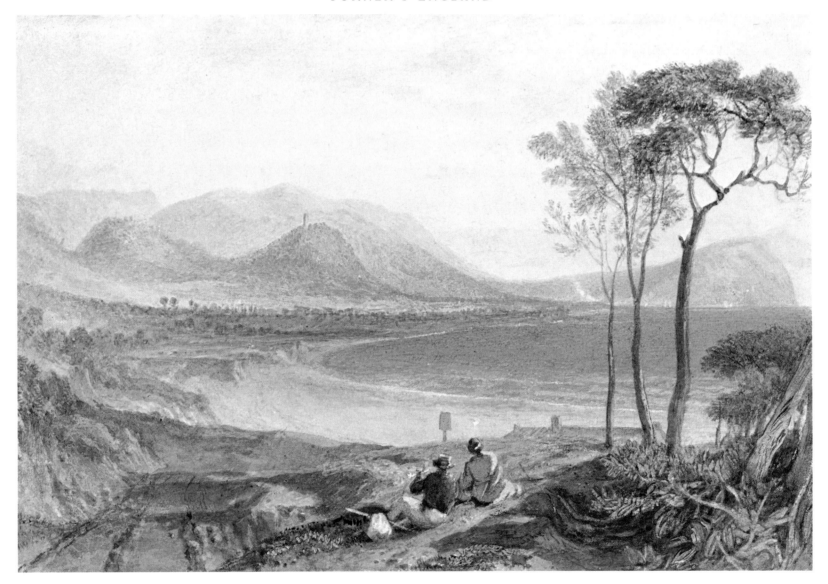

36 MINEHEAD, SOMERSETSHIRE

This peaceful view of Blue Anchor Bay takes in Dunster Castle in the centre and
Minehead on the right. Above Minehead looms the vast bulk of Porlock Hill.

In the foreground is the Blue Anchor Inn, a farmhouse inn which had already stood
on this spot for more than 200 years by the time Turner visited it in 1811 (its successor
still stands there today). Immediately in front of the inn-sign rest some travellers, who
thus amplify the purpose of the building. The late afternoon sunshine casts long
shadows, and the whole work is filled with a sense of repose.

c. 1818 15.2 × 22.2 cm (6 × 8¾ in)
Lady Lever Art Gallery, Port Sunlight, U.K.

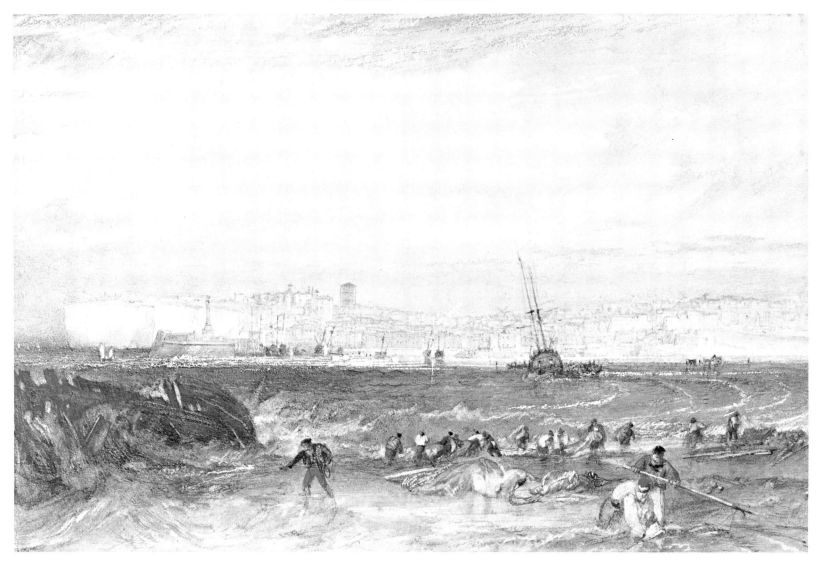

37 MARGATE, KENT

Turner may have gone to school in Margate, and his first drawings of the town date from his tenth year. For the rest of his life he demonstrated his fondness for the place by returning there, and he painted it numerous times.

Here we view the town across a foreshore filled with figures salvaging wreckage, and their intense activity contrasts with the calmness across the bay where soft evening light illuminates the town and cliffs. In the middle-distance a beached merchant-brig is exchanging cargo, and several bathing machines can be seen in the harbour.

The hillside is dominated by a curious structure. This was Hooper's Mill, a windmill with horizontal sweeps that were controlled by a system of vertical shutters.

The mill was built in the early 1800s under Royal patent and was still operational in 1825, but soon afterwards it was badly damaged in a severe gale and subsequently demolished. The building reappears in a view of Margate made for the 'Marine Views' series (94), and it may also be observed in another watercolour of Margate dating from 1826–27 (108).

c. 1822 15.5 × 23.6 cm (6⅛ × 9¼ in)
Yale Center for British Art, Paul Mellon Collection, U.S.A.

61

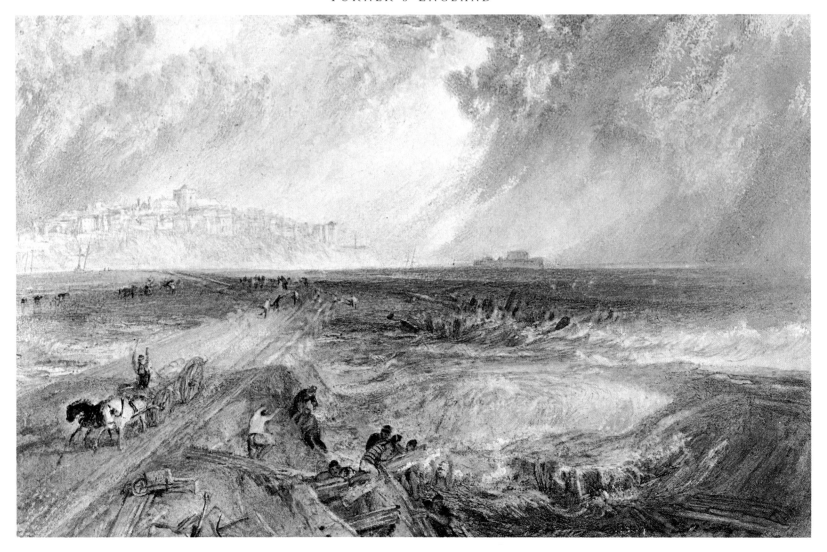

38 RYE, SUSSEX

As we have already seen (11), Rye and Winchelsea are joined by the Royal Military Road, and here again we perceive the road but looking in the opposite direction from Winchelsea towards Rye, with the river Brede running across the scene in the middle-distance and passing under the Strand Bridge at Winchelsea to the left. In the foreground, construction work on the creation of a junction between a further leg of the Royal Military Canal and the Brede has been taking place behind a temporary timber dam, but unfortunately the incursion of a spring tide on the river has overwhelmed the barrier and the workmen are fleeing in panic or clinging to the timber shuttering of the demolished structure so as not to be swept away by the flood.[33]

Turner has greatly increased the height of Rye itself, and to the right of the town is Camber Castle, with the sea beyond it. The whole image is filled with a strong rhythmic pulse, and the sudden tonal shifts between warm ochres and intense blues greatly augment that dynamism. For another, closer view of Rye that also shows work on the Royal Military Canal, see 244.

c. 1823
National Museum of Wales, Cardiff.

14.5 × 22.7 cm (5¾ × 9 in)

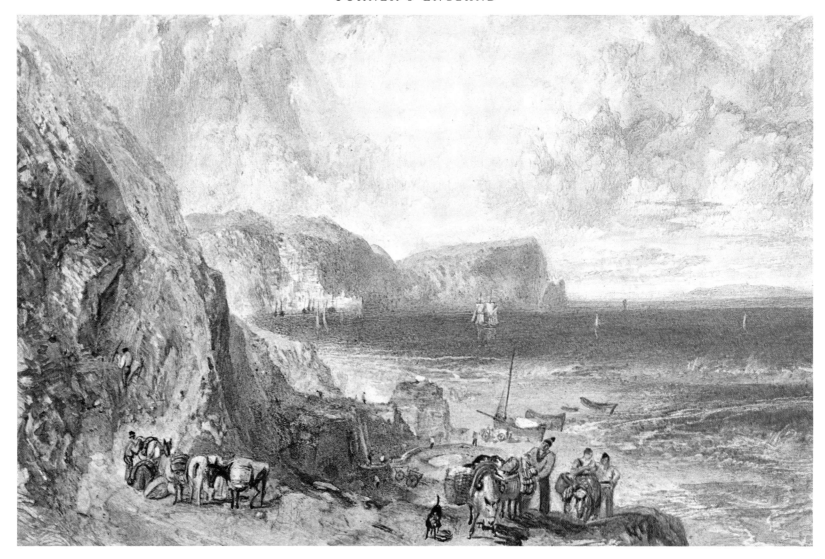

39 CLOVELLY BAY, DEVONSHIRE

We look from the village of Buck's Mills towards Clovelly and Hartland Point across the bay. Lundy Island can be seen in the far distance on the right.

In the foreground, herring fishing boats are drawn up on the semicircular Gore, a spit of rock running out from Quay Point. Near them is a pool that may have been artificially constructed for salting the fish. Also to be seen are limekilns which processed lime brought from Pembrokeshire (the lime was used to neutralize acids in the local soil). Making their way up the hillside are donkeys whose panniers would probably have been filled with seaweed, which was widely used as compost in the area.

A storm is clearly in the offing, with masses of cumulus clouds piling up in the distance. Their congested forms are matched by the packed shapes of the cliffs, and the gold to blue polarity of the colouring serves to convey the oppressive afternoon heat.

c. 1823 14.7 × 22.6 cm (5¾ × 8⅞ in)
National Gallery of Ireland, Dublin.

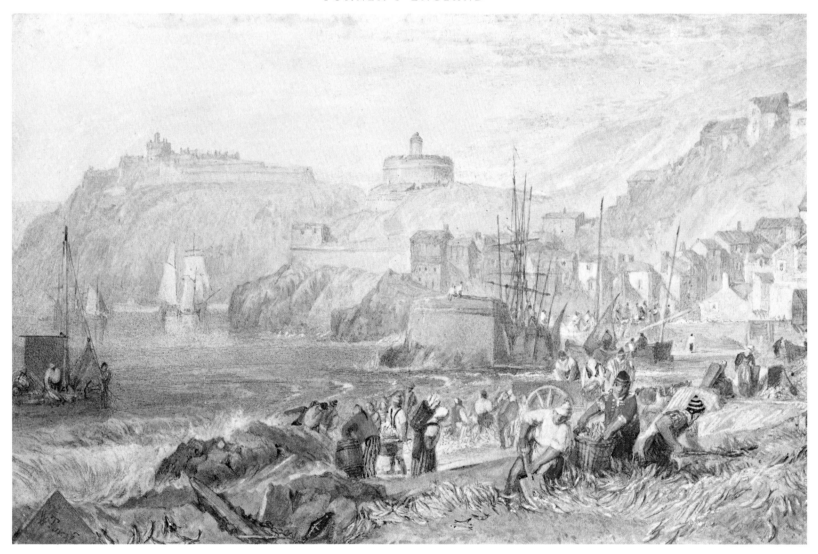

40 ST MAWES, CORNWALL

Turner was very attracted to this view, for in addition to making it the subject of an oil painting exhibited at the Royal Academy in 1812, he also drew it again in the 'England and Wales' series (252).

In the distance, across Carrick Roads, is Pendennis Castle which appears several times in this book (26, 29 and 113). On the near side of the Fal estuary is St. Mawes Castle, built by Henry VIII in 1543, which is also represented elsewhere (113, 252). The foreground is filled with figures pulling their nets ashore or shovelling pilchards that have been dumped on the beach. Here Turner was recording the precise effects of a local economic depression, for when the painter had visited St Mawes in 1811 and made the sketches upon which this work was based,[34] it was proving impossible to sell more

than a small amount of the pilchards that were being landed because of the closure of foreign markets due to the Napoleonic wars. As a result, the fish were being dumped on the beach, rather than being taken directly to curing sheds to be cleaned, salted and stored, and subsequently they were sold off very cheaply for use as manure.[35]

A number of red shirts set off the blues, whites and yellow ochres that are distributed across the design, and the moist haze and rising temperature of the early morning sunshine are vividly projected.

c. 1822, signed 14.1 × 21.7 cm (5½ × 8½ in)
Yale Center for British Art, Paul Mellon Collection, U.S.A.

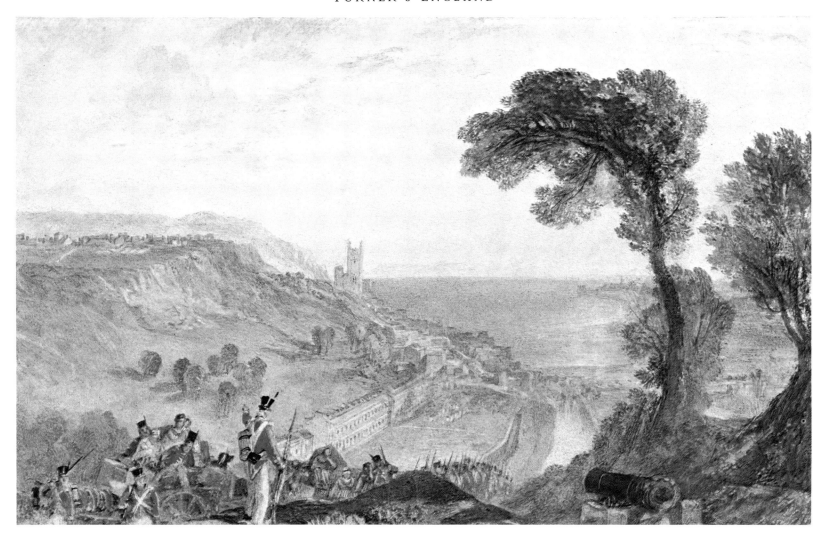

41 HYTHE, KENT

This is another drawing in which Turner markedly compressed a landscape, for on the left side of the work we are looking eastwards along the coast towards Folkestone and Dover, while on the right we look westwards along the coast to Dungeness. Hythe itself is viewed from the Ashford road, with St. Leonard's church in the distance.

In front of the town is the Royal Staff Corps barracks, with soldiers parading before it. The barracks dated from 1808–10 and it was the main depot of the Royal Waggon Train, a corps that serviced the Royal Military Canal, seen under the oak tree in the centre. A cannon is juxtaposed vertically with the canal, while in front of the Royal Waggon Train depot is a military, or, Royal waggon train making its way inland,

perhaps in order to defend the coastline from incursion by the French (the sentry in the foreground is pointing in the direction of France). The sense of protection suggested by the troops is also extended to Hythe by the oak tree whose exaggerated form curves around as if to embrace the town within its reach; Turner may have borrowed this associative device from a painting by Claude Lorrain that is known to have especially affected him.[36]

c. 1823
Guildhall Museum, London, U.K.

14 × 22.9 cm (5½ × 9 in)

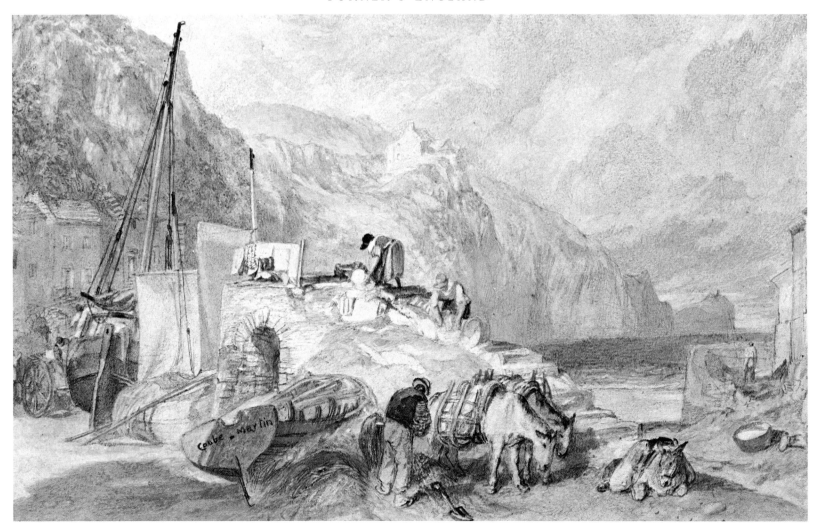

SOUTHERN COAST

42 COMBE MARTIN

We look along Combe Martin Bay towards the Burrow Nose in the distance. In the foreground women lay out washing to dry on a limekiln in the early morning sunshine, while a man pitchforks laver (an edible marine algae eaten locally) into panniers on the donkeys.

The work is subtly unified by a series of circles or semicircles that run across it from the wagon-wheel on the left to the linen-basket on the right, and these shapes are often replicated or reversed vertically. When the drawing was engraved, Turner added a small fishing-smack to the distance and some masts on the right[37] but unfortunately (judging from the engraving), important features of the watercolour such as a man

standing on the extreme left and a washerwoman on the extreme right are masked by the picture mount, which it was impossible to remove for photography.

Although Turner wrote the name of the place in the drawing, the work was not exhibited in his lifetime and the only authentic spelling of the title must therefore be taken from the engraving. (In fact Turner wrote *Coobe Martin* on the stern of the boat.)

c. 1824 14.6 × 23.3 cm (5¾ × 9⅛ in)
Ashmolean Museum, Oxford, U.K.

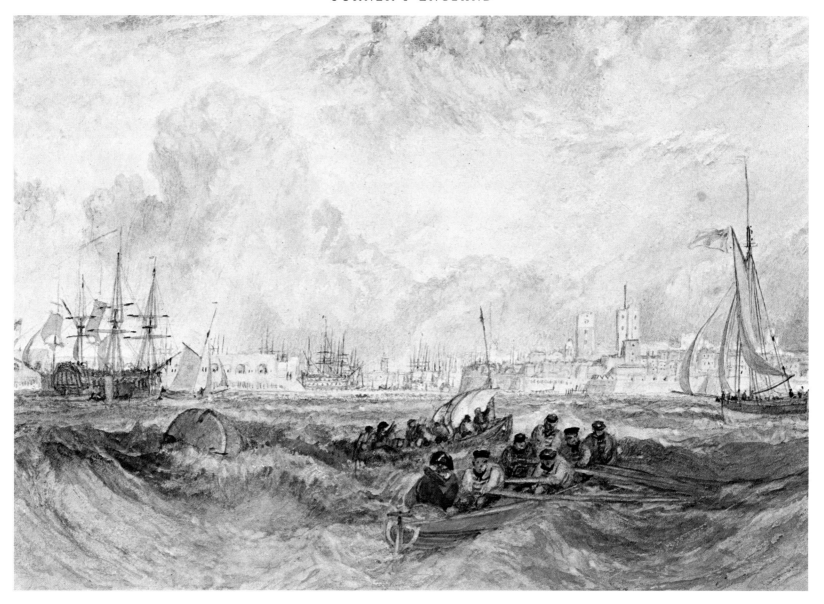

43 PORTSMOUTH

Turner also depicted this scene in 'The Ports of England' (107) and 'England and Wales' series (174). Although in the latter work he adopted a closer viewpoint and one turned slightly to the left, in all three watercolours he emphasized the naval associations and windy character of the place.

On the left two frigates are anchored off the blockhouse at Gosport, with the harbour beyond filled with ships, one of which is a man-of-war. On the right the skyline of Portsmouth is dominated by the towers of Burridge's Folly and the Admiralty semaphore, towards which sails a Royal Navy longboat. The design also includes the cathedral (behind the longboat), but this is now completely obscured by the picture frame and is not apparent in the reproduction.

The circularity of a massive cumulus cloud is repeated by the round buoy far below it, while an important alignment is effected in the centre. In the far distance, just to the right of the man-of-war, is the tower of the Dockyard semaphore which controlled the entrance of ships to the harbour by means of signals. Below the tower is a naval officer signalling his orders to the men lowering the sail of his gig, while before him is the rudder of the gig in the foreground. By this means the theme of naval control is concisely repeated three times in one vertical line.

c. 1824 15.2 × 21.8 cm (6 × 8½ in)
Lady Lever Art Gallery, Port Sunlight, U.K.

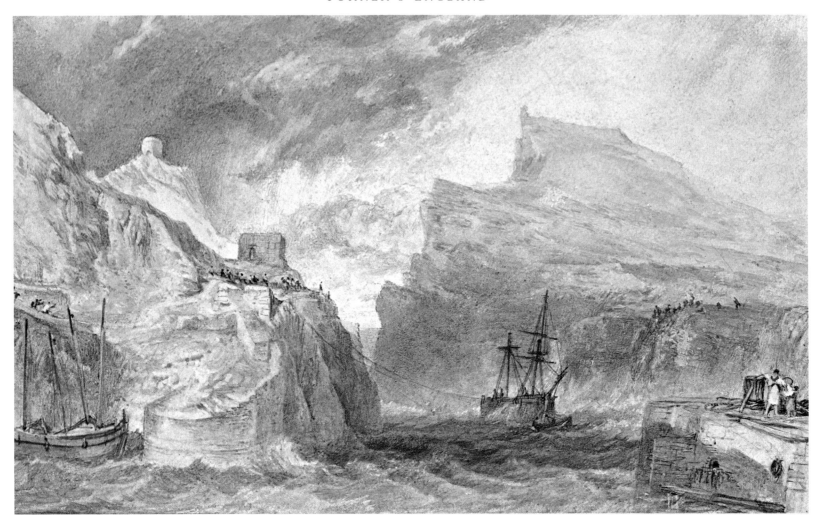

SOUTHERN COAST

44 BOSCASTLE, CORNWALL

In Turner's time Boscastle was a small but important trading port. Owing to a strong tidal flow, passage into its harbour was extremely dangerous in stormy weather and on their approach all large ships had to have their impetus controlled by restraining hawsers. Here these lines are attached to a partially dismasted brig. Turner emphasized the check on its motion by placing a small boat immediately under its bow. As it would have been suicidal to sail a small craft just in front of such a large vessel, we can only assume that rather than portraying impending disaster, the painter wanted to imply that the slack will be taken up forthwith, thus preventing the collision.

The composition is unified by a sequence of semicircles that run up the boats and the quay on the left, to the escarpment leading to the heights of Botreaux Castle on the right. At the bottom right, a mother and child are linked by a hoop whose circular shape is repeated by the mooring ring on the pier immediately below it. The sense of security afforded to the child by her mother and the hoop parallels the sense of security afforded to the damaged ship by the mooring.

c. 1824 14.2 × 23.1 cm (5½ × 9 in)
Ashmolean Museum, Oxford, U.K.

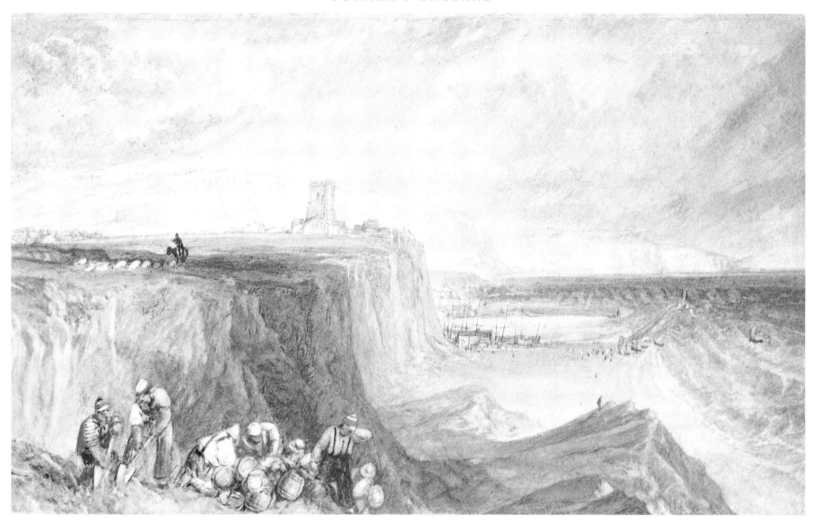

SOUTHERN COAST
45 FOLKESTONE, KENT

In the early nineteenth century Folkestone was notorious for smuggling, and areas of the town were honeycombed with secret passages and hideouts to facilitate the activity. Turner visited the place in 1821 and may even have witnessed smugglers at work, for four drawings he made of Folkestone portray the various stages of a smuggling operation (see also 95, 172 and 245).

Here we witness the third phase of a smuggling run: in the foreground the smugglers have hauled their kegs of spirits up the cliffs, and they are now burying them for later dispersal inland. One of the smugglers covers his face with his arm, a gesture that suggests both his tiredness at having carried the kegs up the cliffs after probably being awake all night, and his understandable wish for anonymity.

Along the Lees is the church of St Mary and St Eanswythe, known locally as 'Hurricane House' due to its exposed position, while below it is the Stade or harbour, with the cliffs stretching away towards Dover. The morning light is soft and warm, and the gentle rhythmic pulse of the tide is very apparent.

c. 1822 15 × 24.2 cm (6 × 9½ in)
Taft Museum, Cincinnati, U.S.A.

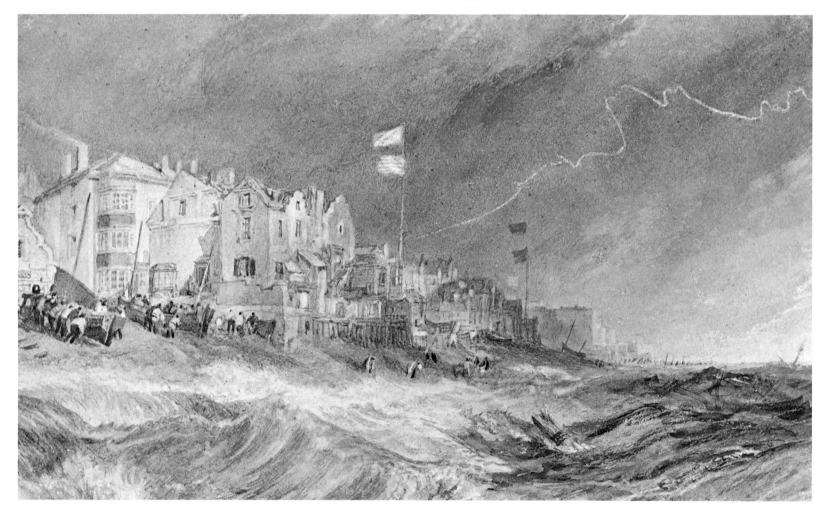

SOUTHERN COAST

46 DEAL, KENT

Deal is situated near the Goodwin Sands, an area of the English Channel that is especially hazardous to shipping. This danger presented the local inhabitants with a flourishing source of income, and the town was particularly renowned for its hovellers, lugger crews of up to ten men whose livelihood depended on salvaging wreckage and who were paid on a 'no wreck-no pay' basis. On public holidays these hovellers would even parade through the streets of Deal wearing their own dress uniform of tall hats and pumps.

On the left the hovellers are running out their hovelling luggers. In the sea near the centre is a fragment of wreckage, while the wreck that the hovellers surely intend to hovel can be seen on the right in the far distance. Beyond the hovellers may be seen the Royal Hotel, while Sandown Castle, which has since been destroyed by marine erosion, is visible in the distance. Along the beach are the signals-flags that appear in the later 'Ports of England' series drawing of Deal (109). In the centre some men prepare to fire the minute-gun into the strong north-easterly wind.

c. 1825 13.5 × 24.1 cm (5¼ × 9½ in)
Private Collection, U.K.

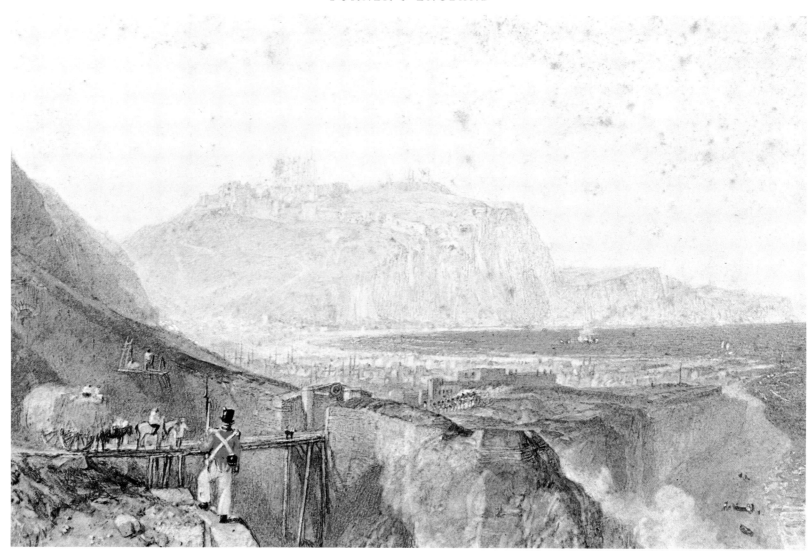

47 DOVER FROM SHAKESPEARE'S CLIFF

The Western Heights are a vast complex of fortifications originally built between 1793 and 1814 to meet the threat of French invasion. They included a number of deep, brick-faced 'lines', dry moats whose approaches were covered by gun-emplacements, and one such defile fills the foreground of this drawing, with the gun-embrasures on the left. Some workmen on a temporary scaffold are busy pointing the brickwork of the moat which a heavily laden handcart is preparing to cross (the land above the redoubt was cultivated). The vertiginous passage is emphasized by the figure pointing into the depths below, although in reality the fosse was only about 9 metres (30 feet) deep. A dog that has crossed safely seems transfixed by the firing practice taking place beyond (with guns aimed towards France). Further military associations are indicated by the smoke billowing out over Shakespeare beach on the right and the ship testing its guns in the distance where the cliffs recede along the coast to the South Foreland. The castle appears brilliantly hazy in the damp, late afternoon sunlight, while the shadowed cliffs beyond it appear both firmer and cooler in tone. The drawing is at present badly foxed but its rich colours remain undimmed. Turner's initials appear surreptitiously in the bottom left-hand corner.

c. 1825, signed with initials
Private Collection, U.S.A.

15.9 × 24.1 cm (6¼ × 9½ in)

71

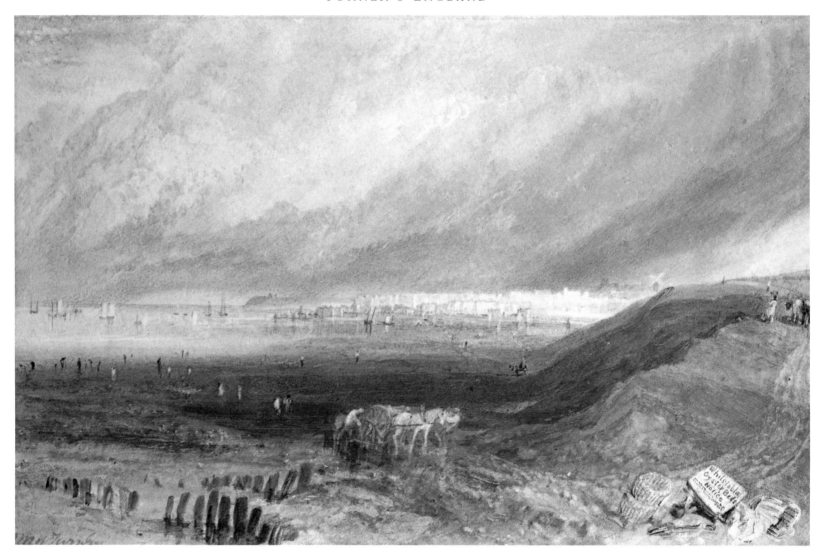

48 WHITSTABLE, KENT

Whitstable has been famous for oysters since Roman times and Henry VIII instituted the Company of Dredgers to control their collection. Here we see the dredgers at work in the distance, while beyond them a storm passes over Long Rock Point and Whitstable gleams in the damp, late afternoon sunshine. A horse-drawn cart brings the harvest ashore, and the effort of crossing the mud-flats is made very apparent by the men pulling and pushing the vehicle. Beyond them a line of figures leads the eye into the distance, and the accents they create are repeated and amplified by the stakes in the foreground. In the bottom right-hand corner an overturned basket and cloth resemble oyster shells, a typical Turnerian visual pun. This watercolour especially demonstrates Turner's matchless ability to capture the moistness of sea air.

c. 1825, signed
Private Collection, U.K.

16.1 × 24.3 cm (6⅜ × 9½ in)

49 WHITBY

This watercolour was not engraved until 1844 but it was probably made for the projected next section of the 'Coast' scheme, up the east coast of England, well before Turner's break with the Cookes in 1827.[38] It shows a great stylistic similarity to the 'Southern Coast' series watercolour of *Dover from Shakespeare's Cliff* (47), which dates from around 1825, and it is almost exactly the same size as that work (the vertical measurements of both watercolours are identical). When Turner did finally embark upon the 'East Coast' scheme around 1827, he had clearly changed his mind about the type of paper to be used for the series, and perhaps this drawing was omitted for that reason. This would also explain why the design has such affinities with the late 'Southern Coast' watercolours and why its detailing would have been suitable for line-engravings.[39]

We look southwards from Upgang, and the cool, misty late afternoon sunlight is rendered with absolute precision. Turner's incomparable ability to capture the dampness of wet sand is visible on the beach, although the grainy texture of the sand was achieved not by rubbing the paper but by laying down washes of colour and then stippling over them when dry.

c. 1825
Private Collection, U.K.

15.9 × 24.8 cm (6¼ × 9¾ in)

50 GROUSE SHOOTING

Both this drawing and its companion (51) were reproduced as chromo-lithographs in 1852, just after Turner's death. However, it has been suggested that the prints were produced with the painter's sanction, and that he might even have seen proofs of them before his death in December 1851, so the original designs are therefore included in this book.[40] The two watercolours were commissioned by Sir William Pilkington of Stanley Chevet, near Wakefield, who eventually owned twelve watercolours by Turner, the majority of which were of Yorkshire subjects. Pilkington himself was an amateur painter and was related by marriage to Walter Fawkes.

The grouse are being 'dogged', or stalked by pointer dogs who have clearly got the scent of the birds (note their tails). The lateral arrangement of the staffage, its overall containment within the contour of the nearby moor, the dark tones of this adjacent area of land, and the minute detailing of rocks and heather in the foreground all serve by contrast to point up the vastness and luminosity of the hills beyond.

c. 1813

The Wallace Collection, London.

28 × 39 cm (11 × 15⅜ in)

51 WOODCOCK SHOOTING

Sir William Pilkington is known to have regularly visited Farnley Hall for the woodcock shooting, and Turner based this work on a pencil study of sportsmen and beaters contained in a sketchbook that was in use at Farnley in November 1812.[41] (It could even be that the sportsman who appears in some of the sketches and in this work was Pilkington himself.) Turner visited Farnley that autumn because he felt generally run down, suffered from excessive acidity and agreed with the hope that the 'Air, moderate exercise and changing His situation [would] do most for Him'.[42] Although it is not known whether Pilkington and Turner met at Farnley that year, it seems likely that they did, given the commissioned creation of this work shortly afterwards.

In addition to being a vivid portrayal of woodcock shooting, this is one of Turner's most magnificent and complex depictions of woodland, with much care given to the exact appearance of trees, gorse and bracken on a grey November day. The woodcock has just been flushed from cover by a beater in the undergrowth immediately below it, while the solitary spruce tree not only locates the woodcock spatially but also serves by means of its serrated shapes subtly to heighten our sense of the sudden, flapping uprush of the bird.

1813, signed and dated
The Wallace Collection, London, U.K.

28×40 cm ($11 \times 15\frac{3}{4}$ in)

52 BAY WINDOWS IN THE FLOWER GARDEN AT FARNLEY

REMOVED FROM LINDLEY HALL, AN ANCIENT SEAT OF THE
PALMES FAMILY BY W. FAWKES, ESQ., A.D. 1814

Walter Fawkes, the owner of Farnley Hall and Turner's great friend and patron, shared Whitaker's antiquarian interests, and he incorporated a number of the more interesting features of old houses that he owned in Yorkshire into the fabric of Farnley Hall itself. These fragments served to enhance the historical associations of the museum he was creating to the memory of one of his ancestors, General Thomas Fairfax, of Civil War fame. In 1814 Fawkes privately published a work entitled 'Architectural Remains removed to Farnley Hall' which contained three etched views of the recent architectural additions. It has been suggested that these three etchings were made by Turner but this seems impossible as they are so amateurish, and by 1815 the painter had considerable experience as an etcher. In any event it appears that Turner used these designs as the basis of three watercolours.[43] (For the etchings from which he

developed the other two watercolours, see 242–243 below.) Fawkes subsequently allowed Dr Whitaker to use the etchings in 'Loidis and Elmete' in 1816, although they were altered for that publication.

The diagonal roofline on the left breaks up the frontality of the planes, and the innumerable highlights scratched through the paint give a brilliant sparkle to the scene. The many straight lines throughout the work were all drawn by hand, rather than ruled, which gives them a very slight irregularity that obviates any sense of formal monotony.

c. 1815
Private Collection, U.K.

Bodycolour and black chalk on grey paper
30.3 × 40.3 cm (11$\frac{9}{10}$ × 15$\frac{4}{5}$ cm) (sight)

LOIDIS AND ELMETE
53 *GLEDHOW*

Gledhow Hall is situated to the north of Leeds and in Turner's day it stood in open countryside; now it is part of the town, although the park has survived. Turner made this watercolour for the owner of the house, John Dixon, who subsidized the engraving of the work in 'Loidis and Elmete'. The painter probably visited Gledhow in 1815 and sketched it from a number of viewpoints.[44]

The hall and its grounds are portrayed from the south-east soon after dawn, with children gathering brushwood and a faraway herdsman and his cows providing the sole staffage. The lower half of the scene is still in shadow, and the coolness of this area is intensified by the mist rising from the pond. Its silvery greys contrast strongly with the golden colour of the far hillside and the very subtle pinks in the clouds and house

above, and Turner was to employ a very similar distribution of mist and warming light in a later 'England and Wales' series drawing of *Richmond* (140).

As was common by 1816, the inner life of Turner's trees is fully communicated, and in the nearest of the ash trees the painter not only expressed the organic dynamism of the tree but also made it appear to greet the advent of the day through the blooming spread of its branches and foliage. The youthful, lithe quality of the tree also matches the inner life of the nearby children, which is clearly why they were located adjacently.

c. 1816 28 × 40.6 cm (11 × 16 in)

Private Collection, U.K.

54 LEEDS

It has recently been plausibly suggested that Turner made this drawing for engraving as the frontispiece of 'Loidis and Elmete' but that Whitaker rejected the design because it takes too positive a view of the effects of industry upon Leeds.[45] Certainly it would hardly have fitted in with the antiquarian tenor of Whitaker's partwork. The design was subsequently reproduced as a lithograph by J. D. Harding in 1823.[46]

This is one of the great images of the Industrial Revolution. By 1816 Leeds was the major flax-spinning centre in Britain, and the industriousness of the place is fully projected by the multitude of factory and mill chimneys belching forth their smoke in the early morning breeze, on 'the kind of morning . . . that local clothiers and millowners welcomed' because it hastened the drying of the cloth.[47] We view the town from Beeston Hill, and from left to right are tentermen stretching newly woven and washed cloth to dry on frames; children picking mushrooms; masons at work on a wall that leads the eye into the scene; a man and a woman who are perhaps factory hands returning from a night-shift at one of the mills in the valley;[48] a clothworker carrying a roll of cloth, possibly to have it tentered in the field on the left; and two milk carriers on their way home from delivering the milk to Leeds. All this figuration adds to the busy dynamism of a work that yet again reveals Turner's alertness to the economic specifics of place.

1816 29 × 42.5 cm (11⅜ × 16¾ in)
Yale Center for British Art, Paul Mellon Collection, U.S.A.

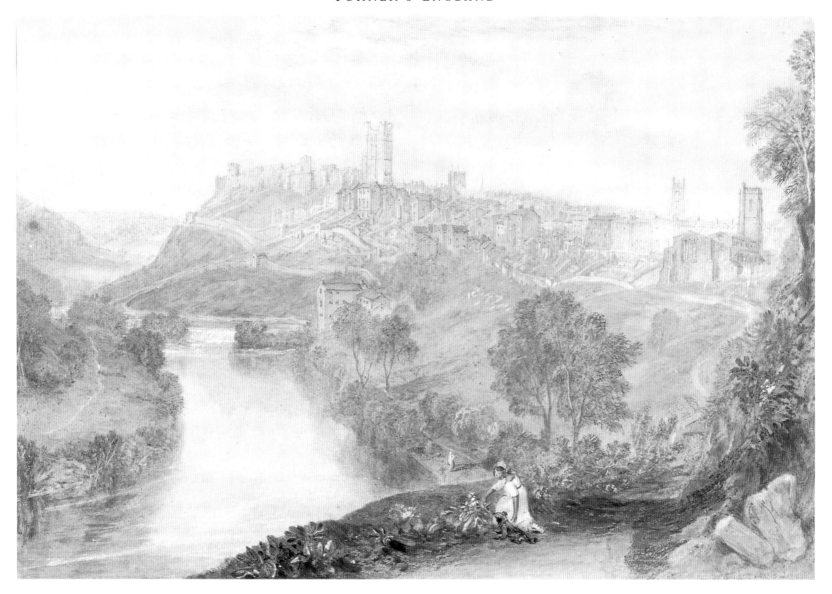

55 RICHMOND, YORKSHIRE

Turner made two elaborate views of Richmond from the east looking up the river Swale, here as seen from the north side of the river, in the other (which was made for the 'England and Wales' series, 140) as perceived from its south bank. In both works the painter introduced a girl with a dog or dogs into the foreground, and they equally appear in two other representations of Richmond (155, 248). Naturally, Turner may have seen a girl with canine company at Richmond and thereafter linked them with the town, but it has also been suggested that he consistently connected them because of the associations of the popular ballad, 'The Sweet Lass of Richmond Hill', which seems very possible.[49] Here the girl is clearly of middle-class origins, and is at her ease, whereas in the other designs the girls work for a living.

Unfortunately this watercolour is very faded but the complexity of Turner's architectural observation survives intact. Ruskin owned the drawing and, in addition to enjoying the representation of Richmond, he also regretted what had been lost in the later industrialization of the town:

> There is no more lovely rendering of old English life; the scarcely altered sweetness of hill and stream, the baronial ruins on their crag, the old-fashioned town with the little gardens behind each house, the winding walks for pleasure along the river shore – all now in their reality, devastated by the hell blasts of avarice and luxury.[50]

c. 1816

29 × 41.7 cm (11⅜ × 16⅜ in)

Victoria and Albert Museum, London

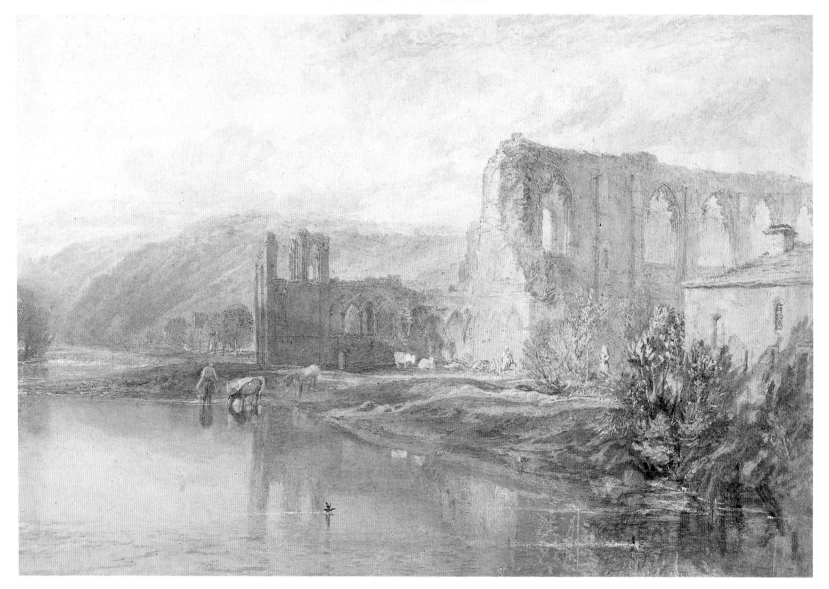

56 ST AGATHA'S ABBEY, EASBY

Easby Abbey was a Premonstratensian establishment founded in 1155 and situated about a mile down the Swale from Richmond. Turner had first sketched the ruin in 1797 and from those studies he worked up an impressive watercolour around 1800.[51] On the 1816 tour he again sketched the abbey and later, when back in London, created some colour studies[52] in preparation for this design. However, he probably based the final drawing equally upon the watercolour of around 1800.

As in the earlier drawing, Turner portrayed the abbey in evening light and from the south side of the river, although for this work he adopted a more distant viewpoint so as to include a good part of the refectory on the right and the old barn in front of it. To the left of centre, above the watering cows, a leaning wall is reflected diagonally on the river, and our awareness of that diagonal is furthered by the contrasting vertical reflection of the moorhen skimming the water nearby.

c. 1817
British Museum, London

28 × 41.5 cm (11 × 16¾ in)

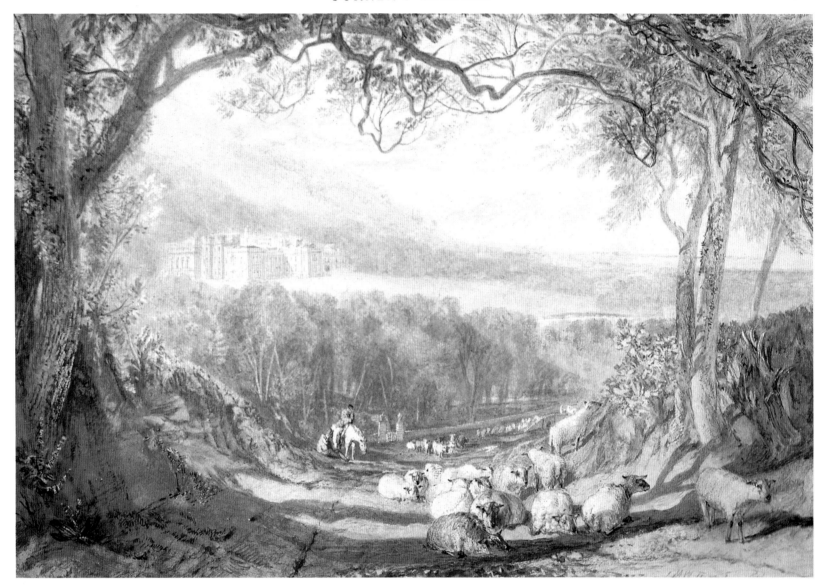

57 ASKE HALL

Aske was built around a fifteenth-century pele-tower and its grounds were landscaped by Capability Brown. The hall is situated about a mile and a half north of Richmond and it was the home of Lord Dundas. Whitaker tells us that the name 'Aske' was derived from the Old English word 'ascth', meaning summit, which signified its situation 'looking down on the fertile vale of Gilling', and that there was no better site for a house in all Richmondshire.

Turner sketched Aske and its environs on the 1816 tour and in this final design he portrayed the hall as seen by evening light from the south. The branches of the ash trees on either side of the Richmond-Gilling road form a pictorially effective framing device, and their subtly undulant lines equally express their own inner life. The marked convolution of one of the branches echoes the shape of the head of a sheep immediately below it, while the arched neck of another sheep grazing the roadside herbage to the right of centre reinforces the curvature of the road where it passes into shadow slightly beyond it. Our sense of that circularity is furthered by the counter-curves of the bridge immediately beyond the grazing sheep and the neck of the horse opposite.[53] Moreover, these curves in turn parallel the shapes of the hillsides above them, thus adding even further to the unity of the composition.

c. 1816
Private Collection, U.K.

28 × 41.3 cm (11 × 16¼ in)

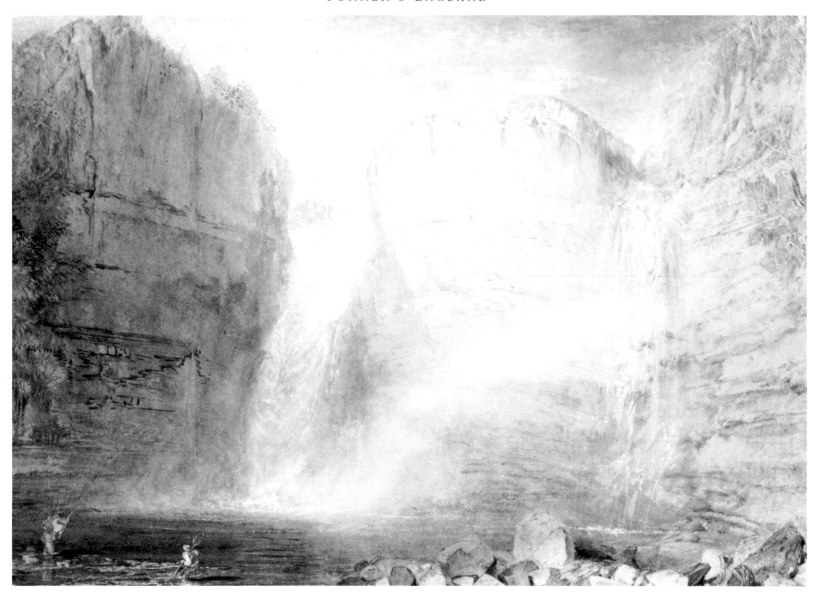

58 HIGH FORCE OR FALL OF THE TEES

High Force waterfall is situated about six miles upriver of Middleton-in-Teesdale and when Turner visited it in 1816 the sun may have come out for a change, for on one of his sketches he noted a rainbow.[54] An apocryphal story also tells us that the painter stayed so long sketching one evening at High Force that he was overtaken by darkness and was only rescued by a passing shepherd after being lost for some time.[55]

As always, the painter rendered the dynamics of falling water and the geological structures with unerring accuracy, but unfortunately there can be little doubt that in common with many of the other 'Richmondshire' watercolours, the indigo used in the drawing has faded, thus upsetting the tonal and colour balances. This fading is especially apparent on the left where the overdrawn blacks denoting the strata in the thin-bedded limestone stand out unnaturally from their background, which originally would have been much darker. As a result of this diminution of the tonal range, the side of the falls in full sunlight enjoys an unchallenged intensity, although accustomed as we are to the high tonalities of Turner's late works, that brilliance does not perhaps seem untoward. The fly-fisherman and his companion both establish the scale of the falls and also lend an extra note of vitality to the scene, although it hardly seems necessary.

c. 1816
Private Collection

28.5 × 40.7 cm (11¼ × 16 in)

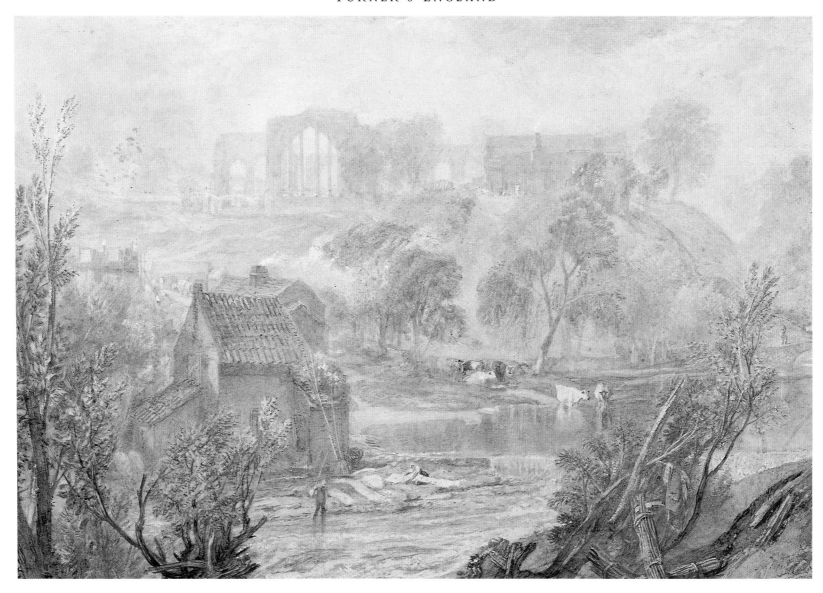

HISTORY OF RICHMONDSHIRE

59 EGGLESTONE ABBEY, NEAR BARNARD CASTLE

Egglestone Abbey was a Premonstratensian foundation dating from 1198 located about half a mile to the south-east of Barnard Castle. It was in a very ruinous state by the early nineteenth century. Turner had sketched it on his first North Country tour in 1797, and he did so again in 1816.[56]

We view the abbey in midday light from the north side of the Tees, and although the watercolour has faded because of the use of indigo, nonetheless the somewhat soggy atmosphere remains, this being yet another of the 'Richmondshire' series designs in which the painter captured the constant wetness of the summer of 1816 (and that dampness comes over equally in the undimmed tones of the engraving). The aftermath of a storm and the coolness of temperature are particularly signified by the numerous highlights sparkling off wet roofs and trees; by the long pall of smoke issuing from the

paper-mill, which indicates both the need for warmth and the strength of the breeze; and by the rain-clouds passing away to the west. A sense of disturbance is also introduced to the scene by the broken branches of the tree (one of which supports some clothing), by the storm-tossed bundles of firewood in the foreground, and by the jumble of buildings, trees, people and animals beyond. These include a fly-fisherman, a woman laying out paper to dry in the sun,[57] some watering cattle, and a number of men rebuilding a fire-damaged part of the mill.

c. 1816
Private Collection

28.6 × 41.9 cm (11¼ × 16½ in)

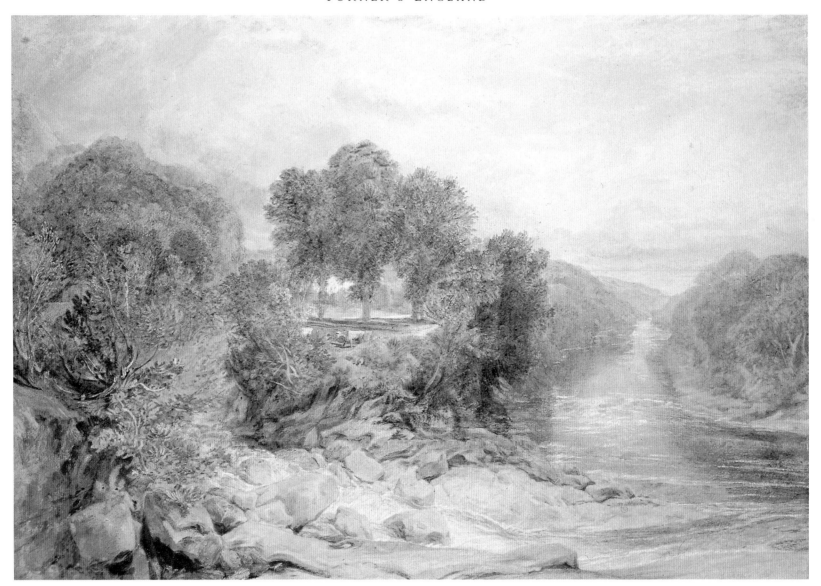

HISTORY OF RICHMONDSHIRE
60 JUNCTION OF THE GRETA AND TEES AT ROKEBY

The Greta feeds into the Tees just over two miles from Barnard Castle, and we view the confluence from the east, with the Tees on the right looking upriver. It has been suggested that in 1816 Turner visited the spot when it was raining, but there are no indications of rain in the final design, for the Tees appears to be unusually placid, although the colour temperature is undeniably cool.[58]

In the distance, between the trees to the left of centre, may be caught a glimpse of Rokeby Hall, then a house of some cultural renown due to its owner, John Morritt (amongst the pictures hanging there was Velasquez's 'Rokeby Venus'). Around 1832 Turner made another, even more lovely view of the confluence of these two rivers to adorn the volume of Sir Walter Scott's *Poetical Works* containing the poem 'Rokeby'.[59]

c. 1816
Ashmolean Museum, Oxford, U.K.

29×41.4 cm ($11\frac{3}{8} \times 16\frac{1}{4}$ in)

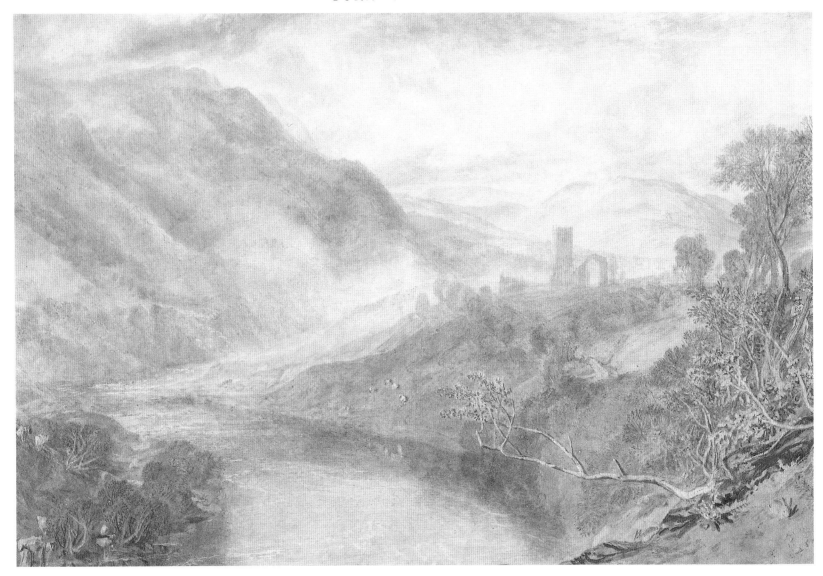

HISTORY OF RICHMONDSHIRE

61 MERRICK ABBEY, SWALEDALE

Marrick Priory was a Benedictine nunnery founded around 1150 and situated about six miles upriver from Richmond. Here we look eastwards towards the remnants of the building, beyond which is to be seen the crenellated tower of St Andrew's church, which was built in 1811 from the original priory tower. In the distance are Swaledale and Arkendale, while on the left Turner took his usual liberties with topography by heightening Harkerside Moor into a veritable mountain. In the foreground at bottom right, the way that the solitary arch of the priory is overshadowed by the church tower is paralleled by a rabbit who is overshadowed by a standing huntsman angling himself for his shot. Such staffage does double duty, for it introduces associations of impending death that are not irrelevant to a portrayal of a dead building.

This is yet another work that has severely faded due to Turner's use of indigo, although that loss receives partial compensation from the ingenuity and breadth of the design. The eye is directed around the near curve of the Swale by a single pointing branch in the foreground, while the sweep of the river lends an immense sense of breadth to the landscape beyond.

c. 1816

28.2 × 41.3 cm (11 × 16¼ in)

Private Collection, U.K.

85

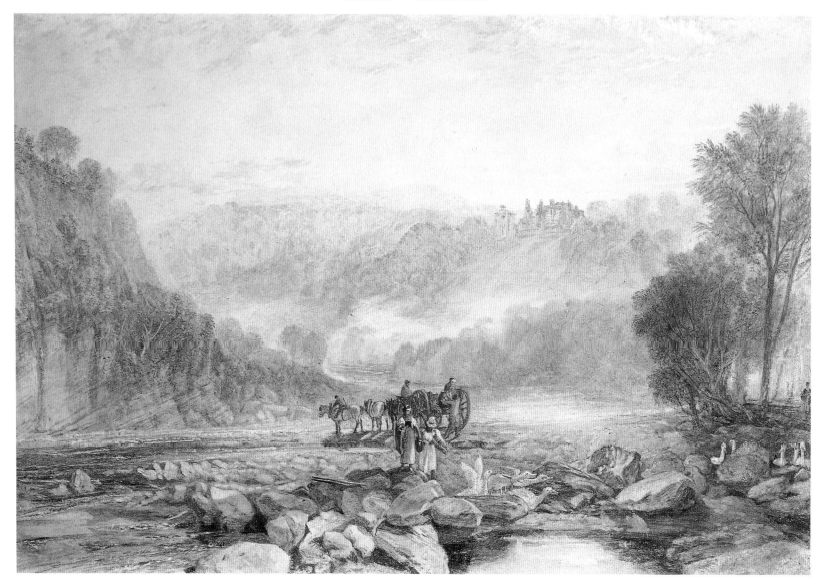

HISTORY OF RICHMONDSHIRE

62 WYCLIFFE, NEAR ROKEBY

Wycliffe Hall is situated on the south bank of the river Tees some five miles to the east of Barnard Castle and just downriver from the 'Meeting of the Waters' represented in the *Junction of the Greta and Tees at Rokeby* (60). In Turner's day the house was thought to have been the birthplace of John Wyclif (1330?–1384), the religious reformer and translator of the Bible into English, although this is now doubted. Turner sketched the house from the riverside in 1816 but his pencil studies contain no indications of weather and lighting, although the word 'calm' which is written on one of them suggests that the Tees was placid for once during that stormy summer. On another sketch there is a horse-drawn trap, and a similar vehicle appears in the final image, although not in the same location.[60]

The design is one of Turner's most considered allegories, for ultimately it works on three levels. When the watercolour was engraved in 1823 (ill. 11), engraver John Pye

remarked to Turner that 'the geese are large'. Turner replied, 'they are not geese, but overfed priests'. Turner told Pye that the light over Wycliffe's house indicated the symbolic light of the Reformation. Wycliffe's followers are driving away the geese-priests.[61]

And further light is shed on this meaning by a variant of the story:

Pye . . . stated that Turner, when 'touching' the Proof [of the engraving], introduced a burst of light (the rays seen above the Hall) which was not in the Drawing. On being asked his reason he replied: 'that is the place where Wickcliffe was born and the light of the Reformation'. 'Well,' said Pye, satisfied, 'but what do you mean by these large geese?' 'Oh, they are the old superstitions which the genius of the Reformation is driving away!'[62]

It has been suggested that Turner 'made up that explanation of the geese on the spur of

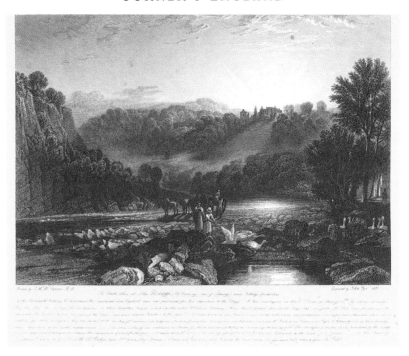

11 John Pye after J. M. W. Turner WYCLIFFE, NEAR ROKEBY, *engraving, 1823, proof state, British Museum, London*

the moment'[63] and that 'the children are in fact shooing the geese away in order to take their eggs',[64] but evidence furnished by the painter himself proves that he did intend to create metaphorical levels to the image.

When John Pye had completed the engraving, Turner had a long title and inscription added to the plate. Three or four proofs of this state of the print were produced and then Turner changed the title and had the inscription removed. One of these proofs is illustrated here. Turner may have suppressed the wording for political reasons, since the final part of the inscription reveals his knowledge of radical politics and likely sympathy with such ideas. These could have proven very damaging to a Royal Academician in 1823.

Turner's longer title reads 'The Birthplace of John Wickliffe (*The Morning Star of Liberty*) near Rokeby, Yorkshire', and the 242-word inscription which follows is divided into four sections, each marked off by a ruled line. The first section records how Wyclif was responsible for translating the Bible into English, while both the first and second sections tell of the harsh legislation that was passed in order to prevent the dissemination of Biblical knowledge in the vernacular. By contrast, the third section records that by 1818 a Biblical distribution society founded in 1804 had translated the Bible into 126 languages or dialects and issued over two million copies of the book. In the final section we are informed of the trial of one Humphrey Boyle at the Old Bailey in May 1822, when 'Women and Boys were ordered to quit the court while the defendant read extracts from the Bible'. When we consider the trial of Boyle it becomes clear that Turner cited his case because it exemplified contemporary religious and political persecution.

Humphrey Boyle was a shopkeeper who worked for a Radical London bookseller, Richard Carlile, who himself went to prison for a total of seven years in 1819 for selling literature that had been banned because of its content, books that included Tom Paine's *The Rights of Man* and *The Age of Reason* which were thought to undermine the political and religious status quo. Boyle was accused of political sedition and religious profanity. In an attempt to embarrass his accusers on the second count, he read out in court the most sexually embarrassing parts of the Bible, and it was because of this recitation of the peculiar sexual proclivities of the ancient Palestinians that the courtroom was cleared of women and boys. Boyle must have known, however, that

the outcome of his trial was a foregone conclusion, which proved to be the case, and on being found guilty he was sentenced to eighteen months' imprisonment.

Boyle was not the only one of Carlile's shopworkers who went to prison for trying to disseminate libertarian ideas freely in the 1820s: Carlile's wife and sister had also worked in the family bookshop ('The Temple of Reason', off Fleet Street) and they too had then been sent to join Richard Carlile in Dorchester gaol for their troubles. Eventually they were followed by a succession of volunteers who came from all over Britain in order to fight for free speech, and to go to prison for it for a combined total of over 200 years. And it was from a banned report of the trial of Carlile's sister in 1822 that Turner had obtained the major part of the inscription to the *Wycliffe, near Rokeby* engraving, for its wording is virtually identical with a passage in that pamphlet.[65]

Turner's reason for citing the Boyle trial seems clear. Boyle had been prosecuted both for his religious freethinking and for his wholly interlinked demands for political reform. In citing his case, Turner was not only identifying with Boyle's demands for toleration and libertarianism, but he was also attempting to demonstrate that the historical cycle that had been initiated so valiantly by John Wyclif had now come full circle. This may have been an ironic and pessimistic view of human affairs but it certainly accords fully with Turner's long-term view of history as he stated it elsewhere.

In both the watercolour and engraving of *Wycliffe, near Rokeby* Turner therefore created an image that works on three levels. It is, of course, primarily a lovely dawn scene, and we are fortunate that the original drawing has not lost all of its colour, unlike several other watercolours made for this series. But the design is also an elaboration of the supposed historical associations of Wycliffe Hall and, in the engraving bearing the long title and inscription, equally it operates as an allegory of English religious and political liberty, the principles that John Wyclif had fought for still being relevant to contemporary society. In sum, *Wycliffe, near Rokeby* superbly exemplifies the way that by 1823 Turner had imbued landscape imagery with huge degrees of ingenuity and significance, as well as beauty.

c. 1816
Walker Art Gallery, Liverpool, U.K.

29.2×43 cm ($11\frac{1}{2} \times 16\frac{7}{8}$ in)

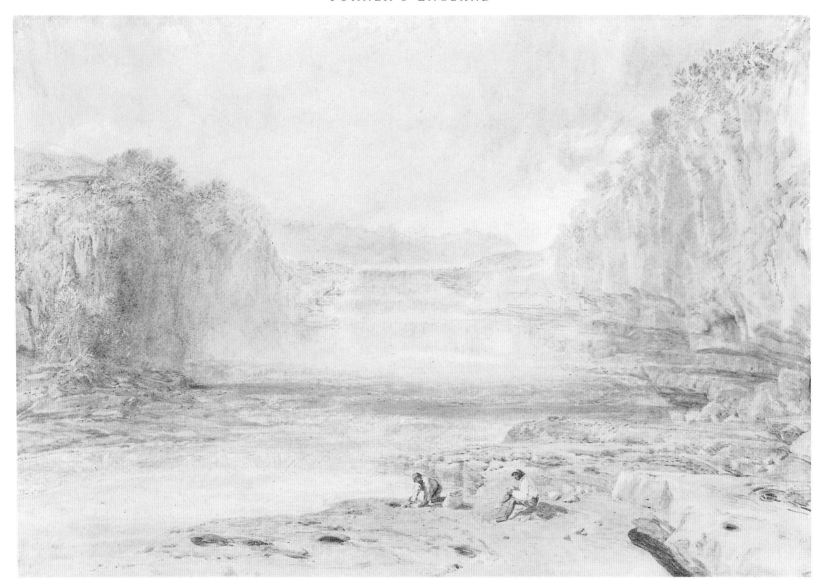

HISTORY OF RICHMONDSHIRE

63 AYSGARTH FORCE

Aysgarth Force is the lowest of three adjacent waterfalls on the river Ure in Wensleydale, and when Turner sketched it in 1816 the river was immensely swollen with the rains that were such a feature of that terrible summer. Unfortunately this work is perhaps even more faded than any of the other 'Richmondshire' drawings, probably due to an indigo underpainting of the whole sheet, and as a result it is impossible to perceive the original lowering storminess of the sky, although of course it can still be seen to the full in the engraving that was made of the design. It is also difficult to apprehend that the slightly darker series of horizontal lines a short way up the limestone scarp on the right denote an overhang caused by the erosive power of the river, although given his usual propensity for dramatization, naturally Turner had greatly accentuated that feature of the rockface.

c. 1816
28 × 40.4 cm (11 × 15⅞ in)
Indianapolis Museum of Art, Indianapolis, U.S.A.

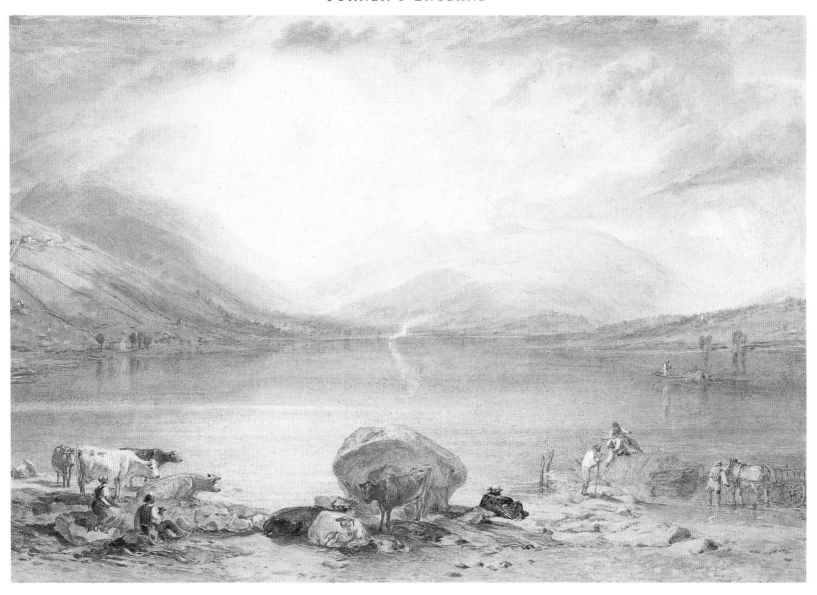

64 SIMMER LAKE, NEAR ASKRIG

When Turner sketched Semer Water in 1816 he considerably raised the rather low moors around it, probably to make them more dramatic; in the final design they were further enlarged, and here seem immense. The sketch bears no indications of weather or light,[66] but the simmering heat projected in the scene may have resulted from Turner's penchant for puns, taking its cue from the 'Simmer Lake' of the idiosyncratically spelt title.

The heat might also reflect a related association. In the centre foreground is the Carlow Stone. According to local legend this was dropped by the Devil when he failed to throw it from one end of the lake to the other; his fingermarks are supposedly apparent on top of the boulder, and Turner represented those crevices. Just to the right of the stone is a black cow whose rear haunch is drawn up in an anatomically impossible way and whose upward-pointing horns and long tail are somewhat emphasized. This curious creature looks very like traditional representations of the Devil in a louche, reclining pose, and it was undoubtedly intended to relate to the diabolical associations of the adjacent stone. Moreover, a series of pronged shapes which reinforce the association are aligned across the foreground: from left to right these include the pointed shadows on a cowgirl's bonnet, the ears of a cow to the right of her, the horns of the 'devilish' cow, the prongs of a mooring post, the prongs of a pitchfork, and the prongs of a horse-collar. Although Whitaker did not mention the legend of the Carlow Stone in his 'Richmondshire' text, he might well have told it to Turner, who of course alternatively could have picked up the tale in the locale.

c. 1817
British Museum, London

28.7 × 41.2 cm (11¼ × 16¼ in)

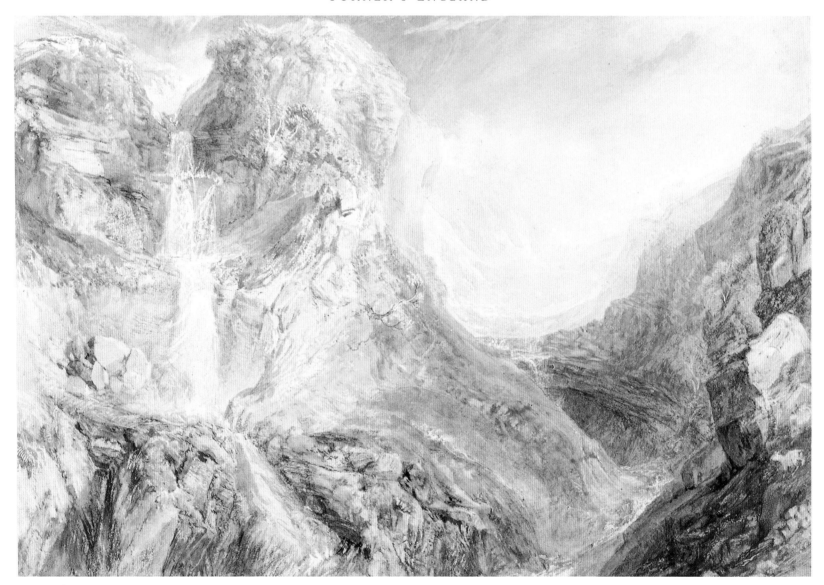

HISTORY OF RICHMONDSHIRE
65 MOSS DALE FALL

Mossdale Falls are situated about three miles to the west of Hawes in Yorkshire and their waters feed into the river Ure. In reality the most dominant waterfall, which descends from Sandy Hill into Great Gill, is only about 40 metres (130 feet) high but here Turner has characteristically elevated it in the most spectacular fashion, and infused the limestone cliffs with some primordial force in the process; it is as if we are witnessing the Creation, so powerful are the dynamics that run through the stone.

The composition is underpinned by a complex network of intersecting arabesque lines that equally do much to imbue the desolate landscape with power. Amid a welter of highlights and shadows, fractures, fissures and erosions of the rock, the hurtling of waters down and through the crevices, and the swirlings of cloud and mist turning around the distant and vastly heightened hills, only a solitary goat denotes any kind of animal existence; this landscape is alien to humankind, and it would only have been softened by our presence.

c. 1816 29.1 × 41.8 cm (11⅜ × 16⅜ in)
Fitzwilliam Museum, Cambridge, U.K.

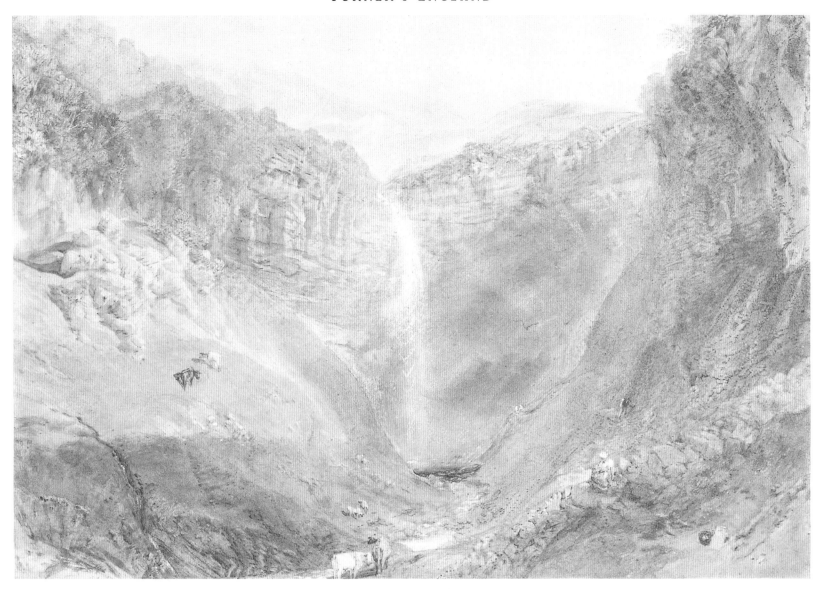

HISTORY OF RICHMONDSHIRE
66 *HARDRAW FALL*

Hardrow Force in Wensleydale, Yorkshire, produces the highest unbroken fall of water in England, with a drop of some 29 metres (96 feet), although predictably Turner made it seem much higher by placing two tiny figures at its base in the distance, mere dots in the landscape. (If we take it that these people are of average height, then Turner has raised the fall about five times above its true height!) Another recent visitor to the site is returning along the path, and a milkmaid who seems rather indifferent to the majestic scenery around her rests in the early morning sunlight on a dry-stone wall while her cows wander off up the hillside to the left.

Turner characteristically depicted the fall of water not as an unbroken flow but as a series of waves, and such surges can also be perceived in his other waterfalls reproduced in this book (58, 65, 139), being obviously intended to impart the dynamic pulse of falling water rather than merely its flow. Of equal insight but greater verisimilitude is the artist's depiction of the characteristic stratifications of the limestone escarpment, where he revealed his usual and total grasp of the underlying fundamentals of geology.

c. 1816 29.2 × 41.5 cm (11½ × 16⅜ in)
Fitzwilliam Museum, Cambridge, U.K.

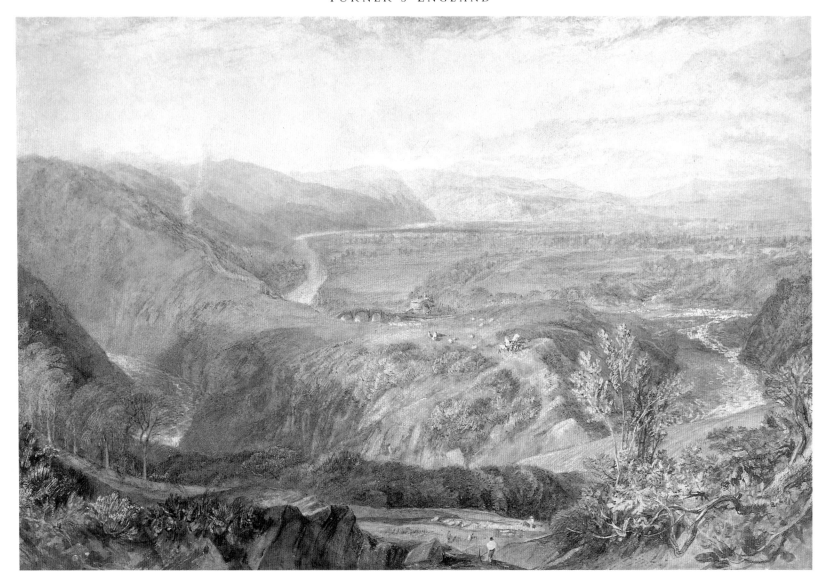

67 CROOK OF LUNE, LOOKING TOWARDS HORNBY CASTLE

This is one of the grandest and loveliest panoramas that Turner ever created. The 'crook' of the river Lune is located about four miles upstream from Lancaster, and in the view we look north-eastwards in evening light across that large winding of the river towards Hornby Castle, which stands directly opposite our viewpoint (as the title tells us), with the 723-metre (2373-foot) Ingleborough Hill located beyond it in the far distance near the top right of the drawing. In order to subtly draw our attention to Hornby Castle – which also appears in the next two works in the 'Richmondshire' series to be discussed – Turner aligned it with the lowest point of the declivity in the foreground (next to the quarryman with his pick), with a horseman passing along the Lancaster road beyond it, and with a group of feeding cattle on the bank of the river

opposite us. The nearby declivity does much to pull us into the scene. Its twin diagonals are subtly reinforced by the diagonal line that runs down from the near bank of the Lune on the left to a shadow on the rocks, and on the right by the counter-diagonal of the convoluted branch at our feet, a convolution which takes its cue from the winding of the river. The saplings in the foreground both establish a necessary vertical and add a further idealized note to the scene, while the overall colouring has fortunately remained firm and beautiful.

c. 1817 28 × 41.7 cm (11 × 16⅜ in)
Courtauld Institute Galleries, London, U.K.

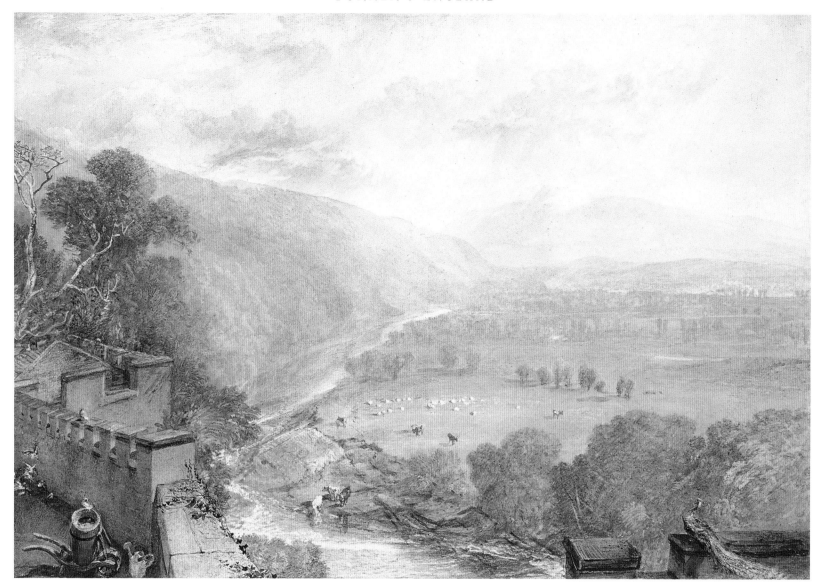

68 INGLEBOROUGH, FROM HORNBY CASTLE TERRACE

In the previous watercolour Turner depicted Ingleborough Hill beyond Hornby Castle; here we perceive the hill as seen more closely from the castle itself, looking eastwards towards Tatham. A further representation of Hornby Castle, viewed from the direction in which we are now looking, appears in the work discussed on the following page.

On the left is the river Wenning, which leads the eye towards Ingleborough in the distance, while in the foreground is the Hindburn that feeds into it. The general lines of both rivers intersect with the circle of the barrel near the bottom left of the image, a circle that acts as the compositional hub of the design and a form that is itself balanced by the peacock on the right. The fluttering of the pigeons on the left adds a touch of

virtality to an otherwise static scene, and that sense of movement is reinforced above the birds by the sharply angular trunks and branches of the trees, some boughs of which were clearly scratched out of the dark underpainting by the wooden end of a brush. It has been asserted that this is a dawn scene, but that is not the case, as the sun is well up and the timing is mid-morning.[67] The colouring is gentle and warm, and it shows no traces of the yellowing and fading that have so sadly afflicted a number of the other drawings in this series.

1818, signed and dated
Private Collection

28.6×41.9 cm ($11\frac{1}{4} \times 16\frac{1}{2}$ in)

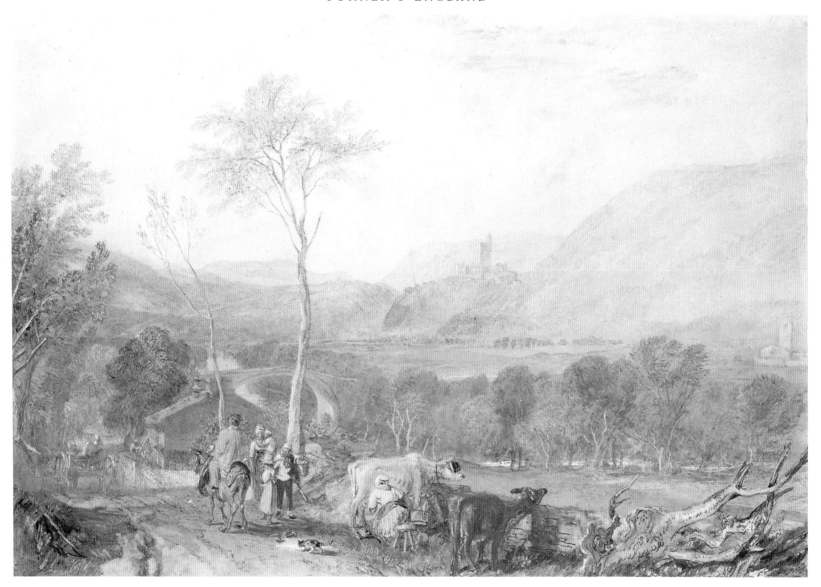

69 HORNBY CASTLE FROM TATHAM CHURCH

Despite the title which tells us that we are viewing Hornby Castle *from* Tatham Church, the church itself can be seen in the distance on the right. Both the castle and the hills beyond catch the last of the afternoon sunshine, and the tonal control apparent in the drawing of the hills is particularly masterly, given that they have virtually disappeared in the glare. The central trunk of the nearest of the trees was painted over the forms of the hills whose blue tones can be seen through the overlaid but now transparent wash of colour. Although the sky has yellowed very slightly, the effect is not untoward as it adds to the general sense of warmth, and the rich reds of the nearest cow and foliage on the extreme left, plus the wide range of blues and greens, give the work a slightly autumnal tinge.

On the road leading down to the bridge over the Wenning is a rustic wearing a smock. He is seated upon an old nag, talking to a woman burdened with children, one of whom has spilt some milk which is being lapped up by a cat as a milkmaid replenishes the supply. In the immediate foreground a cow rubs its neck upon a dry-stone wall, and the curve of its neck is amplified by the succession of curves running through the boughs and branches on the right, a typical Turnerian use of the similarity of forms to intensify our experience of things.

c. 1818
Victoria and Albert Museum, London

29.2 × 41.9 cm (11½ × 16½ in)

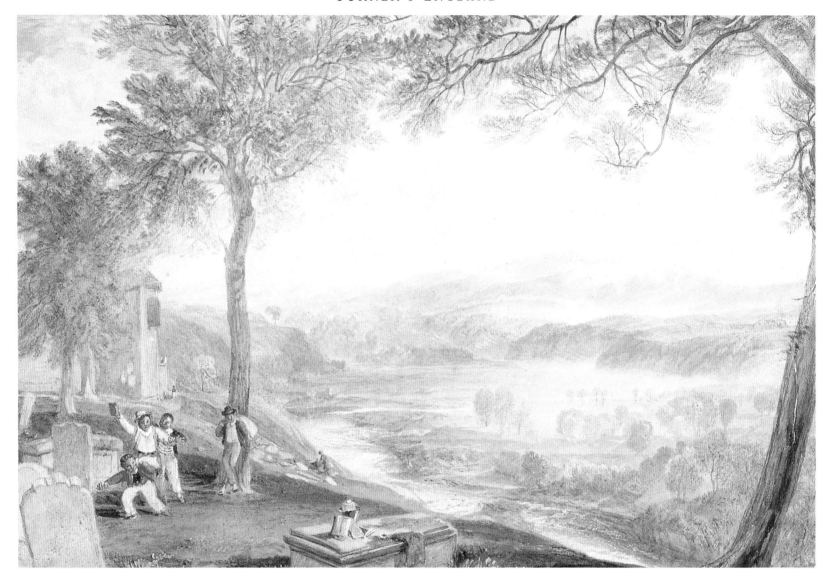

HISTORY OF RICHMONDSHIRE
70 KIRKBY LONSDALE CHURCHYARD

Morning mists waft along the Lune valley as the sun rises above Barbon Fell, but the tranquillity of the scene is disturbed by some boys in the foreground who are throwing books at a target they have made of their school books. This staffage is surely ironic rather than merely playful, for one day these boys will also end up in a graveyard (or perhaps even in *this* graveyard). The way that Turner made the tomb the nearest object to the viewer supports this moralistic interpretation, for quite naturally the painter always used such proximity when he especially wanted us to notice something. Moreover, washing is being laid out to dry in the early morning sun beyond the churchyard, and this might have been introduced to summon forth associations of shrouds, objects that are appropriate to a burial place. A reminder of the brevity of life was certainly suited to the 'Richmondshire' series, for Whitaker was an ecclesiastic and the series contains other religious allusions (62, 64). Moreover, it was entirely natural for Turner to have moralized in a graveyard, for he was very conversant with a body of poetry in which similar sentiments were drawn from those locations.[68] And we are definitely reminded of the fact that human life is short by the contrasting renewal of the natural world, as the sun rises upon an ineffably calm vista framed by ideally beautiful trees.

c. 1818
Private Collection, U.K.

28.6×41.5 cm ($11\frac{1}{4} \times 16\frac{3}{8}$ in)

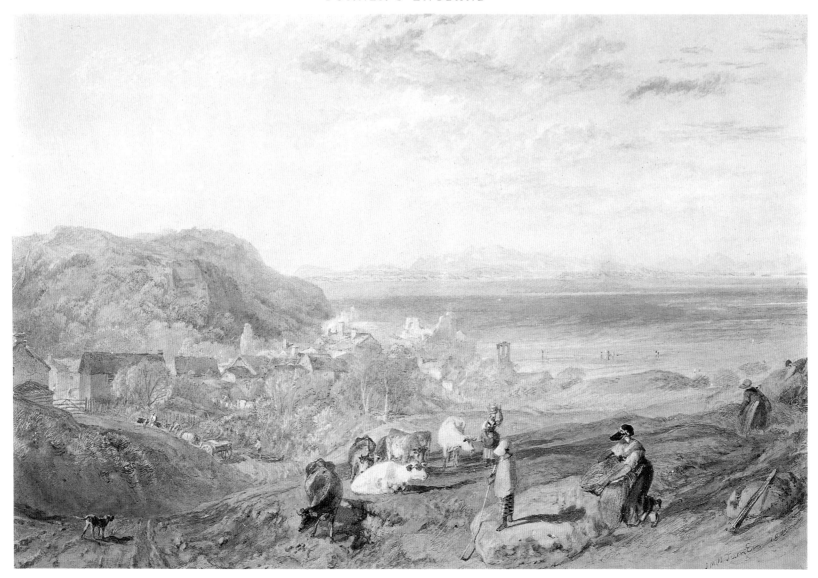

71 HEYSHAM AND CUMBERLAND MOUNTAINS

In this view from Lower Heysham we look north-westwards across Heysham Sands and Morecambe Bay towards the Cumberland and Lancashire mountains. The work was based on a sketch made on the 1816 tour, and on that sketch Turner wrote the names of some of the distant features he could identify or remember, such as Black Combe, Coniston Old Man, Holker Hall, Flookburgh, Castle Head and Arnside.[69] The configuration of the mountains as seen in that sketch and in this watercolour reappears almost identically in the 'England and Wales' series drawing of *Lancaster Sands* (150), so there can be no doubt that Turner partially based that later work upon the 1816 sketch as well.

Unfortunately this watercolour has yellowed and now looks somewhat monotonous in colouring. But Turner's control of aerial perspective is still fully evident, as is his mastery of design. In this respect Ruskin noted how the work is lent compositional unity by the turn of the spine and neck of the nearest of the cows, a line that continues the curve of the road beyond it.[70] Those curves are repeated more gently by the white stick of the little girl standing on the boulder and by the overall lines of the woman to the right of her. The white stick also serves to lead the eye up to the verticals formed by the milkmaid standing beyond the girl and the uprights of the low, two-arched belfry of Heysham church, verticals that in turn connect with the dominant peak of Coniston Old Man in the far distance.

1818, signed and dated
British Museum, London

29 × 42.4 cm (11$\frac{3}{8}$ × 16$\frac{3}{4}$ in)

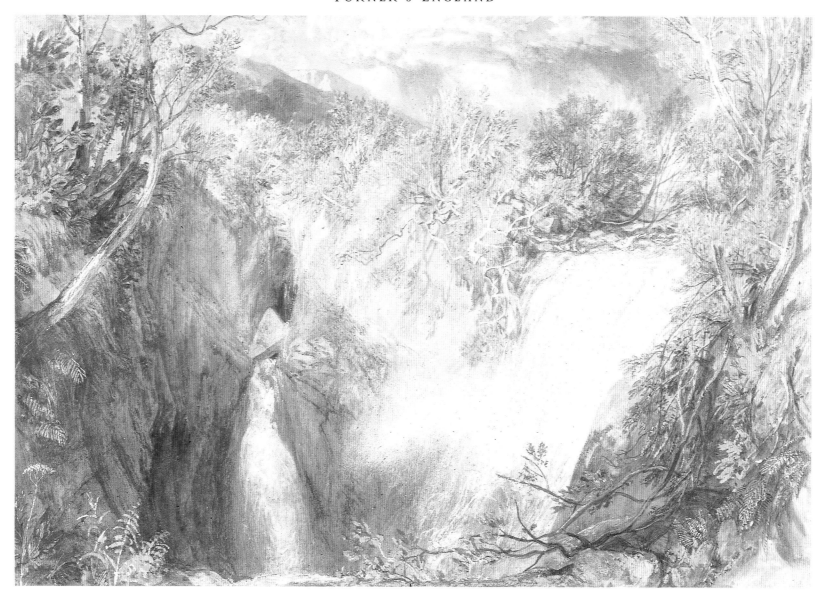

72 *WEATHERCOTE CAVE WHEN HALF FILLED WITH WATER*

Weathercote Cave is situated about three miles from Ingleton in Yorkshire and it is a wide pothole, 21.3 metres (70 feet) deep, in the floor of one of the most wild and impressive valleys in the north of England. Turner had descended to the bottom of the cave around 1808, subsequently making a fine watercolour showing the view looking upwards, with an artist sketching nearby and water pouring down from behind the wedge-shaped limestone rock (known as 'Mahomet's Coffin') that we can see in the centre of this drawing.[71]

When Turner revisited the cave to sketch it in the unusually wet summer of 1816, the normally moderate amounts of water pouring into it had naturally swollen to torrents. As a result, a large pool of water had risen nearly to the top of the pothole, something that is apparent in the sketch, as well as in the words scribbled alongside it which read 'Weather Cote full'.[72] Obviously because in the final design Turner needed to retain some sense of depth in the cave, so that it did not just look like a pond, he lowered the water level so as to make the pothole merely '*half* filled with water'. The convoluted lines of the branches and tree trunks that surround the cave add to the sense of dynamism in the scene, as does the marvellously subtle rainbow. The restricted blue-green colour range and deep tonal contrasts amply convey the bleak evening light, with storm-clouds bringing yet more rain.

c. 1818
British Museum, London

30.1×42.3 cm ($11\frac{7}{8} \times 16\frac{5}{8}$ in)

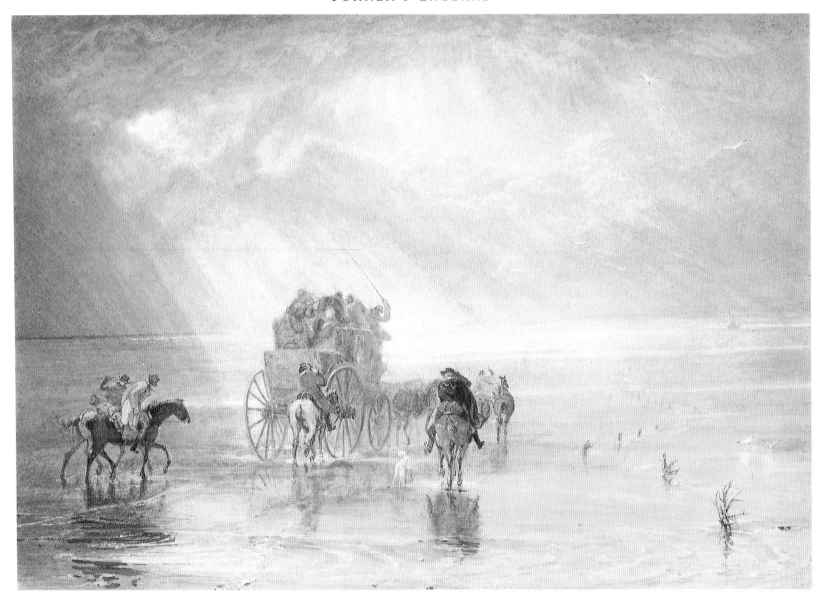

73 *LANCASTER SANDS*

Morecambe Bay, of which Lancaster Sands form a part, is fordable at low tide and in Turner's day people would regularly cross the sands to avoid an enormous detour. Guides called 'Carters' existed to help them, and they were very necessary, for three rivers feed into the bay which is also bestrewn with quicksands and other dangers such as sudden fogs and tidal surges. The regular routes were indicated with twigs of laurel called 'brobs', seen here stretching away into the distance on the right.

Turner crossed Lancaster Sands towards the end of the 1816 tour, and this drawing was almost certainly made for the 'Richmondshire' series, although it was never engraved due to the cancellation of the project. The imagery of the work was surely autobiographical, for this is pretty much how Lancaster Sands must have looked in reality during that abominable summer. Some years later, however, Turner elaborated a much more imaginative and colourful response to the crossing for the 'England and Wales' series (150).

c. 1818
28 × 36.6 cm (11 × 14⅜ in)
City Museum and Art Gallery, Birmingham, U.K.

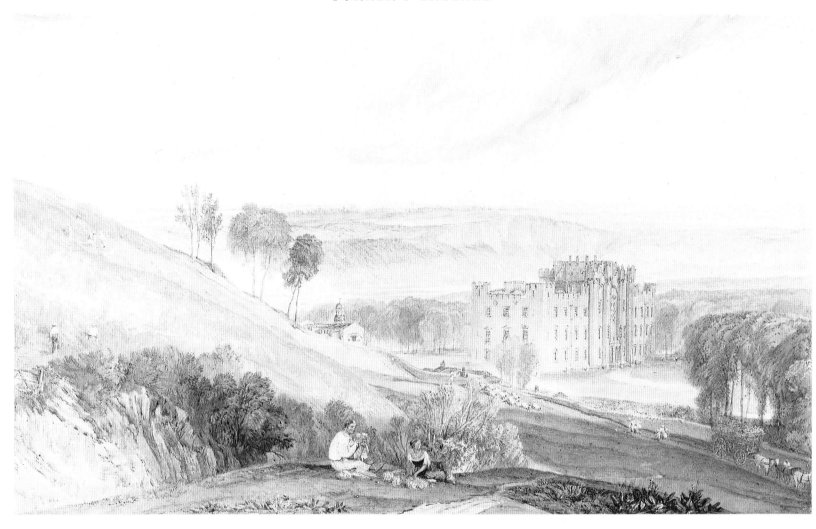

74 HYLTON CASTLE, CO. OF DURHAM.

THE SEAT OF THE EARL OF STRATHMORE

Hylton Castle was owned by the tenth Earl of Strathmore who commissioned this watercolour for engraving in Robert Surtees's 'History of Durham'. Turner visited the house with the Earl at the end of October 1817.[73]

We look southwards during the late afternoon, taking in the west front of Hylton Castle, with the river Wear beyond it. To the left of the house is the castle chapel, partially obscured by the brow of a hill, while in the far distance at the intersection of the hill and the horizon are the rugged Cleveland hills. On the left are numerous reapers getting in the harvest, and in front of the house and making its way along the old Sunderland-to-Newcastle road is a haycart followed by some field labourers and a shepherd with his sheep. The bucolic atmosphere is augmented in the foreground by a swain presenting a posy of flowers to a girl who ignores his advances.

c. 1817
Private Collection, U.K.

19.8 × 28 cm (7¾ × 11 in)

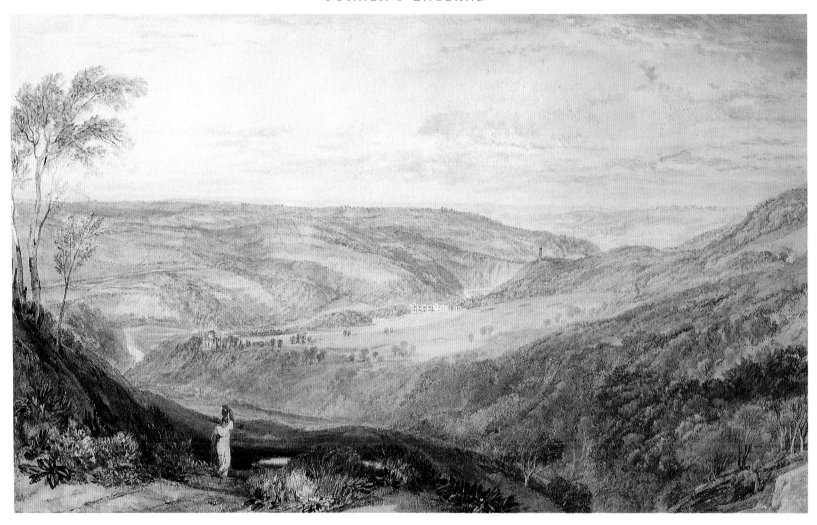

HISTORY OF DURHAM

75 GIBSIDE. CO. OF DURHAM [SOUTH-WEST VIEW]

THE SEAT OF THE EARL OF STRATHMORE

Gibside, near Gateshead, was the Earl of Strathmore's other great property in County Durham and Turner also stayed there with the Earl in late October 1817. He subsequently made two watercolours of the house, probably so that Lord Strathmore could exercise some choice over his contribution to Surtees's learned tome. In the event, the Earl chose to have this watercolour engraved but he purchased both drawings. The unengraved watercolour of Gibside is discussed opposite.

Here we view the house (which has since been demolished) from the south-west, in afternoon light and with the river Derwent running across the vast panorama. On the right may be seen the 46-metre (152-foot high) Column of British Liberty, which was erected between 1750 and 1757 by Sir George Bowes, a coal-owner and Member of Parliament. By the riverside in the middle-distance on the left is the neo-classical

Gibside chapel, the masterpiece of James Paine, which was begun in 1760 and consecrated in 1812. Further associations with the classical world are introduced nearby by the woman in neo-classical garb carrying a vase on her head. The circle of the vase reinforces the circularity of the dome on Gibside chapel, while the upright of a tree on the near bank of the Derwent reinforces the verticality of the distant Column of British Liberty above and beyond it. The colouring is rich and autumnal, very much as Turner might originally have seen it.

c. 1817 26.5 × 44 cm (10⅜ × 17¼ in)
The Bowes Museum, Barnard Castle, U.K.

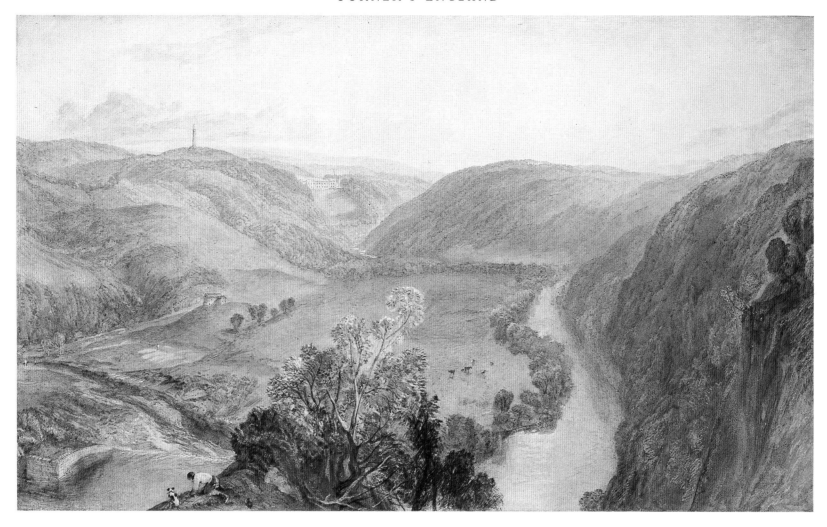

76 GIBSIDE. CO. OF DURHAM [FROM THE NORTH]

THE SEAT OF THE EARL OF STRATHMORE

This watercolour forms the companion to the work discussed opposite. As Turner might similarly have made it with the possibility of engraving in mind, it is included in this book.

Here we view Gibside from the north, with the Column of British Liberty to the left of the house. The eye is attracted to the column by its subtle vertical alignment with both a farmhouse far below it and the boy with a dog in the foreground. This boy peers warily over the edge of the very sheer escarpment and our awareness of both his consciousness of height and the drop in front of him is greatly amplified by the vertical alignment above him. Again the colouring suggests an autumnal timing for the scene, and the banks of the Derwent look very idyllic in the late afternoon light.

c. 1817
The Bowes Museum, Barnard Castle, U.K.

27.5 × 45 cm (10¾ × 17⅝ in)

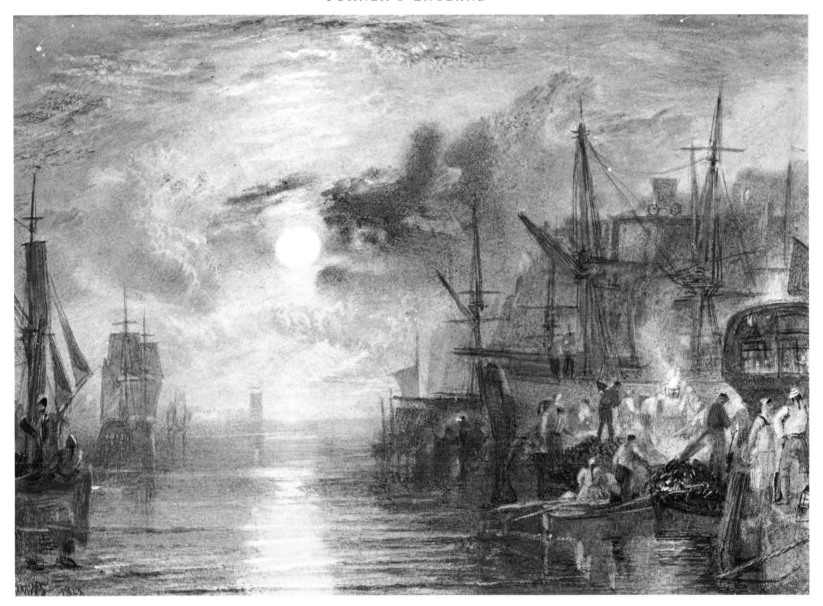

77 *SHIELDS, ON THE RIVER TYNE*

This design probably inspired the commissioning of a later oil painting of the same scene entitled *Keelmen heaving in Coals by Night*,[74] exhibited at the Royal Academy in 1835. The two works are very similar, although the watercolour is less spacious in scale and less silvery in tone, with a range of blues and blacks evoking romantic moonlight.

The coal was carried down the Tyne by flat-bottomed barges (keels) from the coalfields above Newcastle, but after 1823 there was an increasing dependence upon railways to undertake this transportation, and up on the right we can see a coal-wagon discharging coal directly into the hold of a collier-brig. The coal-heaving keelmen (who would literally shovel or 'heave' the coal from barges into collier-brigs) obviously have little time or inclination to contemplate the picturesque qualities of the scene.

1823, signed and dated
Clore Gallery for the Turner Collection, London

15.4 × 21.6 cm (6⅛ × 8½ in)

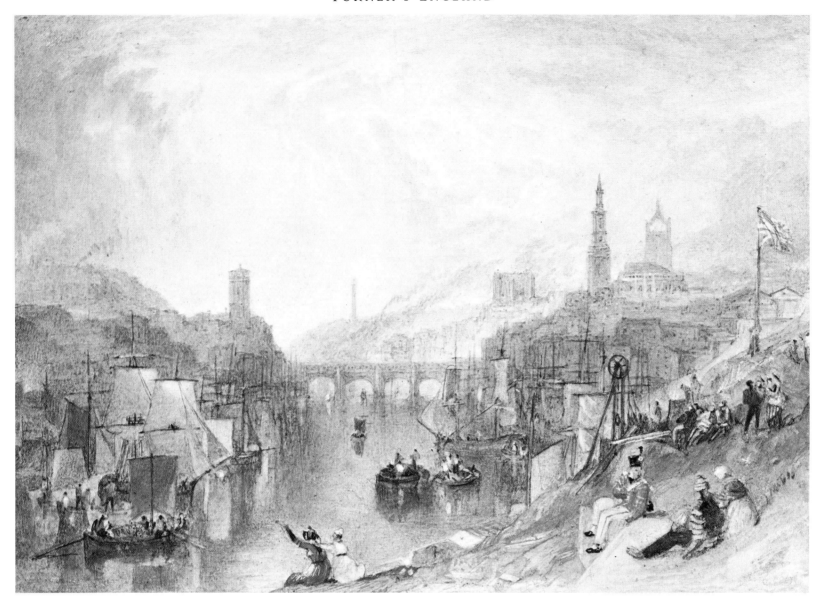

78 *NEWCASTLE-ON-TYNE*

Turner made a number of sketches of Newcastle when staying nearby with the Earl of Strathmore in 1817 (see 74–76).[75] Here we look westwards, with Gateshead on the left and Newcastle on the right. From left to right are the tower of St Mary's, Gateshead (destroyed by fire in 1979); the bridge of 1772 (demolished in 1876); above the bridge, the Elswick shot-tower; to the right of it the Norman castle; then the lofty spire of All Saints; and finally the medieval steeple of the church (later cathedral) of St Nicholas. Before them are the crowded staithes and steep hillsides of the river, with men hauling timber on the right. The marine, sailor and women waving to the keelmen below them all add to the bustle of the scene and equally represent a cross-section of the town's working population. Turner's initials can be made out at the bottom right, where they form the shadow cast by the woman.

c. 1823

15.2 × 21.5 cm (6 × 8½ in)

Clore Gallery for the Turner Collection, London

103

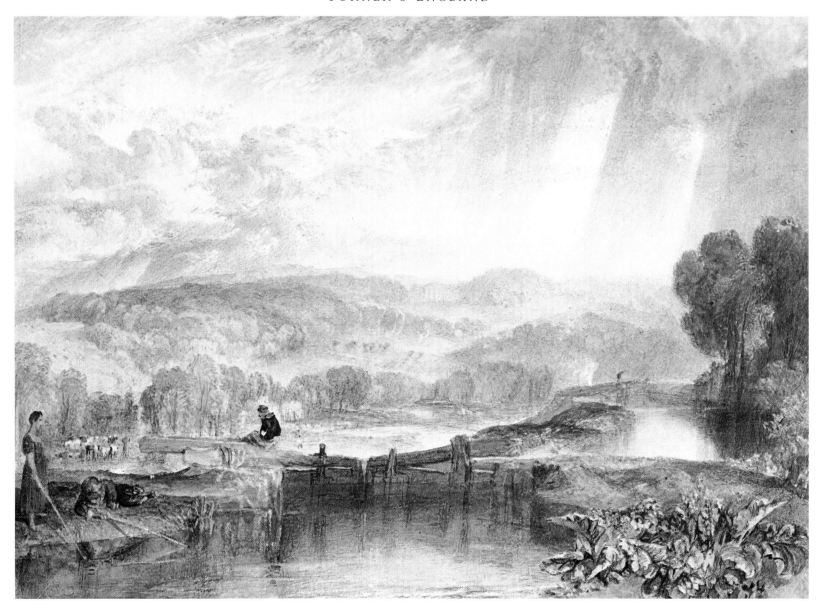

79 MORE PARK, NEAR WATFORD, ON THE RIVER COLNE

Moor Park was enclosed by sanction of Henry VI in 1426. The house itself was built during the reign of Edward IV by George Nevil and was owned at one time by Cardinal Wolsey. The 500-acre estate was later landscaped by James Thornhill and Capability Brown, and was very famous in Turner's day. It is now a golf club.

Turner took his usual liberties with topography here, for the low Hertfordshire hills look more like the Yorkshire moors. The title of the work could mislead the unwary into believing that the body of water in the foreground is the river Colne, whereas in fact it is the Grand Union Canal at Lot Mead Lock; the Colne is only just visible beyond the lock-gates and below them to the left. The shallow V-line of the lock-gates is reiterated by similar lines above, and they lead the eye to the distant house. The temperature of the scene is cool and the atmosphere damp for, judging by the clouds moving off to the west, it has rained recently. The inactivity of all the figures helps to consolidate the mood of complete repose throughout the scene.

1822 15.7 × 22.1 cm (6⅛ × 8⅝ in)
Clore Gallery for the Turner Collection, London

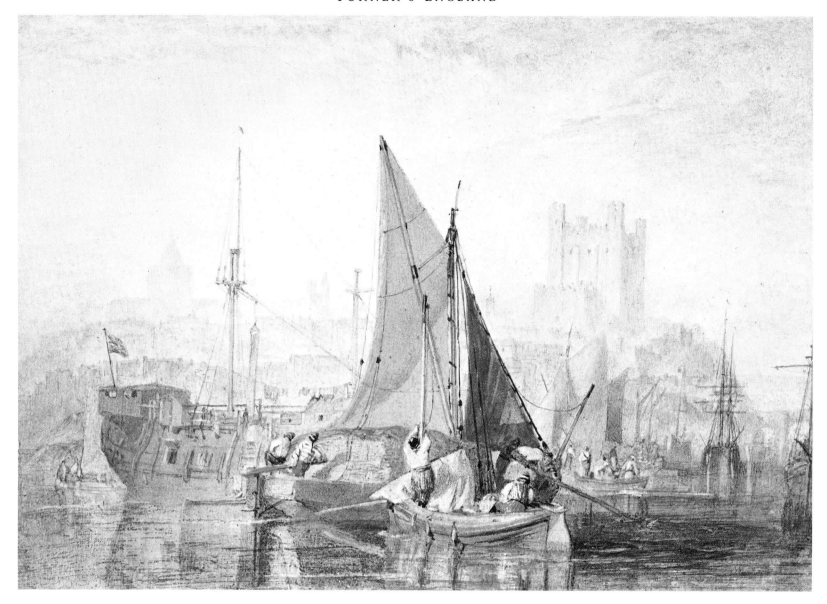

80 ROCHESTER, ON THE RIVER MEDWAY

Rochester was the subject of one of Turner's very first oil paintings (now untraced) and he depicted it several times. Here he virtually obscured the town with a great deal of river shipping, including a Thames barge carrying a cargo of hay, and a prison-hulk, upon which may be seen a washing line and a canvas ventilating-shaft that was designed to pump fresh air down to the lower decks.

The cathedral in the distance on the left is drawn with extraordinary tonal delicacy, and the triangular shape of its spire is amplified by the triangles formed by the rigging of the hulk and the sail-peaks of the nearby barge and ketch beyond it. The twelfth-century castle looks even more foursquare by comparison.

1822 15.2 × 21.9 cm (6 × 8⅝ in)
Clore Gallery for the Turner Collection, London

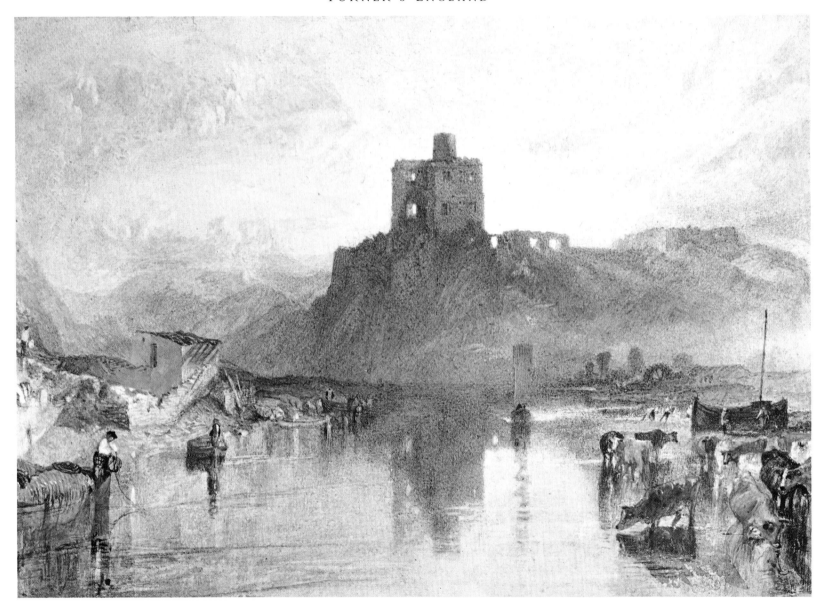

81 NORHAM CASTLE, ON THE RIVER TWEED

Turner depicted Norham Castle in seven important watercolours and many other colour studies, as well as a dazzling late oil painting that dates from after 1844. This is perhaps the most richly coloured of all those works, with the brilliance of the dawn light greatly enhanced by a wide range of textures and stipplings.

The stretch of the Tweed seen here marks the boundary between Scotland, on the left, and England, on the right; Turner therefore introduced a kilted Scot on the left, even though kilts were not usually worn in the lowlands. The remains of the building on the left were still visible when the author visited the site in 1976. Turner made the structure look more Italianate than Borders. He also considerably enlarged and raised the castle, while reinforcing our sense of the rectilinearity of the upper part of its keep by echoing its shape in the oblong sail of the boat beneath it.

1822

15.6 × 21.6 cm (6⅛ × 8½ in)

Clore Gallery for the Turner Collection, London

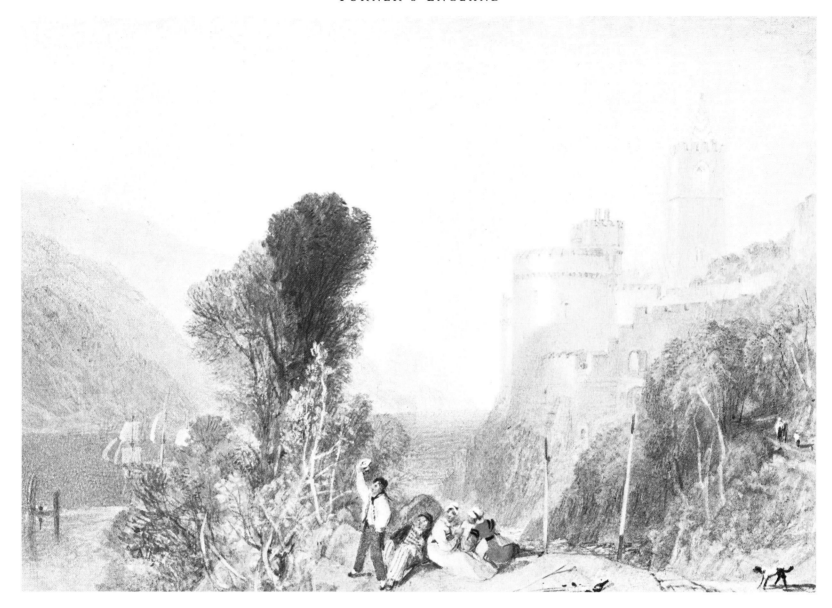

82 DARTMOUTH CASTLE, ON THE RIVER DART

Dartmouth Castle dates from 1494 and stands a mile south of the town of Dartmouth. It appears distantly in further Turner views of Dartmouth or its environs (see 84, 137 and 232).

As in the other view over the Dart in 'The Rivers of England' series (84), the sun has just risen, and the castle and adjacent tower of the church of St Petroch catch the first light. One of the sailors in the foreground looks somewhat the worse for wear but the waving gesture of his shipmate introduces a happier, more sober note. Beyond their discarded swords and bottles, the castle is bracketed by two masts, a framing device Turner had used before in conjunction with this same building (232). These twin verticals are repeated by two chimneys on the turret of the castle, pairings that are further repeated faintly in the distance by the turrets of Kingswear Castle across the Dart.

1822 15.9 × 22.4 cm (6¼ × 8⅞ in)
Clore Gallery for the Turner Collection, London

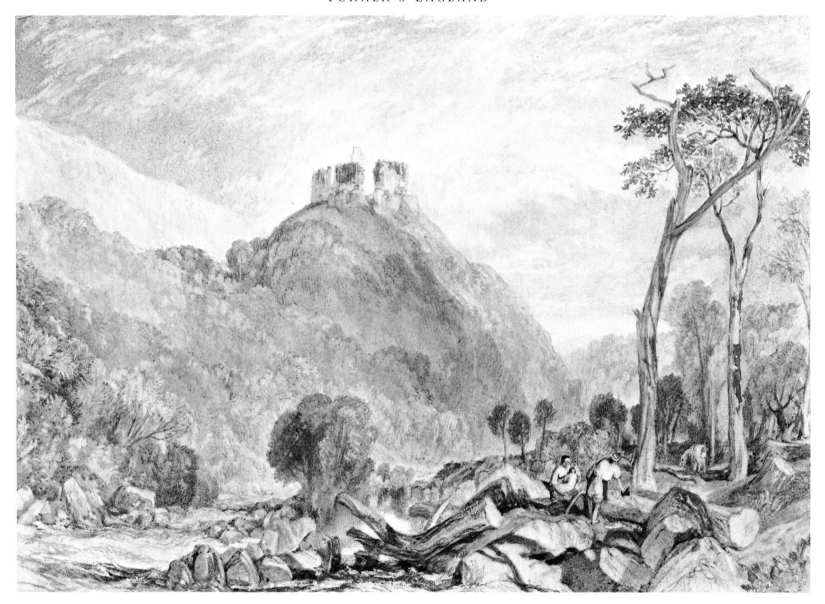

83 OKEHAMPTON CASTLE, ON THE RIVER OKEMENT

Okehampton Castle was one of the largest castles in Devon before its destruction by Henry VIII in 1538. The height of the ruin is subtly augmented both by Turner's choice of a very low viewpoint and by the tree trunk in the centre foreground which reverses the conical shape of the castle hill above it. Other typical Turnerian 'echoes' occur on the right where the forked upper branches of the two nearest trees repeat the shape of the gap in the wall of the castle, while the tormented shapes of the dead branches of the nearer tree amplify the mood of desolation. Similarly, the rushing turbulence of the river is continued by the wavelike shapes which run through the timbers, rocks and shadows in the foreground.

Amidst all this desolation and chaotic movement, rest and renewal are projected by a woodcutter with his wife and child.

c. 1824

16.3 × 23 cm (6⅜ × 9 in)

Clore Gallery for the Turner Collection, London

108

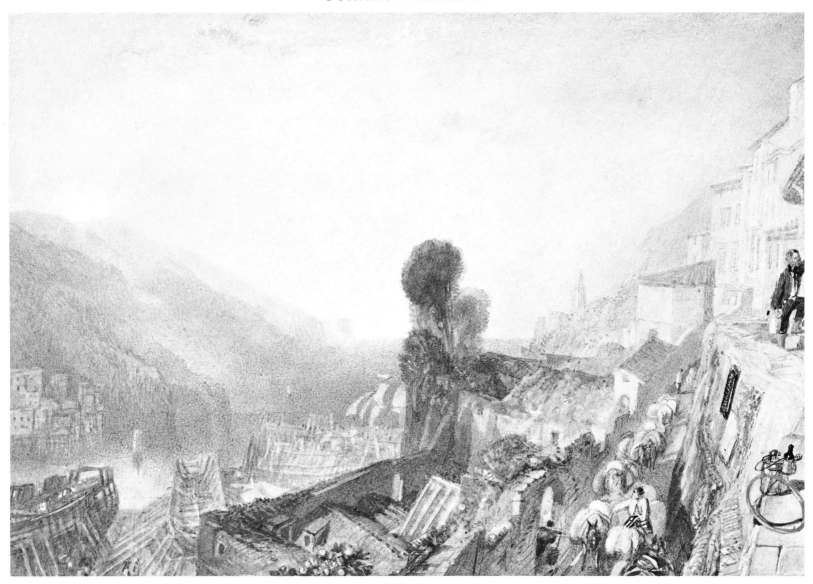

THE RIVERS OF ENGLAND
84 DARTMOUTH, ON THE RIVER DART

On the left the sun rises above Kingswear, while on the right a milkman makes his early rounds. The uplifted arm of the milkman acts as the meeting point of several diagonal lines that run upwards through the work to give it visual cohesion.

In front of the milkman the association between milk and childhood is underlined by the juxtaposition of a milk pail (to which a bottle is attached) and a child's hoop. Below him, a milkmaid steps out of the path of a train of pack-mules progressing down the steep lane on their way to the 'pannier market', a regular market held in Dartmouth for the sale of produce from outlying farms. At the lower left are the shipyards which were very busy during this period: in 1826 no fewer than nineteen vessels were built in them. The central group of trees also appears, albeit somewhat more

dominantly, in the other view of Dartmouth Castle in this series (82).

Like a number of watercolours in both the 'Rivers' and the 'Harbours' series, this drawing is notable for the amount of stippling it contains. These tiny marks are especially apparent on the left, and they increase the textural vibrancy of the work, creating an effect that is equivalent to the surface vibrancy of oil paint dragged across the tooth of a canvas; faced with the flatness of paper, Turner achieved a comparable surface dynamism by more elaborate and patient means.

1822 15.7 × 22.7 cm (6⅛ × 9 in)
Clore Gallery for the Turner Collection, London

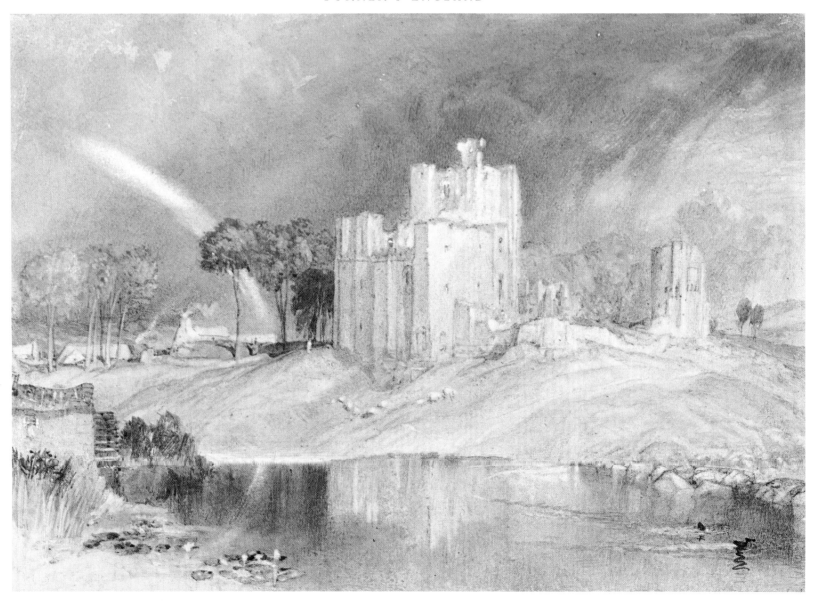

85 BROUGHAM CASTLE, NEAR THE JUNCTION OF THE RIVERS EAMONT AND LOWTHER

Brougham Castle, near Penrith in Cumberland, formed part of a defensive system of Norman castles built to prevent Scots invasion and cattle-stealing in the Borders. The keep dated from the time of Henry II and the castle was destroyed during the Civil War.

We view the castle from the north in late afternoon light, with the river Eamont before us; the Lowther feeds into it just off to the right. Turner visited the site in the summer of 1809 during an extensive tour of the north-west of England in connection with commissions to paint views of Cockermouth and Lowther castles. He then made two detailed pencil studies of this castle which later he synthesized to form the basis of the present watercolour.[76]

The virtual absence of staffage increases our sense of the isolation and desolation of the castle, although its feeling of ruination is somewhat attenuated by the way that the building stands out so brilliantly against the stormy sky beyond.

c. 1824

16.1 × 22.8 cm (6⅜ × 9 in)

Clore Gallery for the Turner Collection, London

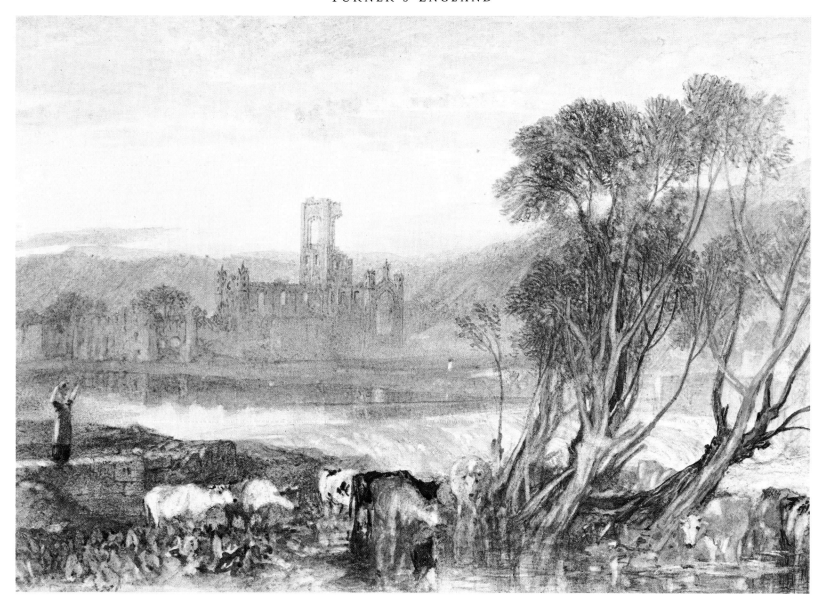

86 KIRKSTALL ABBEY, ON THE RIVER AIRE

Turner first visited Kirkstall Abbey in 1797 and from the sketches he made on that tour he worked up three impressive watercolours, one of which was exhibited at the Royal Academy in 1798. Thereafter he returned to the site a number of times, usually when visiting Farnley Hall; indeed, the basis of this watercolour is a pencil study made while he was staying at Farnley in November and December of 1824, a sketch in which the painter included Kirkstall Weir but omitted the bay-willow trees completely.[77] In the final watercolour the abbey is depicted in summer, as the foliage testifies.

The wistful mood of the design appropriately takes its cue from the ruin, with the tower of the ruined Cistercian foundation catching the last rays of evening sunlight and the mist around the abbey painted in the most delicate tones. On the left a cowgirl waves with both arms, and her gesture is reversed and returned to her by a sapling, as well as by the numerous forked branches of the other trees further to the right.

Nov. 1824–Dec. 1825
Clore Gallery for the Turner Collection, London

16×22.5 cm ($6\frac{1}{4} \times 8\frac{7}{8}$ in)

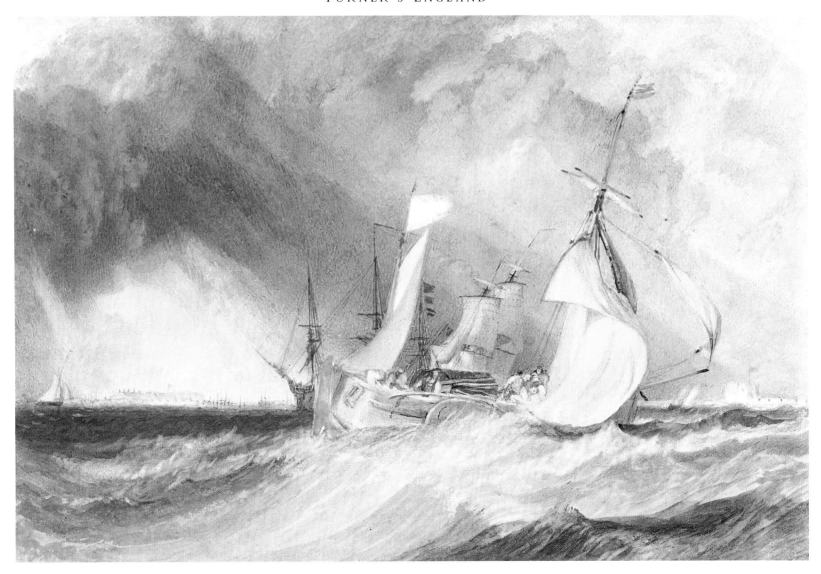

THE RIVERS OF ENGLAND

87 *MOUTH OF THE RIVER HUMBER*

This view encompasses Spurn Head at the right and Grimsby in the distance on the left, with numerous vessels at anchor in the river. As was common in most of his marine vistas, Turner eschewed the even distribution of his shipping across a wide arena and instead jumbled it all up together, revelling in the variety of abstract forms that such a juxtaposition creates. Thus from front to back we see a Billy-Boy (a river barge and coasting vessel of the type used extensively off the east coast) which is running before the wind with its leeboard up, in front of a brig tacking in the opposite direction, and then a man-of-war anchored into the wind. The force of that southerly wind is clearly indicated by all the flags.

The design is unified by a subtle arabesque line which runs around and down the emerging line of light in the distance on the left, along the Billy-Boy's gunwale, and up the edge of its mainsail back into the sky beyond. The stipplings apparent in the storm-clouds impart further touches of dynamism to an image that is already well endowed with a sense of racing velocity.

c. 1824–25
Clore Gallery for the Turner Collection, London

16.5 × 24.3 cm (6½ × 9½ in)

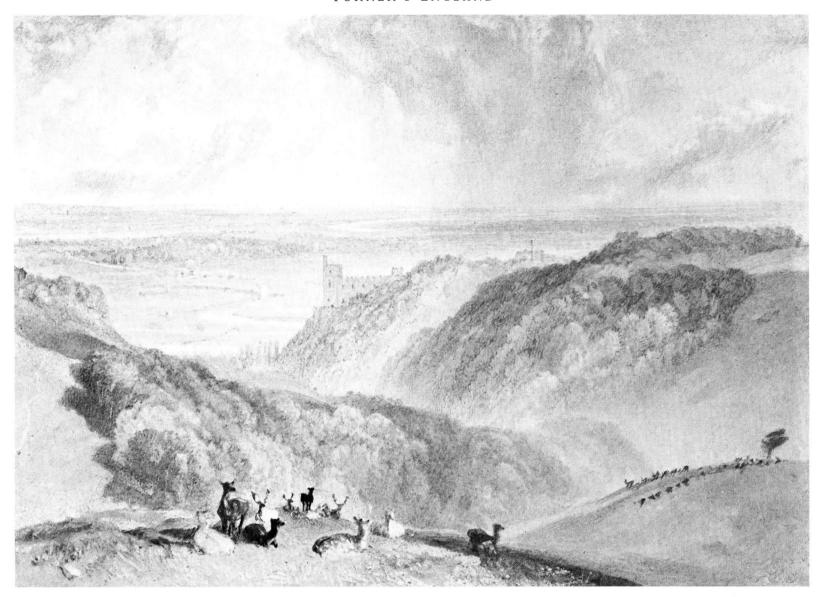

88 ARUNDEL CASTLE, ON THE RIVER ARUN

This is one of Turner's loveliest panoramas. In the distance on the extreme left is Little-hampton, with Martello towers sited at intervals along the coast and in the centre the final wanderings of the Arun to the sea. On one of the windings just beyond the castle may be seen the windmill that appears in the other watercolour of Arundel in 'The Rivers of England' series (92).

Turner created a marvellous range of textures in the foliage of the castle park in the middle-distance, and equally adroit is the way that from right to left the warmth of the colours, the depth of tone and the sharpness of definition are increased as the sun comes out after the rain.

c. 1824 15.9 × 22.8 cm (6¼ × 9 in)
Clore Gallery for the Turner Collection, London

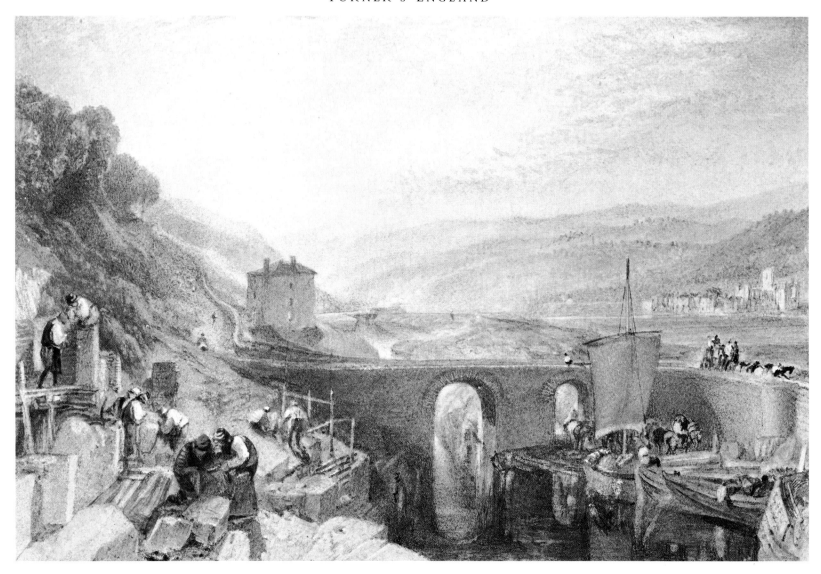

89 *KIRKSTALL LOCK, ON THE RIVER AIRE*

Despite Turner's title, this drawing primarily depicts the Leeds and Liverpool canal which runs parallel to, but south of the river Aire at this point.[78] Kirkstall Lock may be seen centrally in the distance, with the Bradford-Leeds road on the left and Kirkstall Abbey far over on the right. The Aire itself can just be perceived passing in front of the abbey out of the design to the right; thereafter it would flow over the weir depicted in *Kirkstall Abbey* (86), swing around towards us and pass by just off to the right of the image. That Turner knew he was portraying a canal in the 'Rivers' series is beyond doubt, for he wrote the words 'canal road' on one of the sketches which form the basis of this work.[79]

Turner made those sketches while staying at Farnley in the winter of 1824. As with the other Kirkstall drawing in this series, he then transformed the scene into a summer landscape. The late afternoon light radiates intense colours and shadows, while rich textures and multitudinous highlights impart a brilliant vibrancy to the scene.

Leeds was rapidly expanding around 1824–25 and Turner clearly addressed that encroachment here. In the foreground building work takes place on the Kirkstall brewery.[80] The approaching Bradford coach adds an extra dash of movement on the right; below it Turner characteristically named a barge 'Leeds' after its home base.

Nov. 1824–Jan. 1825
Clore Gallery for the Turner Collection, London

16 × 23.5 cm (6¼ × 9¼ in)

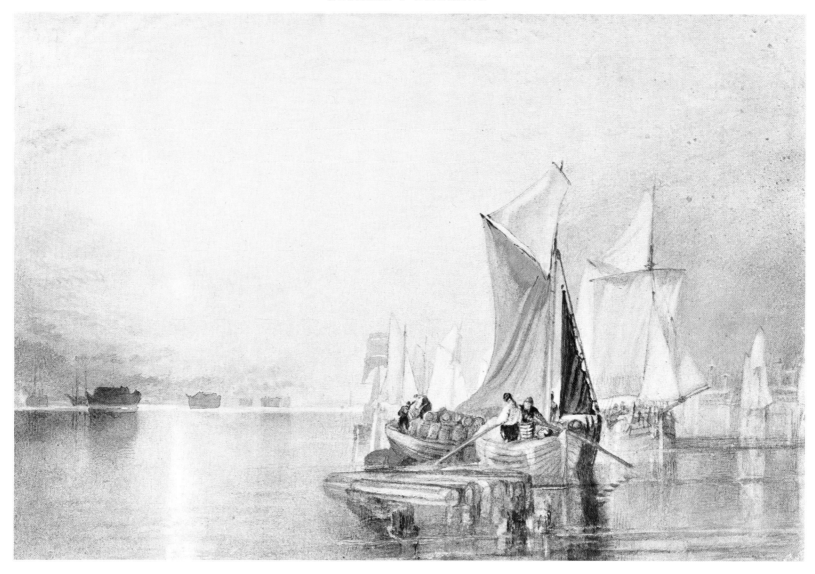

90 STANGATE CREEK, ON THE RIVER MEDWAY

Stangate Creek forms part of the Medway estuary. The first two hulks to be stationed there were originally 44-gun ships which were converted to use as quarantine vessels. Plans to build a nearby lazaret, or quarantine house, came to nothing and by 1820 there were eight such vessels moored in the creek, quarantining goods and people to check the importation of plague from ships returning from overseas.

These hulks can be seen in the distance on the left. On the right are decommissioned navy ships anchored near the top of the creek. In the foreground is a barrel-laden topsail barge, a Thames barge adapted for sea rather than river use, with a Bermuda sloop passing just behind it.

The work is remarkable for its limpidity and delicate colour. The time of day has been described as sunset,[81] but in reality this is a dawn scene, for the hulks were stationed by Chetney Hill at the south-east end of Stangate Creek, which runs along a north-south axis, and we are therefore looking in the direction of the rising sun. When the design was engraved the image became much darker in tone and Turner had a huge buoy placed in front of the floating logs to add to the foreground interest.

c. 1824
16.1 × 24 cm (6⅜ × 9½ in)
Clore Gallery for the Turner Collection, London

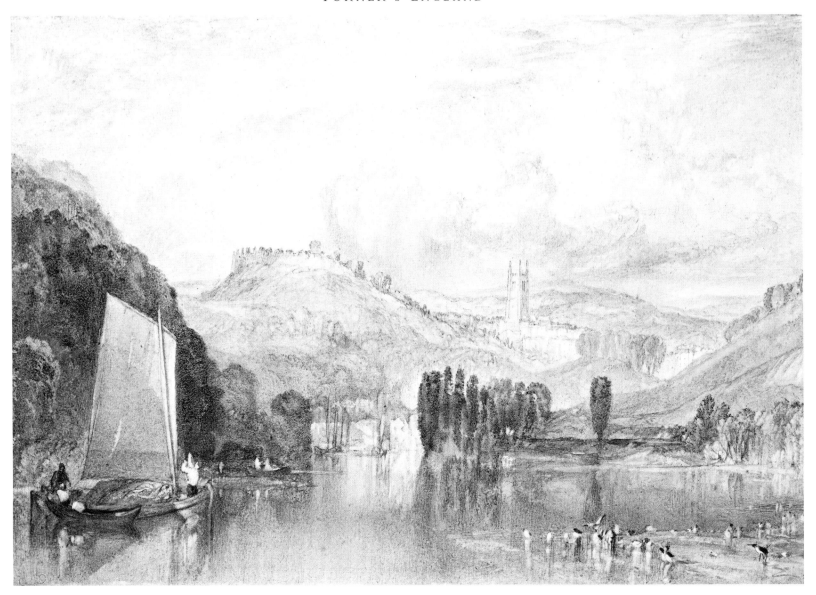

91 TOTNES, ON THE RIVER DART

Perfect stillness follows a storm as clouds pass away to leave the castle, town and river basking in the gentle afternoon sunshine, with just a trace of mist rising above the faraway houses. On the left, the slack sail of a small hoy pinpoints the dead calm, while on the right the resting sea-birds and waders subtly project the mood of utter tranquillity. The confident depiction of trees and foliage, the inexhaustible variety and beauty of the reflections on the river, the intricate counterpoint of the lines of the hills, and the wealth of colour contrasts and marvellously vibrant textures all combine to form one of Turner's most idyllic creations.

c. 1824
Clore Gallery for the Turner Collection, London

16.2 × 23 cm (6⅜ × 9 in)

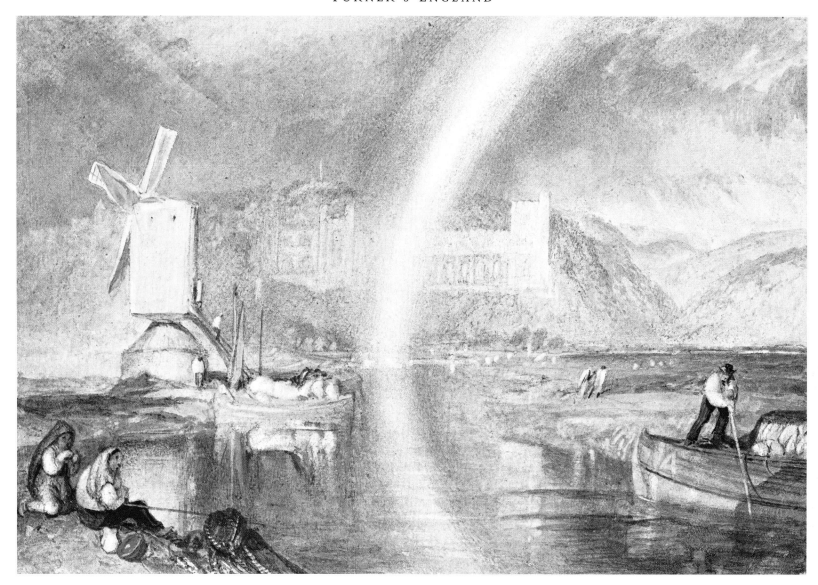

THE RIVERS OF ENGLAND

92 ARUNDEL CASTLE, WITH RAINBOW

As in all his other depictions of Arundel Castle, here Turner depicted the building either before or after a rainstorm; perhaps he was once caught in a shower there (for other examples see 88 and 198 in the 'England and Wales' series). The brilliant sunlight casts strong shadows and the air positively exudes moisture.

Rainbows are an occasional feature of Turner's work in the 1820s (see 93 and 111) but this refraction of light is unusually spectacular, and looks far more fierce than anything one might see in the everyday world. However, fortunately for us, Turner's imagination was never constrained by the parameters of the 'everyday' world.

On the barge on the right may be seen the letter 'A'. Obviously it denotes the name 'Arundel', for in several other works Turner employed just such correspondences between barge names and the places in which they are located (for example, see 89, 134 and 202).

c. 1824

15.9 × 23 cm (6¼ × 9 in)

Clore Gallery for the Turner Collection, London

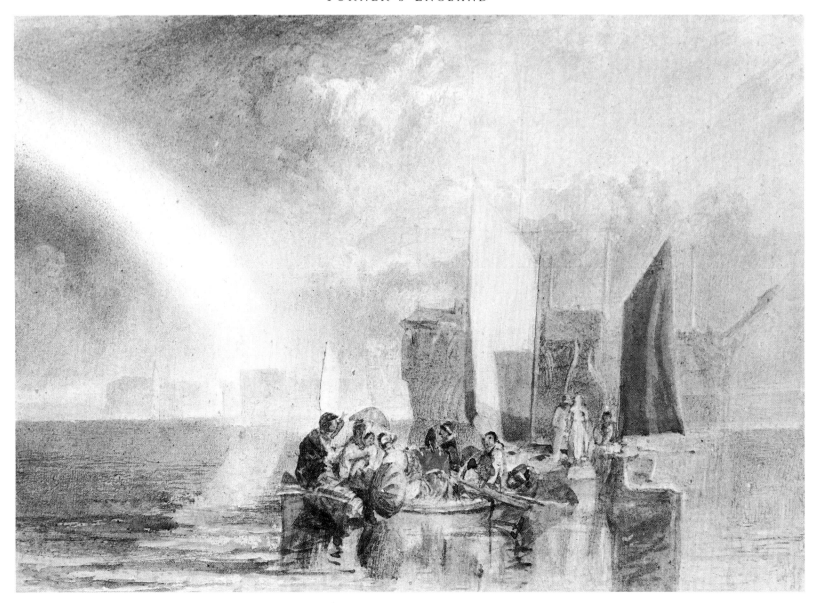

THE RIVERS OF ENGLAND

93 THE MEDWAY

This work was almost certainly made for 'The Rivers of England' series although it was not engraved; a modified version of the design was mezzotinted in the 'Little Liber' series.[82] The hulks are probably ships laid up 'in ordinary' (i.e. with their sails, rigging, guns and re-useable parts removed). Before them are a yawl and a bumboat carrying a marine officer, sailors, women, children and necessary umbrellas. There is a very palpable sense of the warm, moist atmosphere after a storm.

c. 1824 15.6 × 21.8 cm (6⅛ × 8½ in)
Clore Gallery for the Turner Collection, London

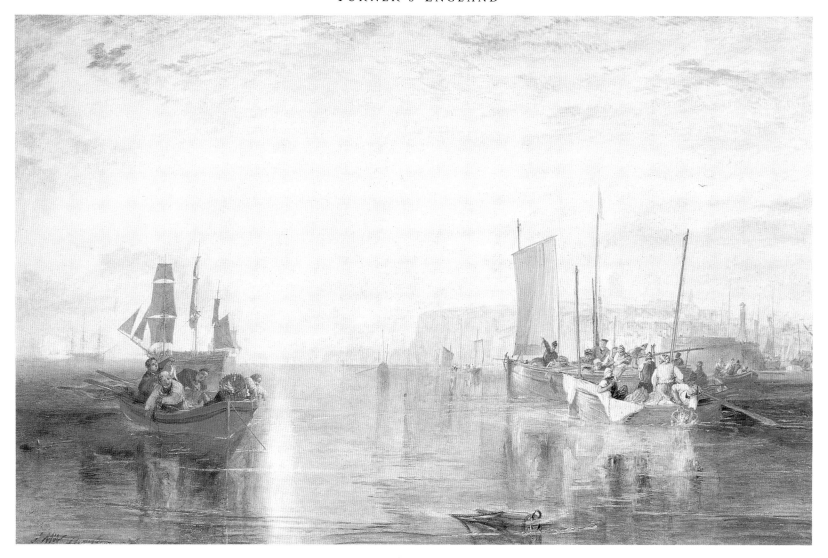

94 SUN-RISE. WHITING FISHING AT MARGATE

This is one of Turner's most radiant dawn scenes and certainly his most grandiose representation of Margate. Hooper's Mill dominates the skyline above the town, and just beyond the pier and lighthouse on the right may be seen a bathing machine which is improbably placed at the comparatively deep entrance to the harbour. As is common in Turner's marine vistas, the shipping is crowded together rather than being evenly distributed, with vessels to both right and left obscuring other craft.

Although dawn is usually a peaceful time of day, that is certainly not the case here, for in addition to the hubbub of fishermen working, bartering and comparing their catches, in the distance on the left a frigate fires the morning gun. All this 'sound' and busy activity points up by contrast the perfect calm of sea and sky.

1822 42.6 × 64.8 cm ($16\frac{3}{4}$ × $25\frac{1}{2}$ in)
Yale Center for British Art, Paul Mellon Collection, U.S.A.

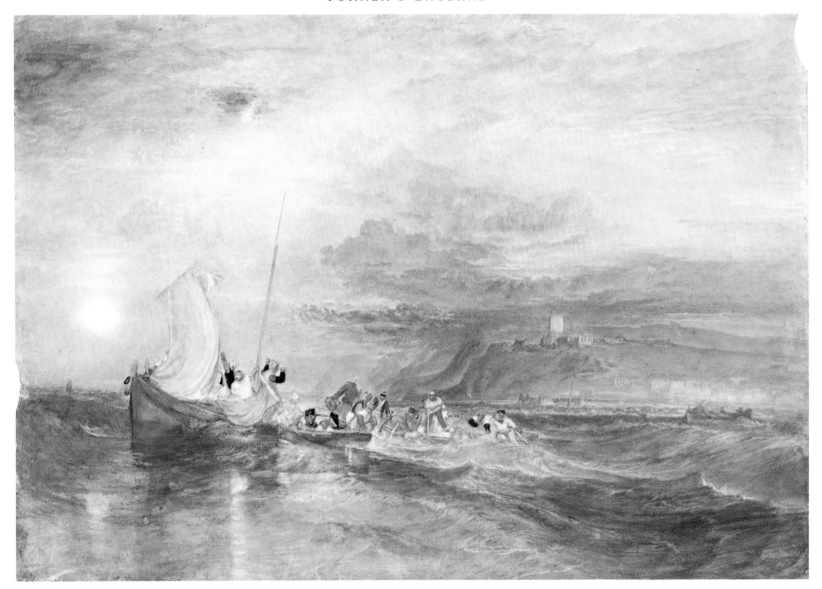

95 FOLKESTONE FROM THE SEA

During the early nineteenth century Folkestone was one of the most lawless places in Britain. Outwardly, of course, it was a moderately prosperous and respectable fishing community whose layout may have struck the casual visitor as being merely quaint and old-fashioned. But on closer inspection some curious features would have revealed themselves. Disguised trapdoors led from houses into labyrinthine passages, underground tunnels connected buildings, and everywhere could be found secret wells, hiding places and false walls. The aim of all this curious architecture was simple – it existed to protect the town's principal industry, for at night Folkestone transformed itself into one of the major smuggling centres on the southern coast of England.

Folkestone had been connected with smuggling for a long time. During the Napoleonic wars, Folkestone smugglers had even carried gold (in exchange for

Continental goods impossible to obtain domestically) across to the French ports to enable Napoleon to pay the very troops who were poised to invade Britain. After the wars ended in 1815, goods such as tobacco and spirits were extremely highly taxed and scarce in Britain, and this led the smugglers to intensify their illicit trafficking. At that time the Folkestone smugglers were still seemingly untroubled in their work – they frequently beached their boats after daybreak – and the individuals concerned even had a regularized pay structure, earning a guinea a week simply for being available for a 'run', while the fee for a successful voyage was ten guineas, about a fifth of the average annual income of a working man.

Cross-channel smuggling reached its peak during the early 1820s. After the defeat of Napoleon, at least 150,000 sailors were turned onto a labour market that was soon in the throes of a major slump. Seamen were particularly hard-hit by the worsening economic conditions, as many of them had spent years in the navy and were untrained or unfit for anything but a life at sea. They were not given any assistance upon their discharge and smuggling provided the only means of support for many of them. As a result, the activity became one of the major growth industries in Britain around 1820.

It has been estimated that the loss to the Treasury from smuggling at that time was rarely less than a million pounds per year, the pound then being worth in real terms at least fifty times what it is worth today. Naturally, smuggling on such a scale and with such indifference to the law caused the government of the day much concern. As a result, in 1816 the Coast Blockade was formed, a successor to the blockade that had been designed to cut off France during the recent conflict. This used warships both to patrol offshore and to land parties of armed sailors who covered the coastline. And the Treasury also set up its own revenue-cutter service, as well as a network of land-based 'riding-officers' whose duties were to patrol inland, detect signs of smuggling and alert the military authorities. Turner portrayed these riding-officers in other water-colours discussed in this book (see 161 and 220).

Naturally, the inhabitants of coastal towns whose economies were sustained by smuggling did not take an entirely passive attitude to the growing pressures being put upon their business. The measure of their rebelliousness can be gauged from an incident in 1820 when a group of smugglers from Folkestone and nearby Sandgate were apprehended and incarcerated in Dover gaol. A gang of their relatives marched the ten miles to Dover and, joined by local seamen and malcontents, they then tore the gaol to pieces to free the smuggling crew, who were chaired home in triumph.

Yet the growing effectiveness of the preventive measures that were being taken by the authorities forced the smugglers to become more discreet in their activities. Due to the shallowness of the waters off Folkestone, a smuggling technique favoured locally was 'sinking and creeping', by which kegs of tea, tobacco or alcohol – usually French wines and spirits such as Dutch gin – were fastened in pairs to a heavily weighted 'sinking rope' and dropped into the sea on a set bearing from landmarks such as the tower of St Mary's Church, seen here in the distance. Later, under the guise of 'fishing', the smugglers would 'creep' those kegs by dragging the sea-bottom with grappling hooks. Turner portrayed aspects of 'sinking and creeping' in his four water-colours of smuggling at Folkestone that are discussed in this book (for the others, see 45, 172 and 245).

In this design we see the first stage of the operation, namely the sinking of the kegs. When the smugglers had begun work the night had been overcast, but due to the clouds having moved off – we can judge the wind direction from the French tricolour on the boat on the left – it has become light earlier than anticipated and consequently the smugglers have been detected by the Coast Blockade whose boat may be seen approaching from the right. Their approach has been noted by a smuggler standing by the foremast of the French lugger and, as a result, some of his companions are raising sail while others prepare to drop the last of their kegs into the water for attachment to the 'sinking-rope'. Simultaneously, the men in the Folkestone cocktail (a six-oared rowing boat) position the rope itself.

The drawing exhibits a beautiful polarity between cool moonlight and the first warm colours of daybreak as the dawn light is reflected by the clouds above Folke-stone. The circle of the moon is amplified by the rounded lines of the foresail, and the marked swell of the sea is depicted with an exact understanding of its underlying motion.

This watercolour was almost certainly intended for the 'Marine Views' series but it was never engraved.[83] Turner made an elaborate colour study for the work, in which a figure warning of the approach of the Coast Blockade is prominent.[84]

c. 1822–24 48.9 × 69.1 cm (19¼ × 27⅛ in)
Clore Gallery for the Turner Collection, London

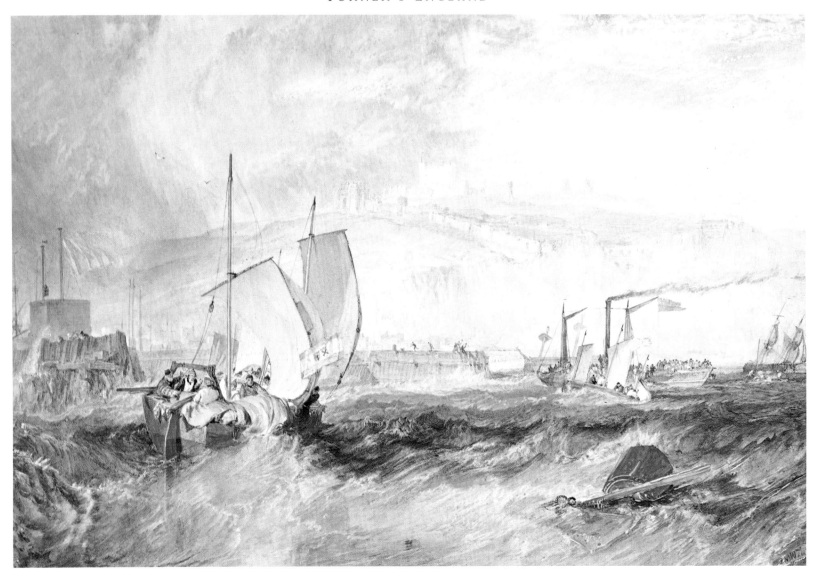

MARINE VIEWS

96 DOVER CASTLE

This outstanding watercolour celebrates the coming of the Age of Steam. At the left and centre are the south and north pier-heads that stand at the entrance to Dover harbour. Owing to a strong westerly wind, the lugger in the foreground and various fishing smacks are finding it difficult to enter port and are reducing sail to avoid being blown out to sea. The vessels on the right will either have to wait for the tide or row into Dover as there is not sufficient room to tack. However, a paddle steamer is cutting easily through the prevailing wind and making for harbour. It is welcomed on the pier by waving men, a startled dog and some running figures who both extend the impetus of the steamer and exemplify the excitement that was felt upon initially seeing this revolutionary form of transport.

The first steamer to cross the English Channel was the *Majestic* in 1816, and in 1821 the *Rob Roy* initiated a regular service. Within a short time there were a great number

of privately owned steamships crossing to the Continent. The steamer depicted here is a vessel that has recently been converted from sail, for she has a sailing hull and a beak-head at her prow. Immediately beyond her is a wrecked brig; the immediate juxta-position of these two vessels is undoubtedly Turner's pictorial comment upon the supplanting of wind-power by steam – indeed, the brig even looks as though it has been pushed aside by the steamer. Sixteen years before painting *The Fighting 'Temeraire'*, Turner took an optimistic view of progress, although he indicated the cost of that change.

Aboard the lugger on the left (detail, ill. 12), members of the crew are shouting at the helmsman or peering around from midships to see what is happening. At the stern is a large arched gallows designed to support the foremast, which was lowered when the boat was drift-fishing and lying to the nets. To minimize excessive rocking, a riding sail would then have been raised on the mainmast. This sail has been in use but on being struck it has been left unfurled and can be seen billowing over the stern. Fishing completed, the foremast and foresail have again been set to give forward motion. As the boat approaches harbour it is again necessary to strike the mainsail to reduce speed. It is being abruptly lowered but, because the riding sail is still unfurled, within a few seconds the whole deck will be covered in canvas – not a healthy state to be in at a harbour mouth with so much shipping in the vicinity. Indeed, it seems that the lugger will soon collide with another boat passing in front of it. The lugger's helmsman is therefore desperately trying to pull the tiller hard to starboard so as to turn the vessel into the harbour, but he is wedged between the gallows and the

unfurled canvas and has no room to move the tiller any further. Despite all the shouting there is little that he can do. As the flag of the vessel would seem to indicate that it is a foreign ship,[85] Turner may here have been contrasting the poor seamanship of foreigners with the good seamanship displayed by his fellow countrymen (the nationality of other, better-managed vessels in the distance is established by the Union Jack and blue ensign they are flying). In 1803 the painter had certainly made such a statement in one of his major oil paintings, a view of Calais pier,[86] so he may have been repeating that dig at foreigners here. The contrast may also have been intended to point up British inventiveness – as exemplified by the steamer – in dealing with the complex problems of wind-propulsion. Turner was not chauvinistic but he was patriotic, and such a contrast would have been highly characteristic.

In the distance the castle and East Cliffs appear ethereal in the damp, late-afternoon sunlight, and the tossing, wind-whipped movement of the sea is portrayed with unrivalled mastery. The towers of the Roman Pharos (or lighthouse) and the church of St Mary in Castro are aligned vertically with the foremast and funnel of the steamer, a pairing that is repeated by the masts of the wrecked brig and the twin sails of the lugger in front of the steamer. Below the steamer in the foreground, a tiller and partially submerged rudder resemble an axe in overall shape; perhaps Turner wanted them to heighten our sense of the steamer cutting through the wind.

December 1822, signed and dated 1822 43.2 × 62.9 cm (17 × 24¾ in)
Museum of Fine Arts, Boston, U.S.A.

12 (detail, DOVER CASTLE*)*

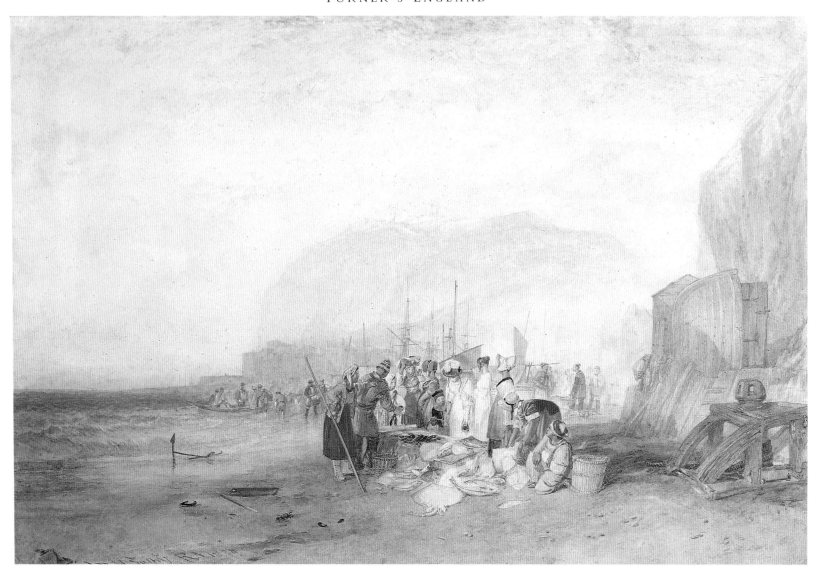

97 FISH-MARKET, HASTINGS

When this watercolour was offered for sale in the mid-1960s it was entitled *Arabs trading on the beach*;[87] such an identification of the staffage (as well as uncertainty as to the precise location of the place depicted) was undoubtedly caused by the fact that the work contains figures not normally associated with a British fish-market.

In the centre, some middle-class ladies and a schoolboy with a hoop are discussing the fish on offer with fishermen and fishwives. This entire group of figures is framed by two people in Greek costume, a woman standing on the left and a man kneeling on the right with his arm in a sling. The woman is wearing the garb of a Greek janissary or soldier and she has her hand on a fisherman's shoulder in an attempt to attract his attention, while the kneeling man wears Attic costume. Turner undoubtedly obtained the details of these clothes from illustrations (ills. 13 and 14) to the second volume of a book entitled *Travels in Italy, Greece and the Ionian Islands* by H. W. ('Grecian') Williams, published in 1820, which was in his library.[88] The costumes were obviously

introduced to allude to the Greek War of Independence that was raging when Turner made this watercolour between January and April 1824 (the work is dated 1824 and was displayed in the W. B. Cooke Gallery exhibition which opened on 8 April of that year).

All through the winter and spring of 1824 there had been widespread activity in Britain to raise money for the Greeks, and the poet Byron was to die at Missalonghi on 19 April, so the allusion was extremely apposite when the work first entered the public sphere. Turner had shown a particular interest in the cause of Greek independence since 1816 when he painted two oils of a Greek temple, one showing it as a contemporary ruin under Turkish control, the other as it might have looked intact in ancient times, with free Greeks parading in front of it; the reconstruction and link with Greek liberty equally alluded to the hope for the reconstruction of Greece and reinstatement of Greek liberties in Turner's own time.[89] Between 1823 and 1824 Turner also made seven

illustrations for an edition of Byron's works that appeared in 1825, one of which depicts the Acropolis with Greeks fighting Turks in the foreground.[90] Additionally, in an 1822 watercolour entitled *The Acropolis, Athens*,[91] Turner took his theme from Byron's *Giaour* and depicted the citadel in the distance with a Turk standing guard over an allegorical figure of Greece, a beautiful but chained nude reclining in the foreground; underneath her is written a quotation from the poem ''Tis living Greece no more'. It seems natural, therefore, that just two years later the painter should have introduced *clothed* symbols of nascent Greece into one of his designs, the clothing perhaps representing the dignity that had been restored to the Greeks through rising against their oppressors (something which also explains why a woman should appear as a soldier – clearly she is an allegorical figure representing Greek Liberty). The martial associations of the Greek woman are augmented by the spear-like boathook she is holding, while the fact that the other Greek has his arm in a sling could have been intended to suggest the suffering that the Greeks had undergone on Chios and elsewhere whilst struggling for their independence.

Clearly the Greeks are positioned at the edge of the crowd in an attempt to draw the attention of the English to their cause. The placing of the hand of an allegorical figure on someone's shoulder in order to seek their attention was a device Turner was to

repeat in the 1830–31 watercolour of *Northampton* in the 'England and Wales' series (190) where a French 'Marianne' reminds a reactionary figure of the recent 1830 revolution in France. In a watercolour made around 1831 of a tomb on the Greek island of Chios, Turner also celebrated the coming of independence and peace to Greece, while in *Nottingham* in the 'England and Wales' series (194) the artist linked the passing of the 1832 Reform Act to Greek independence by placing the Greek flag upon the mast of a Nottinghamshire canal boat. The Greek allusion in this Hastings beach scene is therefore by no means unique. Moreover, the location of a statement about independence and liberty on a beach at Hastings is itself significant for, of course, it was near Hastings in 1066 that English independence was lost for only the second and last time in our history.

The height of the cliffs is typically exaggerated in the early morning haze. On the right is a winch for hauling boats ashore and beyond it is a hut made from an upturned boat; this was obviously a forerunner of the 'net-shops', or sheds in which to hang nets, that stand on the same spot today.

1824, signed and dated — 44.4 × 66.3 cm (17⅜ × 26⅛ in)
Private Collection, U.K.

13 After H. W. Williams, A Janizary, 1820, from H. W. Williams, Travels in Italy, Greece and the Ionian Islands, 1820, opp. p. 370. British Museum, London.

14 After H. W. Williams, Greek dances, 1820, from H. W. Williams, Travels in Italy, Greece and the Ionian Islands, 1820, opp. p. 225. British Museum, London.

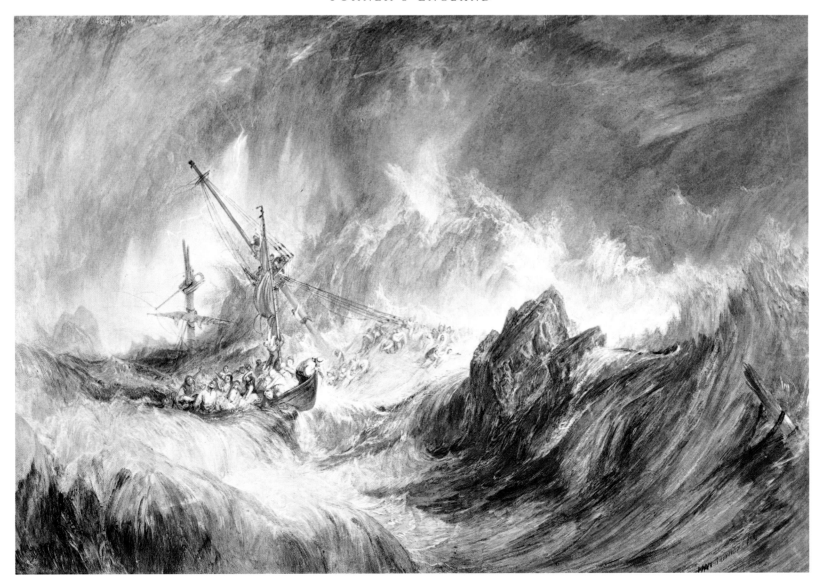

98 *A Storm (Shipwreck)*

Given its date, size and subject, it seems certain that this spectacular watercolour was made for the 'Marine Views' series, although it was never engraved. The work was introduced by W. B. Cooke into his 1823 exhibition under the title of *A Storm;* thereafter it appears in his account books as *Shipwreck*. That title was also used for the work by *The Literary Gazette* in a review on 24 May. It is thus given as an alternative title above.

This is the most cataclysmic storm Turner had painted for about thirteen years,[92] and indeed it is one of the most ferocious seascapes he ever created. The strong greens, blues and blacks in both the sea and sky, the opposing yellows and pinks of the rocks, the streaks of lightning, the white boiling foam and the rhythmic convulsions of the waves animate the scene with a truly terrifying energy.

1823, signed and dated
British Museum, London

43.4×63.2 cm ($17\frac{1}{8} \times 24\frac{7}{8}$ in)

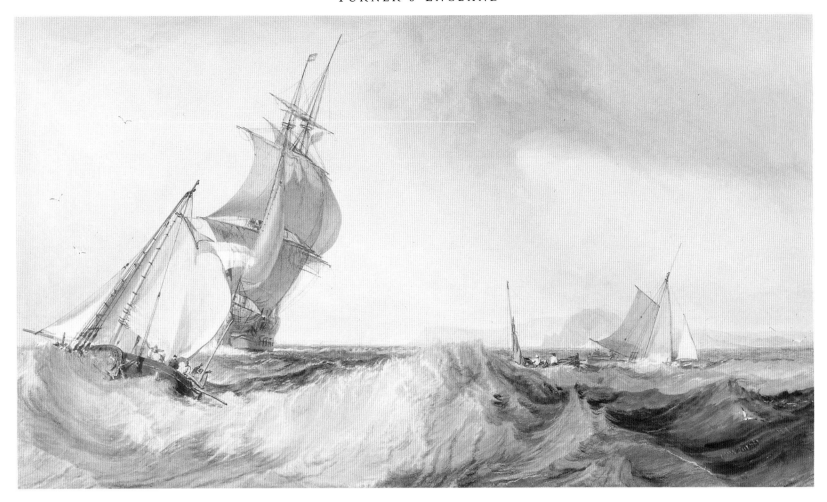

MARINE VIEWS
99 OFF ST ALBAN'S HEAD

This is another watercolour whose date, size and subject strongly suggest that it was made for the 'Marine Views' series, although it was never engraved.[93]

Virtually nothing has been ascertained of Turner's movements in southern England in 1821, but it does appear that he may have sailed along the coast that summer, for two studies of St Alban's Head, near Swanage in Dorset, occur alongside a number of other coastal views in a sketchbook that is known to have been in use at that time. Turner identified one of the sketches as a view of St Alban's Head, and the configurations of the headlands in both sketch and watercolour are virtually identical.[94]

However, topography only plays a small part in this invigorating study of channel shipping, with a strong southerly wind whipping up the waves in the clear morning light. On the left is a Dutch seagoing sloop, or shallow-bottomed fishing boat, passing with its leeboard up in front of a Third-Rate ship of the line, a seventy-four-gun man-of-war; aboard the sloop, fishermen gesticulate wildly that the warship is bearing down on them. On the right are a small fishing boat and a cutter-rigged fishing smack, beyond which appears the distinctive shape of St Alban's Head, with the coastline continuing around to Portland Bill in the far distance.

c. 1822 39.5 × 67.4 cm (15½ × 26½ in)
Harrogate Art Gallery, Harrogate, U.K.

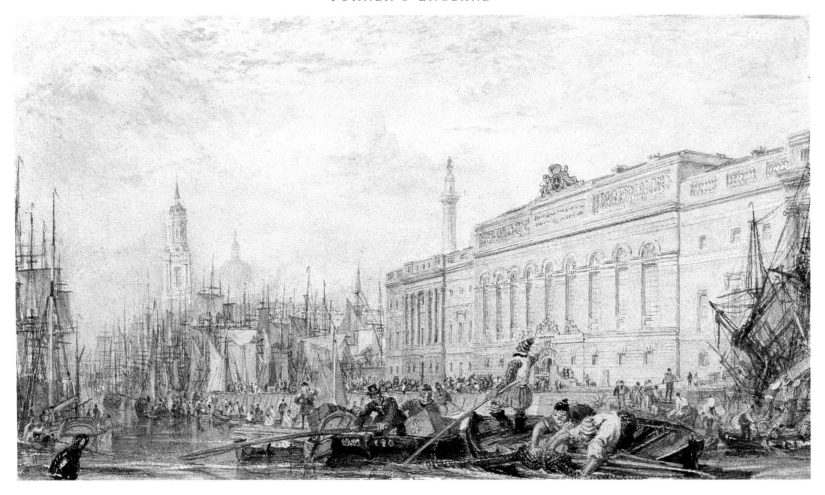

100 THE CUSTOM HOUSE

The customs house depicted was the sixth such building to have stood on this site and in Turner's day it handled nearly half the Customs business in England. It was rebuilt by David Laing between 1812 and 1817, and a central riverside facade designed by Sir Robert Smirke was added to it in 1825, an addition that might suggest a date for the drawing. Turner was friendly with Smirke, who was a fellow Royal Academician, and he had already depicted another of Smirke's buildings at Rosehill in 1810 (1), so perhaps that friendship acted upon Turner's choice of subject.

A lighterman points directly to the Custom House, while two men in the foreground who are vertically aligned with its doorway are lifting a heavy knotted cable from the Thames; the knot may allude to the holding of goods in bond by the Custom House, an interpretation that receives support from the fact that the knot is the nearest object to the viewer.

Beyond the Custom House may be seen the Monument, with the dome of St Paul's Cathedral to the left. In front of St Paul's is the steeple of St Magnus-the-Martyr, another of Wren's creations. The Pool of London is filled with shipping, and the design distinctly anticipates the crowded Venetian canal scenes that were to proliferate in Turner's oeuvre during the 1830s and '40s.

c. 1825

Vancouver Art Gallery, Canada

12.7 × 22.9 cm (5 × 9 in)

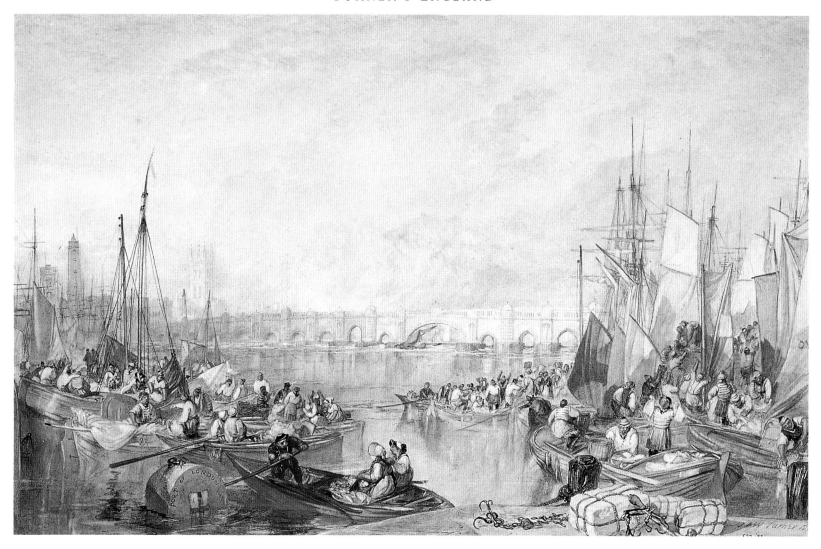

101 OLD LONDON BRIDGE AND VICINITY

We look across the Pool of London, with Old London Bridge (demolished in 1830) and Southwark Cathedral beyond it. A Thames barge has just passed the tide-race under the bridge, its mast lowered to effect the passage. To the left of the bridge are St Olave's Church, built in 1740 and demolished in 1926, and a shot-tower constructed in the 1780s that doubled as a signalling station; it was probably demolished in the mid-nineteenth century. At the lower left is a buoy marked *Port of London* which bears the coat of arms of the City of London; on the extreme right an oyster boat has 'OYS' visible on its sail. The colouring is rich, with the sun just in the process of rising behind us and the lower half of the scene still in shadow. Two shallow diagonal lines run up the edges of the groups of boats to carry the eye into the distance, and they subtly structure the design without at all lessening the sense of disorder inherent to a market subject. One can only regret that the London series never got off the ground, for had it done so, Turner's views of the city would surely have seemed definitive amid all the welter of competing contemporary images of London by other artists.

1824, signed and dated
Victoria and Albert Museum, London

29.2 × 44.5 cm (11½ × 17½ in)

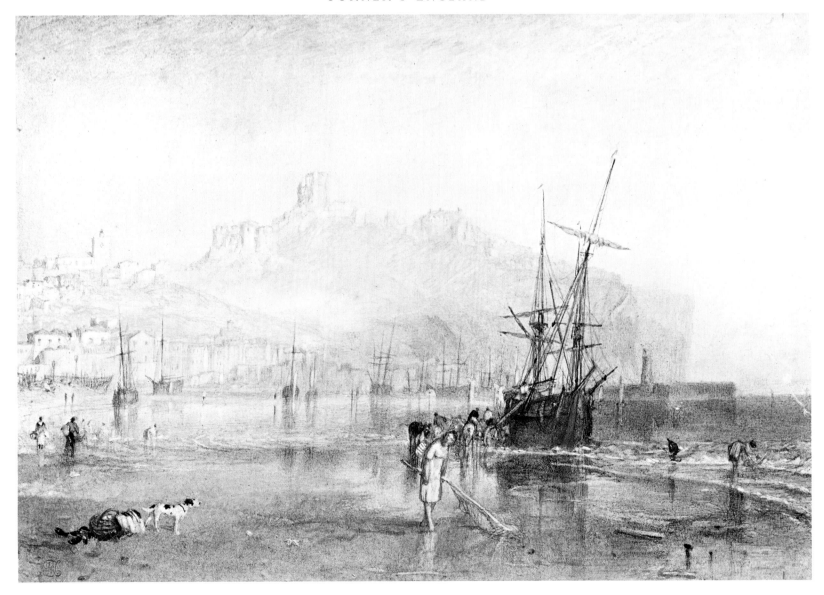

102 SCARBOROUGH

Turner produced several magnificent watercolours of Scarborough. Those made in 1809 and 1811 both also show boys crab-fishing, washerwomen, shrimpers, beached boats and bathing machines.[95] In 1818 the artist created a more distant view of the town, and the version seen here was his final representation of it. As Ruskin noted, in all of the watercolours made after 1809 Turner placed a starfish on the beach; obviously he had once seen such a creature at Scarborough and the association stayed with him thereafter.[96]

In the foreground a cutter is drawn up on the foreshore, with a brig immediately behind it. The vessels are beached because Scarborough harbour is extremely shallow and only accessible at high tide. Through their dark tonal contrast these ships make the castle and town appear very brilliant in the early morning light. The shrimper in the foreground tilts her head in an attempt to get her apprehensive dog to join her, and this witty touch adds to the relaxed and happy mood of the work.

c. 1825

15.7 × 22.5 cm (6⅛ × 8⅞ in)

Clore Gallery for the Turner Collection, London

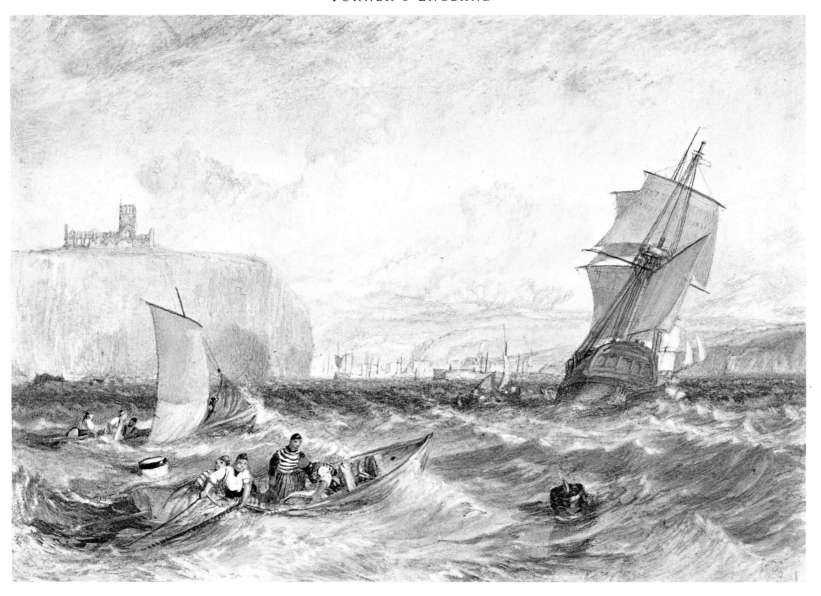

THE PORTS OF ENGLAND

103 WHITBY

Whitby Abbey and the brow of the cliffs catch the first rays of sunlight while the lower part of the rock-face is still in shadow, as are all the vessels in the foreground. The golden colour of the lugsail in front of the abbey complements the pinks beyond it and adds to the sense of growing warmth, while the linear Y-shape formed by the coble's lug and mast deftly leads the eye to the abbey.

The composition is artfully structured by an underlying implied V-shape which runs up the line that leads the eye to the abbey on the left, and up the masts of the brig on the right. These lines are counterpoised by a curve that runs up the gunwale of the coble in the foreground, continues up the curved edge of the course-mainsail of the brig, and finally links up with the tops of the large cloud formations beyond.

c. 1825
Clore Gallery for the Turner Collection, London

15.8 × 22.5 cm (6¼ × 8⅞ in)

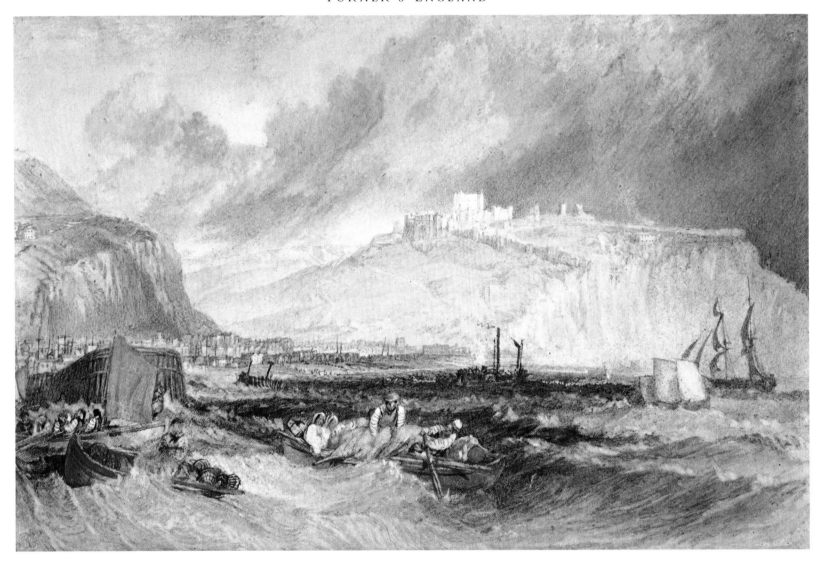

104 DOVER

We view Dover from a similar viewpoint to the one adopted for the larger and more dramatic 1822 watercolour of the town (96), and again survey its characteristic shipping. From the left this consists of a gig with its lugsail being set and its crew hauling on the oars; a lobster boat with a fisherman waiting patiently with folded arms; in the distance the rotting timbers of a beached, wrecked brig (perhaps the same wrecked brig that appears in the 1822 drawing); a small, heavily laden hoy; the cross-channel packet with steam issuing from its funnel in an adroitly simple squiggle; a lugger; and finally, the ubiquitous Turnerian brig.

Ruskin observed how Turner raised the height of the cliffs on the left to alpine proportions, with the result that the barracks on Shakespeare Cliff looks more like a mountain hospice than an establishment that could be reached by 170 steps from the town below. He also celebrated Turner's inventiveness in unifying the work through repetitions of shape, such as the curve of the pier on the left, which repeats the contour of the brow of the cliff above it. And he particularly liked the way that 'the two front sails of the brig [on the right] are brought on the top of the white sail of [the lugger] to help detach it from the white cliffs'.[97]

c. 1825
16.1 × 24.5 cm (6⅜ × 9⅝ in)
Clore Gallery for the Turner Collection, London

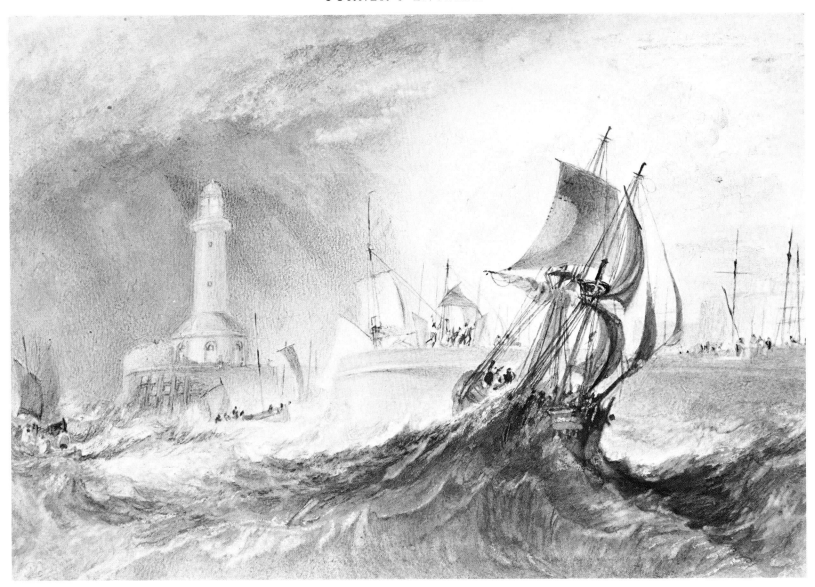

THE PORTS OF ENGLAND
105 RAMSGATE

This drawing should be compared with the 'Southern Coast' view of the town (236), for the same weather, sea and shipping appear in both designs, except that in the other work Turner depicted the scene as it would have appeared just a few moments later. Ruskin noticed this link and marvelled at Turner's ability to recreate from memory the same events at different viewpoints.[98]

The composition is artfully structured: on the left the stormy sky throws forward the lighter-toned sea and lighthouse, while on the right the effect is reversed: the dark masses of the sea and brig push back the light-toned sky beyond. A mass of stipplings adds both a sense of movement and textural dynamism to the storm-clouds on the left.

On the quay some men are struggling to control windswept sails and rigging. The drawing is filled with a tempestuous energy, and Ruskin particularly prized its boldest effect: 'The lifting of the brig on the wave is very daring; just one of the things which is seen in every gale, but which no other painter than Turner ever represented'. He also commented that 'the lurid transparency of the dark sky, and wild expression of the wind in the fluttering of the falling sails of the vessel running into the harbour, are as fine as anything of the kind [Turner] has done.'[99]

c. 1825 16.1 × 23.2 cm (6⅜ × 9⅛ in)
Clore Gallery for the Turner Collection, London

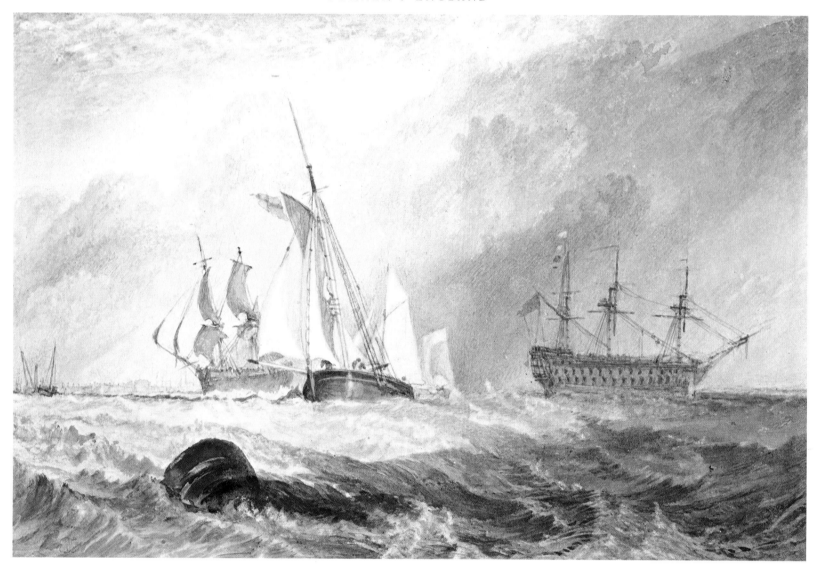

106 SHEERNESS

The Nore is situated off Sheerness at the confluence of the Thames and Medway rivers, and it was a natural choice of subject for this series, for tens of thousands of vessels passed through it every year, thus making it the busiest naval and merchant-shipping anchorage in Britain. Turner had already painted it many times and here he portrayed it in the late afternoon, with Sheerness in the distance on the left. Across the anchorage from left to right are a sheer-hulk, a floating crane that was used for masting shipping; a collier-brig of the type that Turner used frequently for travel to the north of Britain; a navy longboat flying a white ensign; a cutter passing behind it; beyond that a lugger; another distant sailboat; and finally, a man-of-war anchored into the westerly wind.

Ruskin noted the repetition of the shape of the cutter's hull in that of the buoy in front of it, and also called this drawing 'one of the noblest sea-pieces which Turner ever produced . . . the objects in it are few and noble, and the space infinite. The sky is quite one of his best; not violently black, but full of gloom and power . . . the dim light entering along the horizon, full of rain, behind the ship of war, is true and grand in the highest degree.'[100]

c. 1825 16 × 23.8 cm (6¼ × 9⅜ in)
Clore Gallery for the Turner Collection, London

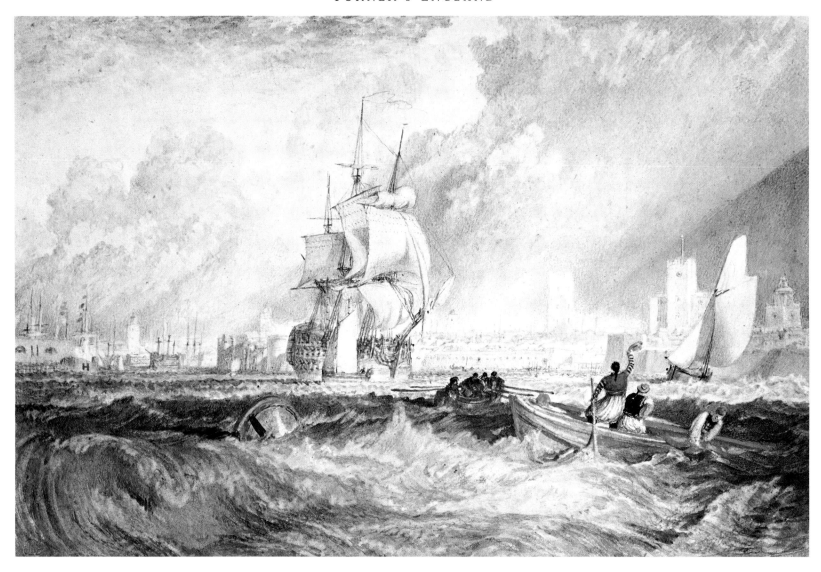

THE PORTS OF ENGLAND

107 PORTSMOUTH

The harbour in front of the man-of-war preparing to make sail is only populated by relatively small boats that serve to emphasize the vast scale of the battleship towering over them as the very embodiment of naval grandeur. The strong north-westerly morning breeze blowing across the harbour is clearly established by the captain's pennant on the battleship, by its billowing sails[101] and by the sails of the cutter on the right. The choppy water in the distance adds a constancy of motion to the scene, and the curved, rushing sweep of the wave on the left is subtly accentuated by the roundness of the nearby buoy.

Above the cutter is the Admiralty Semaphore, a tower bearing a signalling device that could communicate with the Admiralty in London in under three minutes by means of a series of intermediate relay signals. Below and slightly to the left of the semaphore is a signalling figure whose straw hat points directly at it; their visual connection is reinforced by the diagonal line of shadow in the sky beyond the semaphore and by the diagonal line of the cutter's main-yard, diagonals that pull the eye up to the right. The curve of the cutter's mainsail also exactly repeats the curvature of the sailor's waving arm, thus reinforcing it visually. The signalling figure waves to the battleship and epitomizes naval communication, whilst his gesture equally enhances the mood of optimistic, heroic urgency running through the work.[102]

c. 1825

Clore Gallery for the Turner Collection, London

16 × 24 cm (6¼ × 9½ in)

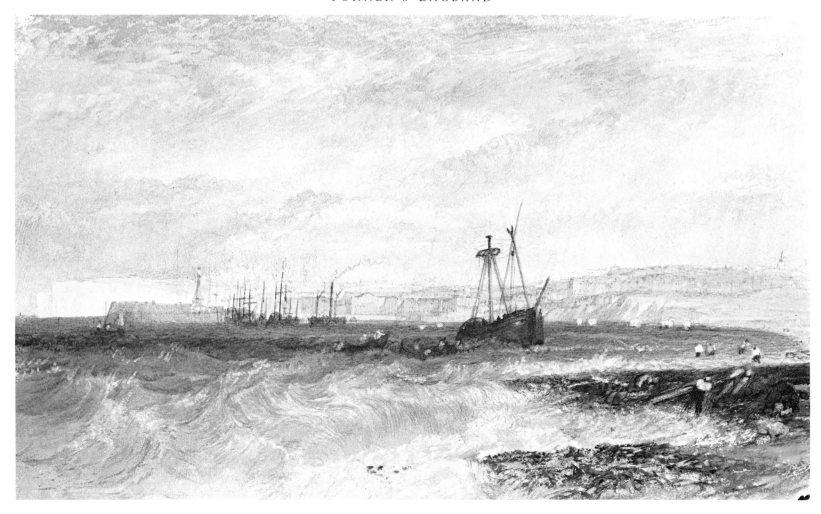

108 MARGATE

In the centre a dismasted brig has run aground and is having her cargo removed from the hold by a pulley erected on deck; presumably the cargo will then be transferred to the waiting boats. Beyond the brig are bathing machines lining the shore, while in the harbour is a paddle steamer. Turner often used such vessels when a regular service between London and Margate was established in the early 1820s. Although the sky is peaceful and the distant cliffs are bathed in afternoon sunlight, the turbulence of the sea and the wrecked brig suggest that there has recently been a storm.

This drawing represents exactly the same view of the town as the 'Southern Coast' version of the subject (37). However, here Hooper's Mill is less clearly defined (it was demolished in 1826) and by the mid-1820s the large church of Holy Trinity was being erected very near to it. Both buildings seem to appear in silhouette in Lupton's unfinished mezzotint of this watercolour, a work that is much darker, stormier and more dramatic in mood, almost turning the late afternoon lighting into night.

c. 1825 15.4 × 25.5 cm (6⅛ × 10 in)
Ashmolean Museum, Oxford, U.K.

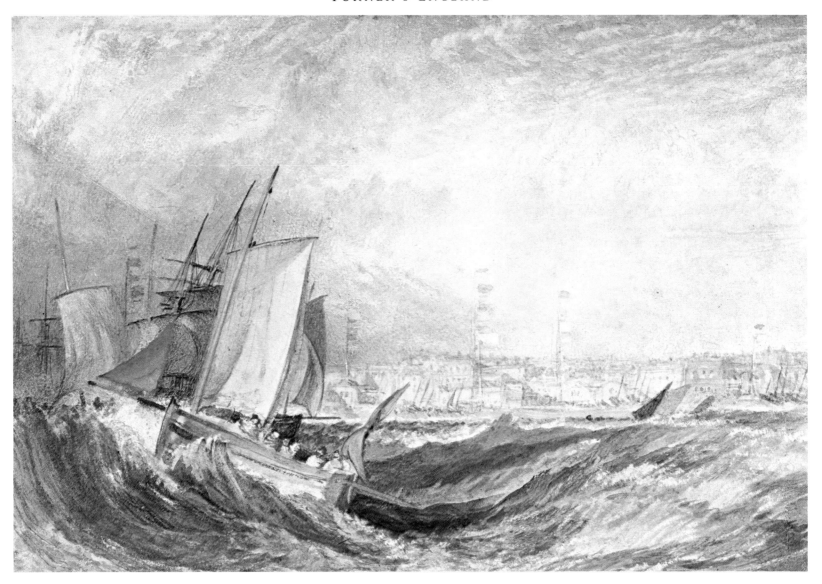

THE PORTS OF ENGLAND
109 DEAL

The Downs, off Deal, formed an important anchorage for ships either sheltering from south-westerly gales in the lee of the South Foreland, or else waiting for favourable winds to carry them around that headland into the English Channel. Often many hundreds of ships would be anchored there, some for long periods in the absence of the necessary sailing conditions. Shore communications with the ships would be effected by signals-flags, a good number of which can be seen hoisted on masts ranged along the beach. These masts were owned by shipping companies, or even by foreign countries who kept consulates in Deal expressly to communicate with their ships.

Also servicing this shipping was a fleet of Deal luggers which ferried supplies and passengers, and stood by to assist in emergencies caused by storms and other hazards (see 46). In the foreground, one such lugger beats around into the wind and trims its sails accordingly; it may be coming about to go to the aid of some of the ships massed beyond in one of Turner's most gloriously abstracted jumbles. These ships are beginning to suffer the first effects of the oncoming storm.

c. 1826

16.2 × 23.7 cm (6 3/8 × 9 3/8 in)

Walker Art Gallery, Liverpool, U.K.

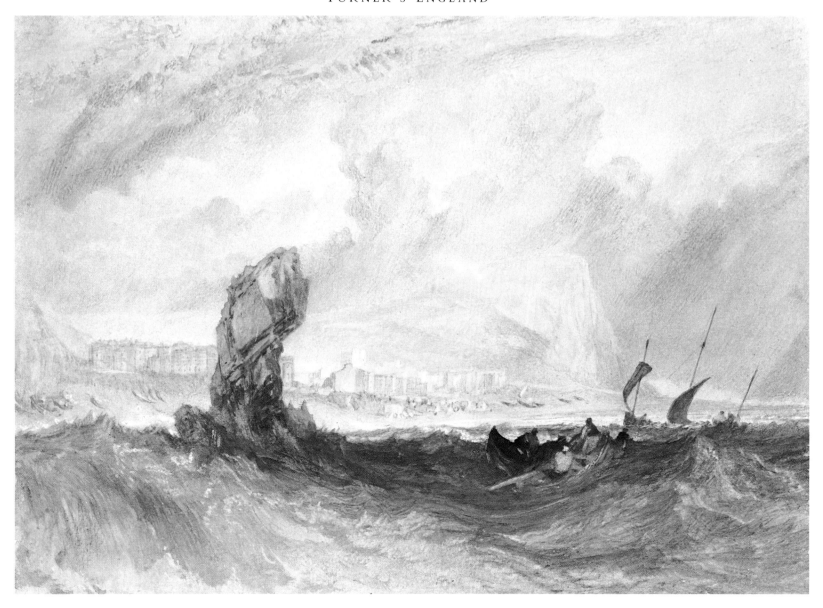

THE PORTS OF ENGLAND

110 SIDMOUTH

Turner visited Sidmouth on the 1811 West Country tour and made sketches of the town and beach respectively on pages 203a and 205 of the *Devonshire Coast No. 1* sketchbook (T.B. CXXIII). These two sketches (ills. 15 and 16) were later synthesized to form the present work. As the second of them demonstrates, Turner did not depict the medium-height sandstone rock he had actually seen at Sidmouth; instead, he made it much more phallic in shape. Such a bawdy emphasis might well reflect Turner's interest in radical politics at the time (see *Wycliffe, near Rokeby*, 62).

In Turner's day Sidmouth was not only a place; it was also a man. Lord Sidmouth (Henry Addington, first Viscount Sidmouth, 1757–1844) had been Home Secretary between 1812 and 1822 and was thus responsible for a great deal of oppressive

15 and 16 PAGES 203A AND 205 OF THE 1811 DEVONSHIRE COAST NO. 1 SKETCHBOOK *(T.B. CXXIII) which were synthesized to form the watercolour of* Sidmouth *(110). The rock that forms such a prominent feature of the work can be seen on the left in ill. 16. British Museum, London.*

legislation, including the suspension of *Habeas Corpus* in 1817 and the draconian Six Acts of 1819. Furthermore, Sidmouth was also held to be largely to blame for the infamous Peterloo massacre of 1819. As such he was despised throughout British society, not least by the radical Whigs, one of whom was Walter Fawkes, a man who undoubtedly contributed towards Turner's political thinking.

In 1823 Sidmouth had been the subject of great popular ridicule, much of it with bawdy overtones, when at the age of sixty-five he had taken a much younger woman as his second wife. The memory of this recent event may have led Turner to remodel the sandstone outcrop at Sidmouth into a more phallic form. Visual support for such an interpretation may be gleaned from the fact that Turner not only made the rock much larger than the one he had actually seen, judging by the sketch; he also elongated a flat-topped form into a pointed one and added to its base two appendages that are not present in the sketch. Turner's responsiveness to the visual similarities of different objects was so marked that it is impossible to believe that he was unaware of the resemblance between this rock and a phallus, and in any case he is known to have read literature discussing the implications and associations of phalluses.[103]

The curve of the rock is reiterated by the shapes of the sails on the right, and its sweep also augments the momentum of what Ruskin described as 'the noble gathering together of the great wave on the left – the back of a breaker, just heaving itself up, and provoking itself into passion, before its leap and roar against the beach.'[104] However, Ruskin could not understand why Turner had emphasized the rock, commenting that 'The detached fragment of sandstone . . . has long ago fallen, and even while it stood could hardly have been worth the honour of so careful illustration'. Given that in Ruskin's day Sidmouth was still only a fishing village, he was understandably mystified by its inclusion as one of the 'Ports of England'.

c. 1825

18.4 × 26.3 cm (7¼ × 10⅜ in)

Whitworth Art Gallery, Manchester, U.K.

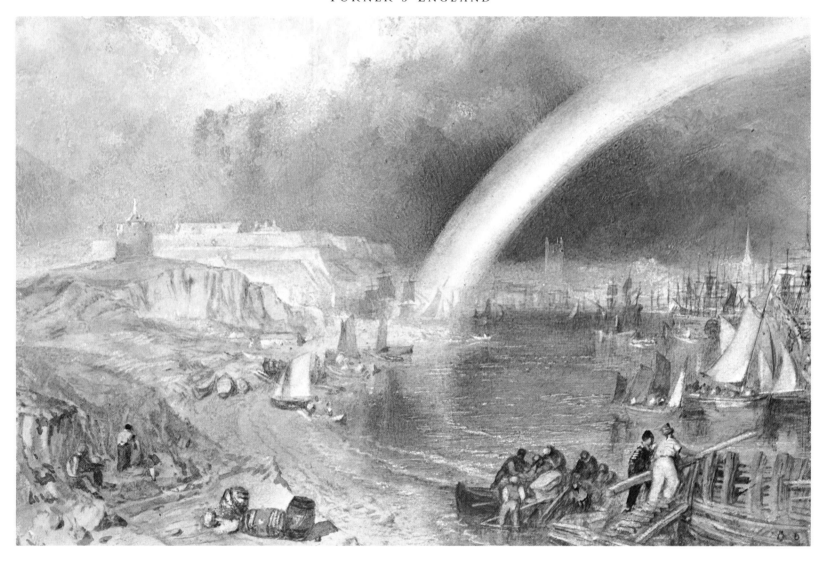

111 PLYMOUTH

In this watercolour we see a very similar, if slightly lower and closer view across Cattewater to the one that Turner represented in *Plymouth, with Mount Batten* (28). A comparison of the two works shows how far the painter had evolved in less than ten years, for whereas in the earlier drawing he had portrayed the place quite straightforwardly, by now his greatly developed 'poetic' imagination transformed the scene into something far more transcendent of everyday reality.

The rainbow seems rather crude, although its reflection on the Cattewater equally demonstrates the thoroughness of Turner's powers of observation. At the end of the rainbow and on the right (above the men carrying spars) are Plymouth long-boomers, local sea-going cutters. The rotundity of the small tower on Mount Batten Point is characteristically reiterated and emphasized by the shapes of the barrels in the foreground.

c. 1825

16 × 24.5 cm (6¼ × 9⅝ in)

Fundaçao Calouste Gulbenkian, Lisbon, Portugal

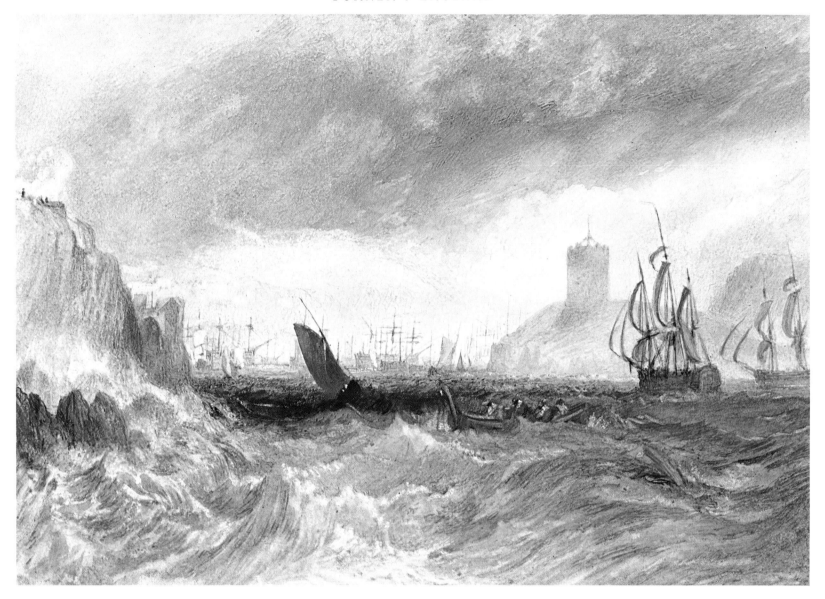

112 CATWATER, PLYMOUTH

This represents the vista one would see from the position of the small lugger apparent in the *Plymouth Citadel* design (228) made over ten years earlier for 'The Rivers of Devon' series. We are therefore also looking towards the viewpoint from which the panorama discussed opposite was developed; the hillside from where Turner presumably surveyed that vista may be seen in the distance on the extreme right. The timing has also been reversed, for this is a morning scene, as indicated by the shadow cast by the tower on Mount Batten Point, whereas the previous watercolour depicts Plymouth in afternoon light.

In the centre is a small boat with a winch attached to its stern, and in the distance ships crowd into the Cattewater, shortly to be joined by two merchantmen making their way up Plymouth Sound, their sails billowing in the strong southerly breeze. The drawing has a lovely colour range, and it is unified by the arabesque line which sweeps up from the wave at the bottom left-hand corner to connect with the line of cloud that passes out of the top right hand corner of the design above the tower on Mount Batten Point.[105] A multitude of tiny stipplings imbue the sky and distant land-scape with dynamism, Turner being not content merely to portray restless forms but equally determined to charge the very surface of his design with the suggestion of energy.

c. 1826 15.9 × 22.9 cm (6¼ × 9 in)

Allport Library and Museum of Fine Arts, Hobart, Tasmania

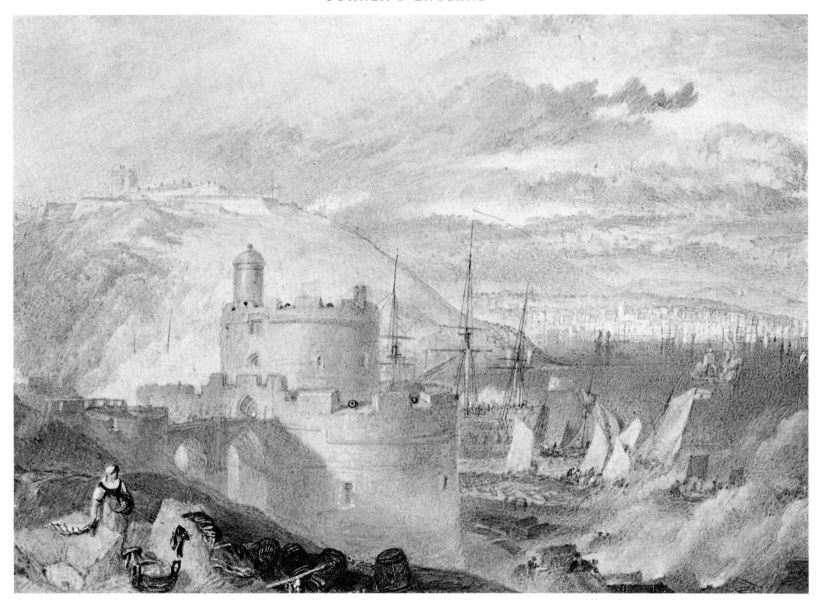

113 FALMOUTH

This magnificent watercolour was based upon two detailed line-drawings in pencil on page 145a of the *Devonshire Coast No. 1* sketchbook of 1811 (T.B. CXXIII – see ill. 17). In the bottom sketch Turner drew St Mawes Castle in the foreground and Pendennis Castle to the right across Carrick Roads; in the next sketch above it he continued the view off to the right across the estuary of the river Fal, so as to include Falmouth in the distance. The central sketch is therefore the extension of the lower one to the right.

In the final work Turner amalgamated the two sketches so that we are looking simultaneously at St Mawes Castle and Pendennis Castle from the north-east, and Falmouth from a due-easterly position; in order to accommodate the distant castle he considerably compressed and heightened the hill on which it stands. From this

viewpoint, therefore, the various castle batteries on both sides of the river and the man-of-war are firing their salvoes *inland*. As this depicts no recorded act of war, it is clear that Turner intended the salvoes to represent a salute. What they might be celebrating is suggested by a close examination of the details.

On the right some storm-clouds are passing away to the north, as indicated by the strong wind denoted by the flags and the captain's pennant on the man-of-war. Obviously the sun has only just come out, thus allowing a washerwoman to lay out her washing in the now warmer clime. A sword and some drums have been abandoned next to her. This radical change in the weather, and the discarded military objects, clearly parallel the coming of peace after war, and the firing guns are therefore celebrating the cessation of hostilities. Given that in many of his portrayals of south-coast naval ports, such as Falmouth, Plymouth and Portsmouth, Turner had repeatedly drawn upon his memories of those places during wartime (in many of them long after the Napoleonic wars had ended), it seems natural that he might have wanted equally to celebrate the end of that war. And this hypothesis receives support from another watercolour also created around 1825, namely the 'England and Wales' series view of Devonport with ships' crews being paid off (159), where Turner certainly celebrated

the ending of the war over ten years earlier. Moreover, in a companion work to the Devonport view (158), Turner similarly used a washerwoman to suggest a recently established state of peace, so this hypothesis is entirely plausible, as well as being consistent with Turner's responses elsewhere.

St Mawes Castle looks dazzling in the bleak midday sunshine, and Turner's mastery of aerial perspective can be especially witnessed in his superb projection of the rotundity of its keep. Our sense of that roundness is reinforced by the barrel in the immediate foreground, while another similarity is vertically enforced between the shape of the small turret on top of the keep and the archway in the bridge over the moat beneath it.

Ruskin found this work 'disagreeably noisy' and complained that 'to have great guns going off in every direction . . . is to my mind eminently troublesome', but he did concede that the drawing of the smoke and the flash of fire on the right was 'very wonderful and peculiarly Turneresque'.[106]

c. 1825

14.5 × 22 cm ($5\frac{3}{4} \times 8\frac{5}{8}$ in)

Private Collection, U.K.

17 PAGE 145A OF THE 1811 DEVONSHIRE COAST NO. 1 SKETCHBOOK *(T.B. CXXIII) upon which the watercolour of* Falmouth *(113) was based. British Museum, London.*

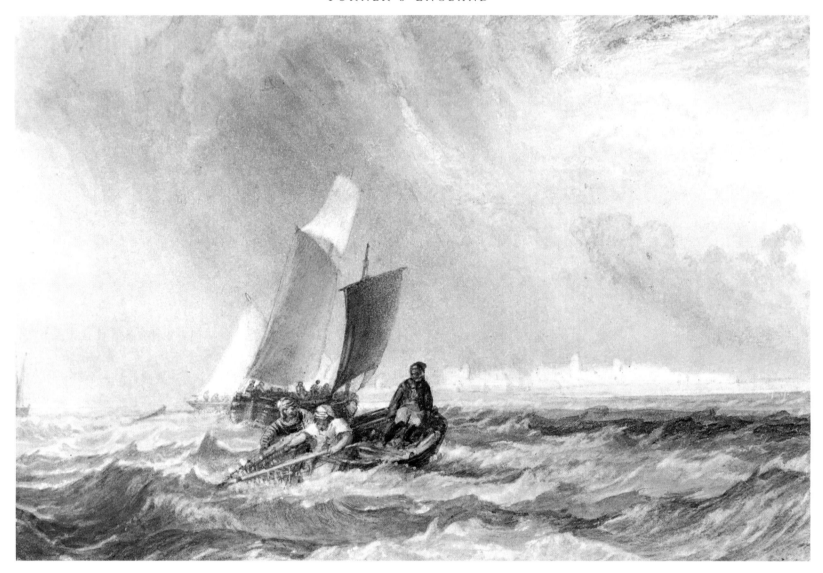

114 RAMSGATE

This drawing is one of a group of works (115–20) whose size and probable date suggest that they were made for inclusion in either the 'Southern Coast' or 'The Ports of England' series. Despite the title, this watercolour does not depict Ramsgate, for that coastline is much higher than the one depicted here, the town being situated upon cliffs that run along the coast from Pegwell Bay to Margate, via the North Foreland. Instead, this would appear to be the view from the sea *off* Ramsgate looking south-west, with Deal in the distance. The long beach at Deal is easily identifiable, and amongst the distant buildings is one that resembles Sandown Castle. The rather vague topographical location of this image might explain why it was not engraved.

In the centre a fisherman in a rowing-boat uses a boathook to pull his net aboard. He is being assisted by a man wearing a jersey whose stripes are reiterated by the adjacent highlights on the hull of a Le Havre trawler. Turner obtained a huge variety of tone and colour from an extremely limited palette in this drawing, and the choppy sea is delineated with superb finesse.

c. 1825 16.1 × 23.8 cm (6¼ × 9⅜ in)
Private Collection, U.K.

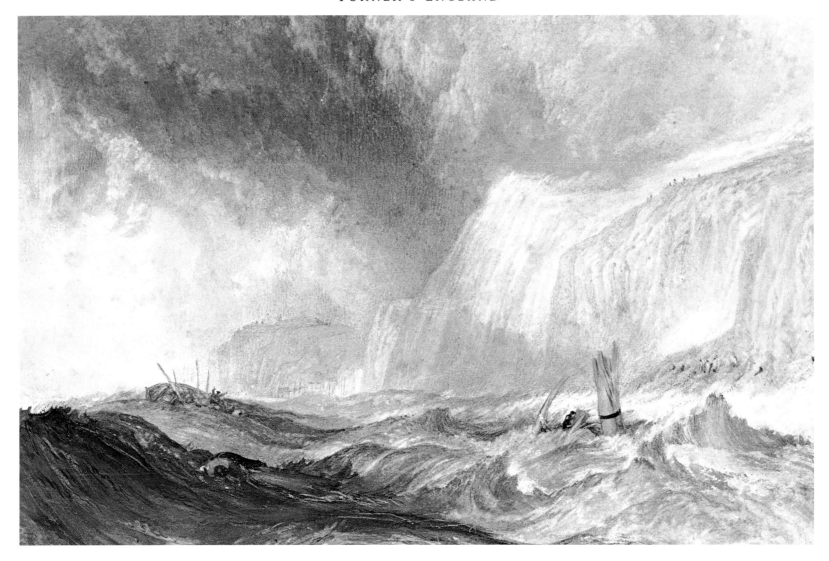

115 SHIPWRECK OFF HASTINGS

The size, subject and widespread use of stippling apparent in this drawing all suggest that it was made for engraving in 'The Ports of England' series, the stippling being an especial feature of the 'Ports' watercolours.

Hastings can be seen in the far distance, and before it a capsizing boat is tossing its luckless crew into the sea; other mariners cling to some wreckage in the foreground. Both groups of sailors are watched from the beach and cliffs by people who can do nothing to save them.

The sense of tragedy is leavened somewhat by the rich colouring of the work, with its contrasting areas of gold, blue, green-grey and white, but the wide tonal range of the watercolour adds greatly to its dramatic impact. The depiction of the sea is as masterly as ever, and it demonstrates Turner's ability to differentiate every kind of hydrodynamic flow, for here we see not a choppy sea but one propelled by a strong underlying swell; this is especially apparent on the left. An equally fine piece of observation is the spume blowing across the brow of the cliffs. The similarity between the top of the shattered mast on the right and the jagged crest of a nearby wave was certainly not coincidental, being a typical Turnerian visual simile.

c. 1825
National Gallery of Ireland, Dublin

19 × 28.5 cm (7½ × 11¼ in)

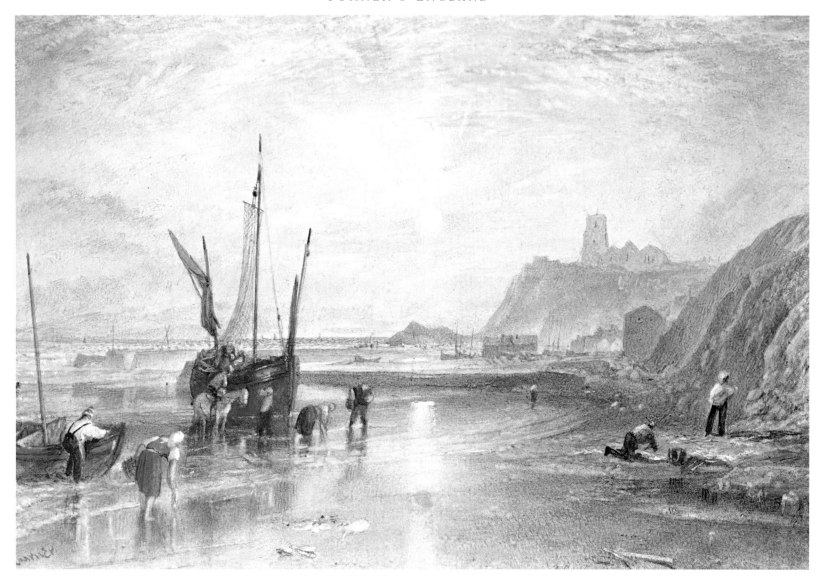

116 FOLKESTONE

The sun sets beyond the Stade, silhouetting the church of St Mary and St Eanswythe on the Lees at the right. Drawn up on the beach is a lugger with a cod bow net hanging up to dry from her mainmast.[107] Fish are being sorted on the beach.

Like *Whitby* (49) and *Tynemouth* (119), this drawing was engraved in 1844 (under the title given above) for 'Dr Broadley's Poems'. Yet it seems to date from much earlier and was probably made originally for engraving in the 'Ports' series. Although it is slightly larger than most of the 'Ports' drawings, it is virtually identical in size to *Sidmouth* (110) which *was* engraved for the scheme. The stippling apparent throughout supports this contention, being a notable feature of the 'Ports' watercolours.

For once Turner chose to ignore his usual link between Folkestone and smuggling

(see 45, 95, 172 and 245). Perhaps he felt that he had exhausted the subject, for in the other watercolours he had fully explored the various stages of a smuggling operation, including its detection. However, the rhythm imparted to the sea on the left is also to be witnessed in the 'Southern Coast' panorama of Folkestone (45), so evidently some other local associations remained with the painter. The wealth of colours, textures, and brilliant highlights make this one of Turner's loveliest sunset scenes.

c. 1828, signed

18 × 26 cm (7 × 10¼ in)

National Gallery of Ireland, Dublin

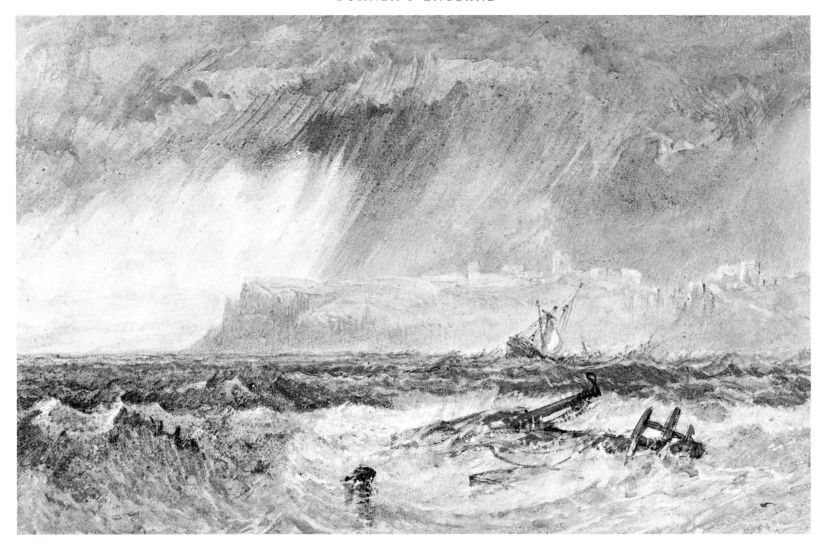

117 OFF DOVER

This unfinished design is similar in size, subject and probable date to the other watercolours created for the 'Ports' series. However, the free handling suggests that it was made by Turner as a preparatory study for a 'Ports' drawing that was never realized. Turner often made colour studies for his works and occasionally he must have developed these beginnings to an advanced stage. This appears to be one such work.

The topography only vaguely resembles Dover, and Turner seems to have moved the castle to the opposite side of the valley in which Dover is situated. However, he was to do this again in the later 'England and Wales' treatment of the town (250), so a cavalier approach to the topography of Dover is not unique. The drawing is unusually rich in colour for a storm scene, although it lacks dramatic focus, which may be why Turner never went on to make a final version of it.

c. 1825 16.5 × 26.7 cm (6½ × 10½ in)
Lady Lever Art Gallery, Port Sunlight, U.K.

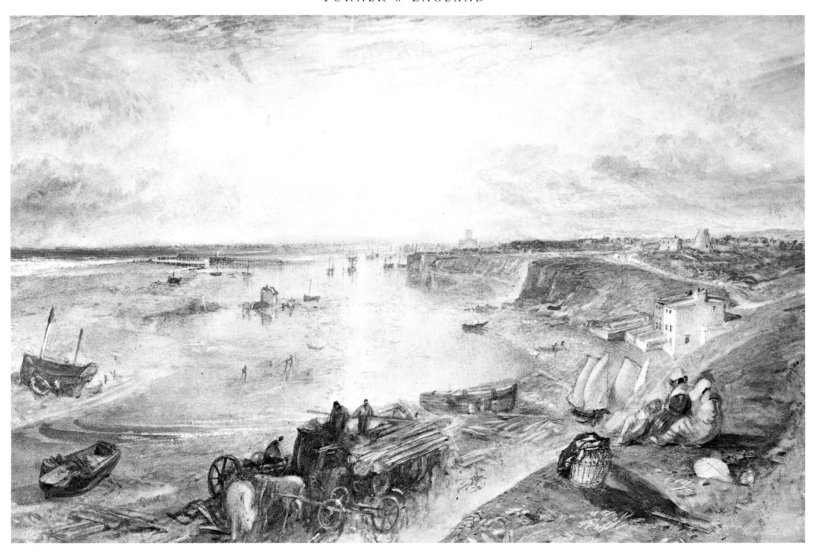

118 SHOREHAM

Although this drawing is not related in size to any of Turner's other groups of watercolours made for engraving, the subject, style and execution suggest that it may have been created for the 'Ports' scheme. The work has been variously dated to between 1825 and 1830, but because the word 'Shoreham' appears on page 88a of the *Brighton and Arundel* sketchbook (T.B. CCX) which was in use in 1824, it may be that the work was made around that time.

In Turner's day Shoreham was a busy shipbuilding centre and trading port, although the harbour was only accessible at high tide because of shifting sands. We view the town from Portslade at sunset. The brilliance of the sunlight is greatly heightened in effect by the dark tones of the figures far below it, and the otherwise featureless horizon is broken by the tower of the church of St Mary de Havra in the distance and a limekiln on the right.

c. 1824 21 × 31.2 cm (8¼ × 12¼ in)
Art Gallery and Museum, Blackburn, U.K.

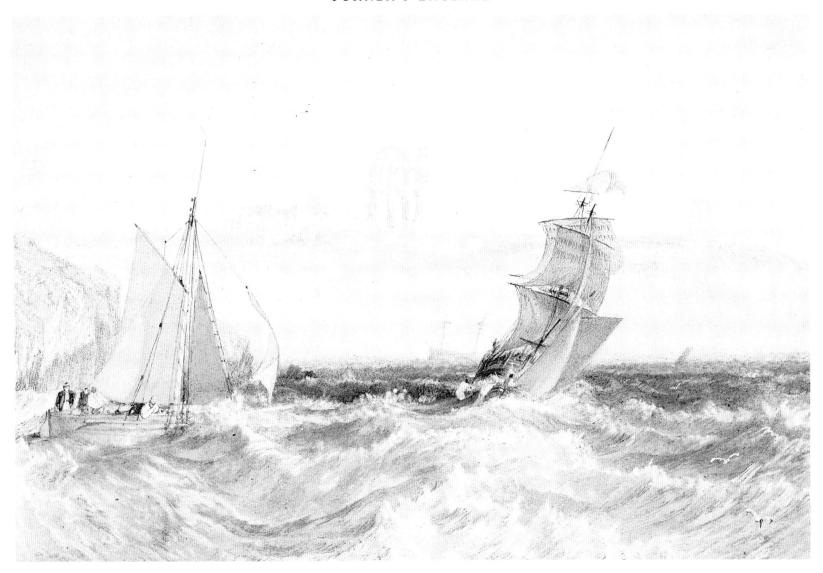

119 TYNEMOUTH PRIORY

This is another watercolour that was engraved in the early 1840s (under the above title) for 'Dr Broadley's Poems', although clearly it dates from much earlier and was probably made for either the 'Rivers' or 'The Ports of England' series; indeed, the distribution of the shipping is somewhat similar to that of the 'Ports' series drawing of *Whitby* (103). Perhaps it was this similarity that led Turner to omit the work from the 'Ports' scheme. Alternatively, because Tynemouth is not a port but a small town at the entrance to one of England's great rivers, the watercolour might instead have been made for the 'Rivers' series. Yet that project already contained two Tyne subjects (77 and 78), which could explain why the design was never placed there either.

The timing is soon after dawn, and the limited colour range evokes the cool temperature. On the left is a cutter-rigged fishing smack; in the centre, and precisely located between Tynemouth Priory and the lighthouse are a distant wrecked brig, a coble, hoy and brig which are either colliding or possibly transferring something between them, and a faraway lugger. On the nearby brig a man climbs the shrouds to secure the main top-gallant sail. The wrecked brig appears in exactly the same spot in the later view of Tynemouth in the 'England and Wales' series (173).

c. 1825

15.9 × 24.1 cm (6¼ × 9½ in)

Art Gallery and Museum, Blackburn, U.K.

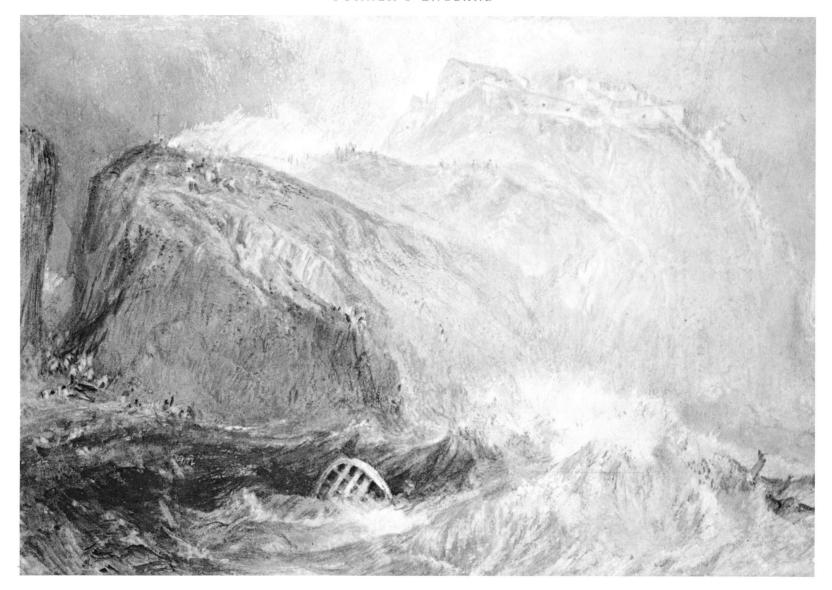

120 TINTAGEL CASTLE

The subject and style of this drawing suggest that it dates from the mid-1820s. The extreme freedom of execution is similarly encountered in *Off Dover* (117); as in that work, Turner may have been simply trying out an idea here for a 'Ports' series watercolour.

Compared with the 'Southern Coast' view of Tintagel (32), the main features of the landscape have been further distorted and the slate quarry has disappeared, while the buildings up on the right seem much more extensive than those in the earlier design. However, given Turner's usual topographical licence, it would be idle to seek for truthfulness to the 'real' Tintagel here.

The watercolour displays the combination of high colour, furious energy and bold dramatic content that so characterizes Turner's output during this period. Rarely is the painter's pessimism regarding religion so clear: on the crest of the hill stands a crucifix, while in the sea a figure clings to a mast-top and on the right another drowns; onlookers line the beach and cliffs, watching helplessly.

c. 1825
Thos. Marc Futter, Esq.

17.7 × 24.4 cm (7 × 9½ in)

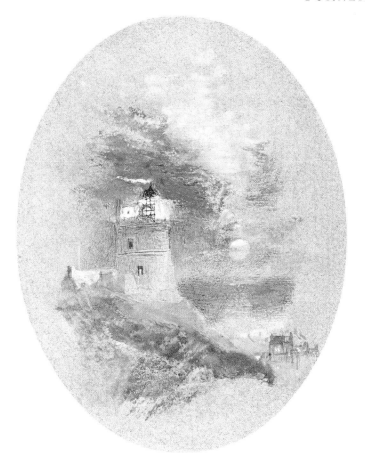

121 *LOWESTOFFE LIGHTHOUSE*

Like Nos. 122–23 and 125–27 discussed below, this work was engraved by J. C. Allen but never published, due to Turner's abandonment of the 'East Coast' scheme.

The original lighthouse at the north end of Lowestoft High Street was built in 1609 and was the oldest existing lighthouse in England in Turner's day. It was replaced in 1854. The drawing shows an abundant use of French ultramarine blue which only became available in the mid-1820s.

When this design was engraved, Turner introduced a ship on the sea, directly under the moon.

c. 1827 Vignette, 12.5 × 9.5 cm (4⅞ × 3¼ in)
Watercolour and bodycolour on blue paper
On loan to the Indianapolis Museum of Art from the Kurt Pantzer Collection, U.S.A.

122 *HASBORO SANDS*

The name Happisburgh is pronounced 'Haysborough', which explains Turner's title, written very faintly in his hand across the bottom of the sheet. Happisburgh is a small fishing village on the Norfolk coast about twenty miles north of Yarmouth. The shoals of Happisburgh Sands have always presented a danger to shipping and the lighthouse was built there in 1791 as a consequence.

The lighthouse is the central focal point of the vignette. Its pointed form is repeated by the fisherman's dark cap beneath. On the beach fishwives gut and clean the fish. Although the drawing represents a dawn scene, in reality the sun would have to rise in the north to be located in the position it occupies here.

c. 1827 Vignette, 16.5 × 12.7 cm (6½ × 5 in)
Watercolour and bodycolour on blue paper
Private Collection, U.S.A.

EAST COAST

123 ORFORD HAVEN

EAST COAST

124 GREAT YARMOUTH FISHING BOATS

The twelfth-century Orford Castle appears on the left of this lovely study of evening light on the river Ore. Our attention is drawn to the sunlight appearing through the window of the keep by the location of a mast immediately below it. In the distance is the west tower of St Bartholomew's church, the top of which collapsed in 1830. Boat-building takes place on the right.

Although this watercolour was never engraved, its circular shape, subject and support all clearly indicate that it was made for the 'East Coast' scheme.

The title of the vignette is written in Turner's hand separately from the design and consequently has been omitted from the reproduction. As that title specifies, the subject is the shipping, and it allowed Turner to indulge his predilection for jumbling vessels together: from front to back are a lobster-boat, a Yarmouth beach-yawl and at least three Yarmouth shrimp-boats, one with raised sails. The colour is limited to the three primaries plus white, but they capture the calm, early morning light completely.

c. 1827 Vignette, 19 × 12 cm (7½ × 4¾ in)
Watercolour and bodycolour on blue paper
On loan to the Indianapolis Museum of Art from the Kurt Pantzer Collection, U.S.A.

c. 1827 Vignette, 23.5 × 17.8 cm (9¼ × 7 in)
Watercolour and bodycolour on blue paper
Private Collection, U.S.A.

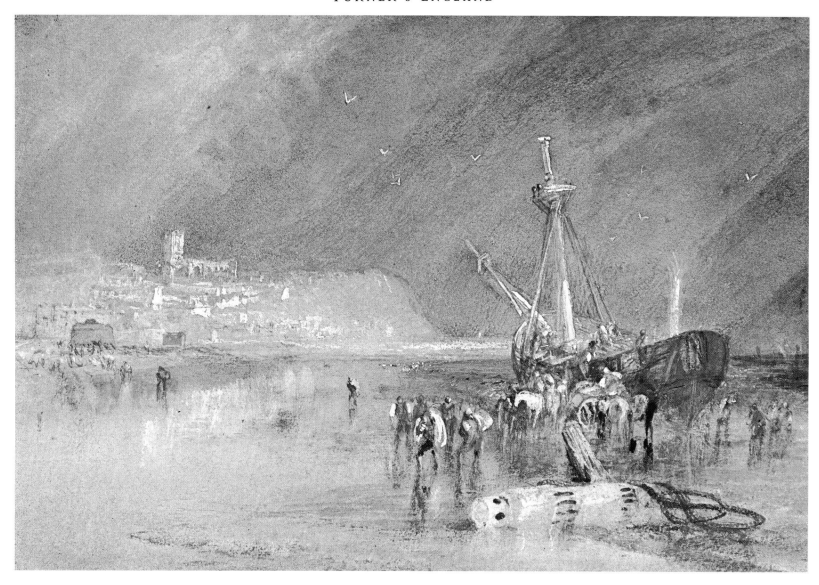

EAST COAST
125 ALDBOROUGH

Here a dismasted brig similar to the one seen in *Orfordness* (127) and *Lowestoffe* (128) has been beached and is having its cargo removed. On the left is the Martello tower at Slaughden and beyond it Aldeburgh, its skyline dominated by the church of St Peter and St Paul. The two halves of the drawing enjoy a maximized tonal contrast, and the buildings were freely painted with small touches of white; coupled with the glistening reflections on the sand, Aldeburgh has a floating, disembodied appearance as a result. On the right may be seen a dab of Schweinfurt or emerald green, which only became commercially available in the mid-1820s.

c. 1827 17.2 × 25.4 cm (6¾ × 10 in)
Watercolour and bodycolour on blue paper
Private Collection, U.K.

126 DUNWICH

During the Middle Ages, Dunwich was one of the most prosperous ports in England. Constant erosion by the sea led to its decline, and by Turner's time it was only an impoverished fishing village.

On the hill stand the ruins of All Saints Church. These have been turned through one hundred and eighty degrees to relocate the tower nearest the sea. The tower itself finally disappeared in 1919.

The watercolour was drawn very freely and when the design was engraved Turner added a bolt of lightning to augment the power of the image. The generally darker tone of the engraving imbues it with more mystery.

c. 1827
Watercolour and bodycolour on blue paper
City Art Gallery, Manchester, U.K.

17.4×25.7 cm ($6\frac{7}{8} \times 10\frac{1}{8}$ in)

EAST COAST

127 ORFORDNESS

Orford Ness is located on a twelve-mile-long spit of land which joins the mainland at Slaughden, just below Aldeburgh. Here Orford Castle and church can be seen in the distance beyond the spit and the river Ore. In Turner's time Orford Ness was uninhabited except for the two lighthouses, the low light (on the right) and the high light, built in 1792. These lights were necessary, for Orford Ness can prove very dangerous, as was demonstrated one terrible night in 1627 when no fewer than a dozen vessels were wrecked there.

After about 1817, when Turner made *Ilfracombe* (233) for the 'Southern Coast' series, and especially during the latter half of the 1820s, the painter consistently regarded lighthouses as symbols of the futility of hope. Such pessimism was consistent with his view that all hope is fallacious, which has certainly proven to be the case here, for between two beacons dedicated to the prevention of shipwreck is a dismasted brig which has been jury-rigged and is now abandoned. Various small boats have attached lines to her bow in an attempt to salvage her, and spectators line the beach.

c. 1827 16.5 × 25.4 cm (6½ × 10 in)
Watercolour and bodycolour on blue paper
Private Collection, U.K.

EAST COAST
128 LOWESTOFFE

This work was partially engraved (as an open etching only) for the 'East Coast' scheme.

Here is yet another lighthouse which has failed in its purpose. On the right is the upper lighthouse at Lowestoft (also seen in 121), with some wreckage immediately before it. On the left is a Yarmouth beach-yawl and beyond it a Lowestoft Drifter, both of which are making their way towards a distant dismasted brig. Turner was again to depict Lowestoft from a similar vantage point in the 'England and Wales' series (213) and there too the lighthouse is juxtaposed with wreckage. The light is aptly bleak, given the subject, and only a few touches of ochre and green enliven the overall coolness of colouring.

c. 1827 17.4 × 25.2 cm (6⅞ × 9⅞ in)
Watercolour and bodycolour on blue paper
Private Collection, U.K.

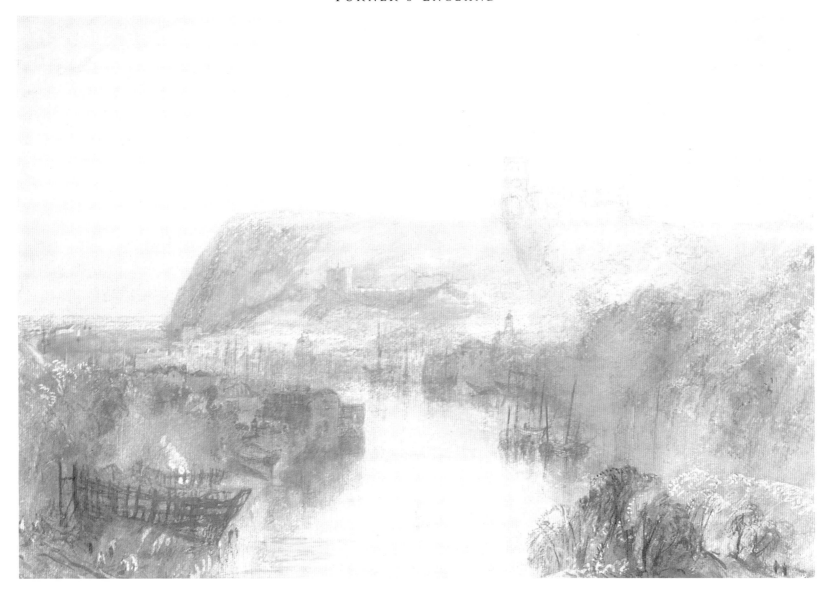

EAST COAST

129 WHITBY

This work was partially engraved (as an open etching only) for the 'East Coast' scheme.

Here Turner pushed the use of gouache (bodycolour) into the territory normally occupied by oil paint, working up a thick scumble in the area of mist below and to the right of the abbey. The highlights on the trees on the right and left add to the brilliance of the scene, while at the bottom left a small fire shines through the timbers of a ship and clearly echoes the similar effect of the rising sun shining through the arches of the ruined abbey, a typical Turnerian visual simile.

c. 1827 15.2 × 24.7 cm (6 × 9¾ in)
Watercolour and bodycolour on blue paper
Private Collection, U.K.

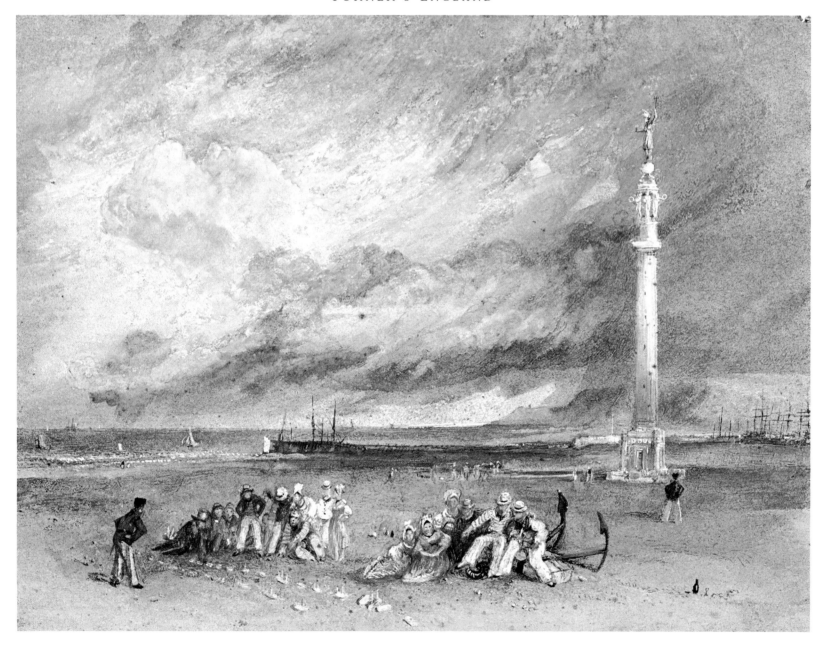

130 YARMOUTH SANDS

This work was never engraved but it was certainly made for the 'East Coast' scheme. It demonstrates Turner's enormously subtle ability to state the truth of place, the immutable underlying fact that gives a landscape its meaning.

On the right is the Nelson Monument, Yarmouth, which was built in 1817 to commemorate both Nelson and his victory at Trafalgar in 1805. It is 44 metres (144 feet) high and is surmounted by a statue of Britannia. In front of it, a group of figures enacts a naval engagement with the aid of ship's models, which are laid out in parallel

18 Plan printed opposite page 49 in volume IV of William James's The Naval History of Great Britain, *published in 1826, showing the lines of battle employed by Nelson at the Battle of Trafalgar, 21 October 1805.*

rows according to the long-established order-of-battle at sea: two lines of warships would sail alongside each other and rake opposing vessels with huge broadsides until they either sank or became unmanageable and were therefore forced to surrender.

Nelson's great tactical coup at Trafalgar, however, had been to sail the British fleet in two columns *at right angles* to the combined French and Spanish fleet, thereby driving wedges into their line (ill. 18). These wedges broke the enemy formation into three sections, giving the outnumbered Nelson time to deal with the second and third

sections while the first section took hours to come about in the calm conditions, by which time the British could deal with them as well.

Turner was undoubtedly aware of 'the Nelson Touch', as both in 1805–06 and 1823–24 he had painted pictures of the battle of Trafalgar for which he had had to research its history. Moreover, a book published in 1826, Volume IV of William James's *The Naval History of Great Britain*, had severely criticized Turner's use of poetic licence in the 1824 painting and had printed a diagram of the battle that is reproduced here, recommending that painters amongst its readers should use the diagram to improve upon Turner's representation of the battle in their own versions of the subject. Turner owned a copy of James's book[108] and it seems that he acted upon the author's suggestion by assimilating the information given in the diagram into this design.

The 'Nelson Touch' is clearly suggested by the two groups of figures beyond the twin lines of toy boats. In the nearer group the skirts of the seated women exactly resemble arrow-heads in shape and detail, and they initiate a massive wedge shape that incorporates the whole group of figures and anchors. A sense of forward motion is imparted to this triangular grouping by the pointing arm of a sailor and by the straight shanks of the anchors behind him. To the left, a second group of figures similarly forms a wedge-shape, and this wedge actually touches the line of toy boats, thus signifying the fact that at Trafalgar it was the right-hand, lee column of Nelson's fleet, led by Admiral Collingwood, which had first engaged the enemy, leading Nelson to remark 'see how that noble fellow Collingwood takes his ships into action. How I envy him'. Of course, Turner shows us two parallel columns of ships, the traditional battle formation, for if he had merely depicted one line of boats we should not know that he was referring to a battle at all; here they represent the method of waging sea battles before Trafalgar.

A storm moves off beyond Gorleston in the distance and reveals peaceful sky to the left; storms are traditional metaphors for war, and were much used in that way by Turner in designs with a military staffage (for other examples see 159 and 167). Below the column on the right a lone tar points up the sense of opposition by balancing and opposing the sailor standing on the left, while in front of him, at the bottom right, are a bottle and a glass. Perhaps Turner intended us imaginatively to toast Nelson's memory by means of them.

c. 1827 18.5 × 24.5 cm (7¼ × 9⅝ in)
Watercolour and bodycolour on blue paper
Fitzwilliam Museum, Cambridge, U.K.

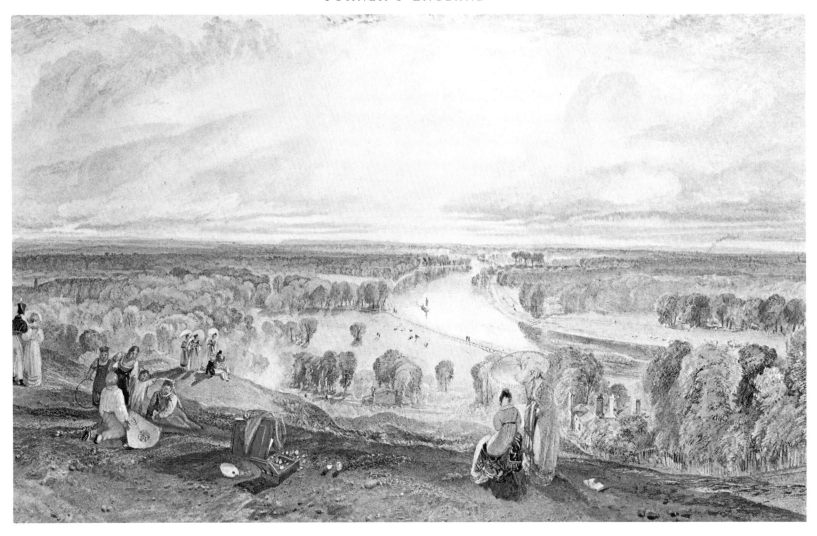

131 RICHMOND HILL

This watercolour was commissioned by the engraver Edward Goodall and was reproduced as a line-engraving in *The Literary Souvenir* in 1826.[109]

Turner loved the view from Richmond Hill and he celebrated it in a large number of works. At the time he made this drawing he still owned a house in Twickenham designed and built by himself, and its exact location is denoted by the pall of smoke in the distance on the right; on the left a man peers at the smoke through a telescope. Further possible allusions to Turner himself include the paintbox, palette and phials (of pigment?) in the left foreground, as well as a picture on an easel beyond the two women to the right.

The design affords an object lesson in how to animate a fairly featureless landscape.

The semi-ellipse of the bend in the river is either repeated, as in the child's hoop on the left and the cloud to the right of the sun, or else it is amplified into a number of full ellipses, such as those formed by the palette, the parasol of the woman standing in front of the easel, and the parasols held by the three women standing on the left. These reiterated shapes are echoed by the many semicircles and full circles of the trees, and together they all invigorate and bind the composition.

c. 1825

Lady Lever Art Gallery, Port Sunlight, U.K.

30×48 cm ($11\frac{7}{8} \times 18\frac{7}{8}$ in)

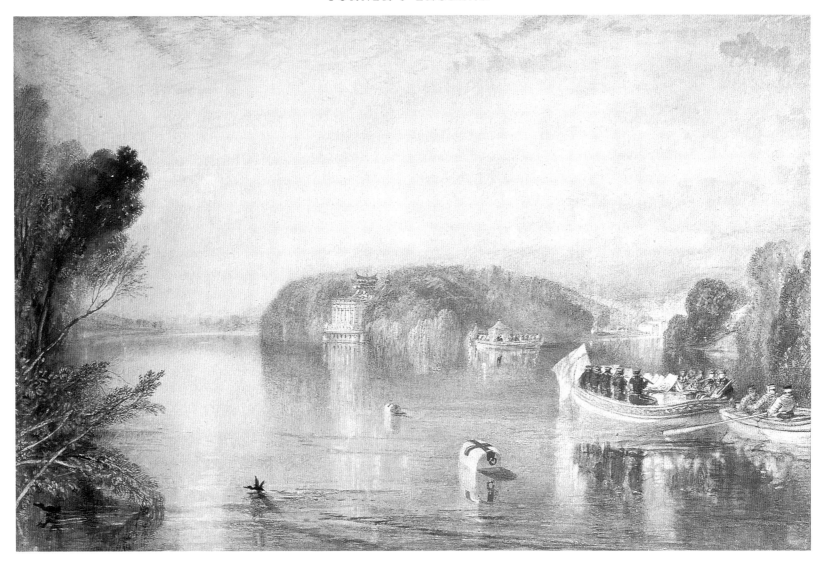

132 VIRGINIA WATER

Turner made two watercolours of Virginia Water; both were engraved and published in 1830 in *The Keepsake*, one of Charles Heath's publications. The pendant (258) is now untraced. According to legend, Turner had originally executed either one or both of the drawings for King George IV, who refused to buy them.[110]

Virginia Water in Windsor Great Park was the largest artificial lake in Britain in Turner's day. It was begun in 1746 by the Duke of Cumberland and was designed by Thomas and Paul Sandby who completed it in the 1790s. Here we look westwards towards the Chinese fishing temple, from ' . . . which George IV used almost daily to enjoy amusement of angling' during the summer months.[111] Nearby may be seen the fishing boat fitted up with an elegant Moorish-style awning that was generally used by the King.

Turner has evidently portrayed Virginia Water on George IV's official birthday and name day, St George's Day (23 April), with buoys decorated with the cross of St George and the flag of St George flying from the stern of the boat carrying a military band which is being towed by a rowboat. As 23 April was also Turner's own birthday, the artist clearly celebrated that double anniversary by alluding equally to himself, for the mallard taking off on the left is obviously a pun upon the second of his forenames, 'Mallord', which he is known to have used in a similar punning way elsewhere.[112]

c. 1829
Private Collection, U.K.

29 × 44.3 cm (11⅜ × 17⅜ in)

ENGLAND AND WALES
133 SALTASH

This is the only drawing in the 'England and Wales' series to have been dated, and perhaps it was therefore the first watercolour to have been made for the scheme. For that reason it is located at the beginning of this sequence of plates.

Yet again, Turner drew upon his memories of a place as he had seen it during the Napoleonic wars. On the left are three hulks, the nearest of which is viewed stern-on. When Turner visited the Hamoaze in 1811 and 1813 many of these ships would have housed French prisoners-of-war, and that does appear to be the case with the second vessel here, for it has a canvas awning and washing hanging on its deck.

In the distance on the right is a sailor waving a straw hat. Such boaters were given to seamen upon their return from lengthy voyages, and this detail tells us that we are witnessing a welcoming-home scene. In another 'England and Wales' watercolour (137) the shape formed by the arms and boaters of sailors returned from a voyage imparts a bawdy meaning that would not have been inappropriate in this context either. And certainly the marines' joyousness at being welcomed home by their women and children is furthered by the widespread distribution of rich golds and crimsons. Saltash appears ethereal in the peaceful late afternoon sunshine, and the pointed tower of St Nicholas's Chapel acts as the apex of the pictorial architecture.

1825, signed and dated
British Museum, London

27.3 × 40.8 cm (10¾ × 16 in)

134 LANCASTER, FROM THE AQUEDUCT BRIDGE

The Lancaster Canal links Stainton in Cumberland to Preston in Lancashire and passes over the river Lune above Lancaster on a canal bridge. Turner had sketched the scene on the 1816 North Country tour, when he paid particular attention to the architectural detailing of the bridge itself.

Activity is here contrasted with inactivity: beyond the bridge agricultural labourers work in the fields, while upon the bridge some figures and animals take their rest. From left to right are a boy fishing from a barge, a feeding barge-horse, two travellers with their luggage (towpaths also served as roads) and a man propped up against the balustrade. He seems to be prostrated by the heat and has removed his shoes to rest in the shade. However, the peacefulness in the foreground may imminently be broken, for the boy fishing on the left seems to be falling into the canal, as he enjoys no visible means of support. The diagonal line of his rod is balanced by the boathook on the right, where the name of a barge usefully identifies Lancaster, and these diagonals neatly bracket the superb vista.

c. 1825

28×39.4 cm ($11 \times 15\frac{1}{2}$ in)

Lady Lever Art Gallery, Port Sunlight, U.K.

ENGLAND AND WALES
135 RIEVAULX ABBEY

Early morning sunlight burns off the mists swirling around Rydale in this portrayal of one of England's most impressive ruins, a Cistercian foundation dating from 1230. Up on the right may be seen the classical temple built by Thomas Duncombe in 1758 to add to the picturesque charms of the site. The composition is subtly unified by a basic X-shape formed by the lines of the hillsides and river, and the colouring is beautifully controlled, with soft pinks, yellows and greens slightly outbalancing the cooler blues and blue-greens to suggest the rising temperature.

This watercolour may have been made as a pendant to *Bolton Abbey*, reproduced opposite, for both works represent Yorkshire abbeys and include fishermen tying a fly, seen here at the lower left.

c. 1825
Private Collection, U.K.

28 × 40 cm (11 × 15¾ in)

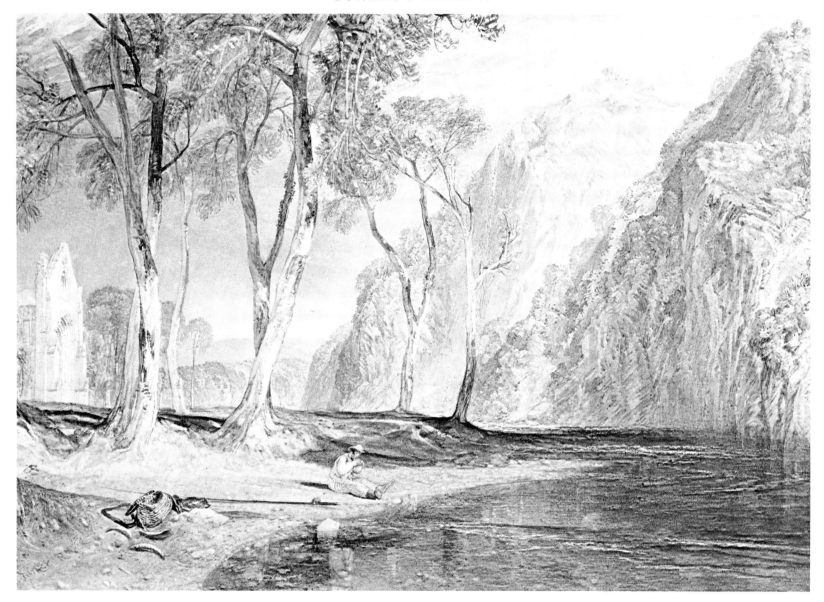

ENGLAND AND WALES
136 BOLTON ABBEY

This is one of Turner's most beautiful images of peacefulness, with the river Wharfe drifting lazily in the morning sunlight and Wharfedale given an alpine scale by the enormous heightening of its far banks. The immensity is equally augmented by the relative smallness of the ruined abbey off to the left and by the greatly elongated ash trees – in relation to the fishermen, their trunks beneath their branches are about 7.3 metres (24 feet) high. Moreover, their tallness is greatly boosted by the fact that we do not see the tops of them but have to imagine them; as a consequence they tower over us.[113] All this stated or implied vastness serves to stress the relative emptiness of the landscape, while the restfulness of the scene is subtly augmented by the fact that the

solitary fisherman is sitting to tie his fly.

The detailing of the trees is of an unsurpassed loveliness; as Ruskin commented, they are 'seen to be all tremulous, perpetually waving along every edge into endless melody of change . . . Texture of bark, anatomy of muscle beneath, reflected light in recessed hollows, stains of dark moss, and flickering shadows from the foliage above, all are there, as clearly as the human hand can mark them'.[114]

c. 1825, signed but not dated 29 × 39.4 cm (11⅜ × 15½ in)
Lady Lever Art Gallery, Port Sunlight, U.K.

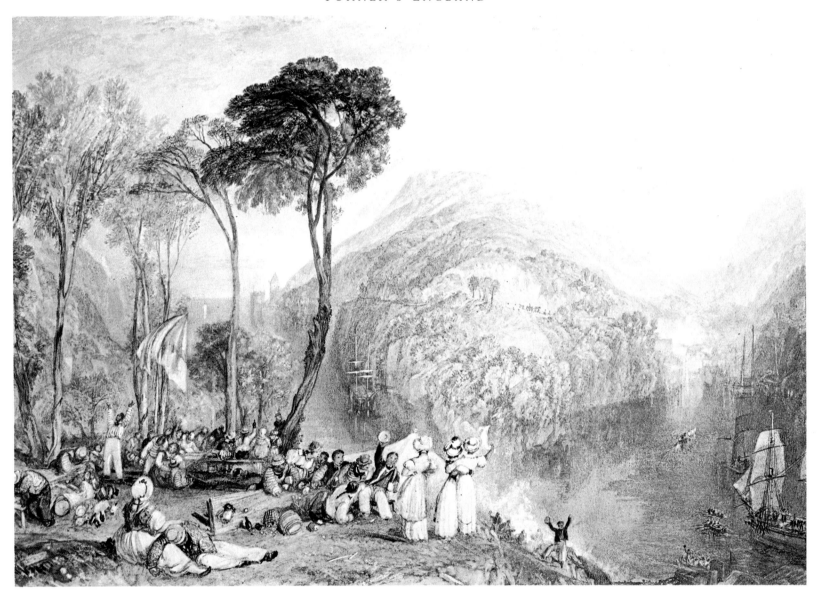

137 DARTMOUTH COVE, WITH SAILOR'S WEDDING

Often after lengthy voyages, and especially during the Napoleonic wars when shore leave was rarely granted for fear of desertion, the ensuing landfalls were celebrated with mass-marriages, as many as two or three hundred occurring in a single week. However, they usually licensed prostitutional debauches rather than marriages in any real sense.

Here sailors wave straw boaters, denoting their return from abroad, and their hats and raised arms often form phallic shapes which suitably express the general air of sexual excitement. The nearest sailor has drunk too much, though, for he is slumped over a seated woman, and one of his arms forms a drooping phallic shape across her lap, while his other arm is placed between his legs. The overall shape made by the waving hats and arms is projected on a larger scale by one of the trees which stands out, dark

and priapic, from its more delicate companions. Equally, the linear gracefulness of these trees echoes the gracefulness of the three women standing in the foreground.

The composition is unified by a shallow X-structure, with one line running up to the cove on the right, and the other following the near bank of the Dart. Far off in the distance may be seen Dartmouth Castle, and another fine detail is the horse and cart ascending the hill on the opposite side of the river. The colouring is soft and gentle, as befits a warm summer's evening, and one can appreciate the sailors' happiness at being home at last.

c. 1825
Private Collection, U.K.

28×38.7 cm ($11 \times 15\frac{1}{4}$ in)

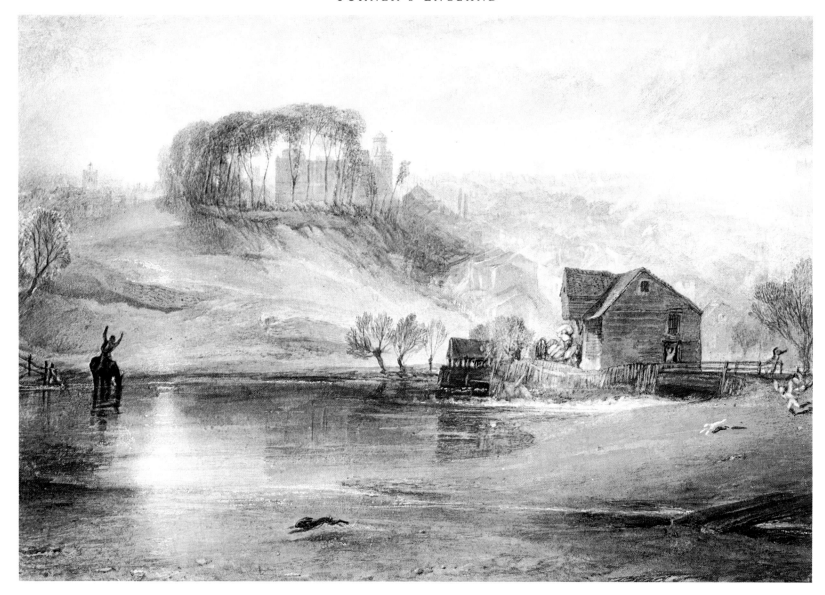

ENGLAND AND WALES
138 COLCHESTER

We look towards Colchester Castle, with Middle Mill on the right. From the mill, and in front of the millrace, a 'mill race' takes place as several children and their dog pursue a hare, a typical Turnerian pun. Similarly, across the pond the rider of a drinking horse raises his arms to shoo the hare, while to the right of him and balancing him are some pollarded willows whose shapes return his waving gestures, a typical Turnerian visual simile.

Turner took his usual poetic licence with the lighting effects here, for the sun seems to be rising or setting in the south.[115] The architectural complexities of the town on the right are fully stated within an extremely limited but high-keyed tonal range, and once again they demonstrate the painter's extraordinary control of light and shade.

c. 1825

28.3 × 40.4 cm (11$\frac{1}{8}$ × 15$\frac{7}{8}$ in)

Courtauld Institute Galleries, London, U.K.

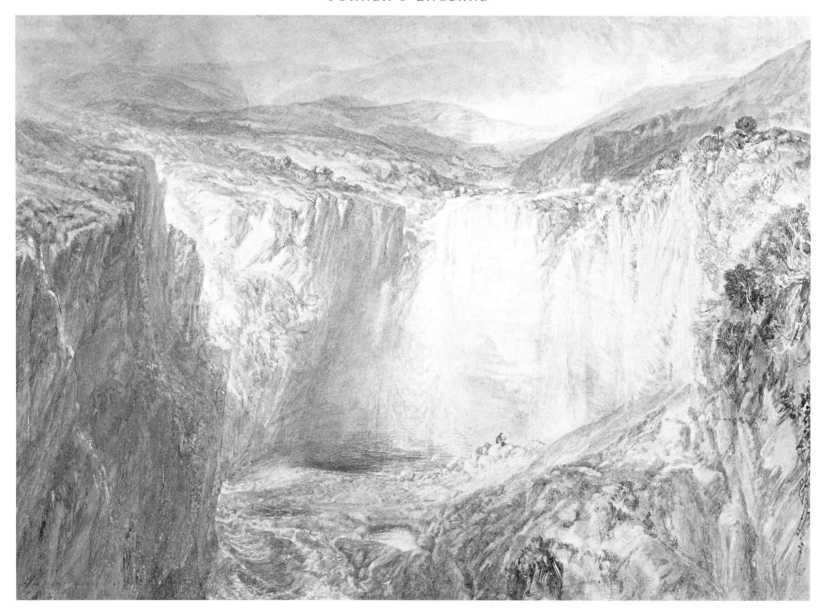

139 FALL OF THE TEES, YORKSHIRE

As the view of High Force waterfall in the 'Richmondshire' series demonstrates (58), in 1816 Turner had surveyed the falls from near the spot in which an artist sits sketching in this watercolour. (Indeed, a seated, sketching figure even appears in one of those pencil studies made at the falls.[116]) In the 'Richmondshire' design, however, we do not see beyond the waterfall; in this watercolour we perceive the vast moors of upper Teesdale stretching away towards Mickle Fell in the afternoon sunshine.

Turner has somewhat heightened the falls, which is perhaps to be expected, although to flesh out the difference he has added a large number of extra strata to the scarp, for in reality there are far fewer horizontal layers of thin-bedded limestone supporting the vertical columns of quartz-dolerite rock. The water is also depicted as falling in concentric waves, which does not happen in reality, but it is thereby given an added sense of propulsion. The eddying of the river is very well captured, as is the fine spray given off by the falling water, which Turner had seen in 1816 in its fullest spate for years.

c. 1825
Private Collection, U.K.

28 × 39.3 cm (11 × 15½ in)

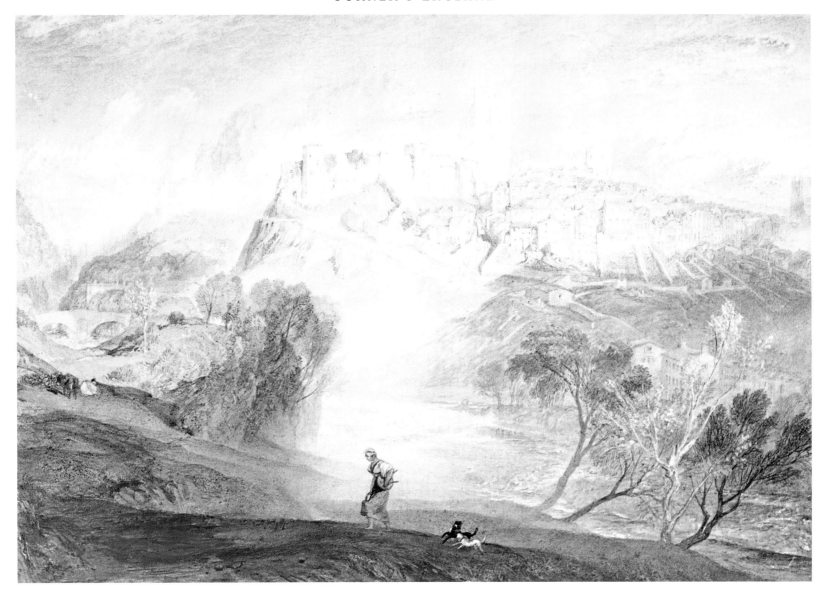

140 RICHMOND CASTLE AND TOWN, YORKSHIRE

Here we see a similar view to one of the 'Richmondshire' series panoramas of Richmond (55), but from the opposite bank of the Swale. Also present is the 'Sweet Lass of Richmond Hill' who appears in all four of Turner's depictions of the Yorkshire town; she is now off to do her milking and is followed by two dogs (in the other designs she has only one canine companion).

The drawing enjoys a wonderful range of colours, including soft golds, pinks and greens. Their warmth is intensified by the contrasting coolness of the lower half of the scene, which is still bathed in shadow, and especially by the area of spray rising above the weir. Turner employed a similar distribution of colours and tones in an earlier Yorkshire scene, the view of *Gledhow* dating from around 1816 (53).

c. 1825
British Museum, London

27.5 × 39.7 cm (10¾ × 15⅝ in)

169

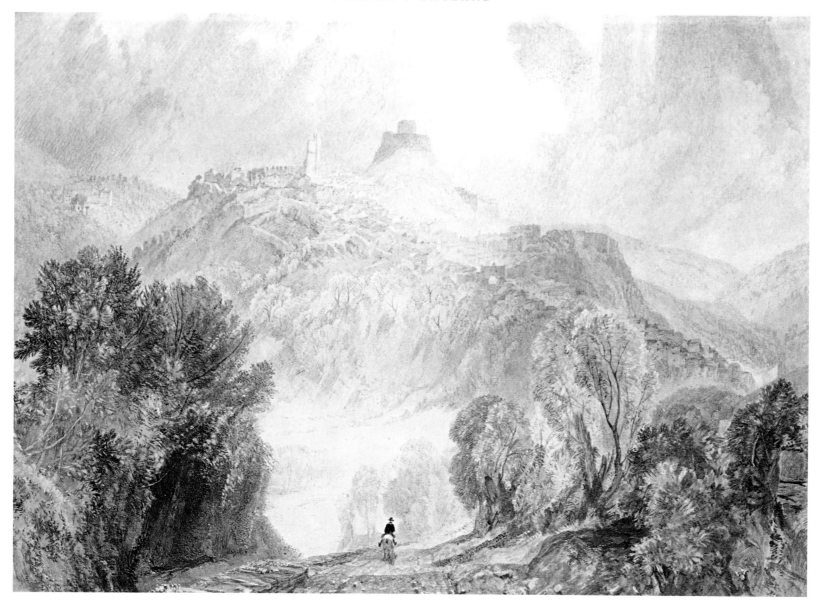

ENGLAND AND WALES
141 LAUNCESTON

In this lovely watercolour Turner again organized his imagery around a central truth of place. The sole occupant of the landscape is a man on a horse (detail, ill. 19) who is exactly aligned vertically with Launceston Castle far above him. The dark tonality of the castle rising above its light-toned hill repeats the dark tonality of the horseman rising above his light-toned horse, while the shape made by the inner keep of the castle rising above its outer keep repeats that of the shape of the man's hat rising above its brim. The vertical alignment, tonal connection between castle and man, and amplification of the shape of the hat by the shape of the castle, were not fortuitous. Instead, as Martha Mel Edmunds has recently convincingly suggested,[117] Turner intended an historical allusion by means of them.

During the Civil War and the Protectorate which followed, Launceston Castle was

used as a prison, and its most famous inmate was George Fox, the founder of the Society of Friends, or Quakers. Born in 1624 and by training a shoemaker from Leicestershire, Fox became perhaps the greatest religious leader to be thrown up by the Civil War. He travelled around Britain propagating his Quaker beliefs and frequently went to gaol for them, eventually on that account serving eight prison sentences totalling six years. The Quakers especially enraged upholders of law and order for their refusals to take legally binding oaths, to treat judges and magistrates with the customary verbal deference, or to doff their hats in court. It was because of this latter refusal that a link between Fox and Launceston Castle came to be especially forged in the public mind.

In 1656 Fox was hauled before the Lord Chief Justice of England, Judge John Glyn, at the Court of Assizes in Launceston. He was charged with having 'spread several papers [i.e. religious tracts] tending to the disturbance of the public peace', with 'having no pass for ... travelling up and down the country' and for 'refusing to give sureties for ... good behaviour'. In court, Fox refused to remove his hat and began a long argument with the judge regarding the Biblical sanction for such a practice. He won the argument but it was a Pyrrhic victory, for Fox so enraged Judge Glyn that upon being found guilty he was incarcerated for nine months in the most noisome part of Launceston Castle, the excrement-filled Doomsdale gaol where there was no bedding nor sanitary conditions of any kind. Through intermediaries Fox continued his proselytizing activities from within the prison, and as one of Oliver Cromwell's chaplains remarked, putting Fox in prison was the surest way of disseminating his teachings in Cornwall. Fox later told of his ordeal in a journal that was first published between 1694 and 1698 and re-published many times thereafter.

The emphasis that Turner gave to the traveller's hat, plus the fact that it is exactly the kind of wide-brimmed hat that was worn by Quakers, clearly alludes to Fox's refusal to remove his hat in court. Moreover, the hat is apparently not the only allusion to Fox in this work. The sky is filled with dark storm clouds that could clearly portend things to come for the man making his way towards Launceston. Yet simultaneously there is an eerie, contrasting quietude to the landscape, with the fields beyond the wayfarer bathed in sunlight. This peacefulness may have been intended to denote the inner calm sought by Quakers amid the storms of life, a spiritual quietude that is central to their beliefs.

Turner knew several Quakers, including the brothers Granville and John Penn, who were grandsons of William Penn, the Quaker founder of Pennsylvania. Naturally he had also been acquainted with Benjamin West, the President of the Royal Academy almost continuously between 1792 and 1820, who was a lapsed Quaker from Pennsylvania. Moreover, during the years in which the 'England and Wales' series was being made, Turner was in close touch with the Edinburgh engraver and practising Quaker minister, William Miller, who was responsible for producing seven engravings after designs for the series between 1828 and 1836 (for example, see *Straits of Dover*, 250).

Nor was Turner's identification with Fox's struggle for freedom of belief inconsistent with other works he had created by the 1820s or would create after that time. As we have seen with *Wycliffe, near Rokeby* (62) made for the 'Richmondshire' series around 1816 and engraved in 1823, Turner had covertly or even openly avowed his opposition to religious and political persecution, while as we shall discover below in connection with the watercolour of *Stoneyhurst College* made for this series (168), in 1829 Turner would again affirm his identification with the demands for religious and political tolerance.

The composition is unified by an arabesque line which sweeps down from the top left, passes around the road in the foreground, moves up through the trees on the right to link up with a ridge in the town, and finally arrives at the castle. This arabesque, plus the tonal lightness of the centre of the drawing, creates a huge void beyond the traveller. The eye is also led upwards by the vertical line of the tower of St Mary's Church to the left of the castle, and by the vertical lines of shadow in the sky, lines that introduce appropriately cosmic associations to the scene.

c. 1825

Private Collection, Iran?

27.9 × 39.4 cm (11 × 15½ in)

19 LAUNCESTON, detail

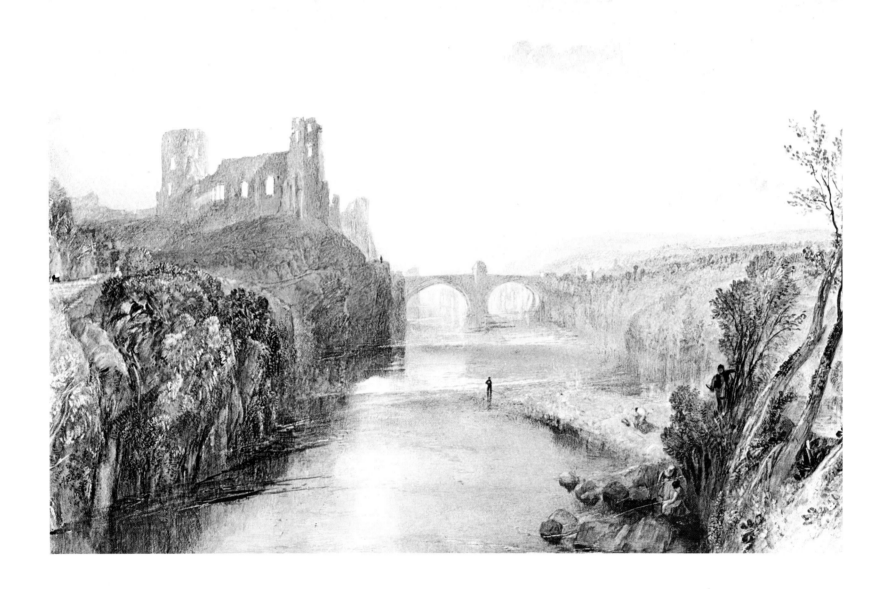

142 BARNARD CASTLE, DURHAM

Turner initially visited Barnard Castle on his first tour of the north of England in 1797, and this watercolour was developed from a sketch made on that trip.[118] When he revisited the banks of the Tees in 1816 it was raining, for the further sketch he then made of this view is disfigured by blotches caused by the downpour.[119]

In the dazzling early morning light, men and women fish while woodcutters hack down brushwood or tie it into bundles; around them the luxuriance of natural forms offsets the austerity of the ruined castle. The woodcutter standing by the trees on the right introduces a dark note, inasmuch as he is about to cut down something living, but that seems to complement the depiction of a dead castle very appropriately.

The composition is buttressed by a shallow X-structure which crosses on the Tees just below the sun. The white patches around the castle and sun probably resulted from later attempts to bleach out a stain, but fortunately they do not detract from the brilliance of the image which has a vivacity much enhanced by the multitude of sparkling highlights to left and right.

c. 1825 29.2 × 41.9 cm (11½ × 16½ in)
Yale Center for British Art, Paul Mellon Collection, U.S.A.

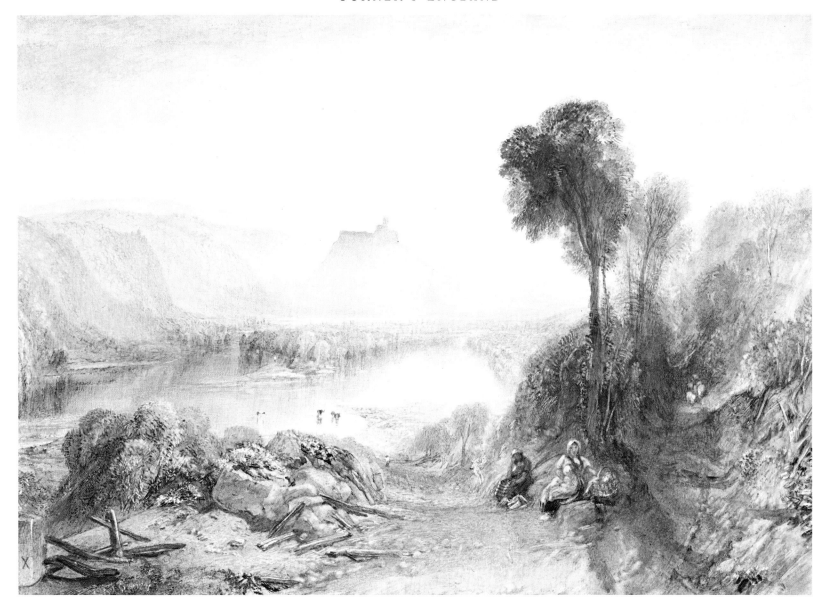

ENGLAND AND WALES
143 PRUDHOE CASTLE, NORTHUMBERLAND

Turner took his usual topographical liberties in this unusually beautiful watercolour, for in reality Prudhoe Castle is much lower, standing on the small hill by the Tyne that we see here below the castle. But the watercolour was based upon sketches that Turner had made in 1817 shortly after returning from a tour of the Rhineland, and that perhaps explains why he raised the castle to Rhenish heights.[120] The image also owes something to the influence of Claude Lorrain, with the trees on the right greatly intensifying the effect of brilliant light in the distance by means of their huge tonal contrast. The composition is subtly structured by three overlapping triangles, one of which forms the road on the right while the others divide the river 'into two channels, the right-hand one being that which it usually takes, but the left [being] also filled in a flood'.[121] As Prudhoe is ten miles from Newcastle, Turner also placed an 'X' on a milestone in the bottom left-hand corner.

In his book on Turner's engravings, W. G. Rawlinson relates being told by the Rev. William Kingsley that this watercolour was made from memory, and that it was later damaged in the centre of the sun's reflection on the water. When Turner saw this, 'he said: "I won't have that tampered with". He moistened his finger with saliva, rubbed the colour off, and then touched it in again. It is now impossible to see the repair'.[122] At the same time the painter also signed the work.

c. 1825, signed but not dated
British Museum, London

29.2 × 40.8 cm (11½ × 16 in)

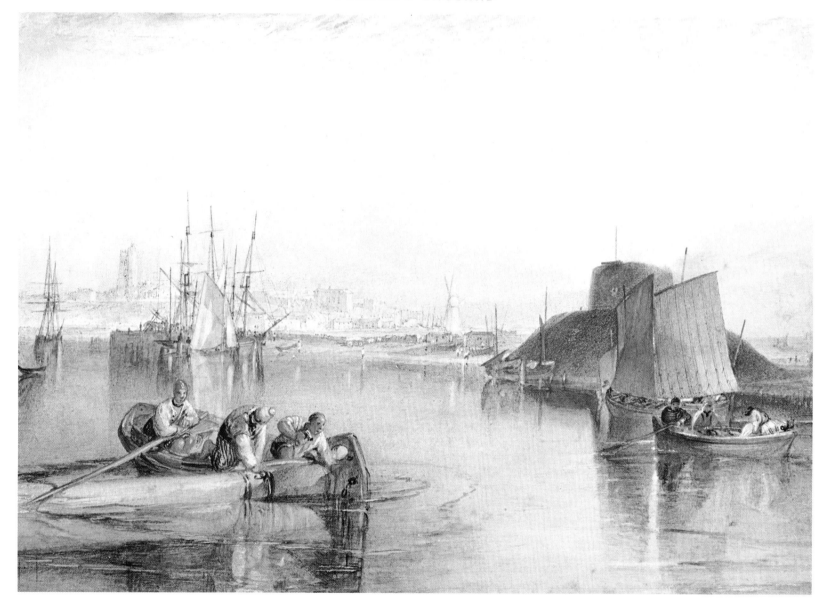

ENGLAND AND WALES

144 ALDBOROUGH, SUFFOLK

In the distance on the right is the sea, and the summer sun rises behind the Martello tower at Slaughden with a brilliance that is enhanced by the rubbing out of tone on the edge of the building. Because of photography we are today all familiar with the way that bright light can eradicate contours, but Turner was one of the few artists in the pre-photographic age to record such an effect, probably becoming aware of it through his study of optics for his perspective lectures. His memory for even the most minute details is equally to be seen in the shadow of the tower falling across the sail of the boat passing in front of it; such a detail is not present in the sketches upon which the work was based.[123]

The composition is structured by two shallow diagonals, one running up the oar at the left and the other up the far bank of the river Alde. By the mid-1820s Aldeburgh was already becoming a fashionable holiday resort, and the letterpress by H. E. Lloyd which accompanied the engraving of this design tells us that because of the influx of 'persons of rank and fortune . . . the morals of the lower classes are much improved'.

c. 1826
Tate Gallery, London

28×40 cm $(11 \times 15\frac{3}{4}$ in$)$

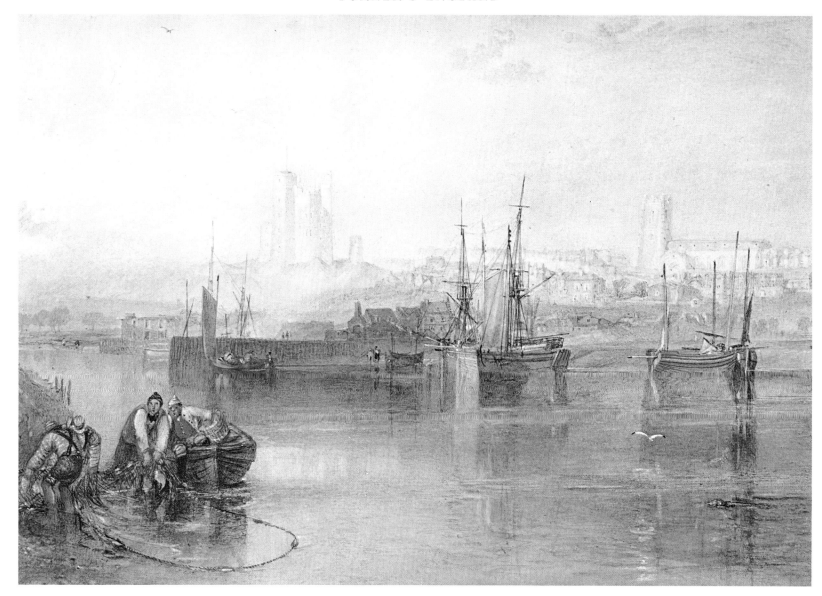

ENGLAND AND WALES
145 ORFORD

This forms the companion to *Aldborough* (which it follows in the order of publication as engravings) and it is also a dawn scene. Moreover, just as the *Aldborough* is dominated by a yellow palette, so this drawing is principally blue in colour, and such opposition serves visually to balance and link the two works as well.

Turner took his usual liberties with topography here by raising the height of the castle, and both castle and church look particularly delicate in the early light. On the left some characterful crab-fishermen are pulling in their net, while on the right is a

crab which has escaped their attentions. This crustacean initiates an extremely subtle diagonal that runs up through the nearby seagull, the diagonal yard-arm of one of the central group of boats, the top of the castle, a bird flying above it and a further bird near the top-left edge of the image, thus adding unity to the design.

c. 1826
Private Collection, U.K.

28 × 40.3 cm (11 × 15⅞ in)

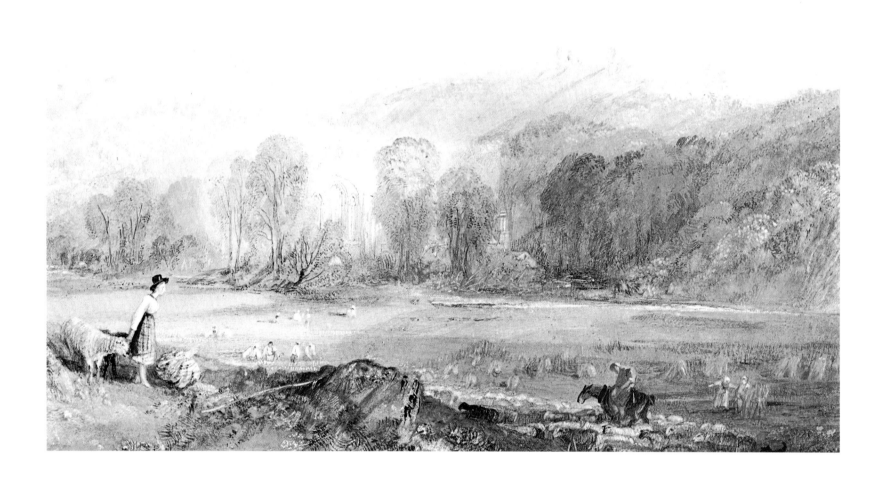

ENGLAND AND WALES

146 VALLE CRUCIS ABBEY, WALES

Valle Crucis Abbey was a Cistercian foundation dating from 1201, and Turner first visited the ruin in 1798 on his fourth tour of Wales, as well as in 1808 when he made the sketch upon which this watercolour was based.[124] He was clever in depicting the abbey from this angle, for the design also therefore includes Castell Dinas Brân, the castle whose ruins are evident atop the distant conical hill to the right of centre.

Despite recent assertions that this is an evening scene,[125] we are in fact looking north-eastwards and the timing is thus early morning, with long shadows being cast across the foothills of Eglwyseg mountain and harvesters busy at work before the day becomes too hot. On the left a Welsh shepherdess is returning two strays to the fold, a touch that speaks not only of pastoral innocence but also perhaps of religious symbolism, given that we are looking at a religious building. The abbey is isolated within a rectangular area of lighter tone, and this shape both helps the ruin to stand out and adds to the cohesion and dynamism of the design. Also worthy of note is the scraping out of the fleece at the lower right, and of the corn beyond the shepherdess; on the 1808 sketch Turner had denoted the presence of this corn not by drawing it but by simply scribbling the word 'corn'.

c. 1826
City Art Gallery, Manchester, U.K.

28.5×41 cm ($11\frac{1}{4} \times 16\frac{1}{8}$ in)

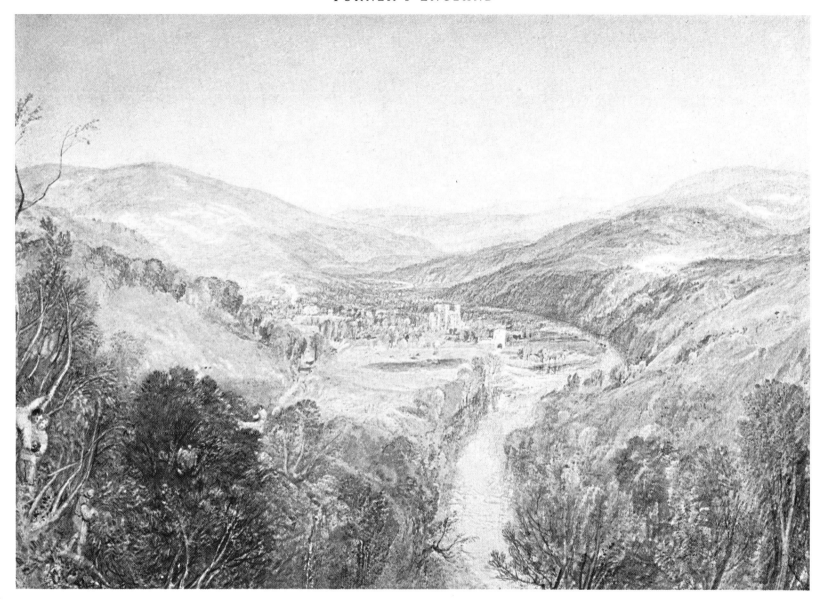

147 BUCKFASTLEIGH ABBEY

Buckfast Abbey, situated in the Devonshire village of Buckfastleigh, was a Cistercian house founded in the tenth century on the site of an earlier Saxon abbey and by 1137 it was the most prosperous monastery in the West Country; it fell into ruin after it was dissolved in 1539. In 1796 a Gothic-style turreted and castellated mansion was built on the site, and it was restored to religious use between 1907 and 1938. Turner probably visited the house in 1814, on a third West Country tour we unfortunately know little about.[126]

We view the abbey from the south in early morning light and with the river Dart leading the eye to the lower reaches of Dartmoor, where the last of the dawn mists can still be seen wafting across the hills. In the foreground three boys are birdnesting, and they add both a touch of activity to the otherwise peaceful scene and some reinforcement to the necessary vertical on the left.

c. 1826
Private Collection, U.K.

27.4 × 39.4 cm (10¾ × 15½ in)

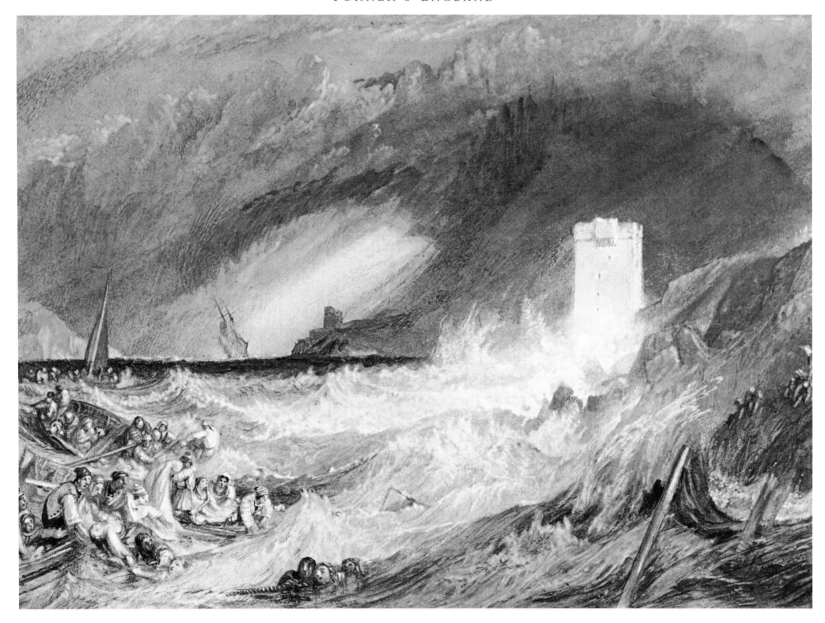

148 FOWEY HARBOUR

This work is very similar to the view of Fowey harbour made for the 'Southern Coast' series (235) about ten years earlier, and that similarity is not surprising, for both images were based on the same sketch made on the 1811 West Country tour.[127] However, whereas in the 'Southern Coast' design a storm is approaching from the south-east, here it is passing away to the west and leaving in its wake shipwrecked and drowning people, with others attempting to save them. As usual, Turner's figures look rather doltish or childlike, but that crudity and simplicity of character serves to underline the intense vulnerability of mankind when faced with the ferocity of nature.

The work enjoys an immense tonal range, with the yellow of St Catherine's Fort and the adjacent whites of the spray standing out brilliantly from the surrounding gloom.

c. 1827
Private Collection, U.K.

28.2 × 39.1 cm (11 × 15⅜ in)

149 OKEHAMPTON CASTLE

Here we look south-westwards towards Okehampton Castle, whereas in the lower view of the building in 'The Rivers of England' series (83) it is perceived from the opposite direction. In the distance may be seen the river Okement. Ruskin wrote of this passage that 'The winding valley in the left-hand distance, painted with little more than a single wash and scratch of light through it, may be taken for an example of the painter's loveliest work at speed'.[128]

The destroyed castle is complemented by further destruction, as a hunter kills one rabbit and then aims at another, the smoke from his first shot still being apparent. The destructive mood is also sustained by the dead or shattered timber lying beyond the rabbits. Numerous stipplings in the trees under the castle add to the rhythmic vivacity of the design whose colour range is equally enhanced by the lovely touch of bluish mist swirling through those trees. The shape of the gap in the castle wall is repeated by the shape of the hunter's hat far beneath it, as well as by a gap in the line of trees before it.

c. 1826

28 × 40.6 cm (11 × 16 in)

National Gallery of Victoria, Melbourne, Australia

ENGLAND AND WALES
150 LANCASTER SANDS

Judging by the storminess apparent in the drawing of *Lancaster Sands* made for the 'Richmondshire' series (73), there seems little likelihood that Turner saw Morecambe Bay looking like this when he crossed it in 1816. Again the brobs can be seen stretching away into the distance, while the sun sets beyond Lakeland mountains whose configuration Turner took from the 1816 sketch upon which he also based the drawing of *Heysham* (71). But although this is one of the painter's most beautiful landscapes, ironically its occupants enjoy no time to turn and view the loveliness beyond them, for they are in mortal danger: the tide is coming in, and in the far distance a man on a horse-drawn cart is already being overtaken by the sea.

On the left a dog barks at a screaming seagull (the mouth of one of the dogs and the beak of the gull are clearly open), and this confrontation between sea-creature and land-creature epitomizes the larger confrontation between sea and humanity that is taking place elsewhere. The two underlying diagonals that structure the composition meet on the right, thus pointing the way, and at their juncture a horse looks particularly exhausted. The sense of momentum in both coaches and people is reinforced by the series of ellipses and curves which run through them, projecting respectively the rolling of the coaches or the leaning, strained movement of the figures as they struggle towards the shore.

c. 1826
British Museum, London

27.8 × 40.4 cm (10⅞ × 15⅞ in)

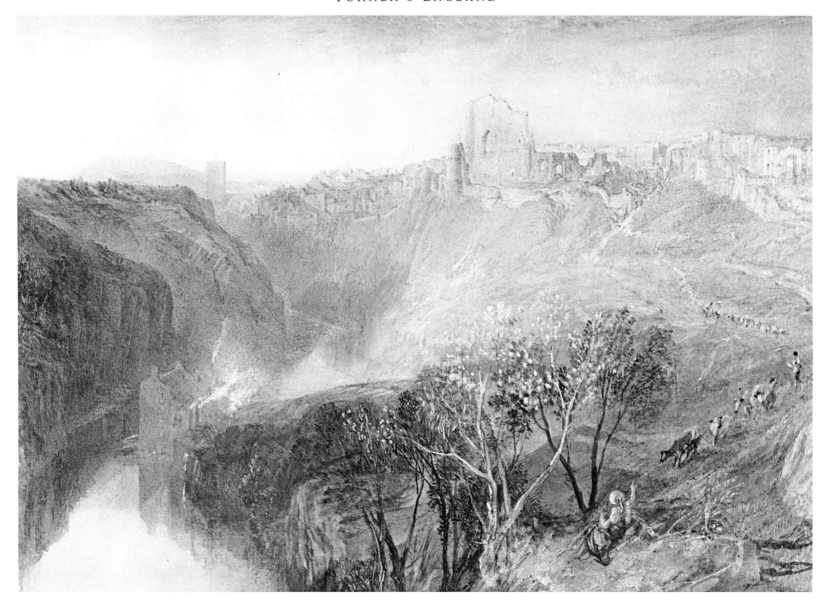

ENGLAND AND WALES
151 KNARESBOROUGH, YORKSHIRE

Knaresborough Castle was built by John of Gaunt in the late fourteenth century and it was partially destroyed by Parliamentarians during the Civil War. Turner based this watercolour on a sketch he probably made[129] while staying nearby at Farnley Hall in 1816, and he certainly seems to have been alert to the layout of the castle.

An unusual feature of Knaresborough Castle was its rectangular keep, and we view the ruin from opposite its south-east corner, from where the keep is perceived as a very shallow parallelogram. Turner took his dramatic and compositional cue from that shape, for in the empty space in front of the castle he amplified it into a large parallelogram formed by the diagonal lines that run up to the right, from the girl to the waving herdsman and thence across to a point below the castle, and up to the left, along the riverbank to the mill and then over to the same point under the castle. The

branches of a sapling in the foreground serve to emphasize the nearby divergence, while the shape of the parallelogram is subtly reinforced by numerous parallel diagonals elsewhere, most notably those to be seen on the far banks of the Nidd on the left, and a pathway running up to the town on the right.

The colouring is especially beautiful, with the warmth of the mid-afternoon light being captured in a range of subtle pinks, yellows, greens and blues. As in *Richmond Castle and Town* in this series (140), the warmth of colours playing across a town is heightened by a contrasted cool haze upon a nearby river.

c. 1825

Private Collection, U.K.

28.9 × 41.3 cm (11⅜ × 16¼ in)

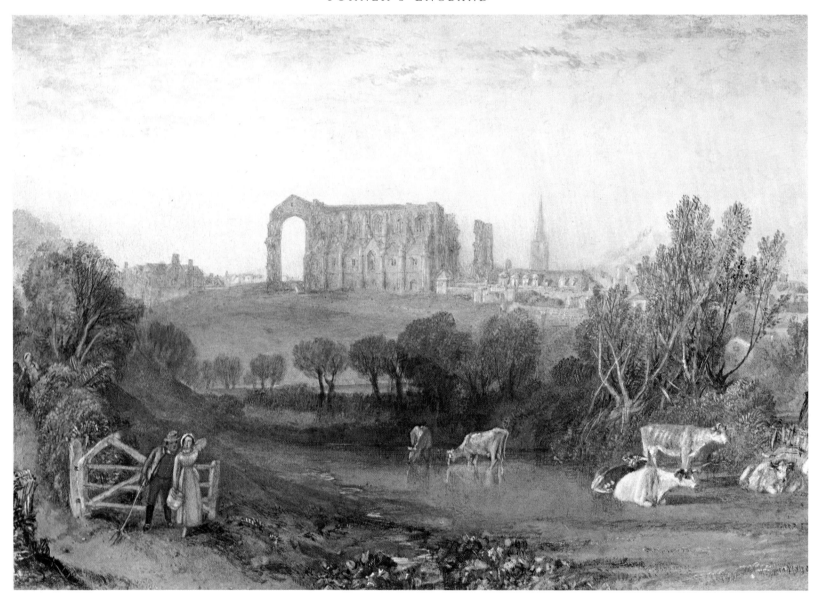

ENGLAND AND WALES
152 MALMSBURY ABBEY

Turner knew Malmesbury Abbey from the Boswell *Antiquities* and he actually visited the ruin on his first-ever sketching tour, made in 1791 when he was just sixteen. He returned there in 1792 and 1798, and as a result of those three visits he created at least 32 studies, preliminary drawings and finished watercolours of the building, as well as several more watercolours after 1798, of which this is the last.

We view the abbey from the north at dawn on a lovely summer's day, with the east arch standing out dramatically from the rest of the building and subtle blue shadows falling across its nave. In colour these shadows prefigure the types of shadowings painted later by Monet, and they certainly disprove the French painter's contention that Turner never analyzed shadows. The softer blues of morning mist in front of the abbey add to the coolness of the lower half of the scene which is still in shadow, thus equally strengthening the warmth of the colouring above by contrast. The curve of the east arch is also subtly reversed by the more shallow counter-curve of the line of tree-tops running right across the composition.

In the foreground a swain whispers sweet nothings to a milkmaid, while some children spy on them nearby. W. G. Rawlinson commented that 'Doubtless Turner had witnessed the scene',[130] although there is nothing to suppose that he necessarily did so at Malmesbury.

c. 1827
Private Collection, U.K.

28.9 × 41.6 cm (11⅜ × 16⅜ in)

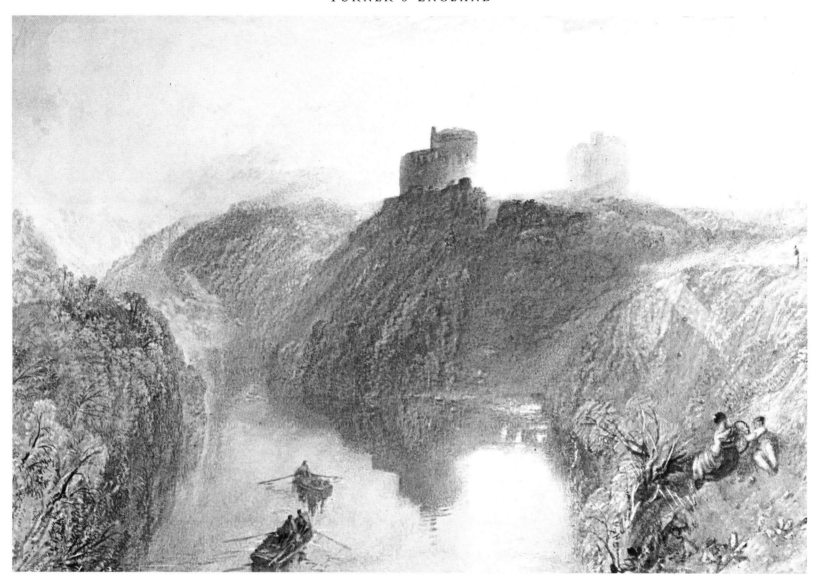

153 KILGARREN CASTLE

Turner sketched Cilgerran Castle, near Cardigan in Pembrokeshire, in 1798 on his fourth tour of Wales, and subsequently he produced three oil paintings of the building, one of which depicts it from the same viewpoint as this watercolour.[131] Those paintings all show the influence of Richard Wilson and are rather limited in tonal range, whereas here we see one of Turner's most vivid dawn scenes, with the brilliance of the sunlight eradicating the contour of the castle's nearer tower. On the river Teifi, the bathing naiads of the early oil have been replaced by more mundane but more convincing fishermen, while on the right a mother and child play with a hoop, their happiness perhaps epitomizing the painter's own happiness at the beauty of the scene. Compositionally these figures also help to offset the symmetry of the design, which is principally structured by the lines of the riverbanks to right and left.

c. 1828
Private Collection, U.K.

27.9 × 40 cm (11 × 15¾ in)

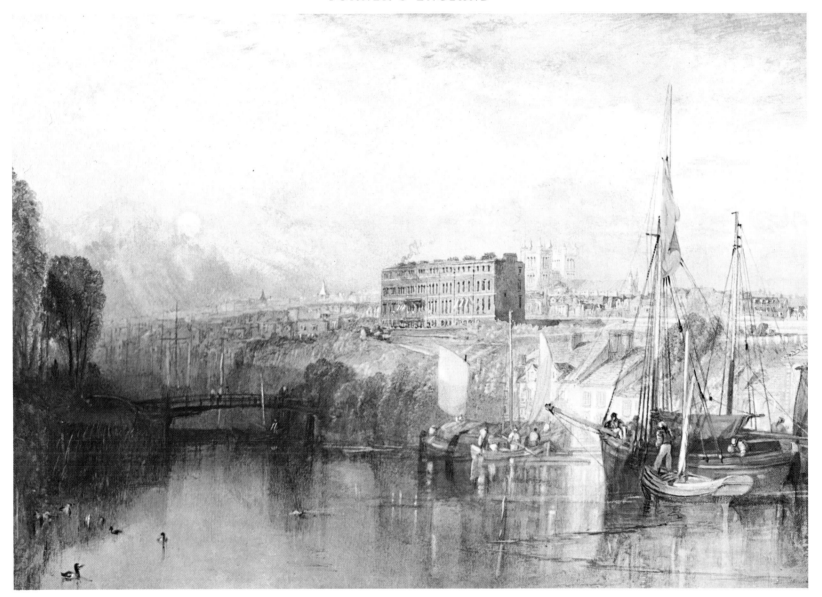

ENGLAND AND WALES
154 EXETER

Turner always had an eye for the unusual, as we have witnessed, and he must have been taken with the repetitive verticals of the towers of Exeter Cathedral and the house windows in Colleton Crescent, as well as by the partial obscuring of the cathedral by the houses. Indeed, he may even have used this masking to comment upon the diminishing importance of ecclesiastical architecture in the modern world, a decline that is matched by the decline in the day as the sun sets beyond the river Exe.

There is no known sketch of this scene in the Turner Bequest. Perhaps the artist worked up the design entirely from memory, which would explain why the perspective of the riverbank on the right is rather unconvincing, with the line of houses beyond the boats appearing to sink into the river. But the reflections on the Exe are handled with Turner's usual mastery, while the colour is rich without seeming too heavy. An occasional mixture of gum with the watercolour can be witnessed throughout the lower half of the drawing.

c. 1827
City Art Gallery, Manchester, U.K.

30 × 42.8 cm (11$\frac{7}{8}$ × 16$\frac{7}{8}$ in)

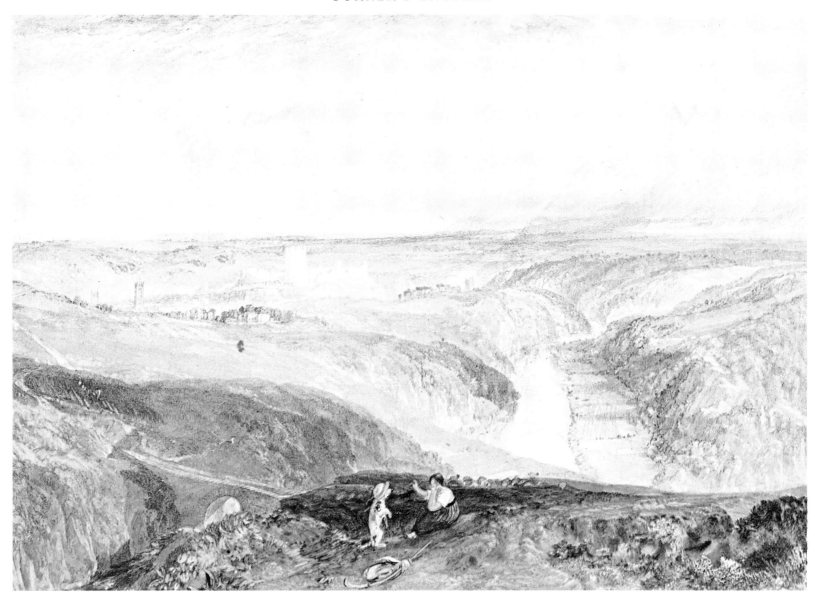

155 RICHMOND, YORKSHIRE

This is one of the widest panoramas Turner ever depicted. From above Whitecliffe Mills we look south-eastwards down Swaledale and over the central Yorkshire plain, with the Hambledon Hills evident in the far distance on the extreme left. Yet again we see a 'Sweet Lass of Richmond Hill' but here she is a shepherdess, whereas in the other 'England and Wales' series view of the town the lass is a cowgirl (140). The begging dog wearing the girl's bonnet contributes an important vertical accent to the predominantly horizontal scene, and that stress subtly reinforces the castle tower in the distance. The composition is further unified by an underlying wash that crosses diagonally from the distant line of rain to the shadow passing through the bridge at the lower left, as well as by the division of the design into three broad bands of colour, namely reddish-brown in the foreground, green in the centre and blue in the sky.

c. 1828

28 × 40 cm (11 × 15¾ in)

Fitzwilliam Museum, Cambridge, U.K.

156 SALISBURY, FROM OLD SARUM INTRENCHMENT

In the distance a vast thunderstorm passes over Salisbury, while in the foreground a shepherd guards his flock and protects some children from the rain with his cloak. Turner was well aware of the traditional Christian symbolism of shepherds and flocks, and here he enforced the parallel between Church and shepherd by making the shepherd stand over his flock, just as the cathedral stands over the town.

Turner heightened the dominance of the cathedral by making the surrounding houses much smaller than they were in reality.[132] There is a vernal quality to the scene, especially beyond the head of the shepherd where the trees display the particular lightness of springtime foliage. Ruskin praised this watercolour for its depiction of rain-clouds, saying that they 'are wrought with a care I have never seen equalled in any other sky of the same kind. It is the rain of blessing – abundant but full of brightness; golden gleams are flying over the wet grass, and fall softly on the lines of willows in the valley'.[133]

c. 1828 27.2 × 39.5 cm (10¾ × 15½ in)
The Salisbury and South Wiltshire Museum, U.K.

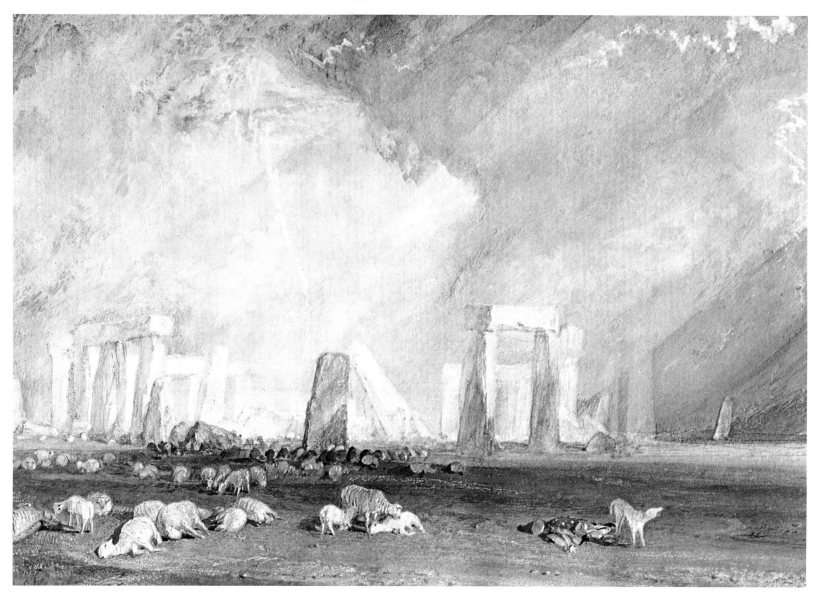

ENGLAND AND WALES
157 STONEHENGE

Salisbury Cathedral is not the only religious edifice on Salisbury Plain. Here the remains of a dead religion are matched by a dead shepherd who has just been struck down by lightning. His dog howls over his corpse while a ewe nuzzles her dead lamb and more lightning strikes in the distance. We can even gauge the path of the fatal bolt from the line of dead sheep to the left. The unadulterated ultramarine blue of the shepherd's jacket chillingly reminds us of the intense voltage of the discharge.

Ruskin called *Stonehenge* '... the standard of storm drawing, both for the overwhelming power and gigantic proportions and spaces of its cloud forms, and for the tremendous qualities of lurid and sulphurous colours which are gained in them.'[134] Unfortunately the 'gigantic gloom' that Ruskin also wrote about has greatly lessened

in the sky due to fading caused by the use of indigo, although the violent angles and 'strange, swift, fearful outlines' he equally mentioned are still very much in evidence.

The engravings of *Salisbury* and *Stonehenge* were published in different parts of the 'England and Wales' scheme (the *Salisbury* at a later date[135]) but the complementary nature of their imagery is so marked that it is difficult to believe that the two watercolours were not conceived as a pair, and they have been reunited here accordingly.

c. 1827
Private Collection, U.K.

27.9 × 40.4 cm (11 × 15⅞ in)

ENGLAND AND WALES
158 YARMOUTH

From foreground to background we see a washerwoman; Yarmouth Sands, with the naval hospital and St Nicholas's Church in the distance to the left and the Nelson Monument in the centre; the Yarmouth-based North Sea fleet lying at anchor in Yarmouth Roads; and finally, a mass of approaching storm clouds.

As in the drawing of *Falmouth* made a couple of years earlier for the 'Ports of England' series (113), a washerwoman and a change in the weather may embody an associative meaning. The washerwoman here has obviously laid out her washing and fish to dry in the sun but, unfortunately, because of a sudden fierce gust of wind, her bonnet, basket and items of wet clothing are now being blown away. In the context of a design whose focal point is a military monument, this immediate change from a state

of calm to one of coming storm suggests a larger change from a state of peace to a state of war, with the Nelson Monument and adjacent fleet perhaps hinting at naval readiness to protect England from threat.

Such an interpretation receives support from the watercolour discussed opposite. At the lower right the wind is clearly whipping up the waves off Gorleston Pier, while at the lower left are some herrings, a reminder of Yarmouth's principal peacetime industry. The overall colouring is very cool, as befits the freshening breeze.

c. 1827 27.9 × 39.4 cm (11 × 15½ in)

Private Collection, U.K.

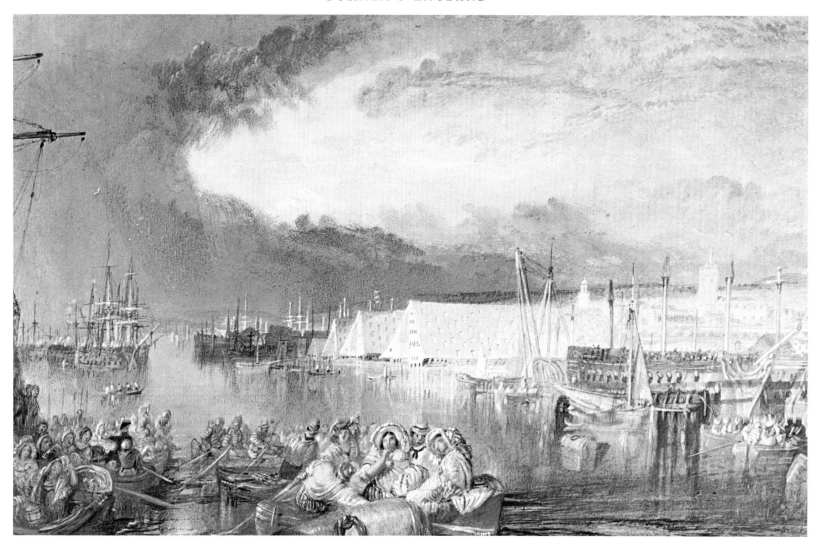

159 DOCK YARD, DEVONPORT, SHIPS BEING PAID OFF

In this work we do not need to speculate as to Turner's use of metaphorical weather effects, for the title makes his covert meaning very clear. Naval crews were paid off at the end of a war, and the sky tells us indirectly that a conflict has just passed, for in the distance dark storm-clouds are passing away to reveal a golden, peaceful sky beyond. Naturally, this associative elaboration of the coming of peace aids the reading of *Yarmouth* as a statement about the coming of war, and the complementary nature of the two works suggests that they were created as pendants, which is why they have been reunited here.

To the right are two hulks, commonly used as barracks, storeships or hospitals; behind them the 'sheers' or crane of a hulk used for masting shipping; next, Devonport parish church; and finally, some of the gambrel-roofed, dry-dock sheds in which men-of-war were built (the apertures through which the battleships were launched can be seen at the ends of the sheds).

Ruskin owned this drawing and praised it for the characterfulness of its figures, the drawing of the men-of-war, and for 'the breaking up of the warm rain-clouds of summer, thunder passing away in the west, the golden light and melting blue mingled with yet falling rain, which troubles the water surface, making it misty altogether, in the shade to the left, but gradually leaving the reflection clearer under the warm opening light.'[136]

c. 1828

28.7 × 43.9 cm (11¼ × 17¼ in)

Fogg Art Museum, University of Harvard, U.S.A.

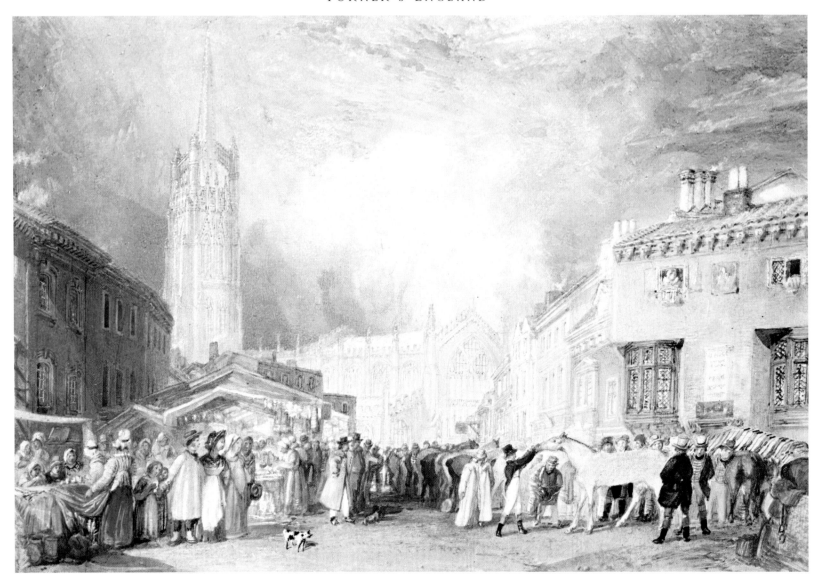

ENGLAND AND WALES

160 LOUTH, LINCOLNSHIRE

There was great agricultural unrest in Britain during the 1820s, and much of it was directed at the Church of England because of its imposition of tithes upon farmers, who were forced to keep down wages so that they could afford to pay them. Naturally that resentment was often coupled with the demand for parliamentary representation, for it was hoped that Reform would lead to the abolition of tithes. Turner may have been addressing both of these related issues here.

The foreground staffage is carefully separated across Upgate into social groups that are distinctly identifiable by their dress: on the left, in front of the market-stalls, is a group of agricultural labourers wearing smocks; in the centre are coachmen, distinguishable by their long coats; and on the right are horse-dealers, farmers and country gentlemen. The social divide between the labourers and their employers is amplified by the empty foreground. The physical separation of the labourers and their expectant looks respectively express their disenfranchized state and hopes for political representation. Similarly, the storm clouds beyond St James's Church could equally epitomize the threat that Reform posed to the Church of England.

The composition is structured by the shallow X-shape of the lines of the street and the skylines on either side of Upgate. The fall of midday light on the left is particularly well observed, and for once Turner's horses are almost the correct size.

c. 1828
British Museum, London

28.5×42 cm ($11\frac{1}{4} \times 16\frac{1}{2}$ in)

161 DUNSTANBOROUGH CASTLE, NORTHUMBERLAND

Dunstanburgh Castle is one of the most impressive and romantic ruins in the north-east of England. Turner initially encountered the building in Boswell's *Antiquities*, and he visited the site on his first northern tour in 1797. From the sketches he made there he developed three oil paintings, another watercolour and a mezzotint print in the 'Liber Studiorum'.

Here the ruin is viewed at dawn beyond a scene of more recent human ruination, with a Treasury 'Riding Officer' supervising the unloading of cargo from a severely damaged coaster. The sea still displays something of the turbulence of the preceding night, although the sky is much more still. The deep blues and rich blacks of the sea offset the tonal delicacy elsewhere, and Turner's virtuosity in rendering architectural details may be witnessed in the economical way he drew the castle gateway, a single tonal wash giving us both architecture and shadow.

c. 1828
City Art Gallery, Manchester, U.K.

29.1 × 41.9 cm (11⅜ × 16½ in)

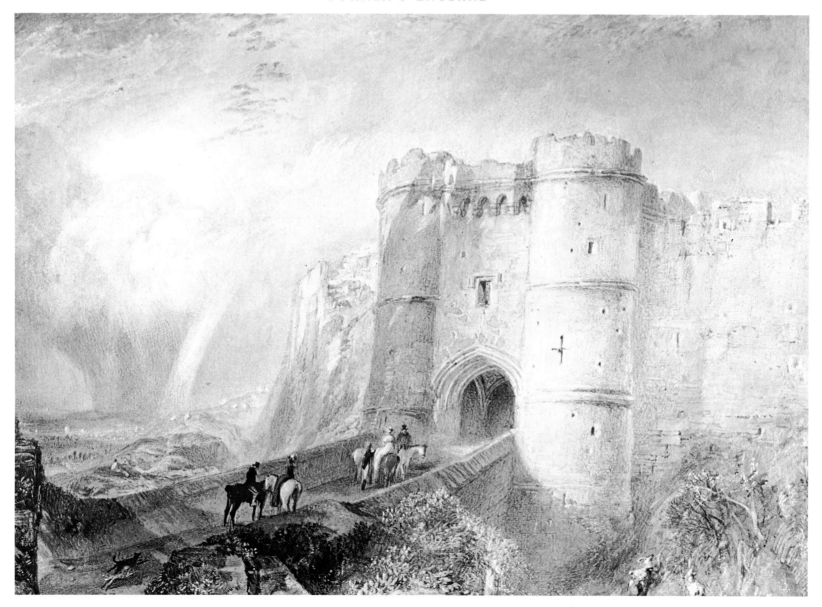

ENGLAND AND WALES
162 CARISBROOK CASTLE, ISLE OF WIGHT

This is another castle that Turner knew from Boswell's *Antiquities*, and he first visited the building in 1795 when he made a large study from which he developed this watercolour over a third of a century later.[137] Now, however, he has moved the viewpoint over to the opposite side of the gateway and reconstructed the landscape on the left from memory.

The dogs running into the scene at the lower left inform us that the elegantly attired riders have only recently arrived at the castle, probably intending to shelter there from the approaching storm. They may not have to worry, however, for in the distance on the left is a man sitting on the grass, a detail which indicates that the ground is still dry.

The rumps of two of the horses echo the rotundity of the gate-towers, as does the roundness of the subtle pink storm cloud off to the left. Moreover, a sequence of curves and counter-curves is distributed through the castle doorway, the rainbow, the line of rain, the cloud formations and the rumps of the horses. The rainbow is not very prismatic in colour, but that was surely intentional, for its muted colour does not lessen the impact of the deep golds and purples inside the castle doorway, which Turner obviously wanted to make as inviting as possible.

c. 1828
Private Collection, U.K.

29.2 × 41.2 cm (11½ × 16¼ in)

192

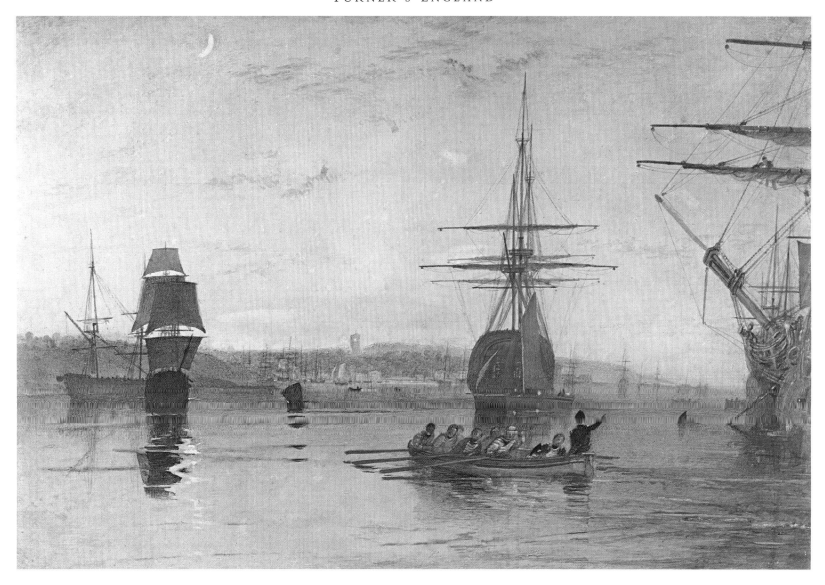

163 WEST COWES, ISLE OF WIGHT

Turner visited Cowes in July and August 1827, when he stayed with the architect John Nash at his home, East Cowes Castle. Nash had commissioned Turner to paint views of the castle, and the two resulting oil paintings were exhibited at the Royal Academy in 1828. Turner made many oil sketches for those paintings and the present drawing obviously grew out of that visit (as did perhaps the *Carisbrook Castle* discussed opposite). But this design is alone in depicting West Cowes, seen in the distance across the estuary of the river Medina, with the west tower of St Mary's Church (built by Nash in 1816) acting as the subtle focal point of the image.

During the 1820s Cowes Roads still served Portsmouth as an anchorage, and here

we see them filled with both civilian and military shipping. It is difficult to know whether we are looking at a dawn or an evening scene, however, for there are not enough clues to inform us of either. The Roads are absolutely still and windless, as the amount of sail hoisted by the vessel on the left indicates, and the intermingled reflections of that ship and the moon are quite masterly.

c. 1828
Private Collection, U.K.

28.6 × 41.9 cm (11¼ × 16½ in)

ENGLAND AND WALES
164 STAMFORD

Stamford, Lincolnshire, is situated almost exactly halfway between London and York, and it was thus the natural place to break the journey between the two towns, consequently having numerous coaching inns. They were very necessary, for by 1830 some thirty stagecoaches and forty mail coaches passed through Stamford every day on the Great North Road. Turner therefore depicted one of the town's principal industries.

The colouring is warm, the atmosphere very wet and clammy; one can readily appreciate the discomfort of stagecoach travel in such weather. On the left, passengers disembark from a coach, with a traveller dropping her suitcase onto a growing pile of luggage and the driver soliciting tips, while a child stands all hunched up next to the coachman. To the right a gaitered cleric makes his way towards the Bull and Swan inn. Two dogs gambol before the clergyman and bark at him just as lightning strikes at the Perpendicular tower of St Martin's Church beyond, one of Turner's wittier parallels. The cleric is aided by a servant from the inn who is wearing a smock which denotes his rustic origins; to the right of them a milkmaid looks on, her load perhaps equally intended to typify the rural but homely comforts of the town. Another stagecoach rushes up the hill in the distance.

c. 1828 29.3 × 42 cm (11½ × 16½ in)
Usher Art Gallery, Lincoln, U.K.

165 ALNWICK CASTLE, NORTHUMBERLAND

In the late eighteenth century the Norman castle at Alnwick was extensively remodelled by Robert Adam in the fashionable neo-Gothic style. We view it from the west, across the Lion Bridge over the river Aln. Turner visited the castle in 1797 when he made the sketch upon which this work was based,[138] and he is reputed to have said that the present watercolour 'was one of the most troublesome works he had ever done'.[139] However, there is certainly no visual evidence of those difficulties, with the rays of moonlight painted with extreme confidence and the multitude of lights and highlights all giving the scene a vivacious sparkle. The pronged shapes made by the paired statues on the castle turrets are reiterated and amplified by the antlers below the bridge, Turner being as alert as ever to the similarities of things. On the Lion Bridge itself we can just see the head and outstretched tail of one of the statues of lions from which the bridge derives its name, those animals being the symbols of the Percy family, the Dukes of Northumberland, who continue to live in Alnwick Castle to this day.

c. 1828

28.3 × 48.3 cm (11⅛ × 19 in)

National Gallery of South Australia, Adelaide

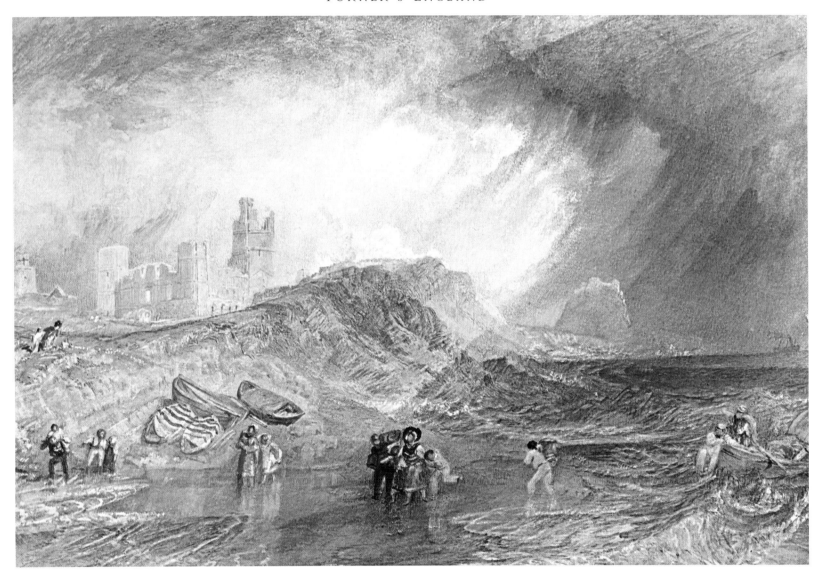

166 HOLY ISLAND CATHEDRAL

Holy Island is named after the monastery founded there in the seventh century; the cathedral dated from the eleventh century and was destroyed during the Reformation. The ruined cathedral is visible next to the lighthouse on the left, while to the right is Lindisfarne Castle which was ruined in the Civil War and rebuilt only in the present century. A passing steamer is also apparent in the far distance on the extreme right.

A massive storm passes away to the south, leaving the cathedral ruins looking bleached and cool in the clear sunlight. The sands between Holy Island and the mainland are fordable at low tide (today there is also a causeway) and in the foreground waves wash up on either side of a spit of sand which may allude to that linkage. On the right, relief supplies are being unloaded from a small boat, probably because the recent storm has prevented the island from being supplied directly from the mainland.

c. 1828

29.2 × 43.2 cm (11½ × 17 in)

Victoria and Albert Museum, London

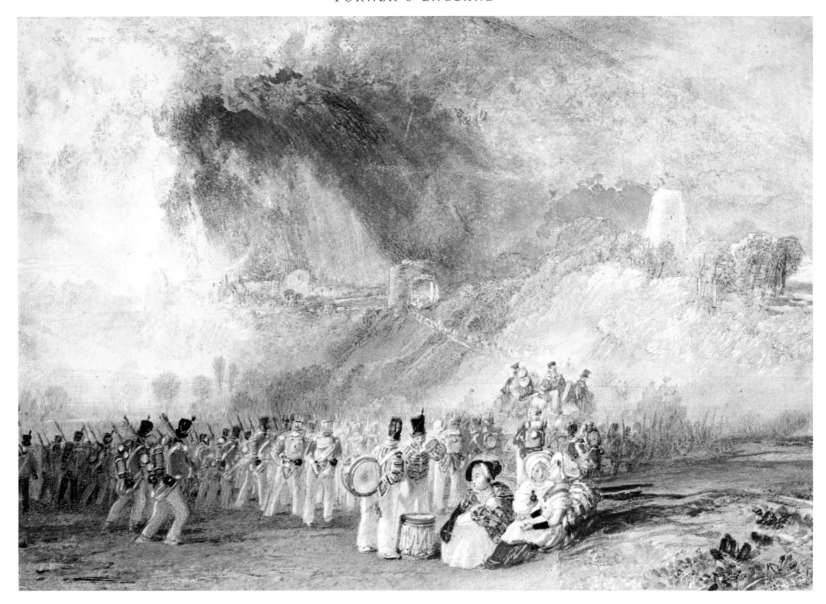

167 *WINCHELSEA, SUSSEX*

As we have seen, Turner had earlier represented this view of the East Gate at Winchelsea somewhat more distantly (11). In that panorama the town is complemented with just a few straggling troops and some rather mild if unsettled weather conditions. Here, however, we are moved closer to Winchelsea and provided with a large army on the march, ahead of which breaks a furious storm, surely to parallel human conflict.

Turner was at his most painterly in this work, using watercolour as freely as oils to create an expressive dynamism that fully projects the sense of conflict. The colouring and tonality are equally forceful, with glaring oppositions of green and red reinforced by polarized whites and blacks. No less hectic is the pace of the figures, so much so that three women are having to take a break whilst their men revive them with some rum.

c. 1828
British Museum, London

29.3 × 42.5 cm (11½ × 16¾ in)

168 STONEYHURST COLLEGE, LANCASHIRE

Initially this drawing poses a moral conundrum: on the left are some boys gesticulating with anger at the theft of their boat by the boys on the right, there being nothing they can do to prevent the seizure. But why is the only adult in the foreground turning around on his horse and signalling to the angry boys to keep quiet, instead of preventing the theft?

To answer that question we need to see the watercolour within its historical context and to remember that Stonyhurst College is a Roman Catholic public school founded in 1794.

By the late 1820s moves for Catholic emancipation in Britain had reached their final phase. At that time no Catholic could sit in Parliament nor hold high office in the military and judiciary. Although several attempts to alter the legislation had been made in the previous half-century, these had completely failed, and despite the repeal of the Test and Corporation Acts in 1828, King George IV was particularly opposed to

any degree of political and religious toleration for Catholics, as was his Home Secretary in the Duke of Wellington's administration, Sir Robert Peel. But in 1828 the issue was forced to a crisis by the election to Parliament of Daniel O'Connell, a Catholic returned by County Clare in Ireland. He was not allowed to take his seat and, faced with the very real possibility of revolution breaking out in Ireland over the issue, Peel was forced to change his mind. After intense lobbying by Wellington and Peel, George IV reluctantly followed him in that decision, and to widespread surprise and the profound anger of hardline Protestants, the King publicly performed a complete *volte-face* by informing Parliament on 5 February 1829 that the legislation must now be changed to permit Catholic emancipation after all. Despite further opposition, the bill to give almost complete political equality to Roman Catholics was finally passed on 13 April 1829, an event that was to be of decisive importance in the passing of the Reform Act three years later.

20 *J.M.W. Turner,* STONYHURST, *c.1800, watercolour, 21 × 35 cm (8¼ × 13¾ in), Private collection, U.S.A.*

The *volte-face* of George IV in 1829 clearly explains Turner's apparent moral anomaly: as the only adult in the foreground, the man on the horse equally indicates the superiority of the monarch to his subjects, and by his turn in the saddle he signifies the reversal of attitude by the King. The passage of the Emancipation Act also explains the significance of the disputed toy: the boat, which has sailed across the Infirmary Pond, symbolizes Catholic emancipation being grabbed by those who want it, and anger is being expressed by those who did not wish to lose their boat (or permit such emancipation), an anger that is being quieted by the horseman/king.

Other details throughout the design also support this interpretation. The horseman is leading another horse: the animals may represent the two Houses of Parliament where the conversion of George IV had had such a crucial influence. The past progress of the boat across the water is suggested by a stately line of ducks who proceed across the pond from left to right, also reaching dry land, while some boys running off to the right further enhance the sense of movement. Immediately above the boys stealing the boat (and/or taking their emancipation) is a procession of Stonyhurst monks and academics whose proximity furthers the association of the boys with Catholicism.

And, most tellingly of all, Turner has surmounted the twin cupolas of the gatehouse of 1592–93 with shining crosses. In reality, the twin towers of Stonyhurst College are surmounted by bronze eagles, as Turner well knew, for he had represented those birds both in the sketch made in 1797 upon which he based this drawing, and in a watercolour that he made of the building in 1800 (ill. 20), a work that was subsequently engraved and the engraving of which was dedicated to Thomas Weld, the Roman Catholic founder of Stonyhurst College .[140] Obviously the shining crosses symbolize the new equality between the two major branches of Christianity, while the washing being laid out to dry in the sun on the far side of the pond perhaps signifies the fact that Christianity had been somewhat cleansed by this event. Moreover, nature completes the allegory, for brilliant sunshine and a rainbow replace the dark storm-clouds also moving off to the right. All the details combine to create a triumphant celebration of the advent of a greater religious freedom and tolerance in British society.

April–May 1829
Private Collection, U.K.

28 × 41.9 cm (11 × 16½ in)

ENGLAND AND WALES
169 TREMATON CASTLE, CORNWALL

This drawing was last sold publicly on 13 May 1857 at Foster's Auction Rooms, London, and thereafter it disappeared completely from public view until it was lent to an exhibition at Falmouth Art Gallery in 1989. It is here reproduced photographically for the first time ever. In the catalogue of the 1829 Egyptian Hall, Piccadilly exhibition, the title of the watercolour was clearly misprinted as 'Tamerton Castle', so here the title given in the catalogue of the 1833 exhibition is employed above instead.

Trematon Castle is located about a mile south of Saltash in Cornwall and it dates from the late twelfth century; Turner almost certainly visited it in 1813 while staying nearby in Plymouth. We look south-westwards at dawn towards the estuary of the St

Germans river, and the scene is utterly calm, with only the distant drover and pack-mules affording any animation whatsoever. In the foreground the air of restfulness is further projected by the girl and her donkeys who are all seated. A typical Turnerian visual simile is evident in the repetition of the shape of the ruined castle by the shape of the girl's hat.

c. 1828
Private Collection, U.K.

28 × 40.7 cm (11 × 16 in)

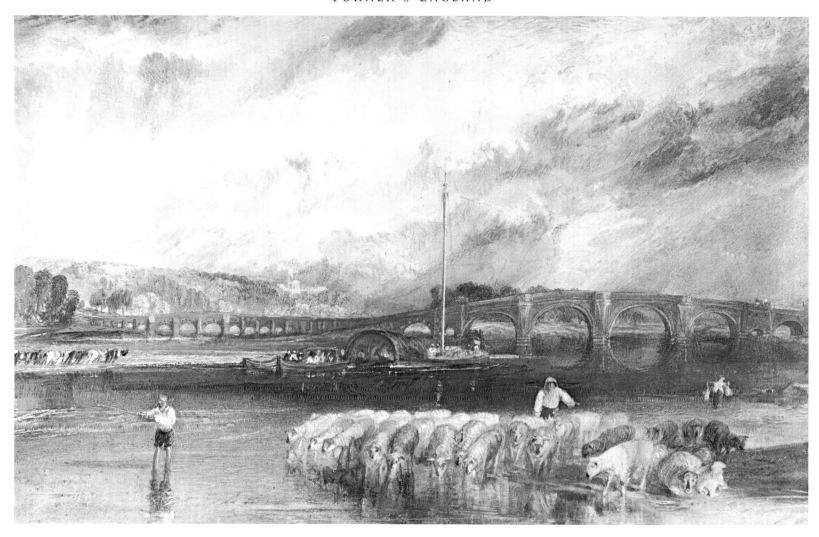

ENGLAND AND WALES
170 WALTON BRIDGE

The bridge at Walton-upon-Thames, Surrey, was built in 1786 by James Paine and it replaced an earlier wooden bridge built in 1750; it was itself replaced in 1863. Around 1806 Turner painted two important oils of the bridge rather in the manner of Aelbert Cuyp, and he also indirectly depicted it looking very Claudian and ideal in the 'Liber Studiorum' image entitled *The Bridge in the Middle Distance*, a design that formed the basis of a brilliant late painting.[141] Here Turner more straightforwardly represented it amid the windswept Englishness of the Thames valley.

The colouring is very fine, with some lovely violet reflections on the water beneath the sheep, and there is also a superb depth of tone, especially in the dark area beneath the barge. The straining mules on the left are pulling a barge from beyond the edge of the design and they form the keystone of the pictorial architecture, with diagonals emanating from them into the sky and down the line of the fishing rod to the edge of the riverside below the sheep. The circles formed by the bridge-spans and their reflections on the Thames are repeated by the canopy of the barge and its reflection in the water, a typical Turnerian visual simile.

c. 1828
Private Collection, U.K.

28.9 × 45.7 cm (11⅜ × 18 in)

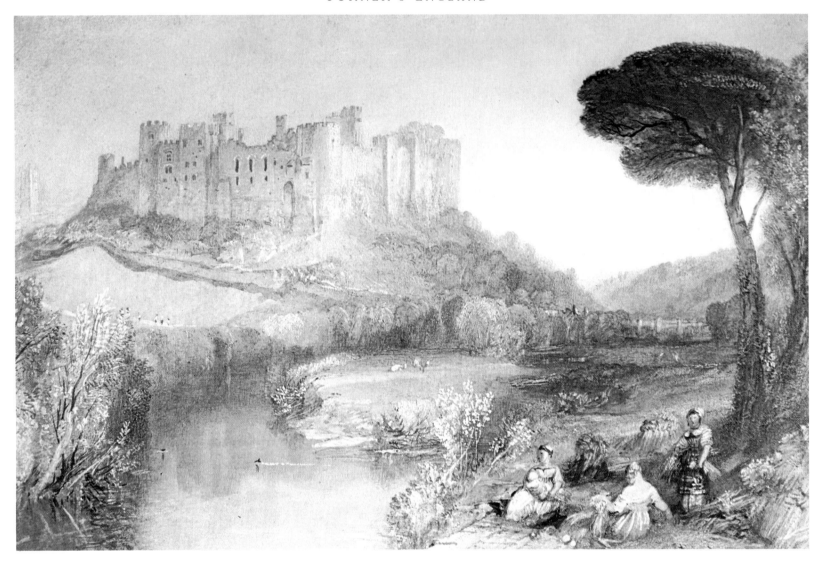

171 LUDLOW CASTLE, SHROPSHIRE

Ruin and fecundity coexist in rural Shropshire as a simple moral contrast is enforced between the dead castle and nature in full bloom, including a mother and child, two women tying or holding bundles of wheat, and verdant trees (one of which is a Claudian stone pine, an unlikely sight in Shropshire). The golden warmth of the foreground is sharpened by a dab of emerald green, while in the middle-distance a moorhen scutters across the Teme, thus animating the rather still scene.

Ludlow Castle had been allowed to fall into ruin throughout the seventeenth and eighteenth centuries, and by the time that Turner visited it in 1798 (when he made the study from which he developed this watercolour over thirty years later[142]) it looked a very sorry sight from close to. On the left is the tower of St Laurence's Church; in the distance on the right is Ludford Bridge. The brilliance of the foreground and middle-distance is considerably heightened by the extensive scratching-out of highlights, most noticeably on the leaves of some saplings by the riverside and the wake of the moorhen across the water. This scratching was probably accomplished by one of Turner's thumbnails, which was kept sharpened for the purpose.

c. 1830 30.5 × 45.7 cm (12 × 18 in)
Private Collection, U.K.

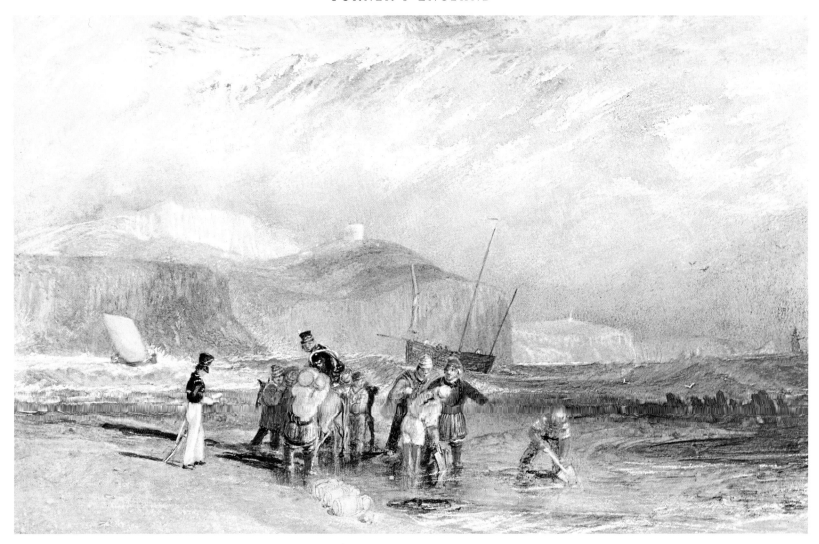

172 COAST FROM FOLKESTONE HARBOUR TO DOVER

This is the last of Turner's four drawings representing a smuggling operation at Folkestone (see also 45, 95 and 245), and it also shows the final phase of a crime: detection by the Law, as two members of the Coast Guard direct the digging-up of smuggled kegs, with one of the officers looking at a map, a detail which suggests that an informer has been at work. Beyond the right-hand group of figures is a Le Havre trawler with its sails furled or lowered as the crew pulls on the nets. Due to its nationality, this vessel might well have been originally responsible for smuggling the contraband, and it certainly connects with the men digging beneath it (and thus with the kegs), for if we carry the lines of its foremast and mizzenmast downwards, they bracket that group of men. The kegs are lined up along the beach or are loaded onto

mules, and their rotundity is subtly amplified by a Martello tower far above them on the cliffs across East Wear Bay. Further visual unity is imparted to the whole group of men in the foreground by the parallel diagonals of the line of kegs, the back of the Exciseman dismounting his mule, and the pointing arm and digging shovel.

In the distance, amid cool dawn sunlight, the magnificent chain of cliffs stretches away to Dover and the South Foreland. The sky is extremely freely painted but it does not lack veracity as a result.

c. 1829 29.2 × 45.1 cm (11½ × 17¾ in)
Yale Center for British Art, Paul Mellon Collection, U.S.A.

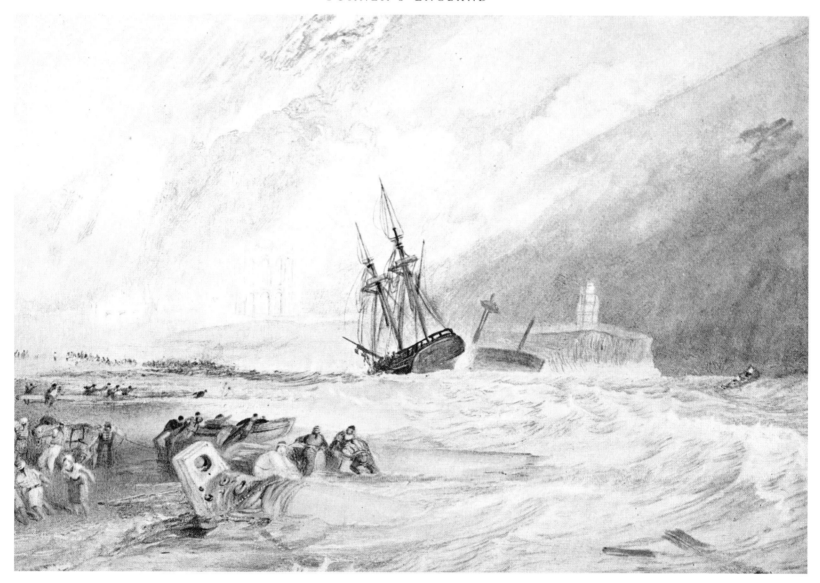

173 TYNEMOUTH PRIORY, NORTHUMBERLAND

This drawing was destroyed by fire in February 1962, but before its destruction it was fortunately reproduced twice in colour: in *The Connoisseur* of November 1930 and in the catalogue of the 1951 'Festival of Britain Exhibition of Local Treasures' at the Atkinson Art Gallery, Southport. The catalogue colour plate is reproduced here. Naturally, something of the original is lost, but even by 1902 Sir Walter Armstrong had described the work as 'badly faded'.[143] Judging by the engraving made from the design,[144] both the sky and sea in the watercolour were originally much darker, and possibly Turner had painted them using indigo, which would account for the fading.

Once again a lighthouse has failed in its purpose, and we see the conjunction of wreck with ruin and the efforts of mankind to salvage something from disaster.

Finden's *Ports and Harbours* (1836) relates that 'in consequence of the danger of the entrance to Shields Harbour in stormy weather with the wind from the eastward, more vessels are lost there than at any other harbour in Great Britain'.[145] Indeed, beyond the endangered brig is a wrecked brig. This is located in exactly the same position in relation to the priory as is the wrecked brig that appears in an earlier drawing of Tynemouth (119). On the far right a lifeboat is going out presumably to help yet another vessel in distress.

c. 1829 28 × 40.7 cm (11 × 16 in)
Destroyed by fire, February 1962

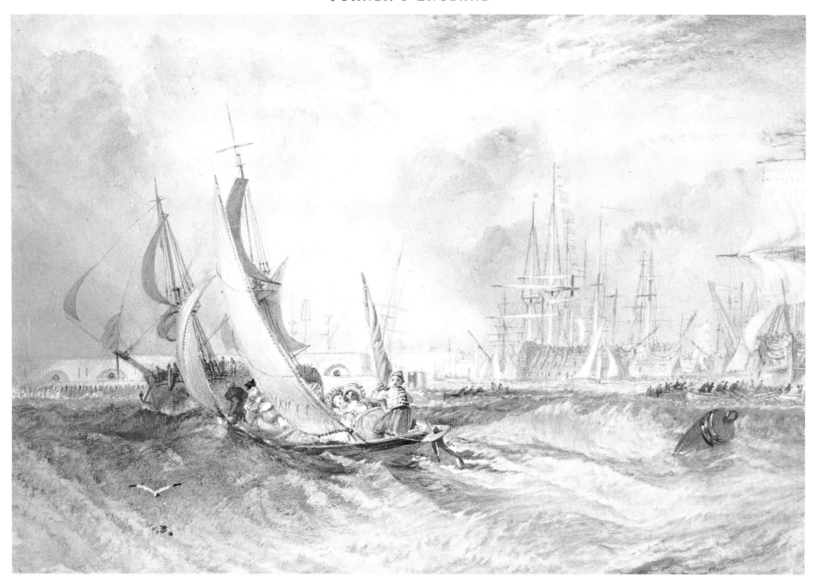

174 GOSPORT (ENTRANCE TO PORTSMOUTH HARBOUR), HAMPSHIRE

Aboard the nearby skiff the circular shape of a woman's hat repeats the shapes of the guns and gun-embrasures of the blockhouse at Gosport. The lady also controls the rudder of the skiff by means of ropes attached to a collar, but unfortunately the helmsman behind her is so preoccupied with the mizzensail that he has failed to supervise her direction of the boat, and thus it seems very likely that it will soon collide with the brig beyond it. The imminence of that collision is indirectly suggested both by the frozen posture of the sailor at the prow of the skiff and also by the seagull poised to swoop down on a crab immediately before the bow of the brig, an impending contact that Turner had similarly used elsewhere to suggest things to come (see 13). The mizzensail forms a huge phallus between the legs of the helmsman, a detail which suggests that the curious arrangement of the man's head – Ruskin thought that Turner

had mistakenly drawn it the wrong way round – was intended to signify that the sailor has had his head turned by the ladies.[146]

In the distance, above the buoy, is the Dockyard Semaphore which controlled shipping movements in Portsmouth Harbour. Both semaphore and buoy afforded safety to shipping, but here the Semaphore has failed in its duty, given the possible collision. Ruskin called this work 'A delightful piece of fast sailing, whether of boats or clouds',[147] and the predominantly bluish colouring evokes the coolness of sea air.

c. 1830
Private Collection, U.K.

28.5 × 41.9 cm (11¼ × 16½ in)

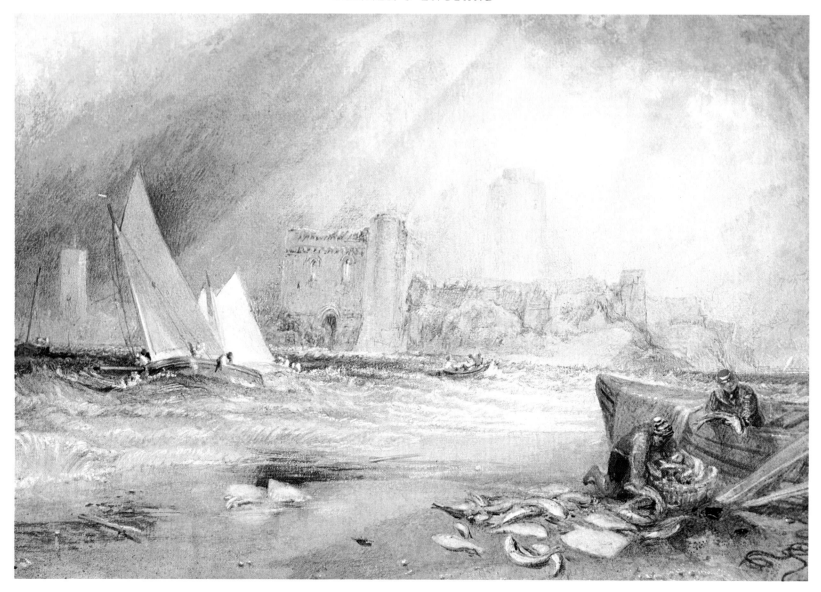

175 PEMBROKE CASTLE, PEMBROKESHIRE

Turner made two other watercolours of this view. One of them was exhibited at the Royal Academy in 1801 and shows a thunderstorm approaching, while the other was displayed at the R.A. in 1806 and reveals a storm clearing up.[148] Here the storm passes by, judging by the fact that the fishermen unloading their catch in the foreground do not appear to be either wet or concerned about the weather. And in any case this seems to be more of a monsoon than a storm in Wales, for the ochre-to-blue polarity of the colouring projects a sense of enormous heat; with this watercolour at least, one can indeed apprehend why the *Observer* newspaper critic wrote of the 1833 Moon, Boys

and Graves Gallery exhibition (in which this work was shown) that 'the general effect is "terribly tropical", *hot, hot, all hot*'.

The rotundity of the castle towers is amplified by the semicircular shapes of the fish, while a highlight aboard the hull of the yawl on the left also gives the boat a very rotund stress.

c. 1830 29.8 × 42.6 cm (11¾ × 16¾ in)
Holburne of Menstrie Museum of Art, Bath, U.K.

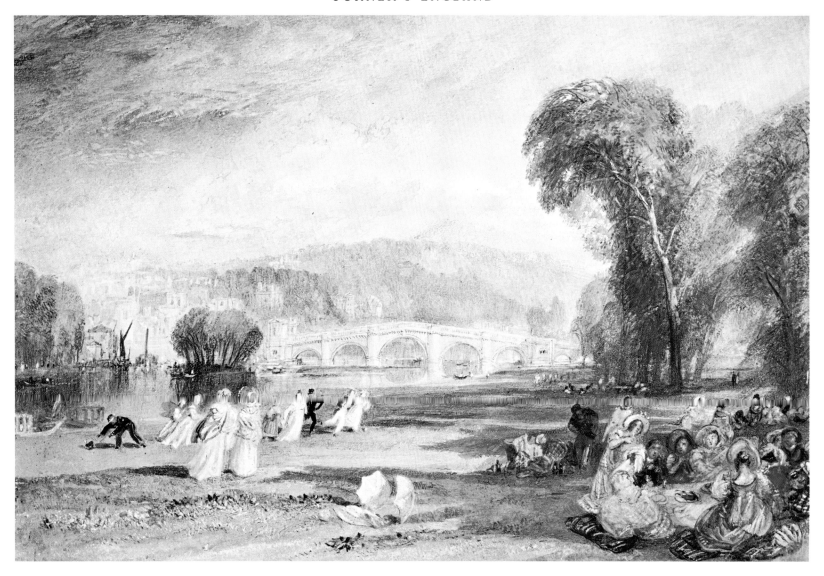

176 RICHMOND HILL AND BRIDGE WITH A PIC NIC PARTY

We view Richmond bridge and hill from the Twickenham bank of the Thames on a lovely summer's afternoon. Turner himself may well have picnicked in these very meadows, for they are located barely three-quarters of a mile from Sandycombe Lodge (off to the right), the house that he had designed and built for himself around 1812. We know for sure that he picnicked nearby, for in 1813 his participation in a local picnic was recorded by another member of the party:

We dined in a beautiful part of Ham Meadows upon half-made hay, under the shade of a group of elms near the river, & had tea at Turner's new house. Miss Perks took a guitar and Edward a flute & we had a great deal of music & singing . . . we had good veal & fruit pies, beef, salad, &c – but our table cloth being spread on the short grass in a lately mown field we reposed after the Roman fashion on triclinea composed of the aforesaid hay . . .'[149]

Here the merry staffage picnic and play blind-man's bluff, or dance to music that is perhaps being provided by an unseen flute and a guitar. The grouping and detailing of the figures at the bottom right evokes Watteau, whose work Turner loved both for its warm colouring and for its projection of an ideal human existence, qualities that are very much in evidence here.

c. 1829
British Museum, London

29.1 × 43.5 cm (11⅜ × 17⅛ in)

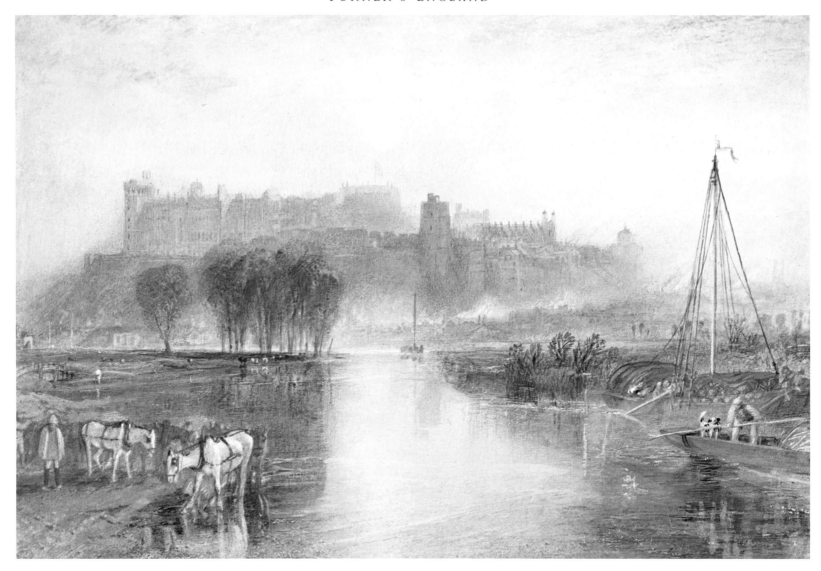

ENGLAND AND WALES
177 *WINDSOR CASTLE*

As a young man Turner had frequently depicted Windsor Castle, and although after about 1809 his interest in the building waned, nonetheless he went on sketching it over the years. This is the last view he made of it. The castle was a natural subject for depiction in this series, for the medieval structure combines impressive architecture with a dramatic site.

We look south-eastwards in early morning light, with the meadows known as the Brocas on the left and a wonderful interplay of shadows across the Castle, the Round Tower and St George's Chapel. The barge on the right is identical to a barge that appeared in a very early view of Windsor by Turner which was engraved for *The Pocket Magazine* in 1795, and equally in both designs the pennant on the masthead of the

barge is aligned with the distant flag on the Round Tower; clearly the painter never lost his associations of place.

The engravings of *Windsor Castle* and *Eton College* were published in the same part of the 'England and Wales' series and they represent complementary times of day. Moreover, the castle and college are very near to each other in reality, which suggests that Turner made the two watercolours as pendants. *Eton College* is therefore discussed opposite.

c. 1829
British Museum, London

28.8 × 43.7 cm (11¼ × 17⅛ in)

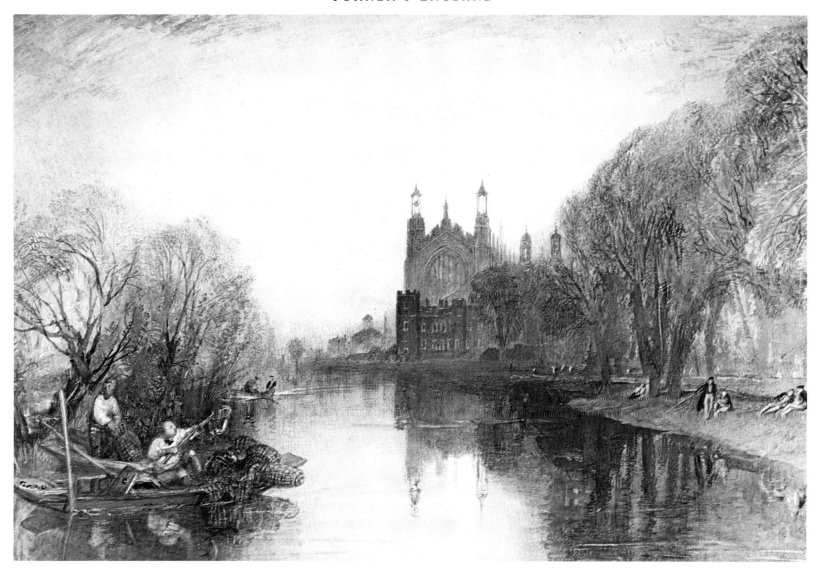

178 ETON COLLEGE

An allegory of learning on a warm summer's evening by the Thames: on the left men work at trapping eels, while at the right Eton Collegers relax, presumably after trapping knowledge. The distinction between work and leisure is further indicated by the net with which the nearest fisherman lifts his eels out of their traps, for it points directly at an adjacent Eton Colleger who is being rowed across the river. Contrasts of intellectual development may be equally signified by the trees, for on the left are stunted, pollarded willows, while on the right are willows in full growth and leafage. The pollarded trees were invented by Turner, for they stand on Romney Island which was completely unwooded at the time, as many contemporary views demonstrate.[150] Trees were frequently employed by Turner to denote things metaphorically, as was

their careful balancing with a staffage to point up antitheses.[151]

Strong colour contrasts complement these oppositions, most noticeably the red of the college and blue of the college chapel beyond it. The composition is artfully structured by an underlying X-shape which runs up the lines of the riverbanks and down the lines of the tree-tops, the upwards diagonal on the left being reinforced by the net-pole which is also aligned with the pall of smoke issuing from a college chimney in front of the chapel.

c. 1829
Private Collection, U.K.

30.5 × 44.5 cm (12 × 17½ in)

ENGLAND AND WALES

179 MALVERN ABBEY AND GATE, WORCESTERSHIRE

Turner based this work on a watercolour of the abbey and gate dating from 1794, where may also be seen the frame-saw, a man working it, and the broken wagon wheel on the left.[152] Now, however, they have been joined by a wheel hub, a wagon harness-block and joinery tools, while a second man climbs out of the saw-pit with a basket, doubtless to shelter with his companion alongside the youth and the milkmaid who has taken off her heavy pails and yoke under the gatehouse. The Perpendicular tower of the priory church catches the last of the sunlight before being enveloped in rain, and the multitude of stipplings on the church and in the sky add further subtle touches of dynamism to the scene. The tree shadows falling across the foreground display great

painterly panache, and the cool greys and purples in the shadows of the church throw the golden colour of the gatehouse into relief.

When the design was engraved Turner added another pair of milk pails and a yoke to the empty space on the right, as well as a massive bolt of lightning striking from the top left.

c. 1830
City Art Gallery, Manchester, U.K.

29.9 × 42.8 cm (11¾ × 16⅞ in)

ENGLAND AND WALES
180 PLYMOUTH COVE

Fifteen or so years after he had last visited Plymouth, Turner here again recreated the kind of scene he might well have witnessed there during the Napoleonic wars, with sailors dancing or in their cups. From the left, beyond the carousing figures, we see the Cattewater crowded with shipping; the tower on Mount Batten Point; a mass of shipping at anchor behind the gigantic breakwater across Plymouth Sound, a structure that was only completed in the 1820s; an ale-tent; town houses, one of which is shored up with timber supports; the huge Citadel on the Hoe, its ramparts three-quarters of a mile in circumference; and Mount Edgcumbe House and park in the far distance on the right, the house indicated by a fleck of white. The composition is structured by two diagonals that converge on the left, and the colouring is subdued, as befits the type of unsettled weather apparent in the distance.

c. 1829
Victoria and Albert Museum, London

28×41.2 cm ($11 \times 16\frac{1}{4}$ in)

181 MARGATE, ISLE OF THANET, KENT

In the 'Southern Coast' and 'Ports of England' views of Margate (37 and 108) we perceived the town from the west in evening light; here we move inland, and apprehend it still somewhat shrouded in early morning mist.

Before the advent of the railways, Margate was a fashionable bathing resort rather than a place for day-trippers, and the elegant associations of the town are certainly amplified by the elegantly attired young woman taking children for a morning stroll. Her graceful lines, and the youthfulness of her charges, are matched respectively by the gracefulness and youthfulness of some beech trees, and the wide range of greens and yellows deployed throughout the lower half of the design intensifies the sense of freshness. In the centre a heavily laden hay-cart is juxtaposed with a somewhat faster

stagecoach moving in the opposite direction along the coast road to London, while beyond them several bathing machines are spread out at low tide across the shallows and beach. By now Hooper's Mill has definitely disappeared and its dominant position on the skyline has been taken over by Holy Trinity Church; nearby, some windmills may just be perceived in the haze. Turner's control of tone in the depiction of the town is quite outstanding.

c. 1830

29.5 × 45 cm (11⅝ × 17⅝ in)

Herbert Art Gallery, Coventry, U.K.

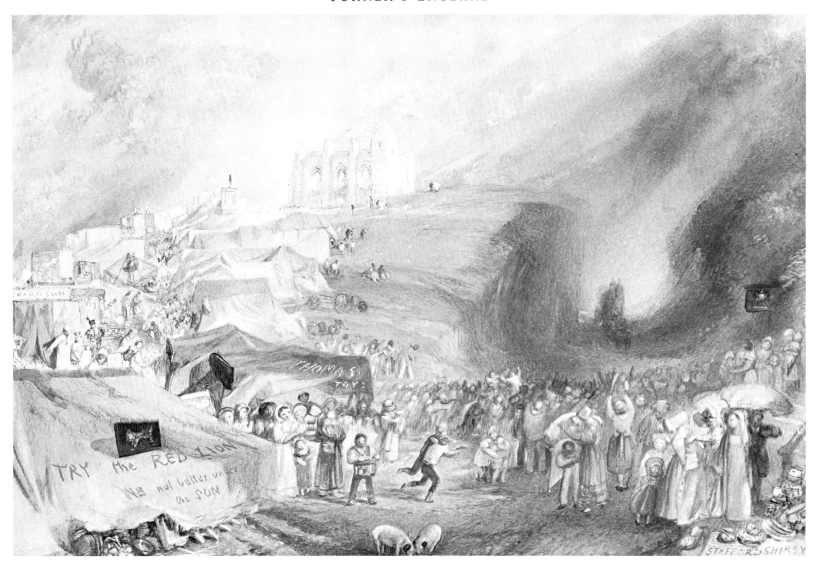

182 ST CATHERINE'S HILL, NEAR GUILDFORD, SURREY

In 1308 Richard de Wauncey obtained the right to hold a five-day livestock fair on St Catherine's Hill every September, and around 1316 he built a chapel there. The chapel fell into ruin during the late Middle Ages, and after 1752 the fair was held every October, when it also became a two-day recreational fair. It was last held in 1914.

On the left is the booth of the London showman, Richardson, who toured many fairs at the time, as well as a beer tent bearing the names of two Guildford coaching inns, The Red Lion and The Sun. In the centre is a crowd surging around a 'backsword' fight in which the contestants beat each other over the head with stout ash-sticks until 'the moment that blood runs anywhere above the eyebrow, the old gamester to whom it belongs is beaten and has to stop'.[153] On the right is the

approaching Portsmouth coach and then an inn, The Half Moon, whose sign may represent a woolsack, a symbol used for licensed premises in Guildford since Elizabethan times. A surviving memoir of the fair in the 1830s tells us that 'Baker the Crock Man from Uxbridge occupied a large portion of the ground for his crockery ware', and Staffordshire crockery can indeed be seen at the bottom right.[154] The composition is unified by the sweep up to St Catherine's Hill chapel, and rain-clouds passing away to the west add a further touch of dynamism to the scene.

c. 1830 29.6 × 44.2 cm (11⅝ × 17⅜ in)

Yale Center for British Art, Paul Mellon Collection, U.S.A.

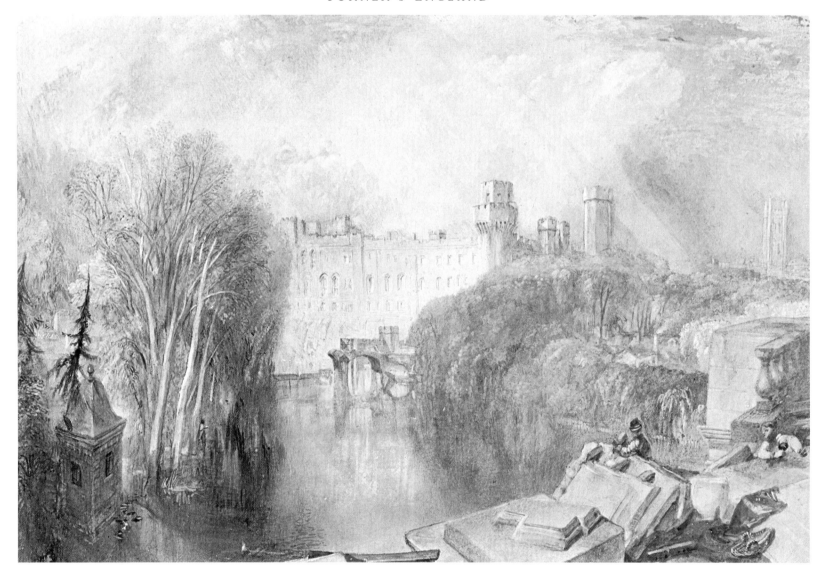

183 WARWICK CASTLE, WARWICKSHIRE

This was another self-recommending subject for the 'England and Wales' series, for Warwick Castle is one of the most impressive medieval fortresses in Britain. We view it from the Castle Bridge over the Avon, in afternoon light and with rain-clouds building up amid a sense of oppressive heat, an effect principally projected by the ochre-to-blue colouring (this being another watercolour shown in the 1833 exhibition where one can apprehend the 'heat' complained of by the *Observer* newspaper).

In the foreground builders are at work, and just in front of us is a small sandstone block whose shape reiterates that of the crenellations on Caesar's Tower and the rest of the castle far above it, a typical Turnerian visual simile. As no repair work is known to have

taken place on Castle Bridge in 1830 (when Turner visited Warwick[155]), there can be no doubt that the painter invented the repairs in order to accommodate this similarity.

The composition is structured by the two principal diagonals emanating from the bottom left-hand corner, and when the design was engraved Turner added a swan at the lower left so as to augment the balance of that structure. The bird also furthers the sense of languidness throughout.

c. 1830 29.7 × 45.1 cm (11⅜ × 17¾ in)
Whitworth Art Gallery, Manchester, U.K.

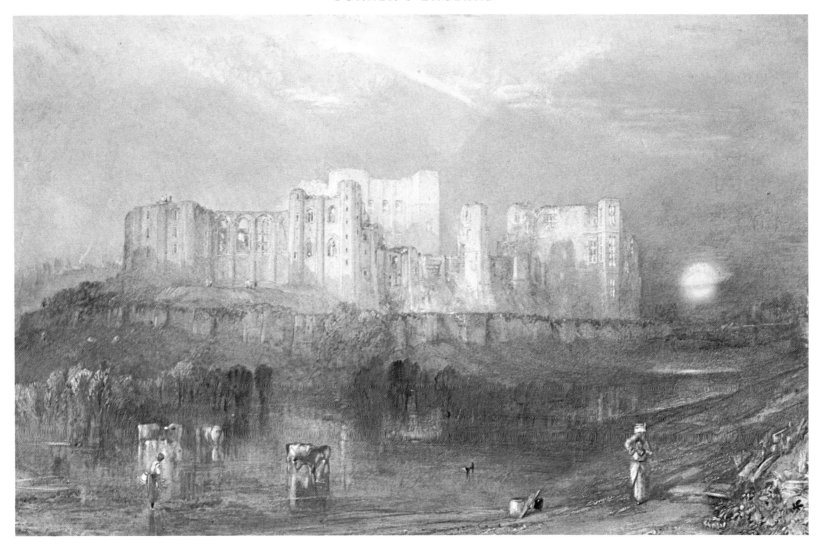

ENGLAND AND WALES
184 KENILWORTH CASTLE, WARWICKSHIRE

Turner would surely have concurred with the writer of the catalogue entry for this work in the Moon, Boys and Graves Gallery exhibition of 1833, that the ruins of Kenilworth Castle 'now await the slow inroads of time to fulfil their term of grandeur', for they look very timeworn and grand in the soft evening light. Given that from the 1820s onwards the painter often used moonrises to signify the coming of death, the orb may well denote such a state here. The milkmaid on the right is extended vertically by the churn on her head, thus strengthening the many verticals to be seen on the castle.

Ruskin saw this watercolour at Thomas Griffith's house in 1840 on the very first occasion that he met Turner: 'I must have talked some folly about it, as being "a leading one of the England series", which would displease Turner greatly. There were few things he hated more than hearing people gush about particular drawings.'[156]

c. 1830 29.2 × 45.4 cm (11½ × 17⅞ in)
Fine Arts Museum, San Francisco, U.S.A.

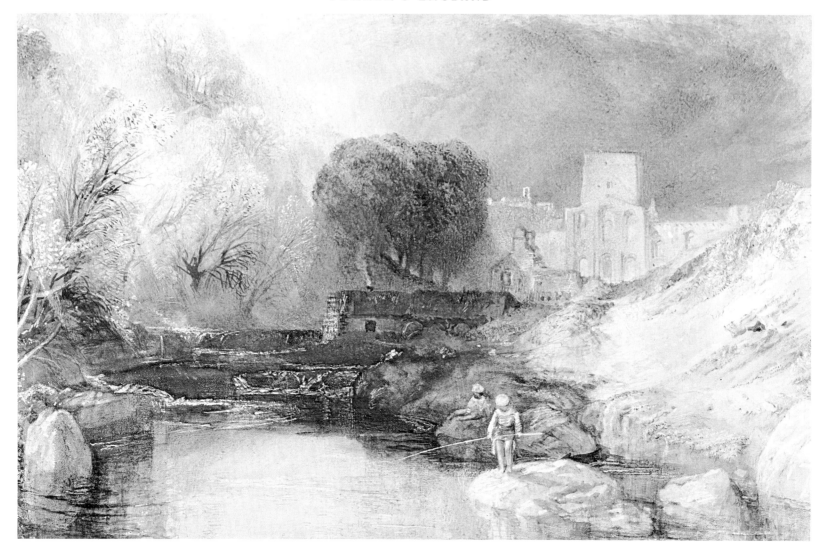

ENGLAND AND WALES

185 BRINKBURN PRIORY, NORTHUMBERLAND

Brinkburn Priory was an Augustinian foundation dating from around 1135; it was destroyed during the Reformation. Turner visited the ruin in 1797 on his first tour of the north of England, when he made the pencil study from which this watercolour was developed.[157] That sketch portrays the view westwards along the river Coquet and it is devoid of any indications of light, weather or staffage.

Here structure, landscape and morality all fuse in a superb balance of oppositions. The composition is underpinned by a basic X-shape which runs up the banks of the Coquet and down the hillsides on right and left. Everything on the left side of the river

is abundant and lush, with a multitude of sparkling reflections on both trees and river. On the opposite bank, however, all is desolation, with no trees at all and merely the ruined priory standing out against the stormy sky. The moral seems obvious: nature is eternal, regenerative, beautiful, whilst all human creations are doomed to extinction.

c. 1830 29.2 × 46.3 cm (11½ × 18¼ in)
Graves Art Gallery, Sheffield, U.K.

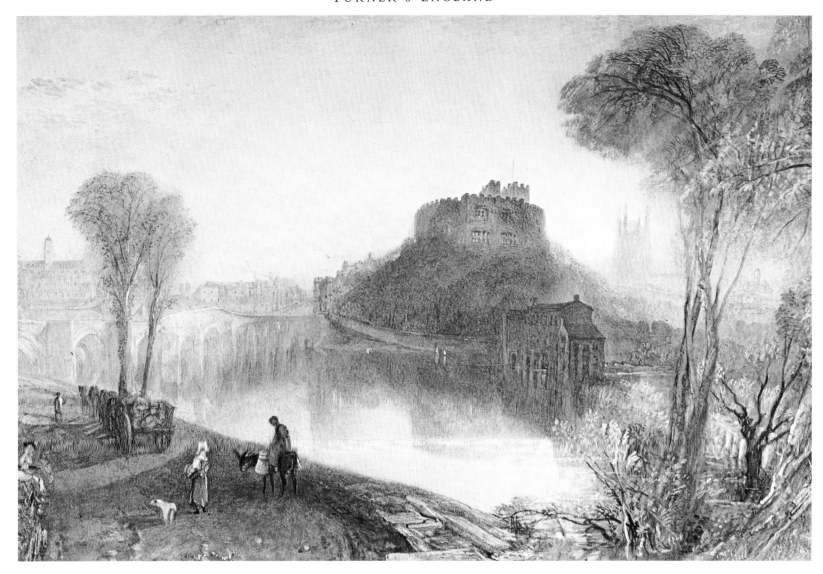

186 TAMWORTH CASTLE, WARWICKSHIRE

Tamworth Castle dates from Norman times and was built to guard the junction of the rivers Tame and Anker. Turner visited the castle in 1830 on his tour of the Midlands to gain further material for the 'England and Wales' series, and he based this watercolour on sketches made on that tour.[158]

The sun sets beyond the Anker, with the Lady Bridge looking ethereal in the evening light; in the distance on the right may be seen the tower of St Editha's Church. The dark tones, rubbed textures and stipplings of the castle, hill and mill contrast with the brilliant tones and broad strokes of the foliage and weir on the right, where Turner scratched out numerous highlights using the wooden end of the brush.

c. 1830 29.2 × 44.5 cm (11½ × 17½ in)
Private Collection, U.K.

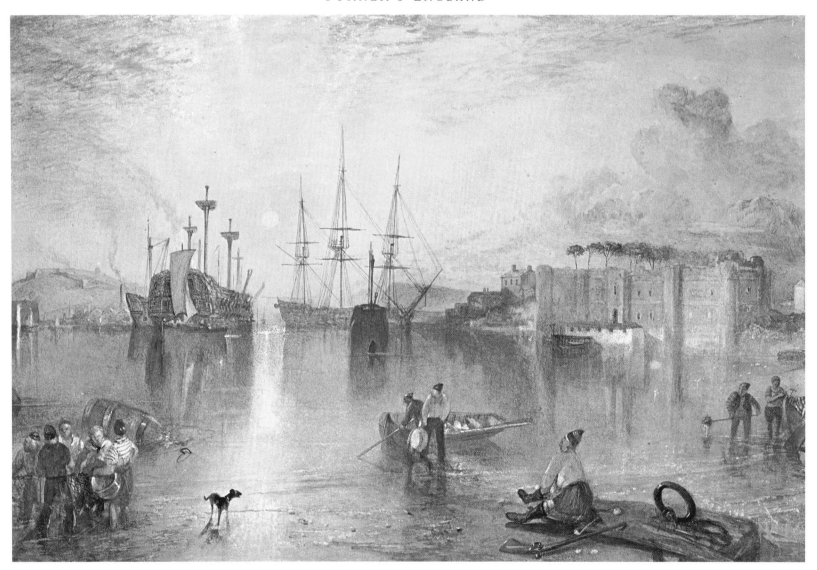

ENGLAND AND WALES
187 CASTLE UPNOR, KENT

The major clue that this watercolour contains a secondary meaning resides in the wall of shipping that is deployed across the Medway in the distance, where from left to right we can perceive a sheer hulk, two ships being remasted, a man-of-war and another hulk viewed stern-on.

Such a blockage of shipping would have been very unusual, if not impossible, in such a narrow channel, and clearly it refers to the most famous contribution that Upnor Castle had made to British history, namely its prevention of the Dutch fleet from sailing up the Medway on 12 June 1667 during the Anglo-Dutch War, an incident certainly known to Turner and referred to in the 1833 watercolour exhibition catalogue.[159]

Further allusions to that defensive action can be seen in the foreground: a gun points towards a massive target-like mooring ring; some sea 'shells' are distributed around the gun; a dog looks very alert; and a rather awkward and seemingly out-of-scale figure pulls on his boot, perhaps thereby enacting a visual translation of a verbal pun, for Upnor Castle had punished ('booted') the Dutch or rendered help in time of peril ('done boot') in defending Chatham, which can be seen in the distance on the left. Although the river runs on a north-south axis at this point, the sun is probably setting rather than rising, and its brilliant reflection on the water is greatly intensified by the contrasting dark tones of the dog.

c. 1831 28.6 × 43.5 cm (11¼ × 17⅛ in)
Whitworth Art Gallery, Manchester, U.K.

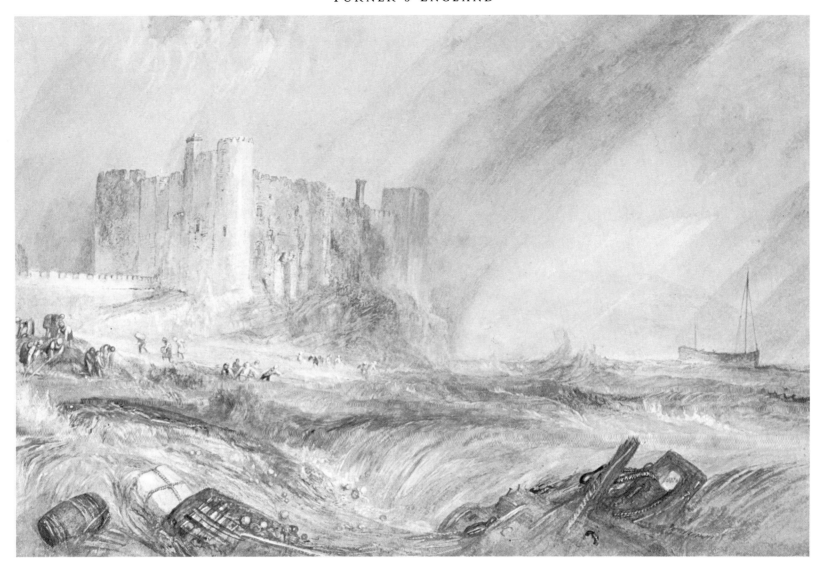

ENGLAND AND WALES
188 LANGHARNE, OR TALACHARNE CASTLE, CAERMARTHENSHIRE

Again we see ruination in both foreground and background, with mankind endeavouring to save what it can. Here Turner once more also demonstrated his acute awareness of a locale, for the inhabitants of Carmarthen Bay were well known for their shrewdness and speediness in salving wreckage; often they would even arrive at the scene of a wreck fully prepared with hammers and hatchets to strip anything that was salvable (and not minding if a beached ship was undamaged, as happened at least once in 1840). In 1833 a Carmarthen tradesman even hired out carts in order to help wreckers to carry away their booty.

The nearby wreckage reinforces our apprehension of the architectural ruin, for the squareness of the castle is repeated by the squareness of the parcel at the lower left, while the shape of the narrow turret and tower on the right side of the castle is repeated by the upper outline of the smashed wreckage in the right foreground (a repetition noticed by Ruskin). The Taf estuary seems to have been widened to oceanic proportions, and the water displays a violence that was rarely matched in Turner's art; as Ruskin commented, 'the surges roll and plunge with such prostration and hurling of their mass against the shore, that we feel the rocks are shaking under them.'[160] This vehemence certainly compensates for the sad fact that the watercolour has faded badly, especially in the sky.

c. 1831 31.2 × 47 cm (12¼ × 18½ in)
Columbus Museum of Art, Ohio, U.S.A.: Bequest of Frederick W. Schumacher

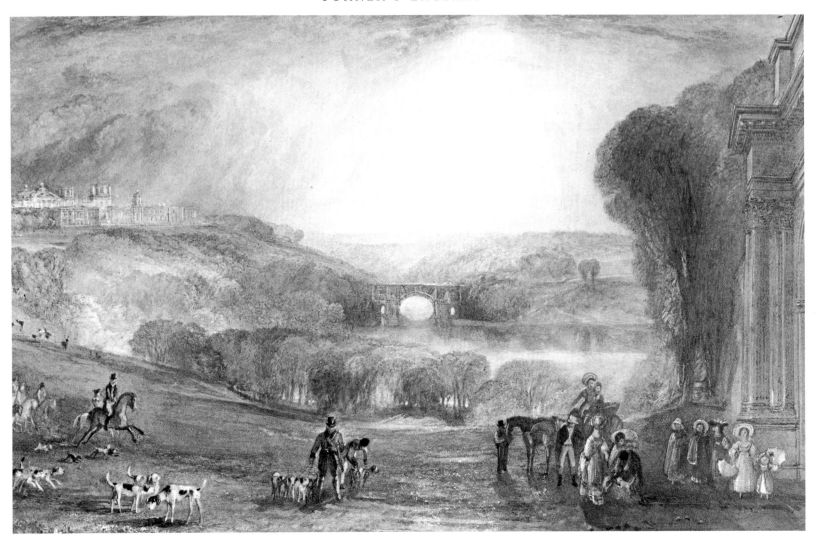

ENGLAND AND WALES
189 BLENHEIM HOUSE AND PARK, OXFORDSHIRE

We survey the Marlborough family seat from the viewpoint of the Woodstock Gate entrance to the estate; Turner has moved the gateway to one side and turned it through ninety degrees so as both to portray the vista as normally seen *through* the arch and include the entranceway within his design. And the panorama from the Woodstock Gate is complemented by a survey of the types of people who could be seen at Blenheim. From left to right are huntsmen riding over the estate; then, a sportsman with further dogs, and a gun under his arm, who stands staring out at us as though to protect the property; next, a lady and gentleman who have left their children in their gig and descended to watch a pair of sparring dogs being separated; and finally, a line of five more children who also watch the incident. The antagonistic dogs are placed directly opposite our viewpoint, and the distant oval formed by the bridge and its reflection acts as the focal point of the whole design. The gold-to-blue colouring, coupled with the gathering storm clouds, projects the same kind of oppressive heat that we have already encountered in the drawing of *Warwick Castle* (183).[161]

The staffage is unusually strung out across the foreground; equally, there seems to

be a sense of disjointedness to it. These factors, in conjunction with the sparring dogs, the man with the gun confronting us and the sense of gathering storm in a portrayal of an aristocratic seat, point to the possibility of there being some underlying meaning to the work. To understand what that meaning could be, we have to perceive the watercolour in its historical framework, as well as within the framework of Turner's known political sympathies.

Turner based this watercolour on sketches that he made on his tour of the Midlands in 1830. That tour probably began at the end of August, after the holding of the General Election caused by the death of King George IV, and it continued until the end of October; the artist is known to have been back in London by 1 November, as he attended a meeting of the General Assembly of the Royal Academy on that date. The watercolour was therefore made sometime after the end of October 1830 and Turner thus had much time to note the great advances that libertarianism had made and was making in 1830. For example, in February of that year, at the London Conference, Greece at last became an independent state under the protection of Britain, France and

Russia. The painter must have been elated, as he had frequently expressed his sympathy with the struggles for Greek liberty since 1816, although the identification probably went back much further than that.[162] Then in July 1830 revolution broke out in France against Charles X who abdicated in August and was replaced by the 'citizen-king', Louis Philippe, with whom Turner was friendly.[163] At the end of August, revolution broke out in Belgium against the Dutch, and Belgium achieved its independence in mid-November. In September, Ecuador and Venezuela seceded from Colombia to become separate states, while simultaneously in Europe the peoples of Saxony, Hesse and Brunswick overthrew their rulers and obtained formal constitutions. And to cap all these revolutions or achievements of independence, in late November revolution broke out in Poland against the Russians. Moreover, in Britain in mid-November 1830 the Tory administration of the Duke of Wellington resigned, to be replaced by a Whig administration led by Lord Grey. As we shall see with the very next work to be discussed in this book, Turner was openly to celebrate this gaining of power by an administration that was committed to the reform of parliament, and by 1830 he had anyway articulated his sympathies with the demands for religio-political reform, as we have noted with the drawings of *Wycliffe, near Rokeby* (62) and *Stoneyhurst College* (168).

The revolutions abroad, and especially the French revolution, were noted with interest or alarm in Britain where there was already much agitation for parliamentary reform, and they further fuelled the existing widespread agricultural unrest, including the 'Swing' disturbances, whereby impoverished agricultural labourers in eastern and southern England destroyed threshing machines and burnt hayricks in protest at low wages, the high cost of basic foodstuffs or the unemployment caused by the introduction of labour-saving machinery. Naturally the aristocracy felt very threatened by the demands for parliamentary, social and agricultural reform, as they dominated Parliament, industry and the land. Nor had the General Election in August

helped their position, for by now public opinion had turned so much against the corrupt voting system of parliamentary elections that the aristocracy who underpinned that system were widely discredited as a result; as a Durham Tory newspaper announced on 20 August 1830, 'The aristocrats' power is fast crumbling beneath their feet.'[164] The 'disgusting spectacle. of corruption and venality...displayed at the general election'[165] by the aristocracy in defence of its interests, coupled with the example of the recent French revolution, led by September 1830 to widespread fears throughout the country of a revolution in Britain as well.

Considered in this context, it is possible to perceive a unifying meaning behind the unusually disjointed staffage and heated weather effects here. Clearly the sparring dogs near the entrance to a great aristocratic seat not only allude to animosity towards the aristocracy but equally refer to contemporary social unrest, as does the lack of visual cohesion to the staffage, while the man holding the gun and standing in a confrontational pose signifies the desire to protect property from change or social intrusion. The group of young spectators just inside the entranceway from the town who are wearing middle- and lower-class clothing, represent the growing middle and labouring classes waiting patiently upon the aristocracy for their rights to parliamentary representation, while the coming storm (and sparring dogs) hint at what might happen if their demands are not appeased. Moreover, the fact that the entranceway has been moved aside could equally have been intended to suggest that old barriers were being moved aside, just as the pictorial emphasis given to the bridge might represent Turner's wish for (social) communication.

There is a large colour-study for this work in the Turner Bequest (CCLXIII–365, ill. 21) and it demonstrates that the dogs were in Turner's mind from the beginning.

Late autumn or winter 1830–31 29.6 × 46.8 cm (11⅜ × 18⅜ in)
City Museum and Art Gallery, Birmingham, U.K.

21 Study for BLENHEIM, c. *1830, watercolour on paper, 37.4 × 58.4 cm (14¾ × 23 in)* T.B. CCLXIII 365, Clore Gallery for the Turner Collection, London.

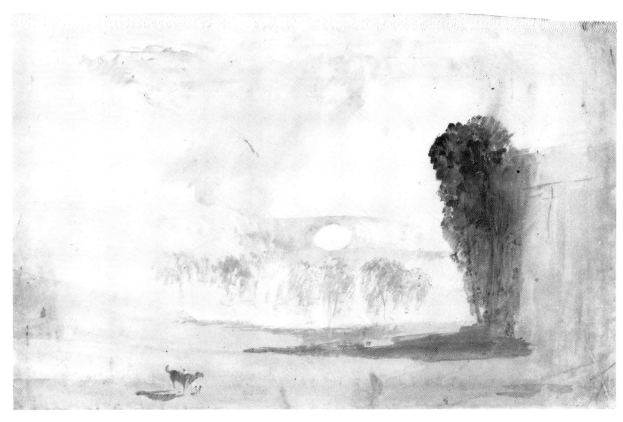

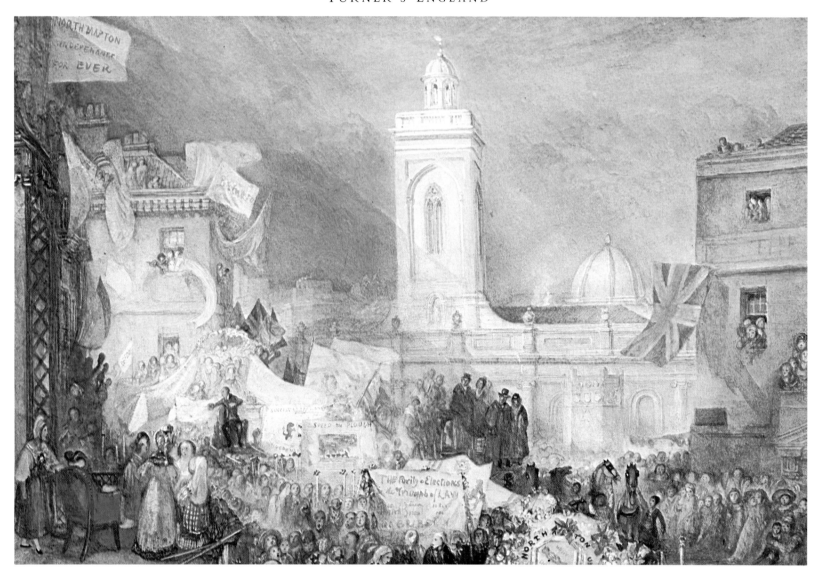

190 NORTHAMPTON, NORTHAMPTONSHIRE

This watercolour was shown in the 1833 Moon, Boys and Graves Gallery exhibition, to which it was lent by Charles Heath who had bought it for engraving. That fact, and the drawing's size, subject and type of detail support the view that it was made for the 'England and Wales' series, even though it was never engraved. Possibly Heath felt that it was too partisan for potential subscribers to the 'England and Wales' series, many of whom might well have taken a rather dim view of a work that celebrated the election to Parliament of a Whig. Along with *Stoneyhurst* (168), *Blenheim* (189), *Ely* (191) and *Nottingham* (194) the work reveals Turner's sympathy with the demands for political change that were to culminate in the passing of the 1832 Reform Act, a watershed in British political history.

When Turner made this watercolour the British electoral system was archaic, corrupt and blatantly unrepresentative. Only one per cent of the sixteen million people in Britain were entitled to vote, and even that electorate was unfairly and unevenly distributed: the majority of the House of Commons was elected by less than fifteen thousand voters. Such a system had been formed in Tudor times and it failed to represent either the new industrial cities or the emergent middle class. Over the previous half-century the pressure for reform had been checked by the outbreak of the French Revolution and the long wars that followed, but despite considerable repression, by the late 1820s the country was in a state of intense political ferment.

The crisis finally broke in November 1830 with the fall of the Tory administration which was opposed to Reform. The new monarch, William IV, held Whig sympathies and he appointed a Whig, Lord Grey, to form a new government. This change in the administration caused the election depicted here. Lord Grey appointed Lord Althorp (the county member for Northamptonshire) as his Chancellor of the Exchequer and, as a result, Althorp had to seek formal re-election, an event that took place on 6 December 1830. As Eric G. Forrester has commented: 'his unopposed

return was the occasion of great Reform propaganda. He made a triumphal entry into Northampton with his carriage hauled by supporters and garlanded with laurel wreaths, escorted by a cavalcade gay with crimson and white cockades and favours, bells ringing and bands playing. Owing to the vast throng the nomination meeting at his suggestion was transferred from the County Hall to the market square where a wagon was used as a stand.' In the speeches which followed Althorp pledged his devotion to the cause of Parliamentary Reform. He was then 'returned to the County Hall on an ornate triumphal car emblazoned with the motto ''Not for himself, but for his country'', and accompanied by a great retinue bearing banners that displayed mottoes such as ''Reform, Peace, Retrenchment'', ''The Friend of the People'', ''No Slavery'', and ''The Freedom of the Press''.'[166] A banquet was later held at the George Inn, which is visible on the right of Turner's watercolour.

Turner drew this scene fairly accurately, the major difference being that the crimson and white cockades and favours are instead coloured blue and white. This discrepancy, and differences in the slogans, suggest that the painter elaborated the watercolour from newspaper reports rather than from witnessing the scene himself. He had visited Northampton earlier in the year on his sketching tour of the Midlands, when he had drawn the facade of All Saints Church on pages 17a–18 of the *Birmingham and Coventry* sketchbook (T.B. CCXL), so it would have proven easy for him to elaborate the staffage.

For the final design Turner swivelled the church through ninety degrees, filled in its portico and moved its cupola into view from its normal position behind the tower. He also supplied the banner slogans: 'Speed the Plough' was the title of an old country dance and obviously it refers to the agricultural interests present;[167] 'NO BRIBERY' alludes to the corruption of the parliamentary process; 'The Purity of Elections is the Triumph of Law' bears a marked similarity to the title of a famous Radical political meeting held in 1829, which was widely advertised as 'The Triumph of Westminster and Purity of Election', a catchy slogan that probably stuck in Turner's memory;[168] and all round are banners for 'Reform' and 'Independence', as well as one stating 'NORTHMAPTON INDEPENDENCE FOR EVER' where in his creative haste Turner transposed the 'A' and the 'M' in Northampton.

On the left Lord Althorp is being chaired by the crowd who bear triumphal garlands above his head. He is acknowledging the crowd, but his arm also indirectly points at the foreground figure in the bottom left-hand corner. This white-haired gentleman, with his old-fashioned tricorne hat and gouty foot resting on a pouffe, obviously symbolizes the spirit of opposition to Reform. Next to him stands a 'Marianne', a French post-revolutionary archetype (equivalent to 'Britannia'), and her hand on his shoulder enacts both a timely reminder of the recent insurrection in France and a subtle suggestion of the alternative to peaceful concession. Such French peasant figures were

frequently drawn by Turner between 1826 and 1830, and they often appear in his later depictions of French subjects as well.[169] On the other side of the seated typification of Reaction stand ladies, two of whom are also in French dress and who are talking to two English ladies (or so the hairstyle of the rearmost woman on the right would suggest). That this foreground figuration *is* allusive is supported by the fact that no public building or balcony is known to have stood on Gold Street between Drapery and College Street, the locale depicted.

To this wealth of social observation and political meaning Turner added the dynamic movement of a gusty December day, especially to be observed in the wind-blown flags and banners at the upper left. The dynamism is further enhanced by the implied movement of the stagecoach as it is led through the crowd, as well as by sharp tonal shifts, exemplified by the sudden softening of tone at the rear of the stagecoach. Turner's superb tonal control may also be witnessed in the aerial lightness of the church and the Union Jack on the right, which is muted in colour so as to attune it to the overall low-keyed tonality of the work. Indeed, the colouring is superbly controlled to capture the bleak autumn sunshine, and its unity is unbroken by the frequent use of strong colours, such as the deep red of the armchair on the left, the emerald green above it, and the reds, creams, golds and blacks of the crowd. The blues are particularly effective, and their intensification beyond the church reinforces the basic diagonal line which runs down from the left to structure the composition. The stagecoach adds a suggestion of social mobility, and its winter-coated passengers, craning to observe the passing scene, typify the mood of human involvement.

Turner was undoubtedly aware of the election scenes of Hogarth, Gillray and Rowlandson, and perhaps it was Hogarth who most influenced him here, for he was undoubtedly acquainted with Hogarth's 'Election' series of paintings and engravings, the original pictures being in the collection of Turner's friend and fellow Academician, the architect Sir John Soane. Moreover, *Northampton* bears a marked visual similarity to one of Hogarth's 'Industry and Idleness' series of prints, namely *The Industrious 'Prentice Lord-Mayor of London* which depicts an election coach moving through a vast throng of people, and which includes many flags and banners, as well as a balcony crowded with onlookers. In *Northampton* Turner was therefore not only signalling his complete identification with the progressive forces for change in British society; he was also triumphantly renewing the tradition of British artistic, political and social comment in the process.

Winter 1830–31 29.5 × 43.9 cm (11⅝ × 17¼ in)
Private Collection, U.K.

191 ELY CATHEDRAL, CAMBRIDGESHIRE

... in the year 1322 the lofty stone tower fell and destroyed the three most western arches: the present magnificent octagonal tower, supported by eight pillars, and terminated by an elegant lantern, which is greatly admired, was erected to supply its place. The view in the drawing represents the south transept and the western Tower.

From the 1833 Moon, Boys and Graves Gallery exhibition catalogue

Turner based this watercolour upon a detailed pencil-outline study (ill. 22) made in 1794 on a tour of the Midlands; both watercolour and study are now in the same private collection. Around 1796 the painter had also created a number of impressive watercolours of Ely Cathedral, of which perhaps the most magnificent is a drawing of the interior dating from 1797 that is now in Aberdeen Art Gallery. Yet in addition to being closely acquainted with the appearance of Ely Cathedral, Turner was evidently just as familiar with the history of the building, and in this watercolour he related that background ingeniously to the social events of his own day.

In the left-foreground three boys are throwing stones into a pond, and the way that one boy stands while his companions crouch on either side of him parallels the way that the octagonal crossing-tower stands above its surroundings. The falling stones clearly allude to the collapse of the crossing-tower and arches in 1322 which is referred to in the 1833 exhibition catalogue, a text that Turner surely had a hand in compiling.

The nearby girl strengthens the connection between falling stones and crossing-tower, for her pointing arm creates a diagonal that leads the eye up to the diagonal gable of the transept behind her, which in turn connects with the octagonal lantern that had been created to replace the destroyed tower. This series of diagonals also receives support from the parallel palls of smoke that are issuing from the chimneys behind the girl and in the far distance on the left, and from the diagonals of the flying buttresses and rakes on the right. Yet in addition to alluding to the history of Ely Cathedral by means of falling stones, Turner may also have been using the thrown stones to refer to contemporary events as well.

The Church of England felt itself to be in an unstable position during the period preceding the Reform Act of 1832. Over the years the malpractices and corruptions of the Church had become intimately identified with those of a long-entrenched political system and closely linked aristocracy. Moreover, the Church felt very threatened by the repeal of the Test and Corporation Acts in 1828 and by the Roman Catholic Emancipation Act of 1829, and it was increasingly under assault from dissenters and freethinkers. To heighten its unease, the tense winter of 1830–31 saw a great deal of agricultural unrest, much of it directed against the Church of England because of the burden of paying tithes (see 160).

In this atmosphere the Church was largely opposed to any measure of Reform, which it felt might also lead to its disestablishment as the state religion in Britain. As a result, when in October 1831 twenty-one of the archbishops and bishops in the House of Lords voted against the Reform Bill upon its second attempt to pass through Parliament and thus defeated the bill by a margin of one vote, Anglican clergy particularly suffered from the widespread indignation that followed. Several bishops had their coaches stoned, the Bishop of Exeter had to have his palace defended by coastguards and yeomanry, and the Bishop of Bristol had his palace burned down by a mob. Naturally, the Anglican clergy were also attacked in lampoons and caricatures by the radical press, and especially singled out for vituperation was the notorious Bishop Sparke, the Bishop of Ely from 1812 to 1832, who was infamous for his nepotism and abuse of ecclesiastic patronage.

In this context Turner's imagery takes on a larger meaning. On the left is an approaching storm, and this is surely both a literal and a metaphorical weather-effect, for it could equally denote the threat posed by Reform to the Church of England, just as the reference to the collapse of the tower of Ely Cathedral in 1322 could hint simultaneously at the possible contemporary collapse of the Church of England if it did not take heed of calls for political and social change. And such interpretations certainly receive support from the staffage. As with the children in *Blenheim* (189), the social class of the foreground figures is identifiable by their dress, the boys being poorly clothed and the girls more prosperously so. Obviously they denote the labouring and middle classes angry at the denial of their right to political representation by the obstructiveness of the Church to Reform, the stoning boys also clearly alluding to the stoning of the Anglican clergy in October 1831.

Moreover, this imagery may well contain an additional level of meaning. By 1830 there was a massive depression in British agriculture, resulting from a succession of bad harvests after 1827. The introduction of labour-saving machinery such as threshing machines exacerbated the already desperate economic situation of the rural poor, and led in the winter of 1830–31 to the 'Swing' disturbances, when poverty-stricken agricultural labourers in East Anglia and elsewhere destroyed threshing machines. Although by the following winter the situation had eased marginally in rural areas, and the protests had been successfully suppressed, an industrial slump created fears of renewed disturbance, and here Turner may have been referring both to those threats and to the bleak state of British agriculture generally, especially in view of the fact that the payment of tithes played an important role in depressing agricultural wages. Thus it may be that the boys throwing stones into a depression in the ground, as well as that depression itself, refers to the agricultural depression and related destructiveness that threatened society and the economic basis of the Church at the time. This interpretation receives support from the fact that the pond is in the midst of such a large, bleak area of land. And the harvesters on the right, with their cottages and grainstack nestling beneath the cathedral, may indicate the old harmonious relationship between Church and peasantry that was now threatened, like the Church itself.

Yet another allusion may reside in the family group sitting on the grass at the corner of the nearest house, for they are reminiscent of a Holy Family as seen in traditional religious art, and are therefore highly appropriate to a portrayal of a cathedral. Our sense of the physical complexity of the cathedral is heightened by its contrast with the empty foreground, and Ruskin praised Turner's immense powers of architectural draughtsmanship in the work.

Winter 1831–32
Private Collection, U.K.

30.2 × 41 cm (11$\frac{7}{8}$ × 16$\frac{1}{8}$ in)

22 Pencil study upon which ELY CATHEDRAL, CAMBRIDGESHIRE *was based. Leger Gallery, London.*

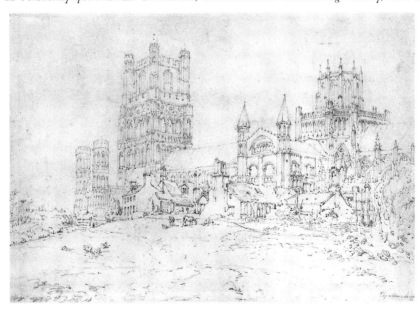

225

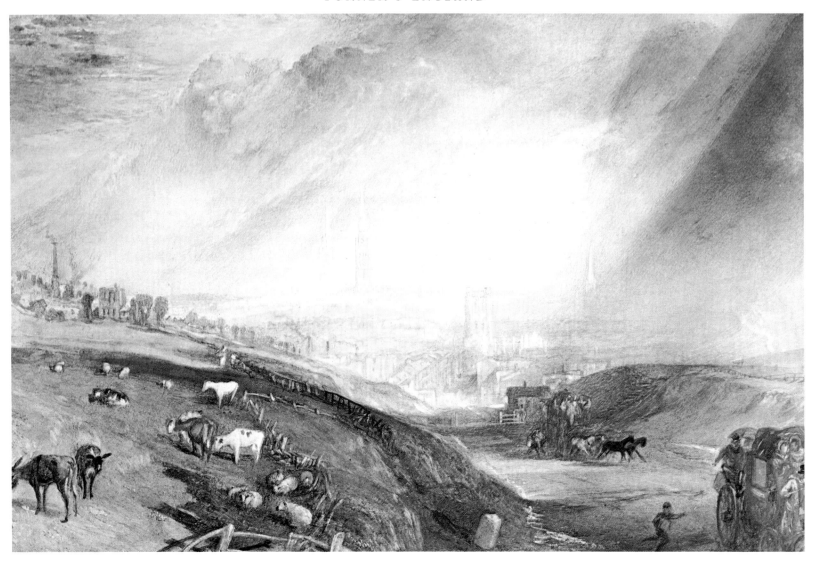

192 COVENTRY, WARWICKSHIRE

A thunderstorm passes away, leaving Coventry gleaming in the brilliant afternoon sunshine. We look south-eastwards down Hill Street, the turnpike road to and from Birmingham. In the foreground a boy runs after the toll being dropped by a coachman – the turnpike can be seen at the bottom of the hill, and the coin is denoted by a tiny scratch on the paper – while another coach follows. On the left, across Hill Fields, may be seen some of the factories that would soon lead to the disappearance of those meadows. Of the three church spires, the leftmost one belonged to St Michael's Church which in 1918 became Coventry Cathedral, destroyed by bombing in 1940. Given that in several of the 'England and Wales' series depictions of churches Turner may have created parallels between threatening storms and the sense of threat felt by the Church of England over the Reform issue, perhaps the sun coming out on

Coventry's churches after a storm may allude to the survival of the Church after the enactment of Reform in 1832.

Ruskin observed the irregular wind denoted by the various palls of smoke blowing in different directions, and how the cattle stand 'stock still and stiff, with their heads down and their backs to the wind'. He also commented memorably that 'Impetuous clouds, twisted rain, flickering sunshine, fleeting shadow, gushing water, and oppressed cattle, all speak the same story of tumult, fitfulness, power and velocity.'[170]

c. 1832
British Museum, London

28.8 × 43.7 cm (11¼ × 17⅛ in)

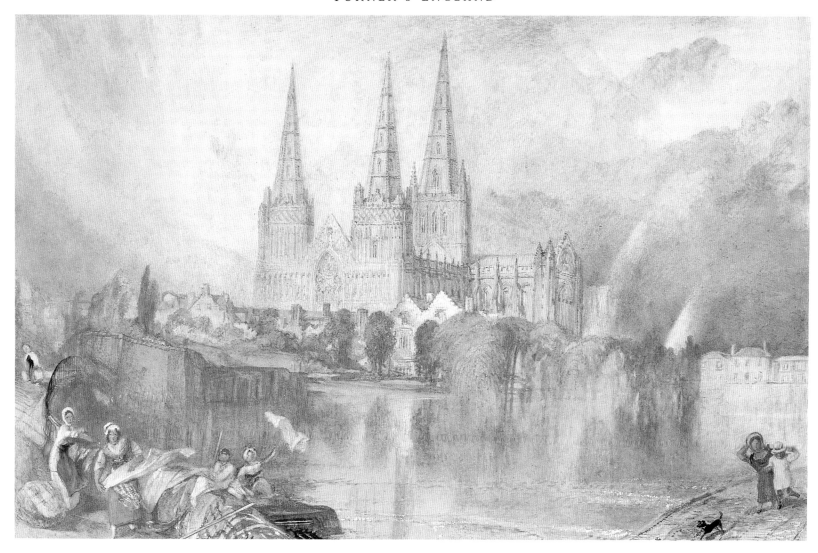

ENGLAND AND WALES
193 *LICHFIELD*

Although this work was never engraved, its size, handling, probable date and subject all suggest that it was made for the 'England and Wales' series.

Turner visited Lichfield on his 1830 tour to obtain further material for the 'England and Wales' series, and the imagery of the work suggests that it was made a couple of years later. A violent westerly wind is coursing from left to right across the scene, as is made clear by the washing being blown upwards at the bottom left and by the children holding their hats to make their way into the teeth of the gale at the bottom right. Yet the cathedral shining magnificently in the brilliant evening sunlight has no problems in resisting the storm, and the double rainbow on the right introduces a complementary allusion, for of course rainbows are traditional Christian symbols of redemption. All this imagery connects allegorically with the state of the Church of England after the threat posed by the Reform of Parliament had passed away in the summer of 1832.

Turner's depiction of the cathedral architecture is especially fine, as is his representation of the multitude of reflections and lights playing across the surface of the cathedral pond.

c. 1832
Private Collection, West Germany

28.6 × 43.8 cm (11¼ × 17¼ in)

227

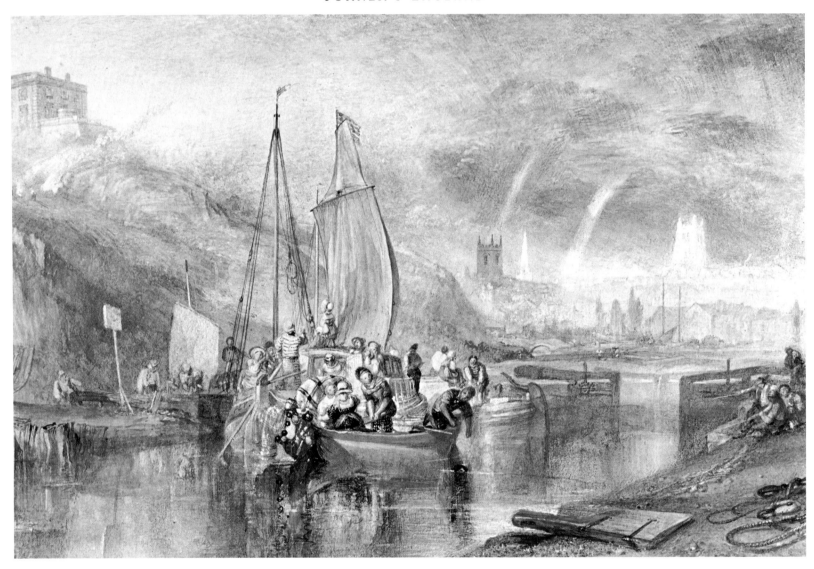

ENGLAND AND WALES

194 NOTTINGHAM, NOTTINGHAMSHIRE

This drawing was based on a design (now untraced) that had been made over thirty-five years earlier and engraved in the *Copper Plate Magazine* of 28 February 1795 (ill. 23). As Ruskin pointed out, 'the one is merely the amplification and adornment of the other. *Every incident* is preserved; even the men employed about the log of wood are there, only now removed far away (beyond the lock on the right, between it and the town) . . . The canal bridge and even the stiff mast are retained; only another boat is added, and the sail dropped upon the higher mast is hoisted on the lower one; and the castle, to get rid of its formality, is moved a little to the left so as to hide one side. But evidently no sketch has been made. The painter has returned affectionately to his boyish impression and worked it out with his manly power.'[171] Yet while Ruskin compared the two images, he failed to see *why* Turner had returned to the subject.

The watercolour clearly celebrates the passing of the Reform Act in 1832. Nottingham Castle was owned by the Duke of Newcastle who under the old parliamentary system had been 'notorious for the number of pocket boroughs in his possession'[172] and who in 1829 and 1830 had provoked national anger by evicting tenants who had voted for parliamentary reform; as *The Times* of 29 September 1830 commented, when aristocrats like Lord Newcastle, 'expel honest men from their habitations for exercising a constitutional right . . . they . . . have perpetrated a *coup d'etat* against the people of England which they, the people . . . may be apt to repay.'

The warning was prescient, for when the second attempt to pass a Reform Bill through Parliament was defeated in the House of Lords by a narrow majority in October 1831, the people filling Nottingham for the annual Goose Fair were so incensed that they mobbed Nottingham Castle and burnt it down. Turner clearly alluded to this firing by depicting stubble being burned immediately beneath the castle. The letterpress issued with the engraving of this design referred directly to the burning, although naturally, because of Turner's potential public for the engravings, it

was rather circumspect on the subject, stating that 'about two years hence [the castle] was attacked and devastated by a lawless mob, out of spite to the noble owner, His Grace the Duke of Newcastle whose political principles were obnoxious to the liberal population of the town'. The burning of the castle was also mentioned in the descriptive notice accompanying the title of the drawing in the 1833 exhibition catalogue.

On 7 June 1832 the Reform Act was finally passed and the long process towards modern parliamentary representation was initiated. Thus in front of a castle that represents Reaction, we see the low sail of the 1795 engraving finally being hoisted and a dense jumble of boats and people preparing to disperse and move off through the now-open lock-gates. Above the sails in the centre may be spied the Greek flag, a potent symbol of liberty in 1832. In the bottom right-hand corner are a discarded rope and tackle, as well as a rudder that exactly resembles a butcher's cleaver (complete with blood-red handle) which have all been laid aside as unnecessary. And once again the elements extend the allegory, for a storm is passing away to reveal rainbows and the town and churches glistening in the brilliant evening sunshine.

The rudder not only resembles a butcher's cleaver; equally it reverses and amplifies the shape of the lock-gate above it, a typical Turnerian visual simile. The conglomeration of boats and people in the centre prefigures the similar arrangements of vessels and staffage that are encountered in the richly hued Venetian pictures that

Turner often painted after 1833. The composition is structured by the strong diagonal of Castle Rock meeting the diagonal of the near bank of the canal on the right. The pale shadows on the canal beneath the lock-gates are especially luminous, and the representation of reflections in this drawing inspired one of Ruskin's most perceptive passages in *Modern Painters*, where he discussed Turner's accuracy in depicting the reflection of the white signpost on the left, noting that instead of the sign appearing as a white shape against the dark base of the hill, it is reflected as a dark shape against the golden upper reaches of the hillside. Ruskin cited this as an example of Turner's ceaseless investigation of every minor visual fact and commented that he did 'not know that any more magnificent example could be given of concentrated knowledge.'[173]

The locale shown here was known as 'the Castle Meadows', and in the years after 1795 when Turner visited the neighbourhood, it gradually became one of the major slum areas in the centre of Nottingham, so that by 1832 the painter would barely have recognized it. The castle itself was not restored until long after the 1831 fire. Only in 1875–78 was it renovated to become the first municipal museum of art in England. This magnificent watercolour now appropriately hangs there.

Summer–Autumn 1832
Museum and Art Gallery, Nottingham, U.K.

30.5 × 46.3 cm (12 × 18¼ in)

23 Engraving by J. Walker of Turner's 1794–95 drawing of NOTTINGHAM. *British Museum, London.*

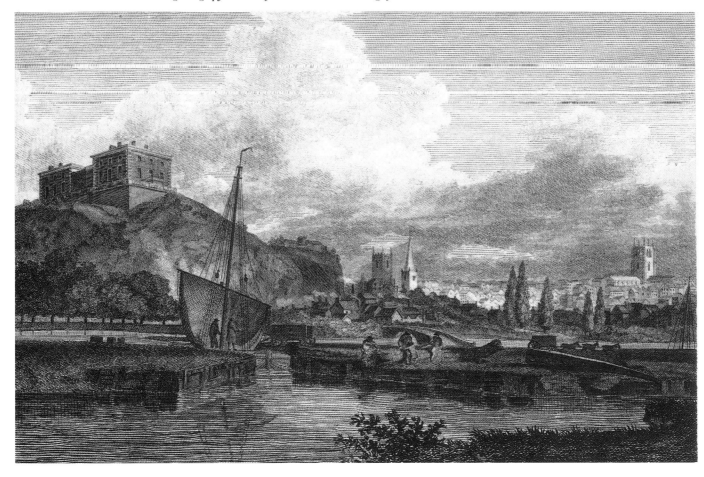

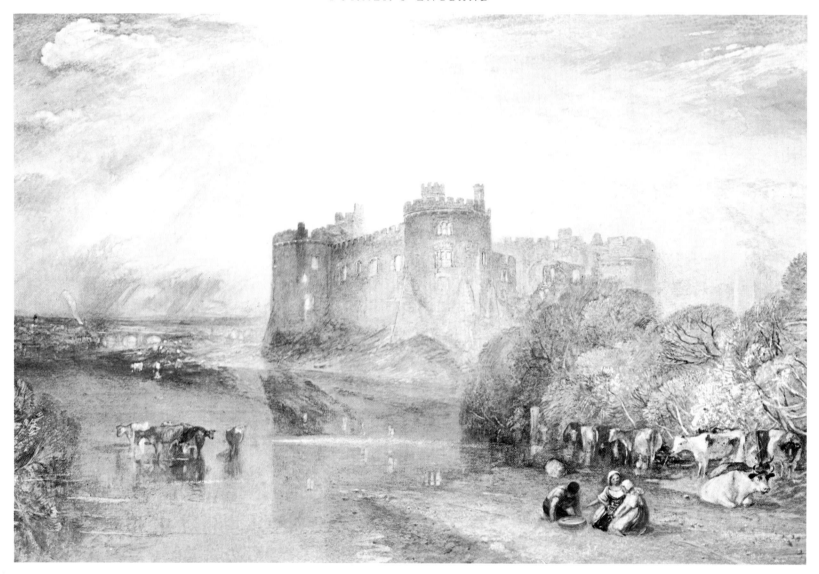

195 CAREW CASTLE, PEMBROKESHIRE

Carew Castle dates from the thirteenth century. It was enlarged in the fifteenth century and destroyed during the Civil War. The building remains one of the most impressive ruins in Wales, and Turner visited it in 1795, on his third Welsh tour.[174]

This is another of the landscapes exhibited in the 1833 watercolour show where the colouring does indeed seem rather hot. We view the castle from the north-west in morning light, with the seventeenth-century Pack Bridge at Carew in the distance. On the right Turner employed poetic licence in bringing the tower of Carew Cheriton Church into the design, for in reality it is over a mile away and is not actually visible from this spot. The painter also appears to have had some trouble with the cows on the left, for they are much too small in relationship to the cattle on the right, and additionally the perspective seems all wrong, with the far bank of the Carew running slightly uphill. Moreover, the representation of the distant part of the scene (with its crudely painted pall of smoke) lack the artist's usual sense of conviction. But even Turner's failures are more interesting than the successes of many another artist, and the image offers incidental beauties, not least of all the massive castle itself.

c. 1832 30.5 × 45.7 cm (12 × 18 in)
City Art Gallery, Manchester, U.K.

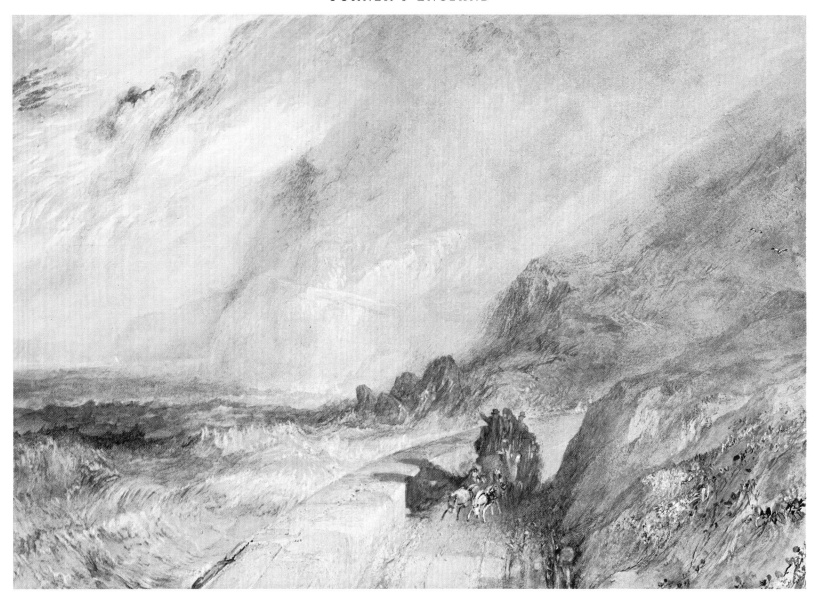

196 PENMAEN-MAWR, CAERNARVONSHIRE

The 457-metre (1500-foot) high mountain, Dinas Penmaen, drops almost vertically into Conway Bay at Penmaenmawr midway between Conway and Bangor in north Wales, and it proved an insuperable barrier to the Romans, who bypassed it when building their coast road. A later road was built over the mountain, and it can be seen crossing Dinas Penmaen to the left of centre (the modern coast road was drilled *through* the mountainside). Yet even after a sea wall was constructed in 1772 and various other improvements were made, the road continued to be very dangerous, especially in stormy weather (as here). The close proximity of the sea afforded one difficulty of course, but another was the constant threat of landslides; as the letterpress for the engraving of this design tells us, 'the earth being washed away by torrents and rent by severe frosts, fragments sometimes fall, and for a time render the road utterly impassable'.

Given these perils it is not surprising that the stagecoach is making a dash for it. The horses are tiny, but perhaps Turner intentionally diminished them so as to increase their work-load in pulling the heavy stagecoach. The composition is structured by the curves that parallel the sea wall, and the reddish colouring, although unnaturalistic and perhaps affected by fading and yellowing, nonetheless still seems convincing rather than unduly hot. In *Modern Painters* Ruskin praised the bank of earth on the right as 'the standard of the representation of soft soil modelled by descending rain'.[175]

c. 1832
British Museum, London

31.2 × 44 cm (12¼ × 17¼ in)

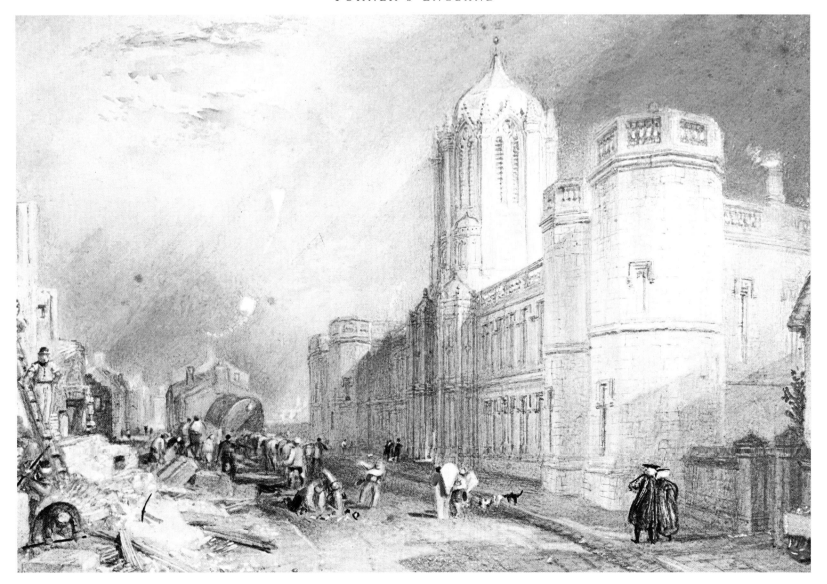

197 CHRIST CHURCH, OXFORD

A clear allusion to the underlying purpose of Oxford may be apprehended on the extreme right, where a table is loaded with prize cups and rosettes (the details are clearer in the engraving). As tables loaded with prizes are not usually to be seen in St Aldate's Street, in this context it must refer to academic distinction, and the allusion seems to be matched by the building works opposite. These are indicated on the sketch from which Turner developed this design,[176] but he had anyway often witnessed builders at work in Oxford, and he reintroduced them into the majority of his portrayals of Oxford colleges not only because the buildings were frequently under repair in reality, but probably also because he fancied that Oxford contributed towards the building of knowledge.

Turner had drawn Christ Church and its impressive Tom Tower many times before,

especially in the 1790s, and he was at his most dashingly confident here, with a rich interplay of tones on the shadowed side of the building and the brightness of the late afternoon sunlight on its southernmost tower being intensified through contrast with the black gowns and mortar boards of the two rather crabby dons passing immediately in front of it. They are walking towards some carefree, kite-flying youths who are perhaps the object of their coming academic attentions, while the adjacent dogs nosing each other introduce a relevant (and witty) note of enquiry.

c. 1832
Private Collection, U.K.

29.9 × 41.9 cm (11¾ × 16½ in)

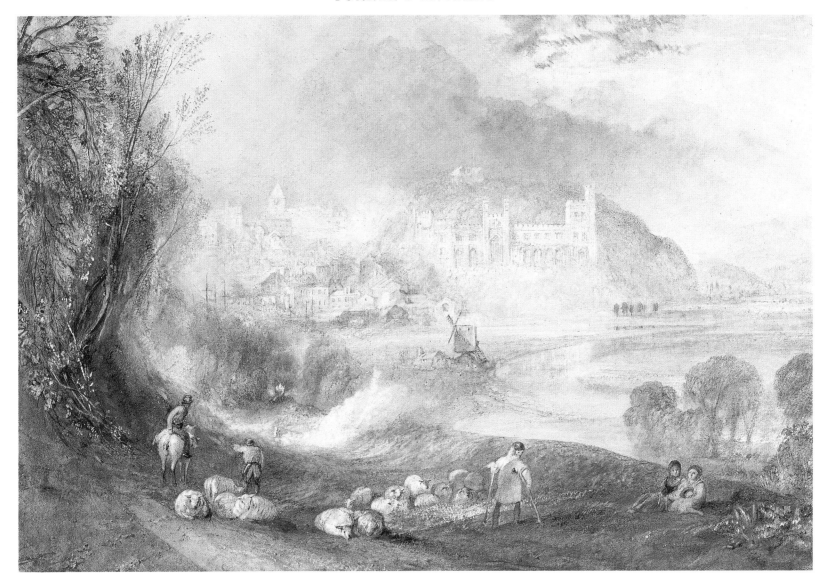

198 ARUNDEL CASTLE, SUSSEX

We look down the Worthing road towards the castle gleaming in the afternoon sunshine, with rain in the distance, Turner's customary association for Arundel (see 88 and 92). From the direction of the smoke and the girls sitting on the presumably dry ground, we can tell that the rain is approaching, something that is also made clear by the town's envelopment in the downpour. At the bottom of the hill the Worthing stagecoach simultaneously approaches, and visible by the Arun is the windmill drawn by Turner in close-up elsewhere. The colour range of the work is dominated by soft yellows and greys, and it conveys the habitual cool moistness of an English summer's day with great precision.

In the foreground a crippled shepherd is both looking at the seated girls and pointing towards the reclining sheep, as though to say 'you all sit but I have to stand, and on crutches at that'.

c. 1833

29.6 × 43.4 cm (11⅝ × 17⅛ in)

Private Collection, Canada (On loan to Toronto Art Gallery)

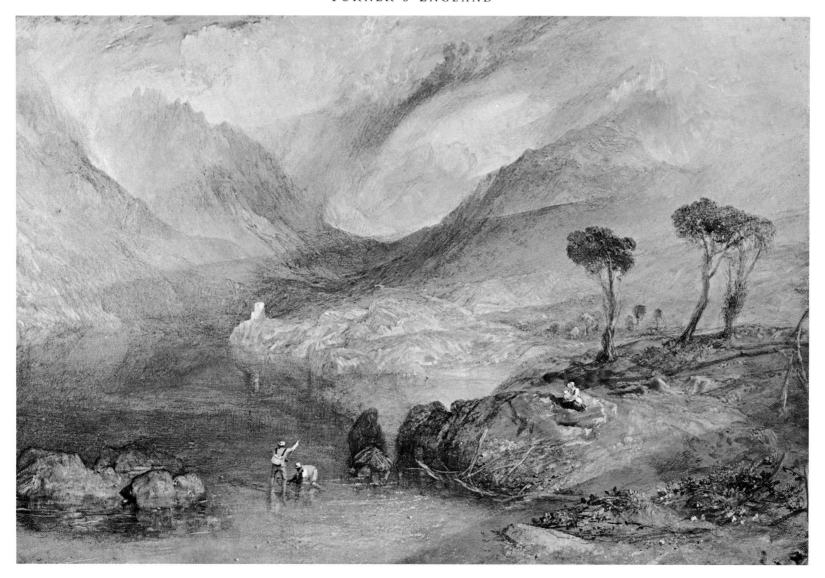

199 LLANBERRIS LAKE AND SNOWDON, CAERNARVONSHIRE

The building on the promontory in the middle-distance is Dolbadarn Castle which Turner had painted in 1800 in an important work that he gave to the Royal Academy upon his election as an Academician in 1802.[177] In that picture he had represented the castle from immediately below, and had both heightened the surrounding mountains and brought them closer together so as to make the castle seem very hemmed in, thus amplifying our sense of the entrapment of the Welsh prince who was imprisoned there. Here, however, Turner took a more distant viewpoint of the castle and opened out Llanberis Pass to give us the summit of Mount Snowdon at the top-right. The relative smallness and scarcity of the staffage served by contrast to enhance respectively the vast scale and emptiness of the valley.

The trees beyond the mother and child may incorporate an artistic memory, for

Turner held Rembrandt's etching of *The Three Trees* in very high regard,[178] and the trio of windswept stone pines look rather like Rembrandt's group of trees, although they have clearly been separated so that they are not bunched beneath Snowdon, the gap allowing the eye to move upwards. The detailing of the herbage at the bottom right, and of the lake beside the fishermen, is especially fine. The composition is firmly unified by the two massive diagonal lines of shadow, but there is also a fitfulness and disconnection in both the play of light and the distribution of the trees and figures that is very apt to the portrayal of such wild scenery.

c. 1832

National Gallery of Scotland, Edinburgh

31.4 × 47 cm (12⅜ × 18½ in)

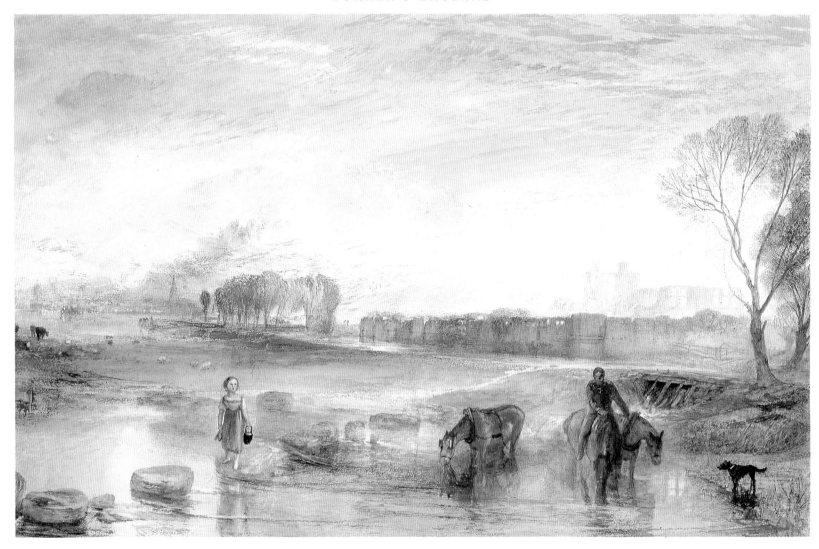

200 LEICESTER ABBEY, LEICESTERSHIRE

Ruskin had problems with this watercolour (which he once owned), for he found it impossible to account for a *full* moon rising adjacently to a setting sun, as in reality only a new moon can appear in the same quarter of the sky as a sunset.[179] Yet the letterpress of the engraving of this design clearly suggests why Turner perpetuated such a solecism, as well as why he complemented that apparent error with a river-crossing:

> The abbey was especially noted as the place where Cardinal Wolsey died . . . stripped of his dignities and wealth and humiliated by his Royal Master Henry VIII He was so weak and depressed when he reached the . . . abbey that he could only thank the abbot and monks for their kindness and tell them that he was to lay his bones among them, in which he proved a true prophet, for he immediately took to his bed and died three days later.

During the 1830s Turner frequently used moonrises in conjunction with sunsets to denote both the coming of night and the immanence of death,[180] and here their close juxtaposition complements the symbolism of the girl crossing the river Soar, evidently to denote Wolsey's passage from life to death in Leicester Abbey. The desolate mood is extended both by the ruins and by the bleak expanse of flooded fields stretching away southwards to Leicester in the distance.

c. 1832
The Art Institute of Chicago

29.5 × 45.5 cm (11⅝ × 17⅞ in)

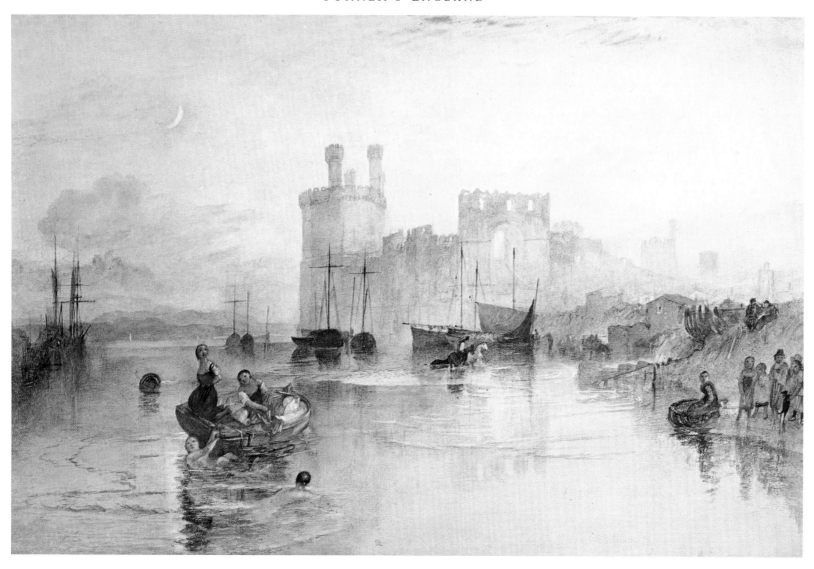

201 CAERNARVON CASTLE, WALES

Turner had made a number of representations of Caernarvon Castle in the late 1790s, including an unusual oil sketch and an exhibited watercolour of the castle depicted from roughly the same position as seen here.[181] Those early works were heavily influenced by Richard Wilson in both style and colouring, and although by the 1830s Turner's style had changed and his colour intensified, nonetheless the association of Caernarvon with a Wilsonesque golden evening light and poetic feeling remained.

Around 1833, as now, the sight of young girls bathing naked in Caernarvon Harbour would have been deemed rather unusual, and that perhaps accounts for the crowd of onlookers at the right. But it is evidently a very hot evening, for even the horses in the distance are being taken for a dip, and maybe these are not ordinary girls but naiads, of the type that Turner had often portrayed in settings he deemed especially

magical. The painter's customary genius for thinking through the ramifications of his imaginings can be seen at the corner of the nearby boat where it tilts as one of the girls launches herself into the water.

Clearly the whole sheet was first washed with yellow and ultramarine blue before being overpainted, and the colouring of the castle as it catches the last rays of direct sunlight is especially lovely. Turner diminished the size of the horses, boats and buildings immediately in front of the castle so as to augment it in scale by contrast, and across the Menai Strait the Anglesey hills appear to be of alpine dimensions.

c. 1833
British Museum, London

27.8 × 41.8 cm (10⅞ × 16⅜ in)

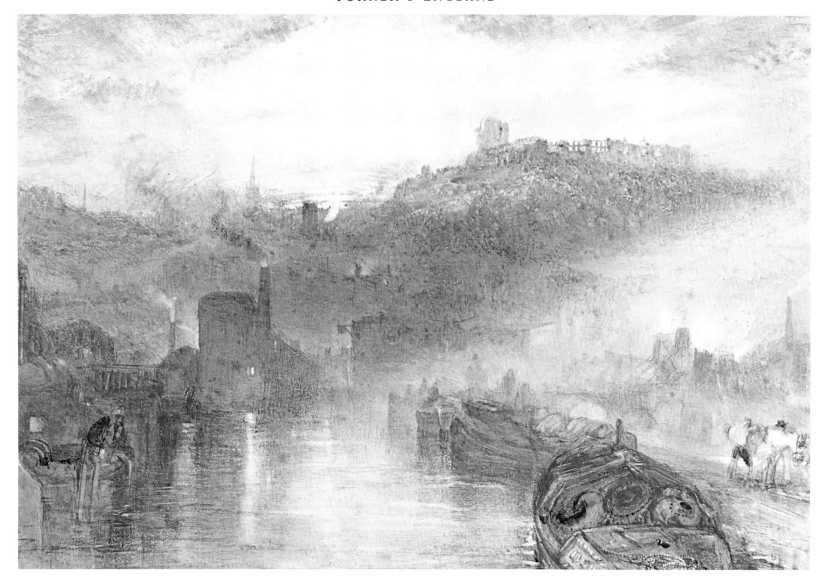

202 DUDLEY, WORCESTERSHIRE

This is another of Turner's definitive images of the Industrial Revolution. On the skyline a new moon rises just after the sun has set, and as we have already noted in *Leicester Abbey* (200), during the 1830s Turner frequently employed the conjunction of a moonrise and sunset to induce associations of the passing of life and the coming of death. Here the new moon seems to amplify what is happening to the landscape, where the old order of things represented by the ruined castle and Cluniac priory just catching the last rays of sunlight, is being replaced by a nightmarish industrial disorder. To point up this replacement, Turner also aligned a smoking factory-chimney beneath a distant church spire: henceforth chimneys will be the major verticals to dominate a landscape.

Below the sunset and moonrise all is ceaseless industry, gloom and glare. From left to right we see a steam-pump which created the currents helpful to barges, of the type that was known to have been at Dudley after 1841; then a welter of dingy buildings, including a warehouse with a joist and crane jutting out from it; and finally a huge arc of reddish light being given off by a hideous landscape of furnaces, foundries, potteries and glass-works. At the bottom right is a barge loaded with sheet-iron hoops, and the vessel is usefully entitled with the name of the town.

c. 1833
Lady Lever Art Gallery, Port Sunlight, U.K.

28.8×43 cm ($11\frac{1}{4} \times 16\frac{7}{8}$ in)

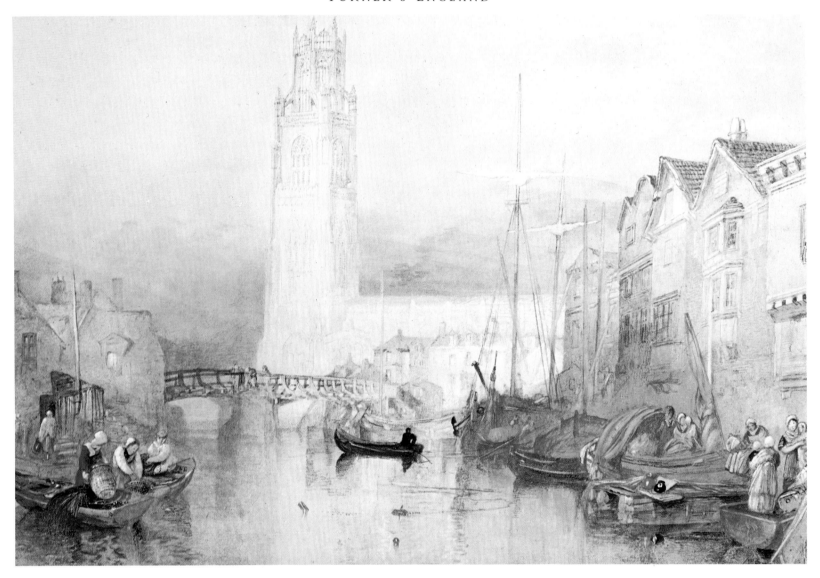

ENGLAND AND WALES

203 BOSTON, LINCOLNSHIRE

In medieval times Boston was the leading port of the English wool trade but it gradually declined as the river Witham silted up. Here, in evening light, we look north-westwards from the docks on the Witham towards St Botolph's Church with its magnificent 86-metre (282-foot) high tower, the so-called 'Boston Stump'. For once Turner shrank rather than heightened a building, for the tower is actually much higher in relation to its surroundings than it appears here. To compensate for this deficiency the painter made the houses in front of the church very small, but due to their relative pictorial unimportance they fail to establish the enormous height of the church by contrast. The drawing also contains an anachronism, for Turner had developed this design from a pencil drawing[182] made in 1797 and by the 1830s the

wooden bridge had long disappeared, having been replaced in 1807 by an iron one.

All is calm as eel-traps are lifted from the river and children are bundled up for the night. The foreground is enlivened with sharp touches of red, which contrast with the soft blues of the sky, and the softness of the light upon the church tower is intensified by the contrasting black tones of a fishing boat before it. To the right of the 'Boston Stump' the crosses formed by the masts and furled sails of two boats were perhaps intended to introduce an apt religious note.

c. 1834 28 × 41.9 cm (11 × 16½ in)

Private Collection, U.K.

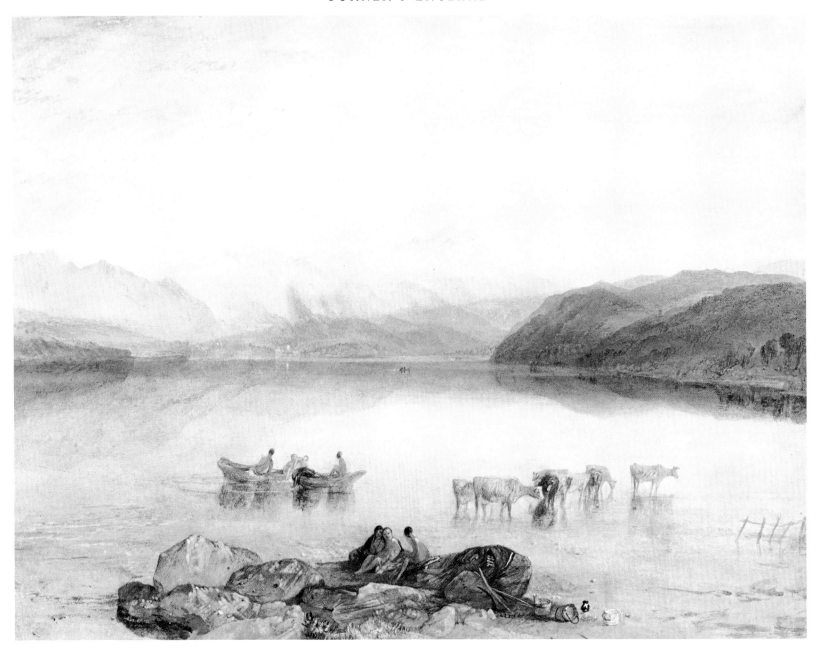

204 ULLSWATER, CUMBERLAND

We look south-westwards from Gobarrow Park (on the north side of Ullswater), with Helvellyn catching the evening light. Turner probably based this drawing upon sketches of Ullswater he had made on his first visit to the Lake District in 1797, and in broad terms it represents the same panorama as appears in a richly detailed watercolour[183] he made around 1815, although here we see the lake from a lower viewpoint, nearer to the shore. In the earlier work cows are being shooed out of the lake by a herdsman; now some milkmaids have abandoned their pails and joined their cattle in the water to escape from the heat, although because it would have been well-nigh impossible to have witnessed nude bathing in Ullswater in the 1830s, these girls might equally be naiads. The landscape certainly merits such unearthly creatures.

The watercolour is remarkable for its limpid mood, and the blue-yellow colouring certainly projects the heat that has compelled the girls to go bathing, although fortunately it never tips over into garishness, unlike some of the earlier 'England and Wales' watercolours that enjoy the same general palette.

c. 1834
Brian Pilkington, Esq.

33 × 42.6 cm (13 × 16¾ in)

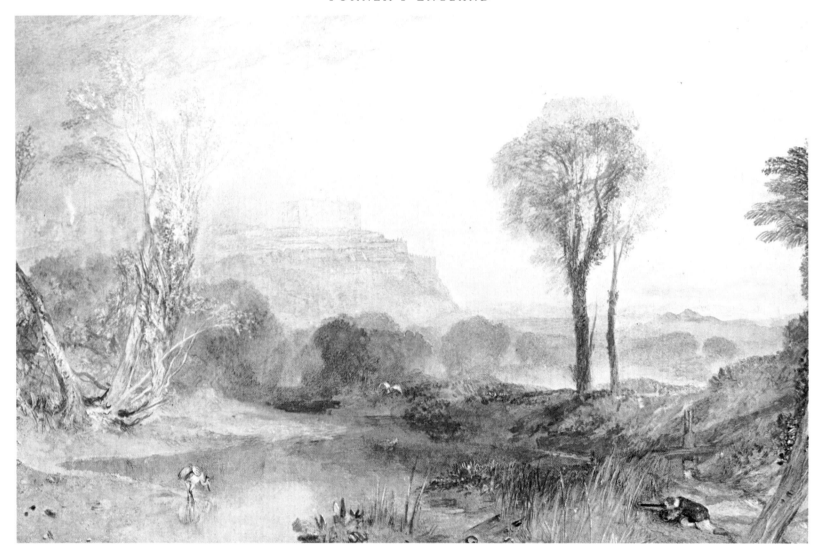

ENGLAND AND WALES
205 POWIS CASTLE, MONTGOMERY

Powis Castle dates from the late thirteenth century, although it was greatly expanded in Elizabethan times. Turner visited the building in 1798 and from a sketch made then[184] he later created this poignant reminder of the loveliness and brevity of life.

At the left is a heron, unaware of the hunter on the right who is positioning himself for his kill. Immediately above the bird are some beautifully florescent elder trees. The gap between them amplifies the U-shape of the bird's neck, thus enforcing the connection between bird and trees, and their golden, luxuriant foliage seems to project the sense of life within the bird itself. Beyond the hunter are two maple trees whose straight trunks similarly amplify the aiming of his gun. In the distance is another bird situated midway between the heron and the hunter at the apex of the shallow triangle

formed by the lines of the river Severn. Given its size, this too is probably a heron rather than any other type of bird, and its important balancing position in the composition may have been intended to suggest that the life of the nearer heron is in the balance, which assuredly it is. Other associations of death are subtly projected elsewhere. On the right is a sluice-gate that can enforce a sudden termination, just like the hunter, while to the left of the man is a circular handled door that not only props up the riverbank but also looks like a coffin lid.

c. 1834
City Art Gallery, Manchester, U.K.

28×48.9 cm ($11 \times 19\frac{1}{4}$ in)

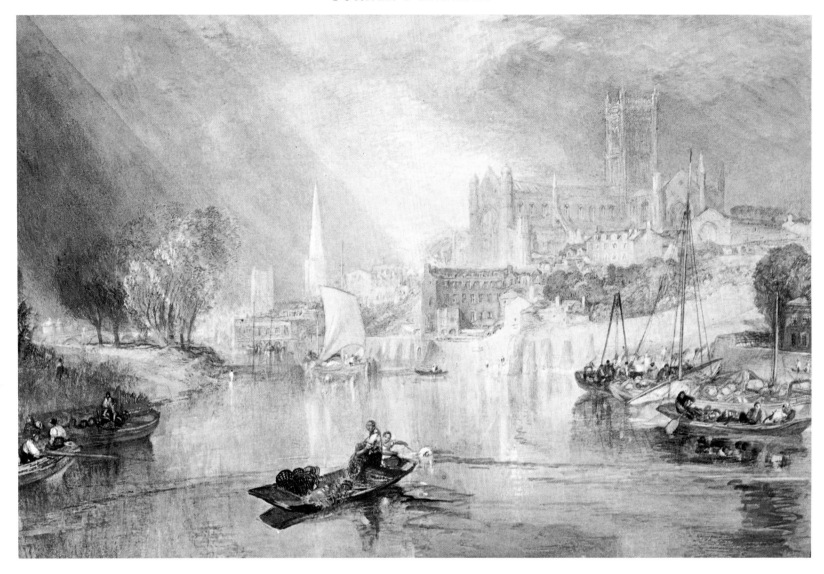

206 WORCESTER, WORCESTERSHIRE

Both Worcester and the river Severn form vital links between the industrial Midlands and access to the sea from Gloucester. Turner based this watercolour on sketches he made on his tour of the Midlands in 1830.[185]

Once again a cathedral has weathered a storm, perhaps thereby denoting the weathering of the storms of change that had taken place around 1832. The new-found sunshine gives the scene a brilliant intensity, and the freshness of colour demonstrates how well Turner could employ green, a colour he did not normally much care for. Here it serves to heighten by contrast the intensity of the reddish sandstone colour of the cathedral, as does the broad ultramarine blue of the sky beyond the building. These intensifications are also augmented by the small dab of unadulterated ultramarine on the boat in the foreground, where some girls are trapping eels.

c. 1834 29.2 × 43.9 cm (11½ × 17¼ in)
British Museum, London

ENGLAND AND WALES
207 LLANTHONY ABBEY, MONMOUTHSHIRE

Llanthony Priory, in the Black Mountains in southern Wales, was an Augustinian foundation dating from the twelfth century. Turner visited the ruin on his very first Welsh tour in 1792 and created several depictions of it around 1794. This watercolour may have been developed from the sketch made on the 1792 tour from which he had also worked up those much earlier designs.[186] All of the watercolours show the building from an identical viewpoint across the Honddu river, and with the same wet and windy weather conditions.

Ruskin owned this drawing, and he wrote that it set 'the standard of torrent drawing The whole surface is one united race of mad motion . . . The rapidity and gigantic force of this torrent, the exquisite refinement of its colour, and the vividness of [its] foam . . . render it about the most perfect piece of painting of running water in

existence.'[187] No less perfect is Turner's depiction of the central band of shadow falling from the right, which was achieved by washing dark tones onto the wet paper, allowing them to 'bleed' into lighter areas, and then adding the details later. The painter's tonal control is at its most masterly in his representation of the distant ruin, which is rendered in barely perceptible tones of white and grey, and the vagueness of the distant forms as seen through rain is intensified by the contrasting sharpness of the boys and foliage in the foreground.

c. 1834 29.8 × 42.6 cm (11¾ × 16¾ in)
On loan to the Indianapolis Museum of Art from the Kurt Pantzer Collection, U.S.A.

208 LONGSHIPS LIGHTHOUSE, LANDS END

The Longships Lighthouse, off the southernmost point of mainland Britain, was still a relatively recent building when Turner painted this watercolour, for it had only been constructed in 1794–95. Due to its extremely exposed and dangerous position it was considered to be a triumph of modern engineering.

However, Turner did not celebrate that achievement here, for this is yet another of his ironic and pessimistic statements of the failure of lighthouses to prevent shipwreck, and perhaps the greatest of them. All is desolation and the futility of human aspirations, with the near part of the scene littered with wreckage, the mast of a foundering vessel being apparent on the rocks in the centre. The eye is led to the distant light by the line that runs down the contours of the cliffs and up through the waves and wreckage, and the seagulls ascending to the right augment the sense of movement.

The sea is charged with immense energy; as Ruskin commented, its whole surface is 'one dizzy whirl of rushing, writhing, tortured, undirected rage, bounding and crashing, and coiling in an anarchy of enormous power.'[188] Only the torches borne by some distant and virtually invisible figures on the cliffs attest to any living human presence in the scene.

c. 1834 28.1 × 43.2 cm (11 × 17 in)
The J. Paul Getty Museum, Malibu, California, U.S.A.

209 THE BURNING OF THE HOUSES OF PARLIAMENT

The date, size, handling, type of detailing and subject of this watercolour all strongly suggest that it was made for subsequent engraving in the 'England and Wales' series. Like *Northampton* (190) it portrays a contemporary event, which is perhaps why it was also never engraved for the scheme – Charles Heath may have found both works over-topical. Turner was far too busy during the 1830s to have produced such a highly detailed drawing simply for his own amusement, and the size of the work suggests that it could only have been created at that time for engraving in the 'England and Wales' scheme.

Turner is known to have watched the burning of the Houses of Parliament on the night of 16–17 October 1834 from a boat on the Thames,[189] and doubtless he also mingled with the crowds watching the fire on shore. In addition to this watercolour he produced two magnificent oil paintings of the subject,[190] as well as a vignette

discussed below (227).

We look northwards across Old Palace Yard, with Westminster Abbey visible on the left and the peaked roof of Westminster Hall apparent beyond the jets of water to the right of centre. Turner subtly stressed the rectilinearity of the architecture on both left and centre so as to augment by contrast the spectacularly uncontrolled nature of the conflagration on the right, and the intensity of the fire is augmented by the darkest area of tone in the entire work being located immediately beneath it. The flow of the crowd, as well as the marvellously virtuoso paint handling, charges the whole scene with immense energy.

c. 1834
Clore Gallery for the Turner Collection, London

29.3 × 44 cm (11½ × 17¼ in)

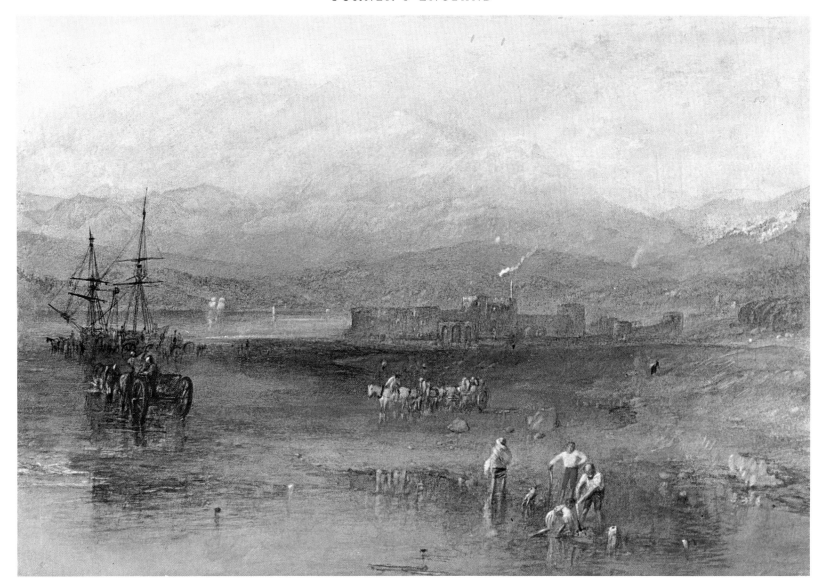

210 BEAUMARIS, ISLE OF ANGLESEA

Like a number of watercolours discussed below (211–16 and 253), this drawing was completed before 31 August 1835, for Charles Heath acknowledged receipt of the works in a letter of that date.[191]

Turner visited Anglesey in 1798, on his fourth tour of Wales, although no sketches of Beaumaris Castle have been identified in his sketchbooks.[192] The castle was built in the thirteenth century by Edward I to control the rich corn-lands of Anglesey, and originally ships could sail right up to it, but by Turner's day the shoreline had receded. The shipping beached at low tide can be seen on the left. 'Beaumaris' means 'beautiful marsh' and that marshiness is evident in the large empty space that stretches out before us. In the distance beyond the Menai Strait is the chain of mountains leading up to Snowdon, and they seem almost unreal in the evanescent evening light, their tonal delicacy being heightened by the opposed strong touches of emerald green, ultramarine blue and vermilion on the breeches of the mussel-gatherers in the foreground.

Summer 1835 29.5 × 42 cm (11⅝ × 16½ in)
Henry Huntington Museum, San Marino, California, U.S.A.

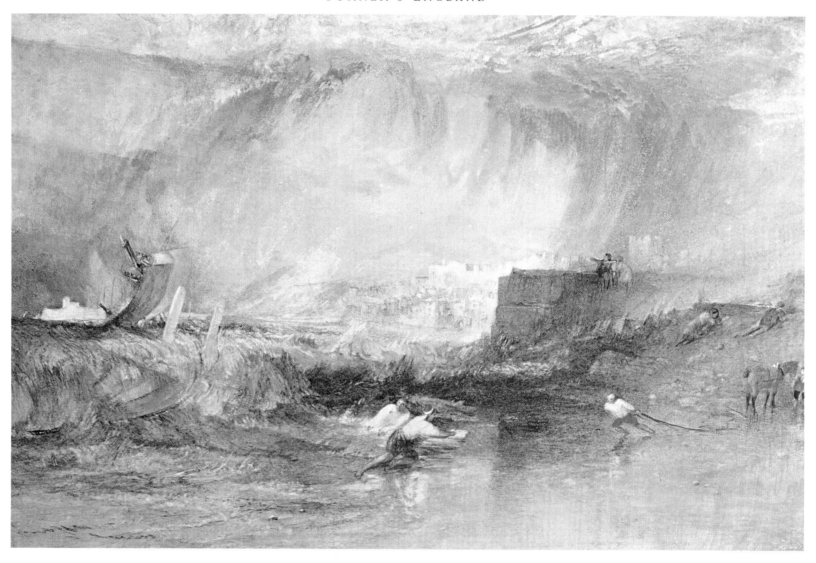

ENGLAND AND WALES
211 LYME REGIS

Here Turner pushed watercolour painting to the frontiers of expressionism, so dynamic and emotionally charged is the handling. The sky especially was rendered with an unusual degree of freedom that seems perfectly suited to the frantic human activity going on beneath it.

Shining brightly in the distance on the left is the Cobb, the eighteenth century breakwater depicted also in the 'Southern Coast' series view of Lyme Regis (23). Before it can be seen a typical Turnerian nautical jumble, comprising the broken mast and foretop of a sinking ship appearing beyond the loose-footed sails of a smaller vessel perhaps going to its aid, and some stanchions being thrown up by the breakers. On the beach two men heave more wreckage out of the sea, while others prepare to attach it to

a horse-drawn line and pull it ashore. In front of a fictional breakwater on the right are some drowned corpses, while on the groin two men look towards the wreck. Beyond them Lyme Regis appears in brilliant light, and its downwardly curving shoreline seems subtly to express the fact that the extremely low town regularly suffered from flooding during spring tides, a liability mentioned in the letterpress that accompanied the engraving.

Summer 1835
Cincinnati Art Museum, U.S.A.

$29.2 \times 44.8 \, \text{cm} \, (11\frac{1}{2} \times 17\frac{5}{8} \, \text{in})$

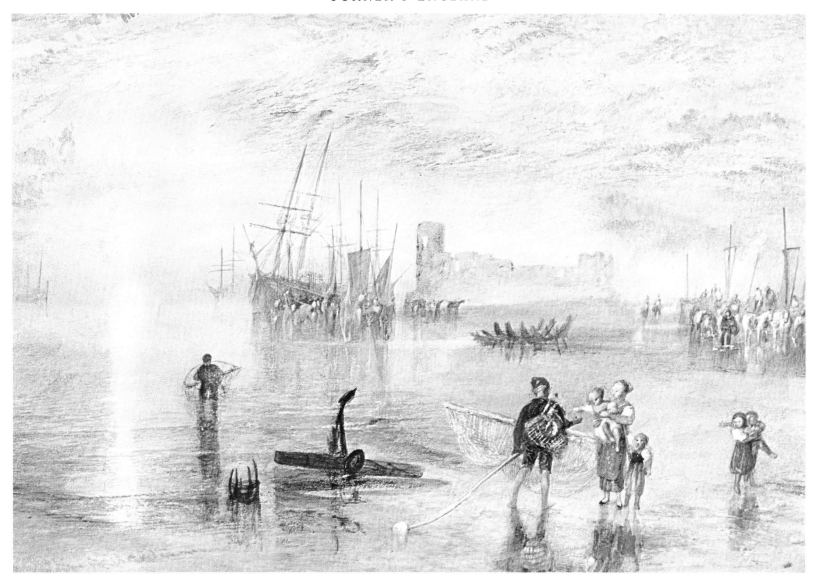

212 FLINT CASTLE, NORTH WALES

Turner initially visited Flint Castle in 1794, on his second foray into Wales, and subsequently he produced two views of it that were engraved in 1795 and 1797.[193] Later he made a mezzotint print of the building in the 'Liber Studiorum', as well as a watercolour dating from the 1820s.[194]

Without doubt, however, this is his loveliest depiction of the castle – indeed, it is one of the most beautiful works he ever created, with its wonderfully wrought cloudscape and superb detailing of the waves and beach. There is some uncertainty as to whether we are looking at a sunrise or a sunset here, mainly because of the omission of the Wirral peninsula across the river Dee, an absence that lessens our certainty as to the direction in which we are looking. However, it seems likely that the sun is rising, given that the shrimpers are clearly on their way to work. One of them seems to be giving a shrimp to a child.

The depiction of the sun and its reflection demonstrates Turner's technical confidence at full stretch: probably using a damp sponge, he simply wiped them out from the initial underlying wash of colour. In the foreground the strong shocks of emerald green and vermilion, as well as the dark tones of the anchor and the shrimper's garb, all serve to augment the colouristic and tonal richness of the landscape beyond, while in the distance the lack of firm demarcations on the beach makes the castle and its surroundings seem to float amid the mists rising off the flats at low tide.

Summer 1835
Private Collection, U.K.

26.5 × 39.1 cm (10⅜ × 15⅜ in)

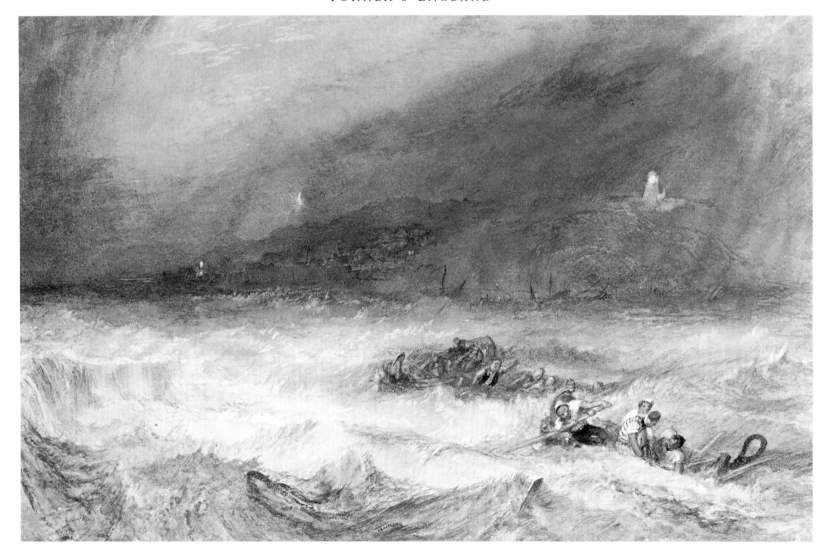

213 *LOWESTOFFE, SUFFOLK*

Topographically this scene is very similar to the view of Lowestoft that appears in the 'East Coast' scheme (128), and once again Turner addressed the failure of lighthouses to prevent shipwreck, with the upper and lower lights at Lowestoft winking out their futile warnings and boats searching amid rough seas for either survivors or salvage. Lowestoft was the home of the world's first effective lifeboat, the *Francis Ann*, launched in 1807, but unfortunately it was also the home of some quite infamous wreckers who in 1821, for instance, had forced the lifeboat to turn away from a wreck they had claimed as salvage, even though the sinking ship was still manned by some of her crew. Consequently four lives were lost.

As in the 'Southern Coast' watercolour, the vista is rather bleak and monochromatic, and Ruskin praised the work as a model of colouring composed almost entirely of variations of grey.[195] At the lower right a boat dips beneath the trough of a wave, the kind of effect that few other marine painters have ever effectively portrayed.

Summer 1835
British Museum, London

27.5×42.7 cm ($10\frac{3}{4} \times 16\frac{3}{4}$ in)

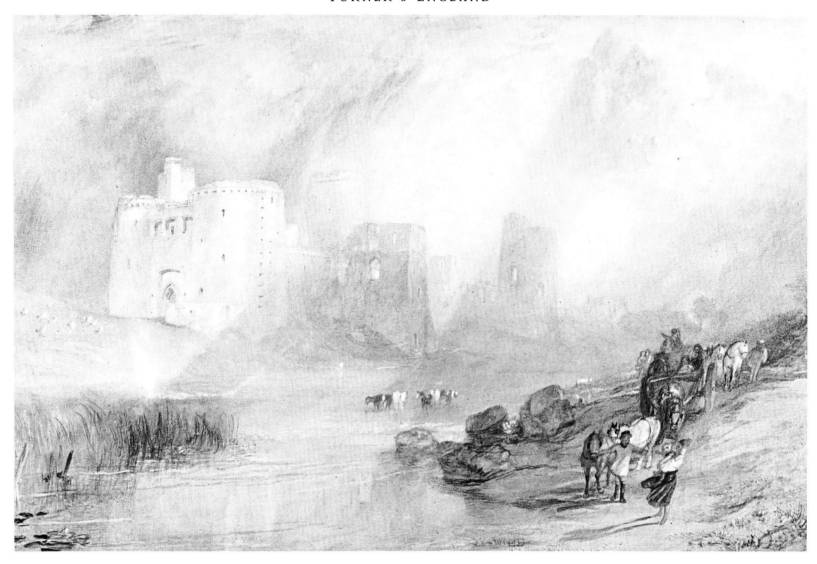

ENGLAND AND WALES
214 KIDWELLY CASTLE, SOUTH WALES

In this unusually beautiful drawing, rain-clouds pass away to leave Kidwelly Castle looking ethereal in the moist, early morning light. The subtle yellows, pinks and mauves of the building and far bank of the Gwendraeth Fach contrast with the brilliant whites, greens and blues of the foreground, where the emergent sunlight enforces a much firmer definition of form. In the river are some rather miniscule cattle whose diminution was clearly intended to augment the scale of the castle by contrast but which are too pictorially unimportant to achieve that aim, although the castle still seems immense without their help.

In the distance, beyond and slightly to the left of the line of carts, is a young couple walking towards us in a close embrace; in the foreground is a man pointing to a child being held by its mother. Midway between them, in the linking procession of approaching horses and carts, is a figure who points towards the castle in a parallel gesture to that of the man pointing at the child, thus linking castle and child. The transition from background to foreground may amplify the process whereby young couples become parents, and the unearthly radiance of the castle in the otherwise bleak light could thereby equally suggest something of the sexual beauty that generates children.

Summer 1835
Harris Art Gallery, Preston, U.K.

28.9 × 44.5 cm (11¾ × 17½ in)

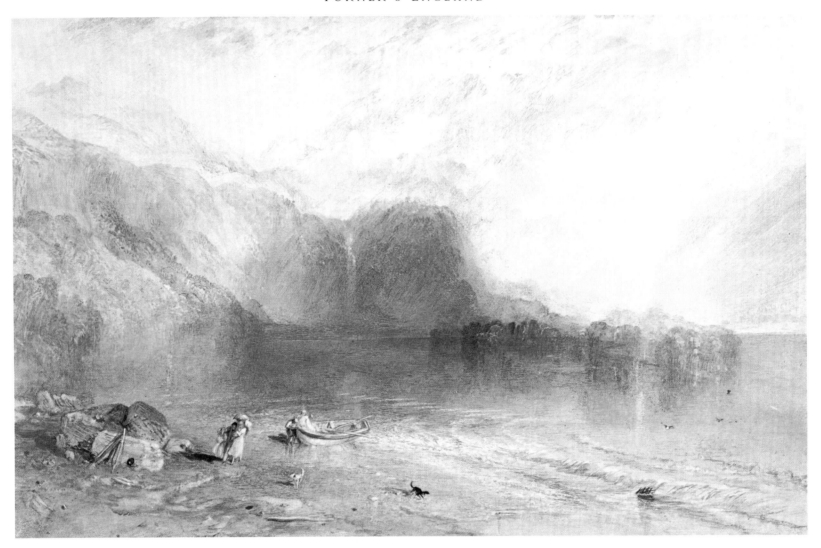

ENGLAND AND WALES

215 KESWICK LAKE, CUMBERLAND

Storminess and stillness are perfectly balanced as the large shadow of a rain-cloud passes over the falls of Lodore on the eastern side of Derwentwater (for which Keswick Lake is the archaic name that Turner had first probably encountered in Boswell's *Antiquities*[196]). In the foreground are some bedraggled figures hurrying from a boat after having been caught on the lake by the rain, the passage of the boat being indicated by its wake which is still rippling across the surface of the water. The drenched coldness of the figures as they huddle together under an umbrella is very apparent, and the two dogs clearly express the general feeling of liberation from the confined spaces of the boat. One of the dogs investigates a piece of flotsam that is being washed ashore, while the dark accent provided by the flotsam leads the eye to the distant rainbow above it. All this foreground activity throws into contrast the quietude of the landscape beyond, while the smallness of the staffage serves to augment the immensity of the surroundings.

Summer 1835
British Museum, London

27.6 × 43.8 cm (10$\frac{7}{8}$ × 17$\frac{1}{4}$ in)

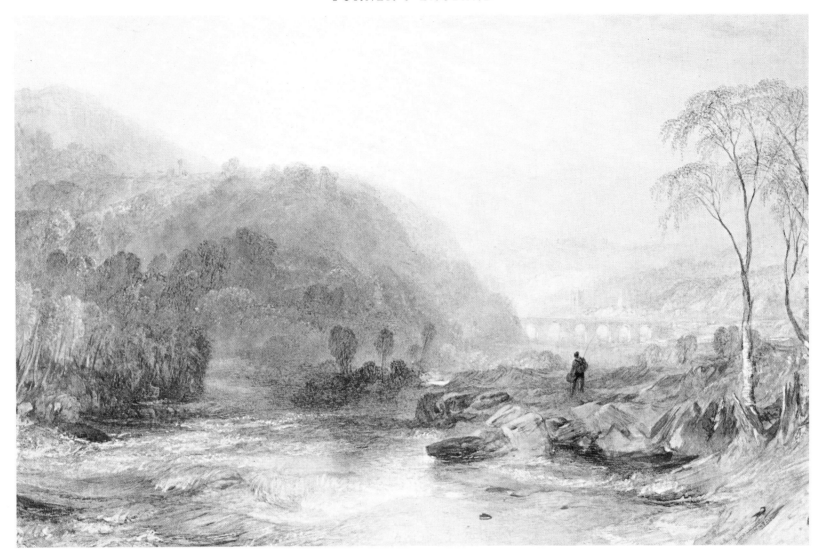

216 LLANGOLLEN, NORTH WALES

Turner visited Llangollen both on his second tour of Wales in 1794 and on his fourth Welsh tour of 1798, when he made the sketch from which this watercolour was developed.[197] Possibly he returned there in 1808 for some trout fishing, and in the 1809 Royal Academy Exhibition he displayed a picture of trout fishing in the Dee at Corwen Bridge, about nine miles from Llangollen. Given Turner's love of fishing, one can readily suspect that in this view looking eastwards along the Dee, he was remembering his own experiences as a trout fisherman many years earlier.

As in the watercolour of Valle Crucis Abbey made for the present series (146), Castell Dinas Brân is included in the scene, high up on the left. The eddies of the Dee are captured with superb precision, and those rippling surges are balanced by more broken dynamics on the right where rock forms and shattered tree-stumps enjoy equal angularity. In the centre it is possible to perceive how the artist flooded that part of the paper with pure ultramarine blue when underpainting the drawing, and characteristically the darkest form in the foreground, that of the fisherman, is located in front of Llangollen, thus both directing our attention to the town and, by contrast, making it seem even more dazzling in the strong dawn light.

Summer 1835
Private Collection, U.K.

26.7 × 41.9 cm (10½ × 16½ in)

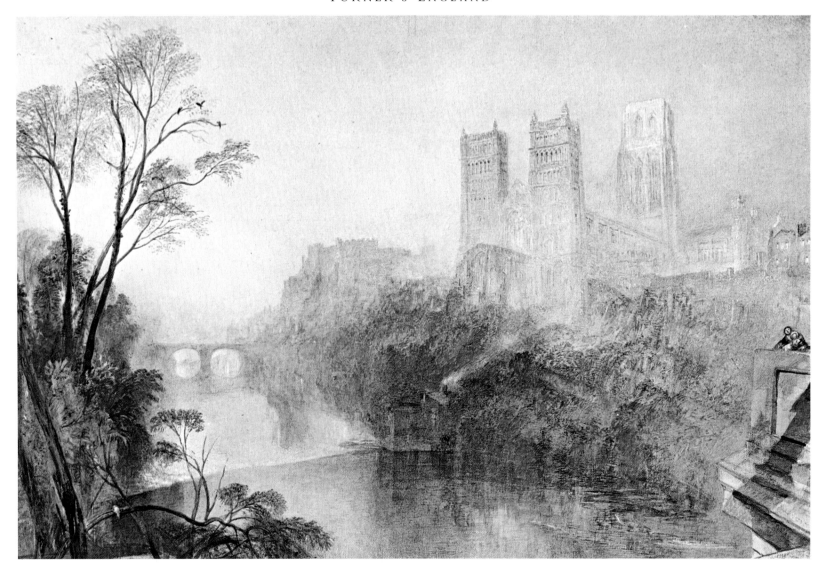

217 DURHAM CATHEDRAL

This drawing, along with nos. 218–23 and 254, was completed before 11 July 1836, for Charles Heath acknowledged receipt of them in a letter of that date.

Durham Cathedral is one of the most impressively situated ecclesiastic buildings in Britain, and as a young artist Turner had sketched and painted it many times. There are two 'colour beginnings' or roughly delineated watercolour studies for this work in the Turner Bequest and both show the cathedral from the same viewpoint. One of them represents afternoon rather than evening lighting, as here, and it is virtually identical in composition to the present work, even including indications of birds, but located at the lower right.[198]

The last rays of the setting sun just illuminate the tops of the cathedral towers, and all is utterly still as the birds settle down for the night. The mother and child standing on the Prebends' Bridge heighten our sense of the hugeness of the cathedral by contrast, and our apprehension of the solidity and rectilinearity of the building is also subtly augmented by the contrasting delicacy, florescence and curvilinearity of the trees opposite. Quite rightly, Ruskin cited these trees as being amongst the finest in all painting, especially because of the gracefulness of their upper boughs.[199]

Summer 1836 29.5 × 44.2 cm (11 5/8 × 17 3/8 in)
National Gallery of Scotland, Edinburgh

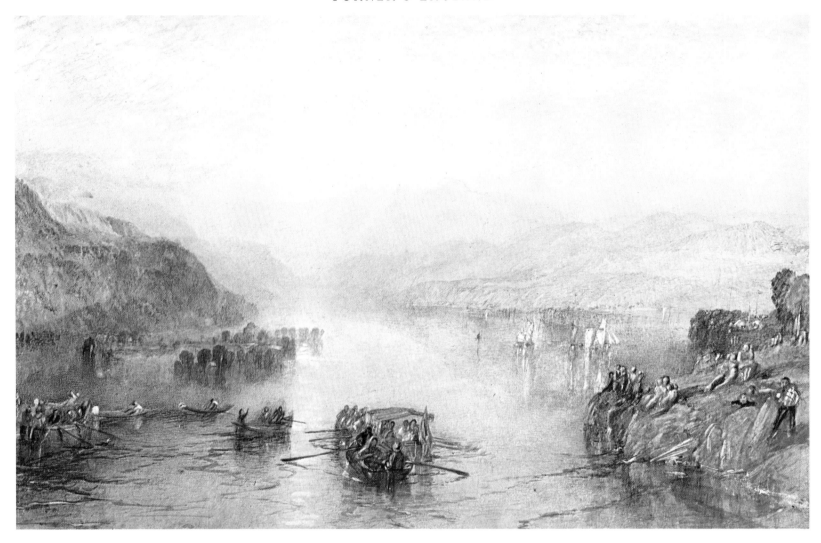

218 *WINANDER-MERE, WESTMORELAND*

The anachronistic title for Lake Windermere that Turner gave to the engraving of this watercolour clearly derived from Boswell's *Antiquities* where the lake was identically titled. The painter initially visited 'Winander-mere' on his first tour of the Lake District in 1797 and, indeed, he synthesized this image from a group of sketches made on that tour.[200] Such an idealizing procedure explains the lack of topographical verity in the work, for although Lake Windermere runs on a north-south axis, the artist has located his sunset at the southern end of the lake (the trees indicate that this is a summer scene, which means that the sun would not be so low if the timing was anything but a sunset). He also characteristically raised the Furness Fells to alpine proportions.

Lakeland tourism had grown immensely since Turner had first visited 'Winander-mere', so the artist was depicting the major growth industry of the region in this drawing. The boats and onlookers create the necessary foreground dynamism and dark, firm tones with which to offset the more placid and ethereal reaches of the lake and mountains beyond.

Summer 1836
City Art Gallery, Manchester, U.K.

29 × 46 cm (11¾ × 18 in)

253

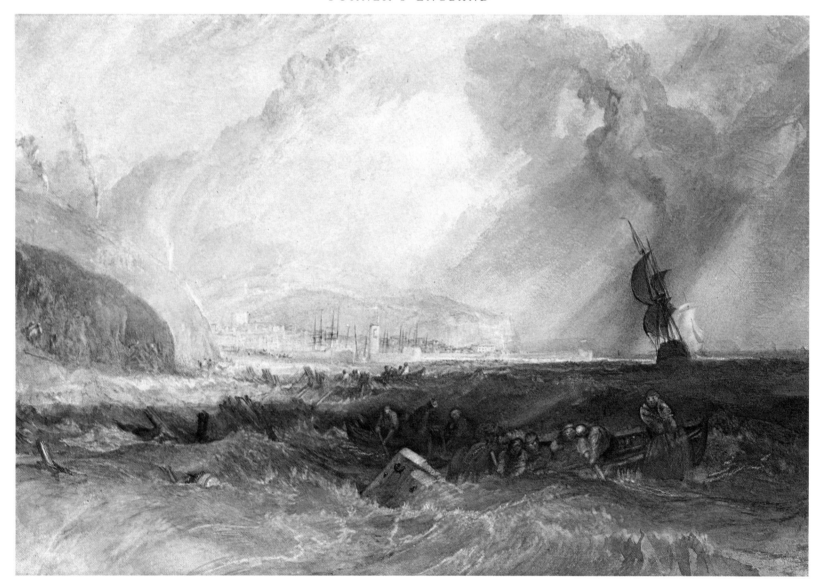

219 WHITEHAVEN, CUMBERLAND

Although there are no sketches of Whitehaven in the Turner Bequest, it seems highly likely that the painter visited the town in 1809 when he was in Cumberland to gather material for a commissioned painting of Cockermouth Castle, which is located about twelve miles from Whitehaven.

Again we see wrecks and wreckers, this time with what even appear to be two coffins in the centre. The sea has a dynamic sense of ebb and flow, and its fresh greens and deep blues are greatly intensified by the contrasting red hat of the man on the right. The composition is unified by a subtle arabesque line which runs down the contour of Redness Point on the left, through the trough in the waves beneath the coffin-like boxes, up to the man with the red cap, and through the brig beyond him to the approaching storm-clouds above.

Summer 1836 31.6 × 46.5 cm (12⅜ × 18¼ in)
Private Collection, U.S.A. (On loan to the Boston Museum of Fine Arts)

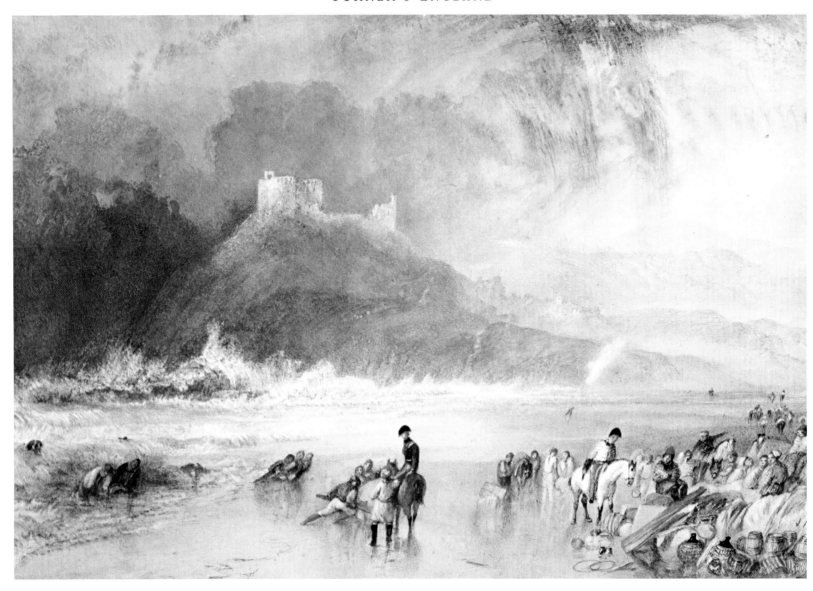

ENGLAND AND WALES

220 CRICKIETH CASTLE, NORTH WALES

As in *Dunstanborough Castle* (161) and other drawings in this series, ruin is juxtaposed with more recent devastation as a passing storm leaves men shipwrecked on the beach, their pathetic salvage being inspected by Riding Officers. As was his wont, Turner has raised Criccieth Castle to a much greater elevation than the one it enjoys in reality, and that height is further augmented by the reduced size of the nearby houses and figures. The scale of his exaggeration may be judged by the man on a horse in the far distance on the right.

The composition is underpinned by two diagonals that converge on the right, one running down the line of the hillside beneath the castle, the other up the shoreline. These lines are reinforced by parallel lines elsewhere, most notably of the lever being used by a man beyond the central Riding Officer, of a spar in the right foreground and of the pall of smoke beyond it. As always, the dampness of wet sand is completely imparted.

When this work was engraved in 1837, Turner had the letters 'C.H.' added to one of the items of cargo in the foreground; they probably stand for Charles Heath, who was certainly 'washed-up' financially by that time.

Summer 1836 29 × 42.5 cm (11⅜ × 16¾ in)
British Museum, London

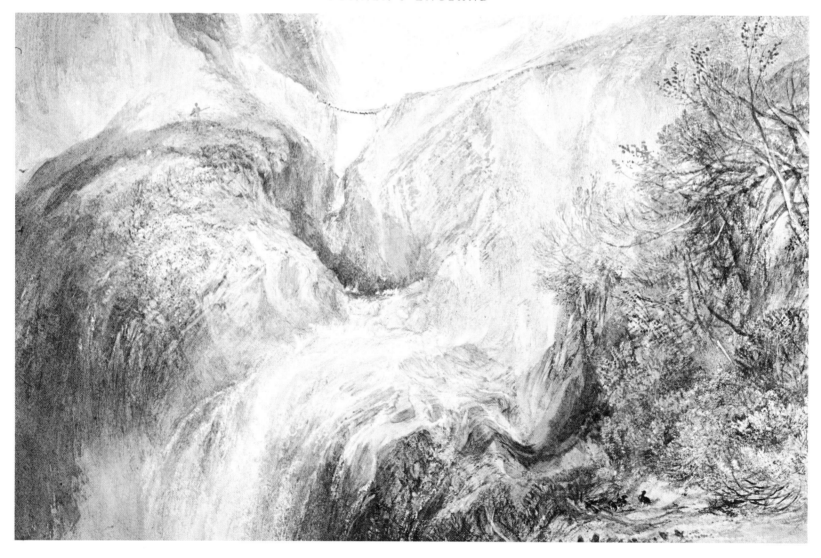

221 CHAIN BRIDGE OVER THE RIVER TEES

Turner sketched the chain-bridge at Cauldron Snout in Upper Teesdale on the 1816 North Country tour[201] and here he superimposed an ominous note upon that topographical framework: death approaches relentlessly from the distance in the guise of a hunter, his gun poised, the grouse in the right-foreground unaware of him. Subtle shadows fall diagonally from the left to connect hunter to prey and, as in *Powis Castle* (205), the side of the river on which a doomed bird appears is filled with an abundance of foliage, while the bank occupied by man is much emptier. Moreover, again the hunter will have some trouble in recovering his spoils, which suggests that Turner was not only addressing the death of particular creatures but also perhaps the approach of death in a more universal sense.

The river falls into a seemingly bottomless chasm and the hills at the top left were also elevated so as to augment the spatiality of the scene. Ruskin especially praised the drawing of the waterfall and the depiction of the foliage on the right.[202]

Summer 1836
Private Collection, U.K.

27.8 × 42.6 cm (10⅞ × 16¾ in)

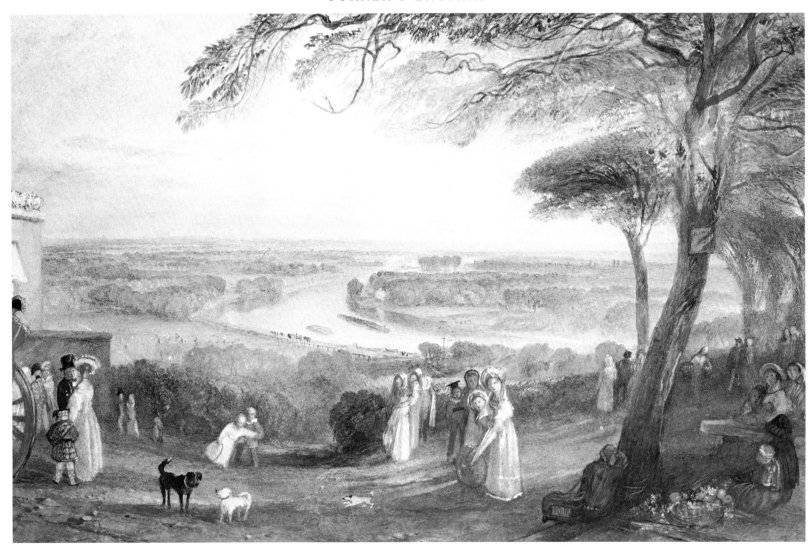

222 RICHMOND TERRACE, SURREY

In 1834 King William IV had a terraced walk constructed from the bottom of Richmond Hill to its summit at the Star and Garter Inn (seen on the left), and perhaps this drawing celebrated that new public amenity. It is the last of Turner's many depictions of the view, and in it he matched the splendid visual panorama with a complementary human panorama. From left to right are a uniformed coachman, a man in court dress and a boy in fashionable Scots attire, perhaps all representing the monarchy and aristocracy; then beyond a large gap filled with some playful dogs and equally playful children are people in middle-class garb, including a schoolboy wearing a mortar-board and a lady with a parasol; and finally we see the labouring classes, including an apparently exhausted hawker slumped beneath a tree and strolling figures in their 'Sunday best'. Nearby, a barrow of fruit and flowers perhaps alludes to the produce of their labours.

Affixed to the tree above the slumped hawker is a board; this almost certainly represents the board that is known to have been nailed to a tree at the top of the walkway on Richmond Hill in Turner's day, and on which were inscribed verses drawn from James Thomson's poem 'The Seasons' pertaining to the famous view from the hill.[203]

The soft light filtering through the trees is particularly beautiful, as are the trees themselves, their graceful branches fully demonstrating their inner organic pulse.

Summer 1836
Walker Art Gallery, Liverpool, U.K.

28×43.5 cm ($11 \times 17\frac{1}{8}$ in)

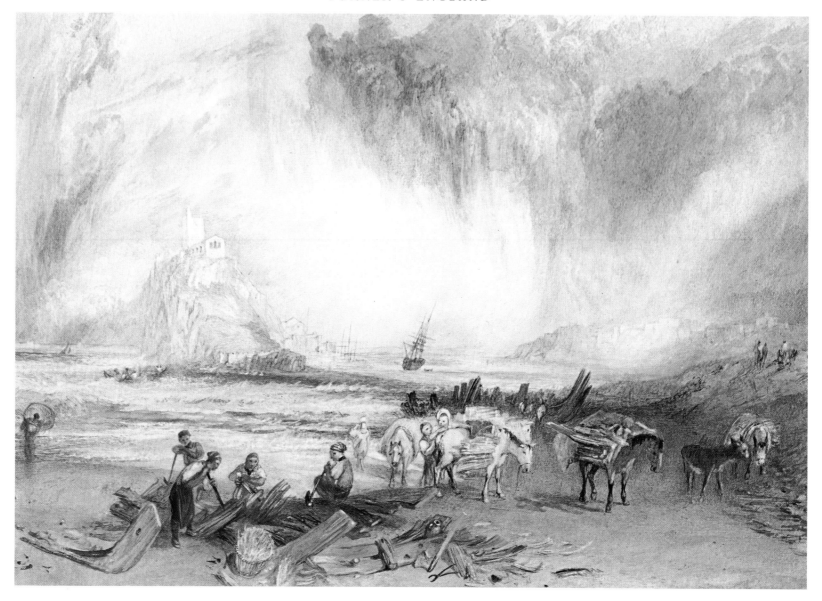

223 MOUNT ST MICHAEL, CORNWALL

Turner created two other watercolours and an oil painting of this view. One of the drawings we have seen already in the 'Southern Coast' series (18), while a second was made around 1834 to adorn an edition of Milton's poems; the oil painting was exhibited at the Royal Academy in 1834.[204]

In the 'Southern Coast' view Turner had complemented St Michael's Mount with fishing, the primary industry of Mount's Bay; here we see a secondary activity of the locale, namely the breaking up of wrecked timber for resale, a major source of income for the coastal poor at the time. The curved shape of a large timber at the bottom left (possibly the stem of a keel) is reiterated by three similarly shaped timbers beyond the pack animals, and the further irregular shapes of that wreck are themselves reversed and repeated more softly by the drifts of rain-cloud above them. The composition is structured around a central vortex of light beyond St Michael's Mount, and that circle is repeated diminutively by the shape of the shrimper's creel on the left and by the basket in the foreground nearby. The depiction of the rain-clouds is especially masterly, as is the interpenetration of rain and sunlight on the right, where Marazion looks dazzling in the far distance.

Summer 1836

University of Liverpool, U.K.

$30.5 \times 43.9 \, \text{cm} \, (12 \times 17\frac{1}{4} \, \text{in})$

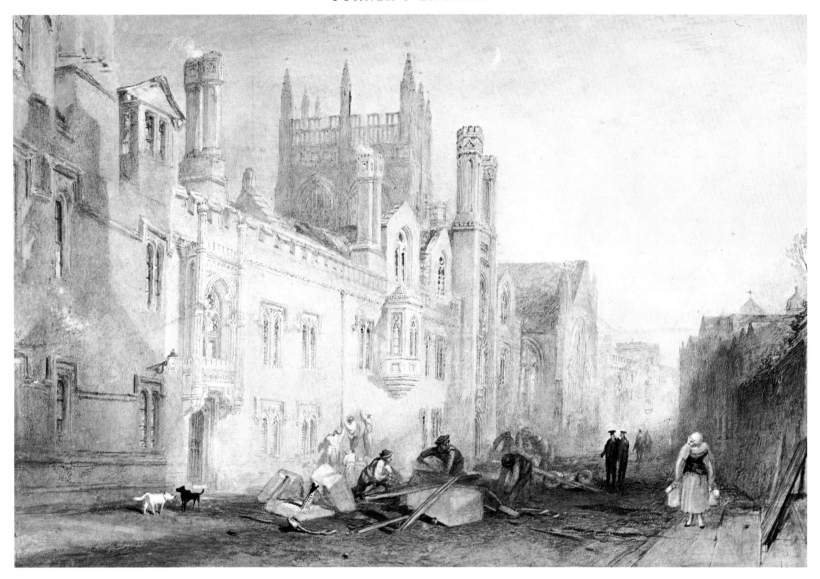

224 MERTON COLLEGE, OXFORD

Although this work was never engraved, its size, handling, subject and imagery all suggest that it was made for the 'England and Wales' series.

From an architectural point of view, Merton College is the oldest Oxford college, dating from the thirteenth century; the gatehouse portrayed here was completed in 1418. Given Turner's love of Oxonian architecture, Merton was a natural choice of subject for the 'England and Wales' series, and the artist clearly lavished much care upon his depiction of it in evening light, with a new moon and sunset complementing the decay that is being remedied so dynamically by a group of builders. Turner visited Oxford in 1830, on his tour of the Midlands to obtain further material for the 'England and Wales' series, and again in July 1834 in order to make a drawing of Oxford for subsequent engraving (226). While building work is known to have taken place on the Merton Street facade of the college between 1836 and 1838, Turner may have introduced it here anyway because associatively it tallies with the idea of the constructive process of education, much as it does in *Christ Church* (197).

Naturally, dons in academic garb are present in the scene, and the elongated shapes of the academics somewhat echo the elongated forms of the turrets over the college gatehouse. On the left two dogs face each other enquiringly, as do other dogs in the Christ Church drawing, whilst one of the builders makes a visual enquiry of a passing milkmaid, who returns his glance.

c. 1838

29.5 × 43.3 cm (11$\frac{5}{8}$ × 17 in)

Clore Gallery for the Turner Collection, London

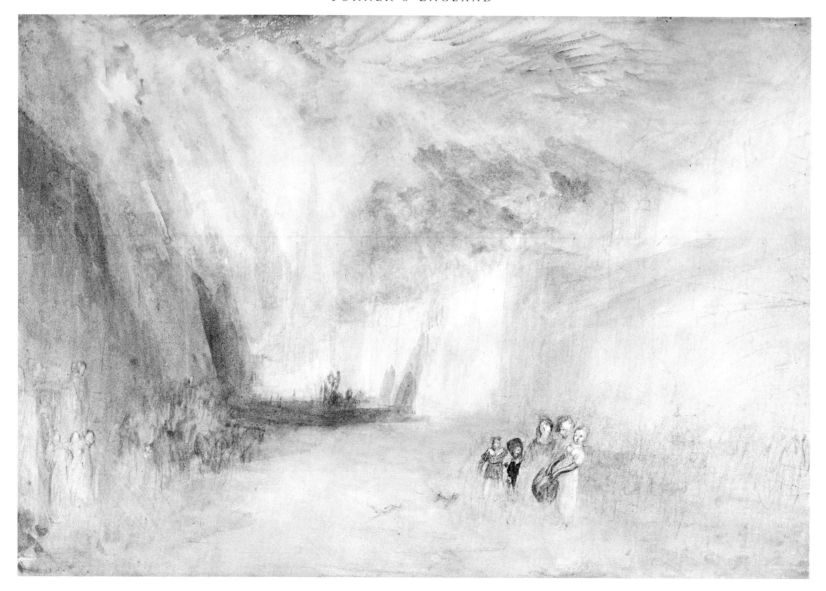

ENGLAND AND WALES
225 THE HIGH STREET, OXFORD

This large 'colour-beginning' is one of a group of similar colour studies of Oxford High Street that were elaborated from a sketch made on the 1830 Midlands tour,[205] possibly with an 'England and Wales' drawing in mind. The fact that Turner created so many variants of the subject without bringing any of them to completion suggests that he encountered some fundamental problem with the design. However, the fairly advanced development of this study does afford us a useful insight into the painter's working methods.

On the right are a group of children standing in front of the Queen's College. Possibly on the left are building works, Turner's customary association for Oxford. In the distance a stagecoach approaches along the High Street, with the spire of St Mary's Church beyond it looking dazzling in the late afternoon sunlight. It is possible to make out Turner's necessarily faint pencil outlines of the architecture and figures beneath the bold initial colour washes, although some of the outlining was also drawn in watercolour and would thus have been absorbed into the overpainting.

c. 1830–35 38.2 × 55.8 cm (15 × 22 in)
Clore Gallery for the Turner Collection, London, (T.B. CCLXIII–362)

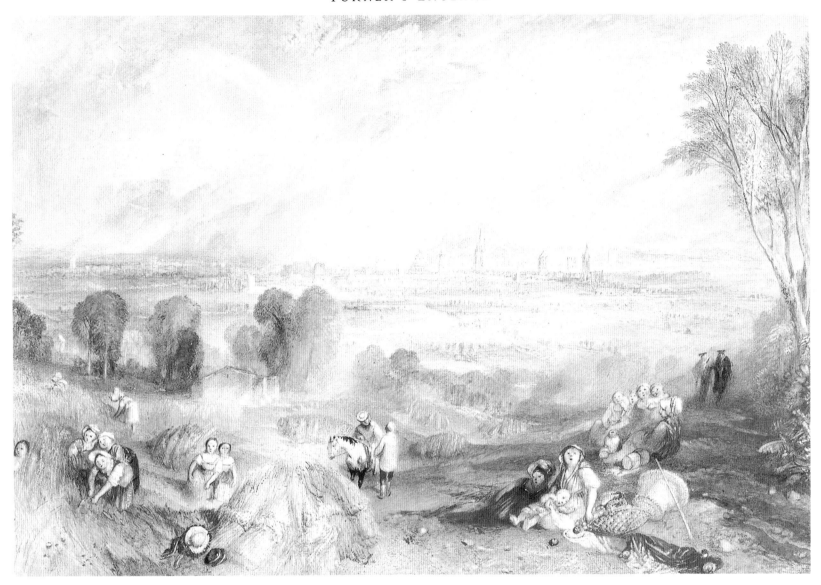

226 OXFORD FROM NORTH HINKSEY

Turner visited Oxford in July 1834 at the behest of a local printseller, James Ryman, who wanted a watercolour of Oxford for engraving. The print, by Edward Goodall, was published in 1841.[206] Goodall's son later recalled that Turner visited North Hinksey three times before the subject finally caught his fancy:

> . . . a thunderstorm was coming on, with dark purple clouds over the city, bringing out all the fine buildings into light against it. 'This will do', said Turner, 'I don't want to make a sketch; I shall remember this'. And he certainly knew every building in Oxford, for he had drawn them when he was a boy.[207]

Although Goodall and his son later had to revisit North Hinksey to deal with some of Turner's usual liberties with topography, nonetheless the younger Goodall was of the opinion that the painter had greatly beautified his subject.

Turner was indubitably an 'Oxford man', for he represented the 'other place' less than half-a-dozen times, whereas he made a great number of Oxford views. This was the last of them, and perhaps the work sums up all the painter had to say about the city. We look at it on a glorious summer's day, with women scything the corn or resting from their labours and two academics taking a stroll as natural ancillaries to the subject.[208]

c. 1835–40

35.2 × 51.6 cm (13⅞ × 20¼ in)

City Art Gallery, Manchester, U.K.

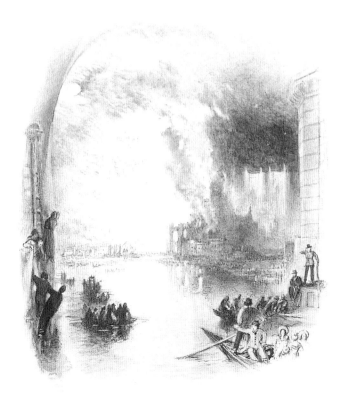

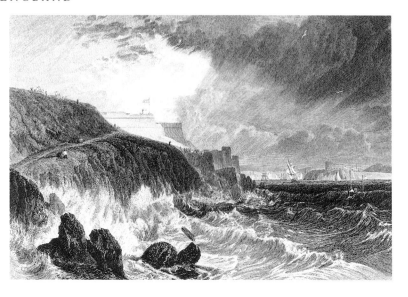

THE RIVERS OF DEVON

228 PLYMOUTH CITADEL

THE KEEPSAKE

227 BURNING OF THE HOUSES OF PARLIAMENT

This is one of the few portrayals of British subjects that Turner made for engraving in *The Keepsake*, the immensely popular annual first published by Charles Heath and still supervised by him after it was taken over by Longman in 1831. Turner created the vignette to illustrate a poem entitled 'The Burning of the Houses of Lords and Commons' by the editor of *The Keepsake*, the Hon. Mrs Norton.

As Turner is known to have witnessed the fire from a boat on the Thames, it seems likely that here he represented the burning from beneath one of the spans of Westminster Bridge just as he had originally seen it. But although the bridge provided him with a natural framing device, he may also have been calling upon his memories of a similar image of a bridge-span framing a London fire by P.J. de Loutherbourg, whom he had particularly admired when young.[209]

We see a fairly late stage in the fire, after the wind had veered around towards the south, and with the Painted Chamber and the Commons Library being consumed by flames. As always in his vignettes, Turner packed a great deal of dynamism into an extremely tiny space, and the intensity and purity of colour greatly add to that power.

c. 1835 Vignette, 11 × 14 cm (4¾ × 5½ in)
Museum of Outdoor Arts, Colorado, U.S.A.

This work is in a private collection in Canada and it has not proven possible to obtain a colour transparency of it for reproduction.

The design was clearly created as a pendant to *Plymouth Sound* which follows. Indeed, when the engravings of the two works were exhibited in 1821, their titles included the complementary descriptions *a gale* (for this work) and *a light breeze*. Moreover, the scene depicted is the extension to the left of the view in *Plymouth Sound*.

Plymouth Citadel dates from the late seventeenth century and it dominates the approach to the harbour. Turner visited it in 1813, and on that trip an incident occurred which affords startling proof of his powers of concentration. Cyrus Redding informs us that

> We were standing outside the works on the lines at Plymouth, close under a battery of twenty-four pounders, which opened only three or four feet above our heads. I was startled by the shock, but Turner was unmoved. We were neither prepared for the concussion, but he showed none of the surprise I betrayed, being as unmoved at the sudden noise and involvement in the smoke as if nothing had happened.[210]

c. 1813 Original drawing size: 17.8 × 29.2 cm (7 × 11½ in)
Private collection, Canada; colour photograph unobtainable Engraving size:
17.8 × 28.5 cm (7 × 11¼ in)
Engraved 1815 by W. B. Cooke

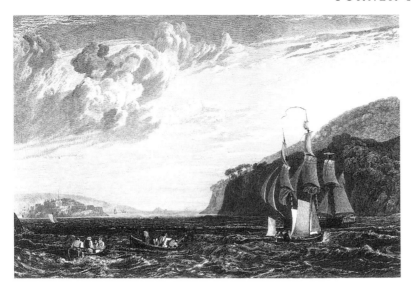

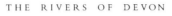

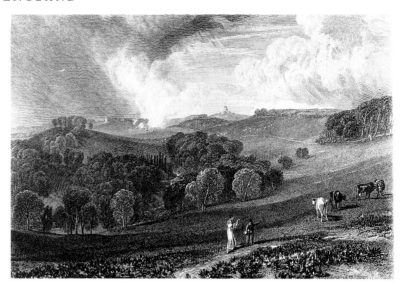

THE RIVERS OF DEVON

229 *PLYMOUTH SOUND*

Nothing is known of the provenance or whereabouts of the drawing from which this engraving was made except that it was offered for sale at Christie's sometime at the end of the nineteenth century. W. G. Rawlinson saw it there but reported that it was 'very faded'.[211]

The design forms a companion to *Plymouth Citadel* (228). We look from Devil's Point towards Drake's Island on the far left, with Mount Edgcumbe seen across Barn Pool on the right. In the far distance in the centre is the Mewstone, itself the subject of a drawing in the 'Southern Coast' series (25).

Turner based this work upon a study made on page 10 of the 1813 *Plymouth, Hamoaze* sketchbook, T.B. CXXXI (Drake's Island is carried over from page 9). The entire right side of the image is contained in that study, including the large ship on the right. In the sketch, however, the vessel appeared as a two-masted brig; here it has been elaborated into a frigate. The scene is suffused with gentle early afternoon sunlight and one can certainly sense the 'light breeze' described by the title of the engraving.

c. 1813 Original drawing size: 17.8 × 28 cm (7 × 11 in)
Present whereabouts unknown Engraving size: 18.5 × 28.5 cm (7¼ × 11¼ in)
 Engraved 1815 by W. B. Cooke

VIEWS IN SUSSEX

230 *THE OBSERVATORY AT ROSEHILL, SUSSEX, THE SEAT OF JOHN FULLER, ESQ.*

The drawing for this engraving was sold at Christie's in the Ackland–Hood sale on 4 April 1908. It was bought by Agnew and has only recently been traced to a private collection in the U.S.A. Unfortunately it has not proven possible to obtain a photograph of the work for reproduction.

The observatory in Rosehill Park was designed for Jack Fuller by Sir Robert Smirke. It stands 197 metres (646 feet) above sea-level at one of the highest points of the eastern Weald and was fitted with a telescope. Turner naturally made it the pictorial focal point of his design by framing it with clouds and the smoke being given off by burning scrub. To add to this emphasis, the sharp vertical of a reading girl was placed immediately beneath it. She is being reminded that it is time to milk the cows, however, and the full udders are indicated by an arrow-like dash of white on the flank of the leading cow.

c. 1815 Original drawing size: 31.8 × 55.9 cm (12 × 22½ in)
Photograph unobtainable Engraving size: 17.8 × 29.2 cm (7 × 11½ in)
 Engraved 1816 by W. B. Cooke

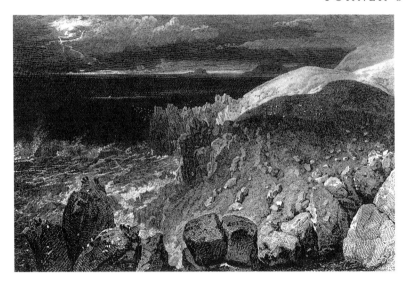

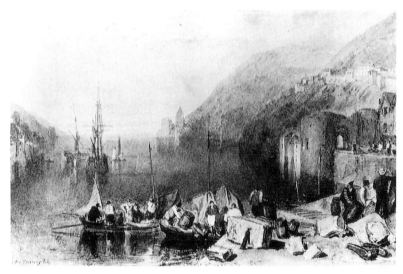

SOUTHERN COAST

231 LAND'S END, CORNWALL

The drawing for this engraving was bought and sold by Agnew in 1893; it is now untraced. In the 1822 W. B. Cooke Gallery exhibition catalogue (no.31) it was titled *The Land's-End, Cornwall. Approaching Thunderstorm*. The work was described by W. G. Rawlinson in 1908 as 'somewhat faded'.[212]

The design shows the view across Whitesand Bay looking north-eastwards to Cape Cornwall, with the Brisons to its left. When the watercolour was exhibited in 1822 it was mentioned in a review by Robert Hunt, the editor of *The Examiner* (4 February, p.75):

> Never have we seen so much done, such gigantic talent, in so little space – a few square inches. It is so truly Miltonic, that the mere space is annihilated, and we would rather possess it – as an imaginative stimulant, than half the esteemed English landscapes ever painted.

The engraving is also a superb work, with a wide tonal range and strong rhythmic pulse. Turner omitted all figuration from the image, thereby stressing the utter desolation of the spot. The brooding calm seems very threatening.

c. 1811
Present whereabouts unknown

Original drawing size unknown
Engraving size: 14 × 22 cm (5⅝ × 8⅝ in)
Engraved 1814 by W. B. Cooke

SOUTHERN COAST

232 DARTMOUTH, DEVONSHIRE

This drawing was sold at Christie's in April 1926 to Princess Obolensky (*neé* Astor). Although it was exhibited at the Fine Art Society in 1946, its whereabouts were unknown until February 1990 when it appeared at Sotheby's in New York, just as this book was going to press. Unfortunately, in the time available it was not possible to obtain a colour transparency of the work for reproduction.

The design was the first and most simple of Turner's treatments of Dartmouth, and it was built around the artist's knowledge of the town's principal industry. In the foreground a fishing-lugger is pulling away from a small hoy landing barrels of Newfoundland cod that have presumably been off-loaded from the brigs in the harbour. The Newfoundland fisheries were Dartmouth's main source of income in the early nineteenth century and around 1811 they still employed a majority of the town's population, despite the inroads caused by the war with France.

In the distance are Dartmouth Castle and St Petroch's Church which are neatly framed by two masts, a device that Turner repeated in the later drawing of the castle he made for 'The Rivers of England' series (82). Judging by the colour reproduction in Sotheby's catalogue, the work has retained its freshness of colouring, and shows the same penchant for blue-greens apparent in other 'Southern Coast' series drawings made around the same time, such as *Teignmouth* (24).

c. 1811
Present whereabouts unknown

14 × 21.6cm (5½ × 8½in)

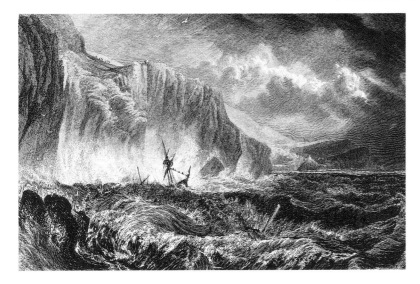

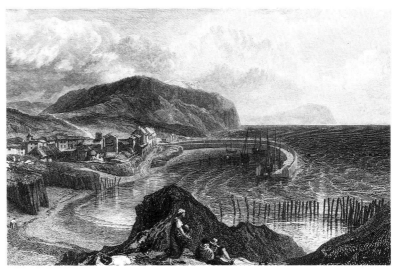

233 ILFRACOMBE, NORTH DEVON

The watercolour for this engraving is in a private collection in Switzerland. It was not possible to obtain a colour photograph of the work, and the only monochrome photo available is of a very poor quality, so the design is therefore better represented by the Cooke engraving. W. G. Rawlinson described the print as one of the 'Finest renderings of a stormy sea in the ['Southern Coast'] series' and doubted if it 'has ever been surpassed in sea engraving'.[213] Certainly the wide tonal contrasts enhance the furious energy of the image.

To the right of centre is a spar that leads the eye diagonally up to the lighthouse on Lantern Hill at the entrance to Ilfracombe Harbour. But the lighthouse has failed in its duty, and at the base of the (greatly heightened) Hillsborough Cliffs is a sinking brig, with figures clinging to its bowsprit rigging. Due to the sheerness of the cliffs, the on-lookers are unable to help the sailors, and doubtless they will soon drown.

c. 1813

Original drawing size: 14.4 × 23 cm (5⅝ × 9 in)
Engraving size: 15.9 × 24.1 cm (6¼ × 9½ in)
Engraved 1818 by W. B. Cooke

Photograph unobtainable

234 WATCHET, SOMERSETSHIRE

The drawing for this engraving was sold at Christie's on 22 May 1880 when it was bought by 'Philpott'. It is now untraced.

We look over Blue Anchor Bay, with Cleeve Hill on the left and Minehead in the distance. Only some women work in the afternoon heat as sailors lie stupefied, a discarded bottle at their feet.

When Turner visited Watchet in 1811 he sketched the place in rough outline only, indicating a square-shaped rock in the foreground.[214] In the final design the rock was sharpened so as to make it echo the shape of Cleeve Hill beyond it, and the pointed shape is also repeated by that of the woman's cap in the foreground. Through its location the rock emphasizes the encircling sweep of the harbour. The composition is artfully structured, with the nets laid out to dry at the bottom left acting as the culmination of a series of ellipses running across the image from the right.

c. 1818

Original drawing size unknown
Engraving size: 15.5 × 24 cm (6⅛ × 9½ in)
Engraved 1820 by George Cooke

Present whereabouts unknown

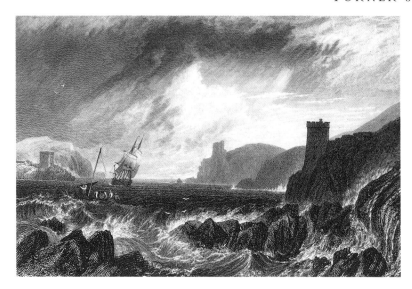

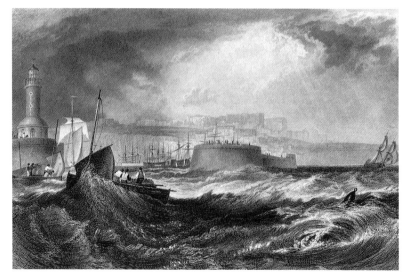

SOUTHERN COAST
235 ENTRANCE OF FOWEY HARBOUR, CORNWALL

The watercolour upon which this engraving was based was last known to belong to A. C. Pilkington; it was sold in 1966 and is now untraced. That drawing was exhibited in 1824 under the title of *Fowey Harbour, Cornwall* but the engraving title is given above, as the print is reproduced here.

As stated above, both the 'England and Wales' series *Fowey Harbour* (148) and this design were based upon the same sketch, which explains their similarity. In each work we see St Catherine's Fort on the right, although here the pair of more distant forts guarding the entrance to the river Fowey are also apparent (in the 'England and Wales' design the fort at Polruan on the far side of the river is not visible). But in this work the weather is in a slightly calmer mood than it is in the other, with a brig entering harbour and a pilchard boat raising her lugsail as a storm approaches.

c. 1817
Original drawing size: 15.2 × 22.9 cm (6 × 9 in)
Engraving size: 15.5 × 23.4 cm (6⅛ × 9¼ in)
Engraved 1820 by W. B. Cooke

Present whereabouts unknown

SOUTHERN COAST
236 RAMSGATE, KENT

The drawing for this engraving was last seen at the Levy sale at Christie's in 1875. It is now untraced.

On the left two fishing smacks have sailed upwind and are lowering their sails so as not to make too much way upon entering harbour. Beyond them is the lighthouse built in 1802, in front of which a man rides his horse. On the right is a similar brig to the one seen in the drawing of Ramsgate made for the 'Ports of England' series (105); here it is putting to sea in a far less dramatic manner. The diagonal of its mainmast leads the eye down the diagonal buoy in front of it to a seeming whirlpool whose circular shape balances the wave on the left. The elipse formed by the whirlpool acts as an intensification of both the elliptical area of light in the sky and of the rotund shape of the east pier below it.

c. 1823
Original drawing size: 16.5 × 24.1 cm (6½ × 9½ in)
Engraving size: 15.2 × 24.1 cm (6 × 9½ in)
Engraved 1824 by Robert Wallis

Present whereabouts unknown

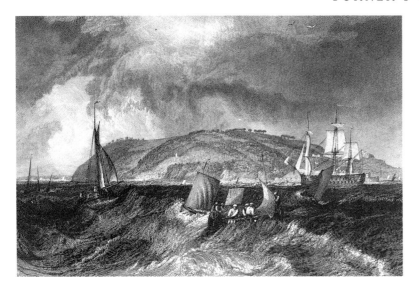

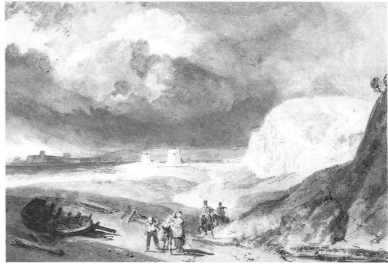

237 MOUNT EDGECOMB, DEVONSHIRE

238 MARTELLO TOWERS NEAR BEXHILL, SUSSEX

Nothing is known about the early history or whereabouts of the original drawing for this engraving. The watercolour was paid for by W. B. Cooke in July 1818, and Turner made a note of it as a work in hand on page 35a of the *Hints river* sketchbook (T. B. CLXI) that was in use between 1815 and 1818.

Mount Edgcumbe, to the west of Plymouth, was a great country house built between 1547 and 1554; the house was virtually destroyed by bombing during the Second World War. The surrounding park was always very famous for its beauty, and it was a 'must' for any tourist visiting Plymouth. Turner was especially drawn to it.

We view Mount Edgcumbe park from Mount Batten Point across Plymouth Sound. On the right, a man-of-war is beating up for anchor. She has backed her foresails and is sheeting-in her top gallants, while on the deck the men are manning the anchor-capstan and preparing to go aloft. In the foreground are a lobster-boat and a lugger, with a hoy approaching on the left. Despite the unpromising nature of this view, the scene is filled with a dynamic rhythmic charge.

c. 1818

Original drawing size unknown
Engraving size: 16.2 × 24.1 cm ($6\frac{3}{8}$ × $9\frac{1}{2}$ in)
Engraved 1826 by Edward Goodall

Present whereabouts unknown

This sepia watercolour was made for the 'Liber Studiorum' where it was engraved by William Say and published in June 1811 as plate 34 under the title given above. In May 1817 a copy of the design engraved by W. B. Cooke was also published as a vignette in the 'Southern Coast' series.[215] Why Turner should have used an image originally made for the 'Liber Studiorum' in the 'Southern Coast' series is open to conjecture, but it may be that he wanted to see how it would 'translate' into line-engraving, or alternatively he was pleased with the imaginative ingenuity he had displayed in the work and wished to capitalize on it by publishing the design in two different places.

On the right is Galley Hill, Bexhill. In the distance may be seen seven Martello towers ranged along the coast, whilst a further, light accent is added to the sequence of similar shapes and tones by a house located between the nearest tower and Galley Hill. At the bottom left, Turner reiterated those eight accents by the eight uprights of the frame-joists and broken bowsprit of a wrecked boat, with a small rowing-boat lying across it.

The Martello towers formed part of the chain of 74 defence forts built to forestall invasion during the Napoleonic wars, and above them is a mass of approaching storm-clouds. Simultaneously approaching us are two hussars who gallop towards a man beating an ass, upon which sits a mother holding her child protectively. By such means, associations of aggression and protection are induced, and they are most appropriate to a landscape dominated by so many military fortifications.

c. 1806–10
Sepia watercolour
Clore Gallery for the Turner Collection, London

18.4 × 27.3 cm ($7\frac{1}{4}$ × $10\frac{3}{4}$ in)

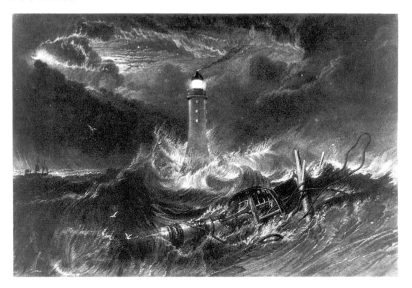

SOUTHERN COAST
239 BRIGHTHELMSTON, SUSSEX

This drawing was last known to belong to a Mrs Robinson of Sheffield who bought it at around the turn of the century. It is now untraced.

Two features of the scene were very topical when the work was made. The chain-pier had only been completed in November 1823, being a structure suspended from four columns that was some 347 metres (378 yards) in length. Turner depicted it several times, and it was destroyed by a storm in December 1896. Beyond the pier is the Marine (or Royal) Pavilion which was also only completed in 1823.

On the hill in the distance is the parish church of St Nicholas. Beyond the pier is Marine Parade which was still under construction at the time Turner made this work. On the pier itself is a signal mast, and before it a lugger is reducing sail as it runs before the wind, while immediately beyond it and tacking into the wind is a Brighton Hoggie, a local shallow-draught, wide-beamed fishing boat.

The importance of the Royal Pavilion is subtly emphasized by the two visual stresses that are located beneath it, the circular shape of a large winch (used to pull heavy vessels onto the shingle), and a buoy before it. The composition is unified by a series of semicircles, to be seen in the rainbow, the wave at the bottom left, the curves of the chain-pier and the hull of the lugger.

1824 15.2 × 22.9 cm (6 × 9 in)
Present whereabouts unknown

MARINE VIEWS
240 THE EDYSTONE LIGHT HOUSE

The drawing for this mezzotint engraving was sold at Christie's on 17 April 1869 and has not been seen publicly since.

Mezzotint is a process that entails working from dark to light, the plate being initially black all over when inked; the lighter areas of tone are then burnished out. Consequently it is an ideal medium for depicting night scenes, and Turner was to experiment with it precisely for that reason in a group of mezzotints known as the 'Little Liber' series.

The third Eddystone lighthouse was built by James Smeaton between 1757 and 1759, and Turner probably visited it from Plymouth in 1813; it was re-erected on Plymouth Hoe in 1882. After 1810 the light itself was provided by 24 oil lamps with reflectors placed behind them, and the smoke given off by the lamps can be seen issuing from the top of the building.

Once again a lighthouse has failed in its purpose, for we see the familiar Turnerian conjunction of warning light and wreckage, in this case the mast and mizzen-top of a distant vessel. The sky is particularly magnificent, both in formal and tonal terms.

c. 1817 Original drawing size: 43 × 65 cm ($16\frac{7}{8}$ × $25\frac{1}{2}$ in)
Engraving size: 21.6 × 31.1 cm ($8\frac{1}{2}$ × $12\frac{1}{4}$ in)
Engraved 1824 by Thomas Lupton
Present whereabouts unknown

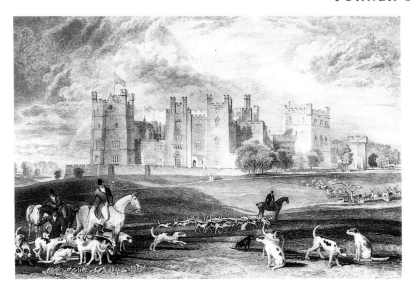

HISTORY OF DURHAM

241 RABY CASTLE, CO. OF DURHAM

Nothing is known of the provenance or whereabouts of the drawing from which this engraving was made.

The design brings together the artistic traditions of both the country house view and the English sporting picture; indeed, it fuses and elevates those traditions magnificently. Turner visited Raby Castle in September-October 1817 in order to make sketches of the building and its surroundings for an oil painting that had been commissioned by the third Earl of Darlington (whose home it was); that picture was exhibited at the Royal Academy in 1818. In the work Turner depicted the house as seen from a distance, with huntsmen and hounds at full tilt before it and the moors of upper Teesdale stretching to infinity beyond.[216] Here, however, we view the castle from a much closer viewpoint, and with the huntsmen and hounds preparing for their sport.

c.1817
Present whereabouts unknown

Original drawing size unknown
Engraving size: 19.6 × 27.9 cm (7¾ × 11 in)
Engraved 1820 by S. Rawle

LOIDIS AND ELMETE

242 FLOWER GARDEN PORCH AT FARNLEY

REMOVED FROM NEWHALL A.D. 1814

As with the design discussed immediately below, the watercolour that Turner made from this etching is in a British private collection but the owner was unwilling to allow it to be photographed. This very poor etching, which cannot be from Turner's own hand as has been supposed, only gives a very rough idea of the watercolour design.

Newall Old Hall was situated near the Otley gateway to Farnley Hall and it was largely demolished after parts of it had been removed to Farnley. Turner had drawn the original doorway *in situ* before its removal.[217]

Photograph unobtainable
Original drawing size: 26.8 × 32 cm (10½ × 12½ in) (sight)
Engraving size: approx. 17.8 × 14 cm (7 × 5½ in)
Engraver unknown

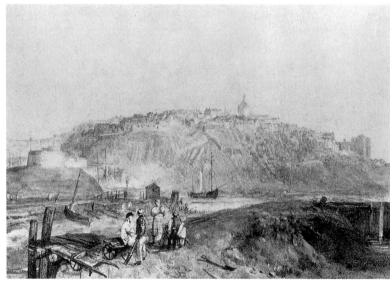





LOIDIS AND ELMETE

243 GATEWAY TO THE FLOWER GARDEN AT FARNLEY,

REMOVED FROM MENSTON HALL, FORMERLY THE SEAT OF COL. CHARLES FAIRFAX A.D. 1814

Turner based a watercolour of this design either on an etching made for the 'Architectural Remains removed to Farnley Hall' (and later re-used in 'Loidis and Elmete', reproduced here), or else upon a sketch that he himself had made around 1814 to supplement it.[218] The sketch contains no figures, and the trees are also much less detailed and sophisticated.

Again, the etching seems very insensitive to Turner's acute responsiveness to light and shade, as well as being rather stiffly drawn and technically inept, so it appears that someone other than Turner made it.

Photograph unobtainable Original drawing size: 32 × 40.6 cm (12½ × 16 in) (sight)
Engraving size: 17.8 × 25.4 cm (7 × 10 in)
Engraver unknown





SOUTHERN COAST

244 RYE, SUSSEX

This drawing was last known to belong to Miss Carol N. Kaye-Taylor of Toronto, Canada; it was auctioned at Christie's on 3 March 1970 but remained unsold. Although the watercolour is slightly larger than the drawings specifically made for the 'Picturesque Views on the Southern Coast' series, it is exactly the same size as *Martello Towers near Bexhill, Sussex* which *was* engraved in the scheme (238), albeit in the form of a vignette. Its subject matter and handling suggest that it was possibly made for the venture but then rejected in favour of another panorama of Rye that was eventually used (38). Although its date has been ascribed to around 1820, it looks to date from slightly earlier.[219]

In both views of Rye, Turner depicted the town from the west, although here it is seen from a much closer viewpoint than in the other watercolour. On the left is Martello Tower No. 30, which still exists, although Turner greatly enlarged it for dramatic effect. Troops march past it on the Royal Military Road to Winchelsea, while to the right of it beyond the foreground figures is the toll-gate and toll-charge sign on the road. From the bottom left and running up to the Rock Channel by the toll-gate may be seen a stretch of the river Brede, which also appears on the right where a sheet-pile dam has been constructed; between both arms of the river is the large earth embankment that was created sometime after 1812 to form a coffer dam with which to construct a new sluice and navigation lock on the Brede – the small pier at the bottom left was presumably used for unloading the banking material from barges. An officer seated on a wheelbarrow amongst the building tools in the foreground is chatting with some civilians, while beyond them is the River Tillingham which runs into the river Rother and thence into the sea, off to the right. As was his wont, Turner greatly raised Rye in height, and the tower of St Mary's Church and the Ypres Tower to the right form pictorial focal points.

c. 1815 18.4 × 27.3 cm (7¼ × 10¾ in)
Present whereabouts unknown





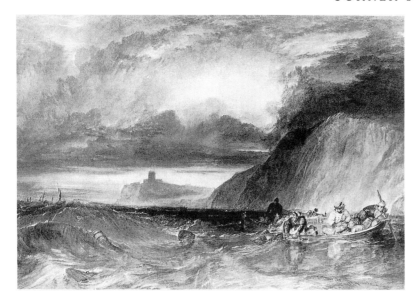

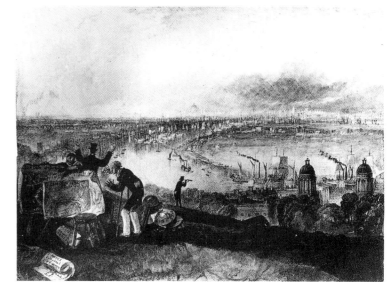

MARINE VIEWS

245 TWILIGHT – SMUGGLERS OFF FOLKESTONE FISHING UP SMUGGLED GIN

VIEWS OF LONDON

246 VIEW OF LONDON FROM GREENWICH

Although this work is in a private collection in the U.K., it was not possible to obtain a colour photograph of it.

In *Folkestone from the sea* (95) we saw kegs being 'sunk' at dawn; here they are being 'crept' after sunset, and the drawing therefore represents the next stage of a smuggling operation. Aboard a small rowing-boat the smugglers peer around warily as they pursue their clandestine activities, and the boat tilts precariously as the heavy kegs of gin are taken aboard.

The drawing was very well received when it was exhibited in 1824. Robert Hunt in *The Examiner* (19 April) wrote that '...water was never more illusively lucid...though MR TURNER draws figures badly, he manages, in spite of this drawback, to give them very expressive action'. *The Literary Gazette* (10 April) called the work one of 'the most spirited effusions of [Turner's] pencil'. Ackermann's *Repository of the Arts* (May) characterized it as 'a fine marine production. There is a richness, a force of expression and a bold tone of nature in every part.' More recently A. J. Finberg wrote memorably that 'The hurried movements of the three picturesque ruffians in the nearer boat, their anxiety to avoid observation either from the sea or the cliffs, the tumult of the scurrying storm-clouds, the majestic roll of the incoming waves fretted with wreaths of foam and angry little jets of spray by those recoiling from the land – all this seen in the gathering twilight, makes up a moving drama comparable in imaginative power to many of [Turner's] earlier sea-pieces.'[220]

1824, signed and dated
Private Collection, U.K.

43.2 × 64.8 cm (17 × 25½ in)

Given its probable date, subject, size and technical approach, it seems almost certain that this drawing was made for the 'Views in London and its environs' series, but not engraved due to the non-appearance of the scheme. The design probably derived from a pencil study of the view from Greenwich that Turner had used as the basis of several works, including a major oil painting exhibited at the Royal Academy in 1809.[221] Unlike those pictures, however, the image contains a great many references to London's past.

We look from Greenwich Park across the approaches to London, with the Royal Naval Hospital on the right. To the left, the reaches of the Thames below the Pool of London are packed with shipping, and the dome of St Paul's Cathedral rises out of the haze beyond a multitude of masts. A Greenwich Pensioner looks at unfurled maps and plans, amongst which are maps of London marked *LONDON 1825 Reign...George IV* and *LONDON 1526 Reign of Elizabeth Regn*, a mistake by Turner as Elizabeth I was not born until 1533. Under them is a *PLAN for [improving?] LONDON* and an architectural diagram containing the words *ST PAULS cathedral Sir C. Wren*. Beyond the pensioner (who has taken off his spectacles to examine these plans) is a folio entitled *DESIGNS OF LONDON* that is propped up against a pile of hemispheres, two of which are marked *N POLE* and *NEW WORLD*. On the ground can be made out various inscriptions, including *Grand plan to reclaim land* and *Thames – SEA*, the 'river' joining the two words being represented by a snaking line. On the river itself some paddle steamers are making their way downstream watched by another pensioner with a telescope. It is not clear why the top-hatted man beyond the maps is raising his arms, but perhaps he is expressing Turner's own responses to the way that the city had changed since he had first painted it.

c. 1825
Colour photograph unobtainable
Private Collection, U.S.A.

Size unknown

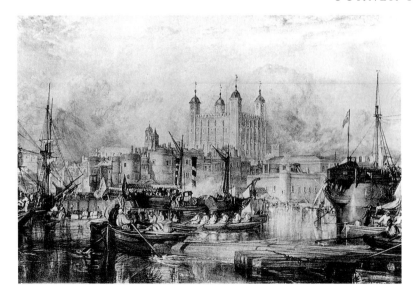

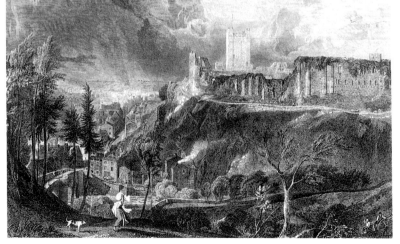

VIEWS IN LONDON
247 THE TOWER OF LONDON

This drawing has not been seen in public since it was lent to an exhibition at the Leger Galleries, London, in 1943, when it was photographed. It is nearly identical in size to the 1824 *Old London Bridge* (101) which was almost certainly engraved for the 'Views in London' series, and the close proximity of the subject (a view of the Pool of London from the opposite side of the river further downstream) suggests a link with that work, as well as with the 'London' series.[222]

The watercolour was last publicly sold in 1890, when it was auctioned under the spurious and clearly erroneous title of *The first steamer on the Thames*, the first steamship on the Thames having been the packet steamer *Margery* which was recorded on the river in 1813 (and which was also the first steamboat to sail from Britain to France). Depicted, however, are the steam packets *Talbot* and *Lord Melville*. The *Talbot* was built in Glasgow in 1819 and became a cross-channel ferry in 1822; the *Lord Melville* was launched in 1822 and probably also sailed regularly to France. Some coaches are being loaded aboard the *Lord Melville*, perhaps for subsequent continental travel, and a small official barge is passing in front of it. The *Lord Melville* is apparent in the pencil sketch from which Turner developed the design,[223] as is the prison-hulk that appears on the right. By locating this hulk so near to the viewer (it appears more distantly in the sketch), it may be that Turner wanted to effect a comparison between a magnificent ancient prison and its sordid modern counterpart. The Tower of London looks particularly solid beyond the wealth of foreground incident, which is matched in dynamism by the stormy sky.

c. 1825
Present whereabouts unknown

30.5 × 43.2 cm (12 × 17 in)

HISTORY OF RICHMONDSHIRE
248 RICHMOND CASTLE AND TOWN

A watercolour of Richmond sold at Christie's on 10 March 1900 was bought by Agnew and thereafter sold on to Sir T. D. Gibson-Carmichael; it may have been the work made for engraving in the 'Richmondshire' series, although nothing further is known of its whereabouts, while its size is slightly smaller than was usual for the designs made for the 'Richmondshire' scheme.

Turner sketched this view on the 1816 tour,[224] and the engraving certainly makes apparent the kind of weather he must have encountered during that terrible summer. We perceive the castle from the opposite bank of the Swale, with the bridge at the bottom left, the castle catching the wan, late afternoon sunshine, and storm-clouds approaching from the west. The girl with dog (Turner's fixed association of Richmond, see also 55, 140 and 155) has a strong following wind and she is therefore having trouble balancing her washing on her head.

c. 1816

Original drawing size: ?26.6 × 36.8 cm (10½ × 14½ in)
Engraving size: 19 × 27.9 cm (7½ × 11 in)
Engraved 1820 by J. Archer

HISTORY OF RICHMONDSHIRE

249 BRIGNALL CHURCH

The drawing upon which this engraving was based was destroyed by fire sometime before 1877 while it was in the collection of C. S. Bale.

Ruskin called the watercolour 'the perfect image of the painter's mind at this period' and said that the engraving conveyed only a feeble idea of it. He also responded to its elegaic mood:

> The spectator stands on the 'Brignall Banks', looking down into the glen at twilight; the sky is still full of soft rays, though the sun is gone, and the Greta glances brightly in the valley, singing its evensong; two white clouds, following each other, move without wind through the hollows of the ravine, and others lie couched on the faraway moorland; every leaf of the woods is still in the delicate air; a boy's kite, incapable of rising, has become entangled in their branches, he is climbing to recover it; and just behind it in the picture, almost indicated by it, the lowly church is seen in its secluded field between the rocks and the stream; and around it the low churchyard wall, and a few white stones which mark the resting places of those who can climb the rocks no more, nor hear the river sing as it passes.[225]

Due to its relative inaccessibility, the church itself fell into ruin after 1834, when much of its fabric was re-used to build a more approachable church on the moors above.

c. 1816

Original drawing size unknown
Engraving size: 19 × 27.3 cm (7½ × 10¾ in)
Engraved 1822 by S. Rawle

ENGLAND AND WALES

250 STRAITS OF DOVER

The original drawing for this engraving was last known to belong to Edward Nettlefold, but it was sold after his death in 1909 and has been untraced ever since.

We look westwards along the English Channel, with South Foreland lighthouse on the right and Dover Castle in the dip of the cliffs to the left of centre: in order to make the castle, pharos and church of St Mary in Castro either partially or fully visible, Turner has moved them about half a mile to the hillside opposite their true location (for the correct siting of these buildings see 17 and 104). The eye is led to the castle by three vessels that are vertically aligned beneath it. Instead of the latest steam-powered cross-channel shipping, to the right we see an old-style, wind-powered channel packet running before the wind, its passengers visible on deck. The small boat on the extreme right was added to the engraving on Turner's instructions and is not present in the original drawing. Structurally the work is underpinned by the cross-diagonals that meet at the declivity in the cliffs, and the semi-ellipse formed by the break in the clouds above and to the right of the crux is reiterated by the semi-ellipse formed by the shape of the nearest boat and sailor at its prow.

The engraving enjoys to the full the particular ability of etched line to render the flow of water, and W. G. Rawlinson aptly commented of the print: 'This is one of the finest seas in the 'England and Wales'; it is superbly engraved by Miller. The sky also, full of wind, light and cloud, is admirably rendered. And the whole scene is so *English*, so exactly what one sees on landing at Dover on a sunny, windy day.'[226]

c. 1825

Original drawing size unknown
Engraving size: 18 × 25 cm (7 × 9⅞ in)
Engraved 1828 by William Miller

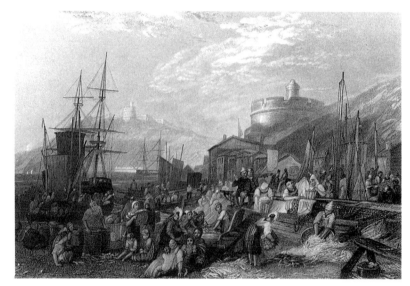

ENGLAND AND WALES

251 HAMPTON COURT PALACE

ENGLAND AND WALES

252 ST MAWES, CORNWALL

Until this drawing reappeared for sale at Sotheby's on 15 March 1990 (No. 96), it had not been seen publicly since 14 May 1859 when it was offered for sale at Christie's by Edward Rodgett and bought by 'Dickson'. Unfortunately its reappearance in 1990 came too late for it to be reproduced in colour in this book.

In the left-foreground are the remains of a basket; obviously the painter saw the similarity between this object and a crown, which is highly appropriate to a represent-ation of a Royal palace. In the same vein it may be that the stately procession of ducks was intended to introduce associations of the royal brood who were connected with the palace. This interpretation receives support from the fact that at the prow of the nearest boat is a clergyman seated on a throne-like chair; like the mallard that leads the procession of ducks, he is also represented in dark tones (unlike his companions), and maybe he too was intended to allude to the King (who was, of course, the head of the Church of England). Moreover, his visible infirmity matches the rather tattered con-dition of the basket, and perhaps jointly they offer Turner's comment on the nature of a monarchy that had disliked his work and had denied him a knighthood when lesser painters at the Royal Academy were often being knighted.[227]

The reflections on the river are superbly complex and the sky is subtly drawn and rich in tone. In *Modern Painters* Ruskin cited the shadows falling across the sandbank on the left as some of Turner's very best representations of shaded ground.[228] In the engraving, pebbles, feathers and a man were added to the sandbank. The willows on the extreme left are very similar to those seen on the left of *Eton College* (178), a drawing that dates from about the same time as this one.

c. 1827
Private collection

28.8 × 40.5 cm (11¼ × 11⅝ in)

The drawing for this engraving was last known to belong to Senator William Andrews Clarke in 1908. Upon his death in 1926 he left the bulk of his collection to the Corcoran Gallery of Art in Washington D.C., but the drawing was not listed in his will.

As in the 'Southern Coast' series view of St Mawes (40), we look towards Pendennis Castle in the distance across Falmouth Roads, with St Mawes Castle on the right, albeit from a much nearer viewpoint. But whereas in that earlier drawing Turner represented the St Mawes pilchard industry at a moment of economic depression, here he depicted it at full strength, much as he had done in a very similar oil painting exhibited at the Royal Academy in 1812.[229]

On the left are luggers and a brig drawn up on the beach, with some of the numerous baskets that were used for transporting the pilchards ranged before them. On the right, men and girls sort the fish, while one of the girls displays a giant skate that has obviously been fished up with the pilchards; nearby some old salts look at it and one of them gestures inland, perhaps suggesting its ultimate destination at the dinner table.

c. 1828

Original drawing size: 29.2 × 41.9 cm (11½ × 16⅜ in)
Engraving size: 16 × 24 cm (6¼ × 9½ in)
Engraved 1830 by J. H. Kernot

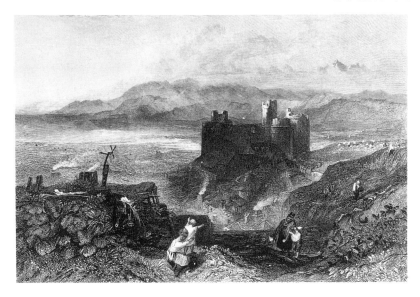

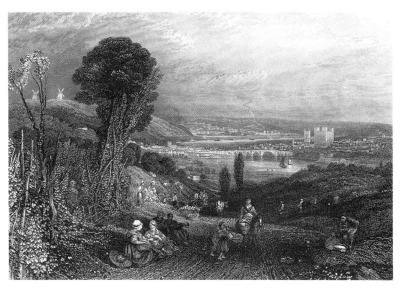

253 HARLECH CASTLE, NORTH WALES

The original watercolour for this engraving was another of the drawings that was with Charles Heath by 31 August 1835. It was last known to belong to George W. Vanderbilt of Ashville, North Carolina, who died in 1914, and it has subsequently disappeared.

Turner may have based the design upon an elaborate, partially coloured study of the view dating from 1798.[230] The castle and distant mountains of Snowdonia catch the last rays of evening sunlight, with the summit of Snowdon just visible above the clouds near the top right. In the foreground a girl supports a child who beckons to an old woman holding a dead bird in her hand; the woman's effort to climb the hill is very evident.

Summer 1835

Original drawing size: ?35.6 × 48.2 cm (14 × 19 in)
Engraved size: 16 × 24 cm (6¼ × 9½ in)
Engraved 1836 by W. R. Smith

254 ROCHESTER, STROUD AND CHATHAM, MEDWAY, KENT

The original drawing from which this engraving was made was destroyed by fire in 1955 while it was in the collection of A.F.L. Wallace.

We look at sunset towards Strood on the left, Rochester with its cathedral and castle on the right, and Chatham in the distance where the Great Lines, Brompton Barracks and the shipbuilding yards by the Medway are visible. The growing conurbation is framed by a landscape filled with activity as labourers process hops, a sower prepares his grain for casting and men plough. The general air of fecundity is epitomized by a mother suckling her child in the foreground, a typification that Turner used also in the watercolour of *Ludlow Castle* in the 'England and Wales' scheme (171). On the left, two children watch surreptitiously, which is something equally to be seen elsewhere in this series (152).

The representation of Rochester and Strood is rather mechanical in the engraving, and one wonders how accurately the print conveys Turner's original handling in this part of the design. Above Chatham a pall of smoke extends the zigzag of the Lines and not only displays Turner's understanding of differentiated layers of air-flow but also subtly denotes the topographical viewpoint of the *Chatham* (255) made for this series.

c. 1836

Original drawing size: 28.6 × 43.9 cm (11¼ × 17¼ in)
Engraving size: 16 × 24 cm (6¼ × 9½ in)
Engraved 1838 by J. C. Varrall

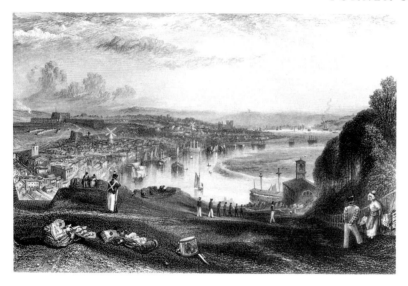

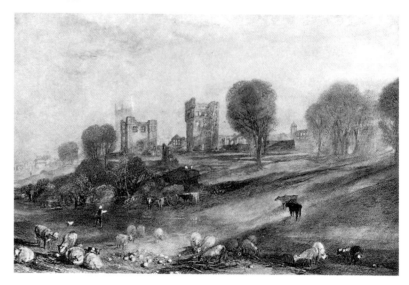

ENGLAND AND WALES
255 CHATHAM, KENT

ENGLAND AND WALES
256 ASHBY-DE-LA-ZOUCH, LEICESTERSHIRE

Although the watercolour from which this engraving was made is in a British private collection, it was not possible to obtain a photograph of it.

The view at sunset from the Great Lines above Chatham, probably at Fort Amhurst, takes in the now-demolished Fort Pitt on the left, with soldiers parading before it, and the old church of St Mary's at the bottom of the hill on the right. In the far distance may be seen Rochester Castle and Cathedral, and we are therefore looking *towards* the viewpoint of *Rochester, Stroud and Chatham, Medway* (254). The river is crowded with shipping, and moored by St Mary's church is a hulk that may be in use as a barracks; its masts and tops form crosses that are rather pertinent to the adjacent church, and marines file down the hill towards the vessel, via the graveyard.

The marines standing guard to the left of centre are roughly indicated in one of the pencil sketches upon which Turner based the work,[231] and the X-shape formed by the webbing of the nearest marine is repeated by the identical shape of the vanes of the windmill immediately above him. Similarly, the circular ammunition-pouch of the marine is aligned with a circular rosette on the pack that is deposited on the ground before him, yet another instance of Turner's penchant for visual simile. The pack, along with the other military ancillaries and the washing, clearly belong to the soldier and washerwoman chatting on the right, and they typify the military and economic basis of life in Chatham.

c. 1830
Photograph unavailable

Original drawing size: 28.2 × 45.7 cm (11 × 18 in)
Engraving size: 15 × 23 cm (6 × 9 in)
Engraved 1832 by William Miller

This drawing was sold in 1907 to a 'J. B. Phipps' by Agnew and has not been seen publicly since. The photograph reproduced here is taken from Sir Walter Armstrong's book on Turner, published in 1902 (p. 106).

Ashby-de-la-Zouch Castle was in reality a manor house with an unusual feature which is visible in the centre, namely the 27.5 metre (90-foot) high 'Hastings Tower' built by William, Lord Hastings in the 1470s and partially destroyed by Parliamentary forces in 1649. The watercolour was based upon sketches made on Turner's 1830 Midlands tour,[232] and the large number of those studies suggests that the painter went to great lengths to find a view of the scene that sparked his imagination. In 1908 W. G. Rawlinson wrote of the drawing that it was 'still very beautiful, although the sky has faded badly. The effect of the long rays of the setting sun breaking through the trees on the right is finely rendered'.[233] (In fact we are looking at Ashby-de-la-Zouch Castle and the tower of St Helen's Church from the south-east, and the shadows on the right are therefore being cast by the rising sun.)

c. 1830
Present whereabouts unknown

30.4 × 43.9 cm (12 × 17¼ in)

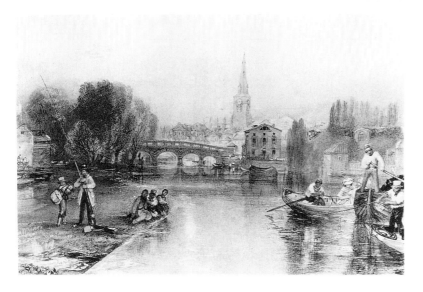

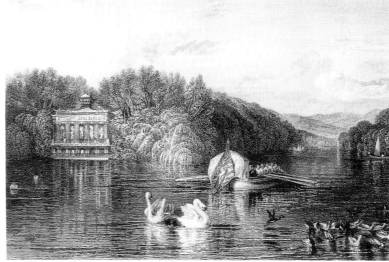

ENGLAND AND WALES

257 BEDFORD, BEDFORDSHIRE

THE KEEPSAKE

258 VIRGINIA WATER (II)

Turner loved fishing and equally he loved confusion, and they are both simultaneously present on either side of this view looking westwards in late afternoon light along the river Ouse towards the Swan Inn, Bedford Bridge and St Paul's Church. On the left a fisherman is accompanied by a boy carrying his basket, while three boats are milling around on the right attempting to avoid being sucked over the shallow weir next to the fisherman. The diagonal stress created by these boats, plus the diagonal line of the weir, leads the eye into the distance.

c. 1830 34.9 × 48.9 cm (13¾ × 19¼ in)
Private Collection, U.K.
Colour photograph unobtainable

The original watercolour on which this engraving was based was sold at Christie's on 21 May 1870 when it was bought by 'Maclean'; it has not been seen in public since.

As suggested elsewhere (132), according to legend Turner either made one or both of the drawings of Virginia Water for King George IV who refused to purchase them. If only one watercolour was created to seek an order from the King, and it was the other drawing that was painted in advance (perhaps to elicit an order for this second work), then that could explain the imagery of the present design.

On the left is the Chinese fishing pavilion that was converted into a Swiss fishing cottage in 1867 and demolished in 1936. In the centre may be seen the fishing boat fitted with a Moorish-style awning in which George IV would go fishing during the summer months. A seated figure, who may represent the King, can be seen between the awning and the oarsmen.

In front of the royal boat are two swans. In Britain these are 'Royal' birds, being automatically Crown property, and one of them is drawing back its neck to frighten away a mallard which, as we have seen above, may indirectly represent Turner himself. If the duck does represent the artist, then the swan could represent George IV shooing away Turner by rejecting the commission for a second design. The emphasis given to the weeping willow above the swans suggests that this was the case, for Turner was well aware of the 'weeping' associations of such trees.[234] It would have been entirely characteristic for him to have used those 'sad' associations to comment ironically upon his failure to obtain Royal patronage.

c. 1829 Original drawing size: 28.9 × 44.2 cm (11⅜ × 17⅜ in)
Engraving size: 9.5 × 13.9 cm (3¾ × 5½ in)
Engraved 1830 by Robert Wallis

INTRODUCTION NOTES

1 T. Miller, *Turner and Girtin's Picturesque Views Sixty Years Hence*, London, 1854, publisher's preface (n.p.).

2 The work was recognized as displaying the influence of Girtin, most notably by Walter Shaw Sparrow in his essay 'Turner's monochromes and early watercolours', in *The Genius of J. M. W. Turner*, London, 1903, p. M.W. *vii*.

3 Andrew Wilton, *The Life and Works of J. M. W. Turner*, London, 1979, p. 186.

4 Joseph Farington noted in his diary on 21 April 1810:

> Mr. Fuller, member for Suffolk [a mistake for Sussex] has engaged Turner to go into that County to make drawings of three or four views. He is to have 100 guineas for the <u>use</u> of His Drawings which are to be returned to Him. (*The Diary of Joseph Farington*, ed. Kathryn Cave, London and New Haven, Vol. X, p. 3640).

Farington must have stressed the word 'use' because he was so impressed by the high amount Turner was able to obtain merely for the hire of his drawings. That *Rosehill* (1), *Ashburnham* (2), *Beauport* (3) and *Battle Abbey* (4) do date from 1810 (and not later as thought by several writers on Turner) is attested by three factors. Turner received the extremely lucrative commission for drawings in the spring of 1810, and he would hardly have kept Fuller waiting long for his watercolours. Four aquatints of these watercolours were then produced, separately from the engravings of any of Fuller's other drawings. The coincidence, between the 'three or four views' ordered (to be made '*use*' of') and the *four* aquatints, seems conclusive. Furthermore, on stylistic grounds alone, these drawings stand apart from all the other works made for Fuller and clearly date from earlier.

5 The painting is no. 511 in the oeuvre catalogue by Martin Butlin and Evelyn Joll, *The Paintings of J. M. W. Turner*, London and New Haven, rev. ed. 1984, and is now in a Welsh private collection.

6 See Nos. 822–25 in W. G. Rawlinson, *The Engraved Work of J. M. W. Turner*, 2 Vols., London 1908 and 1913.

7 Farington recorded seeing the work at Stadler's workshop on 10 June 1811:

> Stadler I called on, & saw a picture by Turner ''A View of Rose Hill,'' Mr Fuller's House in Sussex.

The fact that Farington referred to Fuller's 'House' differentiates the work from the drawing for the coloured aquatint (R. 822) produced by Stadler (which is also called *Rosehill*) but which only shows the estate (see 1).

8 Memoir by P. Cunningham in J. Burnet, *Turner and his works*, London, 1852, p. 34.

9 Joseph Jeckyll to Lady Gertrude Sloane–Stanley, *Correspondence*, London, 1894, p. 294.

10 On p. 59 of the *Hastings* sketchbook, T.B. CXI.

11 *The Gentleman's Magazine*, June, 1834, p. 649.

12 Much of the evidence concerning Turner's dealings with W. B. Cooke over the 'Southern Coast' series is gleaned from a letter written by Cooke to Turner, dated 1 January 1827. It was first published in W. Thornbury, *The Life of J. M. W. Turner*, London, 1862, Vol. 1, pp. 400–3. More recently it has been reprinted in John Gage, *The Collected Correspondence of J. M. W. Turner*, Oxford, 1980, letter 121, pp. 104–6:

January 1, 1827

Dear Sir,

I cannot help regretting that you persist in demanding twenty-five sets of India proofs before the continuation of the work of the 'Coast', besides being paid for the drawings. It is like a film before your eyes, to prevent your obtaining upwards of two thousand pounds in a commission for drawings for that work.

Upon mature reflection, you must see I have done all in my power to satisfy you of the total impossibility of acquiescing in such a demand. It would be unjust both to my subscribers and to myself.

The 'Coast' being my own original plan, which cost me some anxiety before I could bring it to maturity, and an immense expense before I applied to you, when I gave a commission for drawings to upwards of 400l, *at my own entire risk*, in which the shareholders were not willing to take any part, I did all I could to persuade you to have one share; and which I did from a firm conviction that it would afford some remuneration for your exertions on the drawings in addition to the amount of the contract. The share was, as it were, forced upon you by myself, with the best feeling in the world; and was, as you well know, repeatedly refused, under the idea that there was a possibility of losing money by it. You cannot deny the result: a constant dividend of profit has been made to you at various times, and will be so for some time to come.

On Saturday last, to my utter astonishment, you declared in my print-rooms, before three persons who distinctly heard it, as follows:— 'I will have my terms! or I will oppose the work by doing another ''Coast''!' These were the words you used; and everyone must allow them to be a *threat*.

And this morning (Monday) you show me a note of my own handwriting, with these words (or words to this immediate effect): 'The drawings for the future ''Coast'' shall be paid twelve guineas and a half each'.

Now, in the name of common honesty, how can you apply the above note to any drawings for the first division of the work, called the 'Southern Coast', and tell me I owe you two guineas on each of those drawings? Did you not agree to make the whole of the 'South Coast' drawings at 7l.10s. each? and did I not continue to pay you that sum for the first four numbers? When a meeting of the partners took place, to take into consideration the great exertions that myself and my brother had made on the plates, to testify their entire satisfaction, and considering the difficulties I had placed myself in by such an agreement as I had made (dictated by my enthusiasm for the welfare of a work which had been planned and executed with so much zeal, and of my being paid the small sum only of twenty-five guineas for each plate, including the loan of the drawings, for which I received no return or consideration whatever on the part of the shareholders), they unanimously (excepting on your part) and very liberally increased the price of each plate to 40l.; and I agreed, on my part, to pay you ten guineas for each drawing after the fourth number. And have I not kept this agreement? Yes; you have received from me, and from Messrs. Arch on my account, the whole sum so agreed upon, and for which you have given me and them receipts. The work has now been finished upwards of six months, when you show me a note of my own handwriting, and which was written to you in reply to a part of your letter, where you say, 'Do you imagine I shall go to John O'Groats's House for the same sum I received for the Southern part?' Is this *fair* conduct between man and man, to apply the note (so explicit in itself) to the former work, and to endeavour to make me believe I still owe you two guineas and a half on each drawing? Why, let me ask you, should I promise you such a sum? What possible motive could I have in heaping gold into your pockets when you have always taken such especial care of your interests, even in the case of 'Neptune's Trident', which I can declare you *presented* to me; and in the spirit of *this* understanding I presented it again to Mrs Cooke. You may recollect afterwards charging me two guineas for the loan of it, and requesting me, at the same time, to return it to you; which has been done.

The ungracious remarks I experienced this morning at your house, when I pointed out to you the meaning of my former note – 'that it referred to the future part of the work, and not to the ''Southern Coast'' ' – were such as to convince me that you maintain a mistaken and most unaccountable idea of profit and advantage in the new work of the 'Coast'; and that no estimate or calculation will convince you to the contrary. Ask yourself if Hakewill's 'Italy', 'Scottish Scenery' or 'Yorkshire' have either of them succeeded in the return of the capital laid out on them.

These works have had in them as much of your individual talent as the 'Southern Coast', being modelled on the principle of it; and although they have answered your purpose by the commissions for drawings, yet there is considerable doubt remaining whether they will ever return their expenses, and

whether the shareholders and proprietors will ever be reinstated in the money laid out on them. So much for the profit of works.

I assure you I must turn over an entirely new leaf to make them ever return their expenses.

To conclude, I regret exceedingly the time I have bestowed in endeavouring to convince you in a calm and patient manner of a number of calculations made for *your* satisfaction; and I have met in return such hostile treatment that I am positively disgusted at the mere thought of the trouble I have given myself on such a useless occasion.

I remain, your obedient Servant,
W. B. Cooke

As the letter makes clear, Cooke urged Turner to invest financially in the venture but he refused. Instead, Cooke seems to have paid Turner a bonus out of the profits of the scheme (see note 13, below). As John Gage's annotation to this letter suggests (p. 104, note 2), it is not clear how many drawings Cooke initially requested from Turner. Cooke writes of initially commissioning upwards of four hundred pounds-worth of drawings for the series. If these were all from Turner this would have meant Turner would have produced fifty-three of them, i.e. £400 divided by £7.10s = 53 (the letter *is* ambiguous. Cooke states that 'The "Coast" being my own original plan, which cost me some anxiety before I could bring it to maturity, and an immense expense before I applied to you, when I gave a commission for drawings for upwards of £400 . . .'). However, I agree with Gage's contention that this number of works must have been *inclusive* of those contributed by the other artists to the series. There are two views on this. A. J. Finberg (*An Introduction to Turner's Southern Coast*, London, 1927, p. xiii) states, without giving sources, that 'Turner's first contract with Cooke was to supply twenty-four drawings.' On the other hand W. G. Rawlinson, *op. cit.* Vol. 1, p. xxix, tells us that Turner was to make forty from the outset – again without citing sources. As the covers for the parts of the 'Southern Coast' tell us that the scheme was to consist of either forty-eight full-page plates and thirty-two vignettes, or alternatively fifty plates and thirty vignettes (the numbers varied), it seems highly unlikely that Turner would initially have been asked to make more works than were intended for engraving in the series. Moreover, if Turner had made such a number all the other artists would have been excluded. An explanation for the ambiguity is that Turner's agreement to participate was the lynch-pin upon which the decision to proceed was founded. Once his assent had been received then Cooke issued the commissions to all the artists, including Turner. That would explain the ambiguous 'when' in the extract quoted above.

13 The syndicate is listed in John Murray's ledger book 'A', p. 1. The members consisted of W. B. Cooke, George Cooke, E. Lloyd, J. Hakewill, J. and A. Arch, J. M. Richardson, B. King, E. Blore, W. Westall, W. Alexander, John Murray and Turner. However, although Turner was a member, it does not seem that he had a financial share in the scheme (but see note 12 above).

14 Rawlinson, *op.cit.*, No. 76.

15 *ibid.*, p. xxvii.

16 Page 1 of the *Vale of Heathfield* sketchbook, T.B. CXXXVII.

17 For Cooke's illness, see a letter to John Murray in the archives of John Murray (Publishers) Ltd, dated 13 June 1813:

I take the earliest opportunity of informing you of my return to London from the West of England, and have the pleasure of stating that my health is so far improved by the mild Air of Cornwall during the Winter, that I mean immediately to proceed with the work of the *Coast of England*, the Prospectus of which was published some time since . . . I hope with my Brothers assistance to get a sufficient number of Plates ready by the Winter that any future delay in the publication may be prevented and propose publishing the first part of the work in January 1814.

W. B. Cooke

18 Cyrus Redding (1784–1870) was later to write *A History and Description of Modern Wines*, a work that was regarded by the Victorians as the authoritative book on wine. It was first published in 1833 and went through several printings up until 1871. It was republished in 1980.

19 Cyrus Redding, 'The Late Joseph Mallord William Turner', *The Gentleman's Magazine*, February, 1853, p. 152.

20 See Sam A. Smiles, 'Turner in Devon: some additional information concerning his visits in the 1810s', *Turner Studies*, Vol. 7, No. 1, Summer 1987, pp. 11–14.

21 See John Gage, ed., *The Correspondence of J. M. W. Turner*, Oxford, 1980, letter 47, p. 54 (16? or 23 November 1814).

22 See Farington, *op. cit.*, entry for 1 August 1811 where he recorded that Landseer turned the invitation down because he felt that in order to do the subject justice he would have to make an extensive tour for which he was not prepared.

23 See Turner's draft poem in the *Devonshire Coast No. 1* sketchbook, T.B. CXXIII. A transcription of it appears in Walter Thornbury, *The Life and Correspondence of J. M. W. Turner*, London, 1877, pp. 205–217.

24 Better known as 'Dr Syntax', Combe was the author of an influential satire entitled *The Tour of Dr. Syntax in search of the Picturesque*. The work was illustrated by Rowlandson.

25 A letter from W. B. Cooke to John Murray (now in the John Murray archive) dating from the end of 1814, states that Part 4 of the 'Southern Coast' was entirely sold out even though it had only been published in October and November. Cooke speculates in the letter as to the viability of further printing from the plates but also complains that '. . . the work falls desperately heavy on myself and my Brother – When and where are we to expect a sufficient remuneration? – The print only of Lyme [*Lyme Regis*, R.94] is honestly worth half a guinea to pay for the labour bestowed on it – I begin to despair of being paid half the value of time and labour even though the Works sell till the plates are utterly worn out'. He continues in this vein, pleading for greater profit from the project. The letter obviously made its point.

26 W. B. Cooke's account books are reproduced fairly accurately in Thornbury, *op. cit.*, 1877, pp. 633–36, and one of the original books is now in the British Museum Department of Prints and Drawings. They record that Turner made a view of the Eddystone lighthouse (hardly a river in Devon) for this series. Turner hired the drawing to Cooke for £5. The work was eventually assigned to the 'Marine Views' series (see main text below).

27 See the letter of 21 December 1818 from W. B. Cooke to John Murray in the archives of John Murray (Publishers) Ltd:

. . . I have informed you some time ago that Mr Fuller of Rosehill had employed me some Years ago to engrave a Set of Plates for him from Drawings by Turner – Mr Fuller has lent me Two Volumes of Valuable MS copy on Sussex to extract from them the most interesting Notices on the Rape of Hastings [Sussex was divided into six Rapes, or administrative districts] – *it is on this Rape that our present work will treat.* – The work is to be divided into Three Parts – the first Part (Plates and all) is ready for the Press and Mr Fuller urges me to publish the first of March next [in fact the publication date of the first group was 1 March 1819]. As the Plates are *done* [the etched states of these works carry the dates 1816 and 1817 – see Rawlinson, *op. cit.*, Vol. 1, pp. 68–72] I see no reason for Keeping the Work back when it can be realizing in cash. – I shall therefore send you in the course of today a prospectus of the Work also, to insert into your list of Publications under the conviction that you will publish them . . . Mr. Fuller's Work will be a *splendid thing*, and I trust will do credit to all the Parties concerned – Turner has made the Drawings in his first Style [i.e., Turner had made the later Sussex drawings accord stylistically with his earlier set]. The Plates are much larger than the Coast and will be published in Imperial and Royal *Folio*.

Three days later Cooke followed up this letter with another informing Murray of Fuller's agreement to foot the bill for the publication expenses and requesting Murray's speedy consideration of the work for publication. Murray agreed to publish the work, with the first part of the three-part scheme to be called 'Views in Sussex'. Murray stipulated that he should have sole rights of distribution and that for an extra ten per cent commission he would introduce it on all his lists and advertise it in his *Quarterly Review* (see A. J. Finberg, *An Introduction to Turner's Southern Coast*, London, 1927, Appendix A, p. 70).

28 Murray had clearly changed his mind about the venture. This reversal was undoubtedly partly due to his disenchantment with Cooke's constant inability to meet deadlines for the 'Southern Coast' series. By now the tenth part of this scheme was over three years late in appearing and finally Murray withdrew from the project.

The 'Views in Sussex' suffered in consequence. Cooke complained bitterly of this to Turner:

> no failure of Promises (which are in themselves physically impossible to perform, and which are dictated by an enthusiasm or too great confidence in one's own powers as to time) on my part can be any excuse for such malignity or littleness. (Finberg, *op. cit.*, 1927, p. 70).

He threatened Murray with legal action but in the event decided to cut his losses. Thereafter the 'Southern Coast' was published by John and Arthur Arch who owned a print-shop in Cornhill. Cooke and Murray, though, were reconciled before 1822, for the John Murray archives contain a friendly letter from Murray to Cooke dated 29 January 1822.

29 *The Dormitory and transcept of Fountains Abbey – Evening*, R.A. 1798, Private Collection, U.K. The work is No. 238 in Andrew Wilton's list of Turner watercolours, in *The Life and Works of J.M.W. Turner*, London, 1979.

30 See catalogue, *Turner and Dr Whitaker*, Towneley Hall Art Gallery and Museums, Burnley, Lancashire, 1982.

31 *Harewood House, from the south-west*, 1798, coll. The Earl of Harewood, Harewood House. The work is No. 219 in Andrew Wilton's list of Turner watercolours, in *The Life and Works of J.M.W. Turner*, London, 1979.

32 See Farington, *op. cit.*, entry for 15 May 1816:

> Smirke told me that Turner had been engaged to make drawings for a History of Yorkshire: Longman & Co. to be the Publishers; and that he was to have 3000 guineas for his drawings.

On 17 May 1816 he also recorded:

> Turner told me that He had made an engagement to make 120 drawings views of various kinds in Yorkshire, for a History of Yorkshire for which he was to have 3000 guineas. Many of the subjects required, He said, He had now in his possession. He proposed to set off very soon for Yorkshire to collect other subjects.

33 See Gage, *op.cit.*, 1980, letter 68 (dated 11 September 1816), p. 70.

34 *Ibid*, letter 65 (dated 31 July 1816), p. 67.

35 *Ibid*, letter 68, p. 70.

36 'Memoir of Robert Surtees' by James Raine in Vol. IV of 'The History and Antiquities of the County Palatine of Durham' by Robert Surtees, London, 1840, p. 17.

37 On pp. 10–11 of Vol. II of 'The History and Antiquities of the County Palatine of Durham', Robert Surtees states that the illustrations of antiquities were paid for by the subscribers but not 'castles and other residences of gentlemen'.

38 The reference to such a project may be found in a document (part of a collection of letters to and from W.B. Cooke and George Cooke in the John Frederick Lewis Collection of documents relating to British engravers now in the Free Library of Philadelphia, Pennsylvania) signed by Edward Goodall on 21 July 1820 and witnessed by the engraver John Pye and the painter Frederick Nash:

> I hereby promise to engrave fifteen plates for the work on London from Drawings to be made by Messrs. Turner, Calcot [*sic*], Westall, Nash & MacKenzie within the space of 14 year. to be delivered in the following order – one the first year – two the Second year and three each succeeding year – till the whole are completed – all this I promise faithfully to do on condition that I am to be paid fifty guineas for each plate this price I name not liable to any increase or deduction.

(See Eric Shanes, 'Turner's "Unknown" London Series', *Turner Studies*, Vol. 1, No. 2, 1981, pp. 36–42.)

39 See Shanes, *art.cit.*, p. 37.

40 T. Miller, *op. cit.*, 1854, n.p.

41 Rawlinson (*op. cit.*, Vol. II, p. 364) verifies Turner's work on these plates and testifies to seeing the etched initials *J.M.W.T.* on a privately-owned proof of Girtin's *York Minster*.

42 These drawings are *Folkestone from the sea* (95), *Dover Castle* (96), *A Storm (Shipwreck)* (98), *Fish-market, Hastings* (97), and *Twilight – Smugglers off Folkestone fishing up smuggled Gin* (245). The reason none of them have previously been connected with

the 'Marine Views' is because they have been widely dispersed and because they were not engraved by W.B. Cooke. That they were intended for the series is demonstrated by three factors. All but one of them are known to have been made for Cooke, who only bought watercolours from Turner for engraving and who had no large-scale series other than the 'Marine Views' he could have assigned them to at that date. In addition, they are all exactly similar in size, which clearly suggests a series-relationship, and they also share common characteristics of content and handling. The work not bought by Cooke is *Folkestone from the sea* (95), dating from *circa* 1822–4, which has remained in the Turner Bequest. This drawing shows gin being hidden at sea and thus forms a pendant to *Twilight – Smugglers off Folkestone fishing up smuggled Gin* (245) which *was* partially engraved for the series. Although *Folkestone from the sea* is slightly larger than the other 'Marine Views' watercolours, extensive tears and irregularities along the edges mean that it would have been cut down for display or engraving purposes. Turner also made a small introductory vignette for the venture (see below).

43 Rawlinson (*op. cit.*, Vol. II, p.384) cat. no. 798. *Dover Castle* was also engraved (as a line-engraving) by J.T. Willmore in 1851 – see Rawlinson cat. no. 666.

44 Thornbury *op. cit.*, pp. 634–35, and Cooke's account book, British Museum Dept. of Prints and Drawings.

45 Cooke himself related this story in his letter of 1 January 1827 (see note 12 above). We only have his word for it, therefore. He may have misunderstood Turner who was, after all, a *professional* painter.

46 Auction catalogue, Messrs. Southgate, Grimston and Wells, Friday 23 July 1830.

47 Ackermann's *Repository of the Arts* for 1 March 1822 also tells us that 'last year's exhibition was rather discouraging to the proprieters'.

48 On 17 May 1823 Cooke advertised in *The Literary Gazette*:

> Two superb drawings by J.M.W. Turner, R.A. will be added to this splendid collection on Monday next, May 19th, and will be placed in the centre of the rooms. A STORM [98] and A SUN-RISE [94]. These powerful productions from the pencil of Mr Turner (being just finished) will continue a few weeks only for public inspection.

In fact, the view of Margate at sunrise (94) dated from 1822 and was so inscribed by the artist.

49 These were *Twilight – Smugglers off Folkestone fishing up smuggled Gin* (245) and *Fish-market, Hastings* (97).

50 Thornbury, *op. cit.*, 1877, pp. 192–93. 'Mr Munro' was H.A.J. Munro, Turner's patron and friend. They probably met in the mid-1820s.

51 Turner stayed at Farnley for the last time between 19 November and 14 December 1824.

52 They first collaborated in 1810–11 when Heath engraved the figures in John Pye's print of *Pope's Villa at Twickenham*, R.76. Heath also engraved the figures for the engraving made in 1812 of *High Street, Oxford*, R.79.

53 Around 15.2 × 22.8 cm (6 × 9 in).

54 The later collapse of Hurst and Robinson (see main text below) would subsequently endanger the scheme because of Heath's reliance upon them for all the capital necessary to produce the engravings.

55 Letter from Charles Heath to the Yarmouth banker Dawson Turner, Library of Trinity College, Cambridge.

56 On page 88a of the *Brighton and Arundel* sketchbook (T.B. CCX), which was in use in 1824–25, Turner wrote Heath's name alongside the words 'Airdale' and 'Wharfedale', while elsewhere on the page he also wrote 'Knaresboro'. Although there are no Airdale scenes in the 'England and Wales' series, Bolton Abbey is in Wharfedale and the watercolour of that abbey may therefore have been made late in 1824 or early in 1825. A view of Knaresborough also appears in the series and could equally have dated from 1825, although the engraving was not published until 1828.

57 Heath wrote to Dawson Turner on 12 April 1825:

> . . . I shall in my next parcel send you the first Plate for my grand work from Turner of England and Wales 120 Plates to be engraved by all the first rate artists.
> (Library of Trinity College, Cambridge).

58 On 5 December 1825 the giant banking house of Sir Peter Pole & Co suspended

payment and, as they held the accounts of forty-four country banks, in the following weeks no less than seventy-eight banks (including five London banks) were forced to close.

59 Turner wrote to James Holworthy on 5 May 1826 that 'While the crash among the Publishers have changed things to a stand still, and in some cases to loss – I have not escaped' (see Gage *op. cit.*, 1980, letter 116, p. 100).

60 Heath wrote to Dawson Turner on 23 January 1826:

> . . . the news this morning is that Messrs. Hurst and Robinson have commenced paying again – and from the quarters I have heard it from I think it true. but a blow has been struck that will be felt by every one the most distantly connected with them. nearly all the booksellers have suffered and as for getting a farthing in the shape of money it is absolutely impossible and as for Bills no one will look at them. the times are indeed aweful. For myself I know not what to do, I must candidly confess to you that I fear I shall one way and another be implicated beyond my means tho' I trust no one will eventually lose by me . . .
>
> (Library of Trinity College, Cambridge).

61 That Jennings and Company capitalized only half of the scheme is made clear by Heath's later attempts to borrow money from Dawson Turner in order to supply his half of the venture capital (see below).

62 See note 12 above, where Cooke is quoted as stating that Turner's obsession with the proofs '. . . is like a film before your eyes, to prevent your obtaining upwards of two thousand pounds in a commission for drawings for that work' (i.e. the continuation of the 'Coast' scheme around Britain). At twelve and a half guineas for each drawing this means that at least 160 drawings were planned. As 160 is divisible by 40 (i.e. the number of drawings in the 'Southern Coast') four times *exactly*, this means that Cooke eventually planned the entire coastal scheme in four parts with 40 drawings by Turner in each part.

63 See note 12 above for the full context of the statement.

64 See Alaric Watts, biographical sketch in *Liber Fluviorum*, London, 1853, p. xxix. Watts is wrong in stating that Turner received 25 guineas for the watercolours but he may have been correct on this detail. A note on a proof of *Hythe, Kent* (quoted in Rawlinson, *op. cit.*, Vol. I, p. 64, no. 118) suggests that Cooke allowed Turner one preliminary etching and four proofs of each 'Southern Coast' engraving.

65 *Dover from Shakespeare's cliff* (R.125).

66 Frederick Goodall R.A., *Reminiscences*, London, 1902, pp. 161–2.

67 At this time Goodall was also working on two engravings for the 'England and Wales' series, views of *Rievaulx Abbey* (R.209) and *The Fall of the Tees* (R.214).

68 Thornbury, *op. cit.*, 1877, p. 316n.

69 John Ruskin, *The Harbours of England*, London, 1856, p. iv.

70 Rawlinson stated (*op. cit.*, Vol. I, p. xliii) that the work 'failed to attract subscribers' but he also later tells us that 'only a small number of impressions . . . remained unsold from the original issue' (Vol. II, p. 378). Gambart and Lupton were hardly likely to have re-published them in 1856 if they had been a financial failure in 1828. Rawlinson is probably correct, though, in assuming that Turner may have found the tonal range of mezzotint too dark and that this led to his dissatisfaction with the scheme. The incomplete state of *Margate* (R.785) also suggests that Turner was making enormous demands upon Lupton (the print transforms an afternoon scene into one at night). This too may have led to friction.

 A greater mystery concerns the fate of the drawings. Turner unquestionably hired, rather than sold, the drawings for the completed engravings to Lupton; as a result they are all still in the Turner Bequest. The drawings for all the *uncompleted* engravings were sold, however, though it is not known by whom. Turner is unlikely to have split up the series and, as the drawings were probably with Lupton when the two men divided, he may well have sold them to recoup his losses. This would also explain why he did not complete the engravings.

71 Thornbury (*op. cit.*, 1877, pp. 196–8) gives a detailed account of the dispute over Lupton's later engraving of the 1803 painting, *Calais Pier*; but see Butlin and Joll, *op. cit.*, 1984, no. 48, p. 38.

72 Sunday, 7 January 1827. It was to consist of the 'Eastern and Western Coasts', to be published in alternate numbers.

73 Messrs. Arch and Arch had thought of supporting the 'Eastern and Western Coast' scheme planned by the Cooke brothers, but they pulled out when Turner broke off relations with the Cookes. Subsequently the Arches floated the idea for a scheme surveying 'The English Channel or La Manche' from drawings by Turner to be worked up from sketches made on a tour of northern France in the summer of 1826, and the letterpress was to be in French and English, but nothing came of this idea either. There is a copy of the prospectus for the project in the Dawson Turner collection of prospectuses, British Library, London.

74 C. W. Radcliffe, *Catalogue of the Exhibition of Engravings by Birmingham Engravers*, Birmingham, 1877, pp. 5–6.

75 There is a copy in the Ruskin Galleries, Bembridge School, Isle of Wight (Ruskin MS. 54/F).

76 A. J. Finberg, *The Life of J. M. W. Turner, R.A.*, 2nd ed., London, 1961, p. 323. This seems likely, given that Turner clearly embarked upon the 1830 tour in search of new material.

77 For a list of these watercolours, see Eric Shanes, *Turner's Picturesque Views in England and Wales*, London, 1979, p. 156. A concordance in the book (pp. 155–56) also correlates all the other 'England and Wales' watercolours with the sketches, in the Turner Bequest and elsewhere, from which they were developed.

78 Now in the collection of the Dept. of Prints and Drawings, British Museum, London.

79 The Rev. W. H. Harrison, 'Thomas Stothard', *The University Magazine*, Vol. 1, No. V, 1878, p. 301.

80 See Eric Shanes, 'New light on the 'England and Wales' series, *Turner Studies*, Vol. 4, No. 1, Summer 1984, pp. 52–4.

81 See Abraham Rainbach, *Memoirs and Reminiscences*, London, 1843, pp. 135–36, 141.

82 Longman noted the takeover in their Commission Ledger C5, folio 587ff. (Longman ledger books, Dept. of Archives and Manuscripts, University of Reading, Berkshire.)

83 Although the 1833 catalogue entries are anonymous, identical passages in the letterpress establish Lloyd as the author of the exhibition catalogue. To compare them, see the two respective entries for *Dartmouth Cove*.

84 Although various writers have stated that Heath went bankrupt, I have been unable to find any record of official bankruptcy proceedings against him either in the Public Record Office or in *The Times* index of bankruptcies between 1830 and 1841. But it is clear from the Longman ledger books that Longman took over Heath's affairs and supported him while his debts were paid off, for there are entries recording the quarterly (and sometimes more frequent) payments to Heath of £50.

85 His own presentation set of these engravings is now in the Museum of Fine Arts, Boston, Massachusetts.

86 Here a slight discrepancy arises. Longman recorded the result of this part of the sale in their Commission Ledger No. 6, folio 526, where they noted: 'Mem[o]: all the volumes, letterpress, odd plates and reprints made into sets and sold at Southgates £3063-3/-6d.' This must be the sum paid by Turner. The £63-3/-6d was most probably the storage and removal charge for the stock which was considerably bulky.

87 Alaric Watts, *art. cit.*, p. xxi.

88 Alaric Watts commented in 1853 that 'The stock, or the greater part of it, is still lying in Queen Anne Street, of course not improved by keeping and having, in the course of the 14 years which have since elapsed, swallowed up another £3000, reckoning compound interest at five per cent per annum' (*loc. cit.*).

89 I estimate this as follows:

payments to engravers @ £100 each:	£9600.00
payments to Turner @ 30 gns per drawing:	£3055.50
papers, coppers, printing costs etc:	£3000–£5000.00
TOTAL	£15,660.50–£17,655.50

90 Alaric Watts refers in his biographical sketch to 'so Flemish a balance of profit accruing to the publishers' ('Flemish' meaning fine, as in the fineness of Flemish painting) and by this he may have meant gross profit (i.e. income *before* deduction for costs), in which case the sale of the engravings must have been very minute. If on the other hand he meant net profit (i.e. profit *after* expenses had been paid), even a tiny profit would have meant a loss in real terms if it neither afforded Heath any income nor his publishers any substantial return on capital invested. Considering the time the scheme lasted – twelve or so years – it seems more likely that the latter was the case,

but in any event sales must have dried up by the mid-1830s.

91 Heath is listed as being the owner of the drawing in the catalogue of the 1833 exhibition (No. 55) and he would only have bought the work for engraving in the 'England and Wales' series.

92 And he could instead have lost £7.13s.6d. on the whole scheme if the extra £63.3s.6d. referred to in note 86 above was in fact paid by him.

93 Now in the collection of the Library Service of the London Borough of Hounslow.

94 Thus there are a number of works whose titles share the same idiosyncratic spellings of places depicted (for example, 'Winander-mere' instead of 'Windermere' – see 218).

95 The later watercolours made for Fuller are of the same size (presumably they were intended to match up with Fuller's earlier drawings) although the subsequent line-engravings made from them by the Cookes are much smaller. This reflects the fact that the Cookes did not ever seem to have the time or inclination to make large line-engravings themselves.

96 Turner referred to Hogarth's concept in a poem contained in a verse-book still in the possession of a member of the Turner family. The book seems to have been in use in 1808–09. The poem is reprinted in full in Jack Lindsay, *The Sunset Ship*, London, 1966, p. 121.

97 This may have resulted from Turner's exploration of perspective in his role as Royal Academy Professor of Perspective; for discussion of Turner's use of linear structures to support meanings, and their relationship to his teaching of perspective, see Eric Shanes, *Turner's Human Landscape*, London, 1990.

98 Turner referred to 'Ideal beauties' in a lecture manuscript dating from 1808–11, and revised in 1812 and 1818 (British Library *Add. Ms.* 46151, N, p. 8); the reference to 'qualities and causes' occurs in an annotation on page 58 of John Opie's *Lectures on Art*, (London, 1809), which was in his library. For discussion of both passages, see Eric Shanes, *Turner's Human Landscape*, London, 1990.

99 Walter Shaw Sparrow, *art. cit.*, pp. W/vii–viii.

100 B. Webber, *James Orrock, R.I.*, London, 1903, Vol. 1, pp. 60–1.

101 W. L. Leitch, 'The Early History of Turner's Yorkshire Drawings', *The Athenaeum*, London, 1894, p. 327.

102 For a discussion of Turner's colour-idealism, see Eric Shanes, *Turner's Human Landscape*, London, 1990, pp. 281ff.

103 The original drawing for this engraving measured 37.5 × 55.2 cm (14¾ × 21¾ in) and it was sold at the Ackland–Hood sale at Christie's on 4 April 1908 when it was bought by 'Levin'. Its present whereabouts are unknown. The engraving is No. 129 in W. G. Rawlinson's catalogue of the engravings after Turner.

104 John Thomson of Duddingston (1778–1840), a painter and Presbyterian Minister.

105 William Bell Scott, *Autobiographical Notes*, 2 Vols., London, 1892, Vol. 1, p. 84.

106 The painter confused two English kings in the above anecdote, namely King Harold I Harefoot, who died in 1040, and King Harold II Godwinson (?1020–1066) who was killed at the battle of Hastings.

107 John Ruskin, *Modern Painters*, Vol. II, in *The Complete Works of John Ruskin*, ed. E. T. Cook and A. Wedderburn, London 1903–1912, Vol. IV, p. 298.

108 From the letterpress to the 'Views in Sussex' engraving, written by R. R. Reinagle.

109 For discussion of Turner's clues to meaning, see Eric Shanes, *Turner's Human Landscape*, London, 1990.

110 For discussion of Turner's exploration of these mechanisms, see Eric Shanes, *Turner's Human Landscape*, London, 1990.

111 See Gage, *op. cit.*, 1980, pp. 50–1, letter 43, of November 1811, from Turner to John Britton, where the painter equated poets and prophets; the subject is also discussed in Eric Shanes, *Turner's Human Landscape*, London, 1990.

112 Rembrandt was regarded by several of Turner's more important contemporaries as a 'low' painter; see Christopher White, David Alexander and Ellen D'Oench, *Rembrandt in Eighteenth Century England*, London, 1983, pp. 14–15.

113 In volume V of *Modern Painters*, Ruskin quotes Turner as saying 'What is the use of them but together?' (see *Works*, Vol. VII, p. 434).

COMMENTARIES NOTES

1 Butlin and Joll, *op. cit.*, 1984, no. 211.

2 Butlin and Joll, *op. cit.*, 1984, no. 210, *The Wreck of a Transport Ship* of around 1810, bought by the Hon. Charles Pelham who succeeded his father as Lord Yarborough in 1823.

3 Around 1815 Turner also made an extremely similar architectural elevation in watercolour of the home of another of his patrons, Walter Fawkes, of Farnley Hall, Yorkshire (see Andrew Wilton, *op. cit.*, 1979, watercolour no. 587). This similarity was noted by David Hill in his catalogue of the *Turner in Yorkshire* exhibition held at the York City Art Gallery in 1980 (p. 40, No. 51). Hill's statement that Fawkes and Fuller were of similar political persuasion is erroneous.

4 His features are well known to us through the portrait by Sir Joshua Reynolds which was exhibited at the Royal Academy in 1788. The picture is now in the National Gallery, London.

5 M. A. Lower, *The Worthies of Sussex*, London, 1865, p. 98.

6 The letterpress was written by Richard Ramsay Reinagle. Of course, rabbits in the wild are considered to be vermin, hence the 'wildness' referred to.

7 *Vale of Heathfield* sketchbook, T. B. CXXXVII, pp. 68a–69.

8 Eric Shanes, *op. cit.*, 1981, p. 20, No. 12. The work was paid for by W. B. Cooke in July 1817 (see Walter Thornbury, *op. cit.*, 1877, p. 633) but clearly dates from earlier.

9 Turner also represented Winchelsea twice in the 'Liber Studiorum' (plates 42 and 67), and soldiers appear in both prints.

10 See John Gage, *op. cit.*, 1980, letter 74, p. 73.

11 Andrew Wilton, *op. cit.*, 1979, watercolour no. 504. This title has been given to the work by the British Museum for many years.

12 Cat. No. 9. There has been considerable confusion as to whether the drawing exhibited in 1822 is indeed this work or another drawing of Hastings in the National Gallery of Ireland entitled *Shipwreck off Hastings* (115). However, much circum-stantial evidence points to *this* work being the 1822 exhibited picture (and therefore the drawing entitled to be called *Hastings from the Sea*). The reasons are as follows:

Size: The 1822 catalogue announced that the work was to be engraved on a large scale. As this drawing is much larger than the Dublin work it would have merited such a transcription much more readily. In addition, W. B. Cooke lists in his account books that on 31 August 1818 (the year the work is dated) he paid Turner forty guineas for 'Hastings from the Sea for Mr. Fuller's work'. It seems unlikely that he would have paid this large sum for the much smaller Dublin watercolour. Also significant is the fact that when this drawing was finally published as an engraving (R. 665) in 1851, it was accompanied by another work (R. 666) also engraved on behalf of the same publisher, Gambart. This was the equally large *Dover Castle* (96), exhibited in W. B. Cooke's 1823 exhibition. It seems likely that Gambart purchased both works from Cooke (see Rawlinson, *op. cit.*, Vol. II, pp. 344–5). The large size of this view of Hastings also relates it to the similar dimensions of the other 'Sussex' drawings. Furthermore, in the late 1850s a chromo-lithograph (R. 867) of the work was published (very probably also by Gambart). This was titled *Hastings from the Sea* and there seems to be no explanation for the identification other than that it was automatically associated with this work.

Origins: This work was based upon sketches in a sketchbook used specifically for other 'Sussex' drawings (pp. 22a–23, 24a–25 of the *Hastings* sketchbook, T. B. CXXXIX, of 1815–16).

Contemporary reports: Reviews in *The Examiner* (Monday 4 February 1822, p. 75) and *The Englishman* (24 February 1822, p. 4) both give the impression that this was the work on display. The latter review talks of 'large masses' and 'brilliant colours' (terms hardly applicable to the Dublin drawing) in relation to the work. Neither of these reviews (or others traced by the author) refer to the view of Hastings as being in any way stormy.

Dating: Judging from stylistic characteristics the Dublin drawing was made later than 1818, almost certainly around 1825 for the 'Ports of England' series. It shares common features of size, content and handling with those works. The 1818 dating of this drawing, though, brings it closer in date to the other Sussex drawings, with which it also displays great similarities in size, content and technique.

Suitability: The continuation of the 'Sussex' work was to be under the title of 'Views at Hastings and its vicinity'. This large, symmetrically organized, and above all *optimistic* work would have started the series far more aptly than the pessimistic storm-scene alternative.

13 W. G. Rawlinson, *op. cit.*, Vol. II, No. 665, p. 344.
14 See the *Devon Rivers No. 2* sketchbook, T. B. CXXXIII, p. 45. The work might have also been based on a sketch on p. 153 of the 1811 *Devonshire Coast No. 1* sketchbook, T. B. CXXIII.
15 This map is still owned by a member of the Turner family, who kindly made it available for my inspection.
16 W. G. Rawlinson, *op. cit.*, Vol. I, no. 140, p. 76. The plate was etched by W. B. Cooke in 1816 and published on 1 February 1850 by C. Tidbury and Co. Nothing is known of its intervening history.
17 W. G. Rawlinson, *op. cit.*, Vol. II, cat. no. 851, p. 415.
18 See p. 11 of the *Vale of Heathfield* sketchbook, T. B. CXXXVII.
19 John Ruskin, *Notes on his drawings by Turner, 1878*, in *Works*, Vol. XIII, p. 435.
20 See pp. 50a and 52a of the *Devonshire Coast No. 1* sketchbook, T. B. CXXIII.
21 See p. 1 of the *Vale of Heathfield* sketchbook, T. B. CXXXVII.
22 See p. 102 of the *Corfe to Dartmouth* sketchbook, T. B. CXXIV.
23 See p. 54a of the *Devonshire Coast No. 1* sketchbook, T. B. CXXIII.
24 See p. 23 of the *Devonshire Coast No. 1* sketchbook, T. B. CXXIII; and pp. 36a–37 of the *Corfe to Dartmouth* sketchbook, T. B. CXXIV.
25 W. G. Rawlinson, *op. cit.*, Vol. I, No. 95, pp. 51–2.
26 See Walter Thornbury, *op. cit.*, 1877, p. 541.
27 Cyrus Redding, *op. cit.*, 1852, p. 154.
28 *ibid*, p. 155.
29 See M.I.H., *The Builder*, 24 October 1857, p. 609 (reprinted in its entirety in *Turner Studies*, Vol. 5, No. 1, Summer 1985, pp. 25–6) which records Turner's attention being drawn to the propensity of indigo to fade.
30 The capstan and all the foreground detail are also apparent in the plate of the same subject in Clarkson Stanfield's *Coastal Scenery* published in 1837.
31 See p. 102a of the *Devonshire Coast No. 1* sketchbook, T. B. CXXIII.
32 On close examination the work might also operate on another level. The traveller who is indicating the distance is also pointing at the tower of the Anglican church of St Andrews in East Lulworth. From the discarded makeshift fishing-rod in the foreground it is clear that until recently he too has also been fishing. It may be that Turner, undoubtedly aware of Weld's loyalty to the Roman Catholic faith, intended these two figures to represent Catholicism and Protestantism. In this way the itinerant, whose shoelessness may be intended to indicate the self-denial of the Protestant religion, is exhorting his fishing companion to come to church, i.e. change faiths. The seated figure, however, prefers to remain fishing in much the same way as the Weld family had remained true to their beliefs. Turner's later elaborate exposition of the Catholic Emancipation issue in an 'England and Wales' drawing (168) would support this interpretation.
33 Turner may have witnessed such a dramatic event around 1806–07 when he is thought to have visited the area, even though the flood would have been over in a very short space of time. For that reason it seems more likely that he learnt of the flood later.
34 See p. 133 of the *Devonshire Coast No 1* sketchbook, T. B. CXXIII and p. 30 of the *Ivy Bridge to Penzance* sketchbook, T. B. CXXV.
35 See Sam Smiles, 'Picture Notes' on the St Mawes watercolours, *Turner Studies*, Vol. 8, No. 1, Summer 1988, pp. 53–9.
36 Claude Lorrain, *Landscape with the Father of Psyche sacrificing at the Milesian Temple of Apollo*, 'Liber Veritatis' 157, National Trust, Anglesey Abbey, Cambs. For a discussion of this painting and of Turner's responses to it, see Eric Shanes, *Turner's Human Landscape*, London, 1990, pp. 182ff.
37 W. G. Rawlinson, *op. cit.*, Vol. I, No. 119, p. 64, engraved by William Miller.

38 The work was engraved for 'Dr Broadley's Poems' in 1844 (see W. G. Rawlinson, *op. cit.*, Vol. II, No. 639, p. 325).
39 It is also possible that the work was made for mezzotint engraving in the contemporaneous 'Ports of England' series but it is more delicately drawn than the other 'Ports' designs and the quality of the detail suggests that it was made with line-engraving rather than mezzotint in mind.
40 W. G. Rawlinson, *op. cit.*. Vol. II, Nos. 848 and 849, p. 414.
41 See the *Woodcock shooting* sketchbook. T. B. CXXIX, p. 47.
42 Entry for 4 November 1812 in *The Diary of Joseph Farington*, ed., Kathryn Cave, London, 1983, Vol. XII, p. 4249.
43 For elucidation of the seemingly intractable problems concerning the genesis and development of these three designs, see David Hill, catalogue of the *Turner in Yorkshire* exhibition held at the York City Art Gallery in 1980, pp. 40–2.
44 See pp. 12, 15, 15a and 58 of the *Devonshire Rivers No. 3 and Wharfedale* sketchbook, T. B. CXXXIV, especially pp. 15a and 58 from which Turner clearly synthesized this design.
45 See Stephen Daniels, 'The Implications of Industry: Turner and Leeds', *Turner Studies*, Vol. 6, No. 1, summer 1986, pp. 10–17.
46 W. G. Rawlinson, *op. cit.*, Vol. II, No. 833, p. 407.
47 Daniels, *art. cit.*, p. 11.
48 Daniels (*ibid*) notes the similarity of these figures to those of an anonymous engraving of *Factory Children* in George Walker's *The Costume of Yorkshire*, published in 1814.
49 See David Hill, *In Turner's Footsteps*, London, 1984, p. 64.
50 John Ruskin, *Notes on his drawings by Turner, 1878*, in *Works*, Vol. XIII, p. 430.
51 See Andrew Wilton, *op. cit.*, 1979, watercolour no. 273.
52 T. B. CCLXIII-89 and T. B. CCLXIII-360, as well as a watercolour in an American private collection, W. 892.
53 For discussion of the visual affinities in this work, see Mrs Alfred [Margaret] Hunt, *Views in Richmondshire after Drawings by J. M. W. Turner*, London, 1891, p. 20; and Eric Shanes, *op. cit.*, 1990, pp. 79–80.
54 See p. 9a of the *Yorkshire 5* sketchbook, T. B. CXLVIII.
55 Mrs Alfred Hunt, *op. cit.*, 1891, p. 63.
56 The early sketch appears on p. 27 of the *North of England* sketchbook, T. B. XXXIV; the 1816 sketches are on pp. 31 and 31a of the *Yorkshire 4* sketchbook, T. B. CXLVII.
57 It is unclear whether this is paper, however; it may be washing, although the uniformity of the strips, plus the section of material the girl is actually holding, does suggest that it is paper.
58 See Hill, *op. cit.*, 1984, p. 106.
59 See Andrew Wilton, *op. cit.*, 1979, watercolour no. 1086, in which the view is orientated in a more southerly direction and encompasses Mortham Tower situated atop the hill shown on the extreme left of the present watercolour.
60 *Yorkshire 4* sketchbook, T. B. CXLVII, pp. 26a–27. These sketches are reproduced in Hill, *op. cit.*, 1984, p. 70.
61 Memorandum by Dr John Percy of 11 April 1869 (Dept. of Prints and Drawings, British Museum, London), stating also that Percy had been given the information by John Pye on that day.
62 Thomas Miller, *op. cit.*, 1854, p. xix.
63 Jack Lindsay, *J. M. W. Turner*, London, 1966, p. 140.
64 Hill, *op. cit.*, 1980, p. 87.
65 *Suppressed Defence, The Defence of Mary-Anne Carlile*, published by Richard Carlile, London, 1821. The first two sections of the *Wycliffe* inscription were directly quoted by Turner from page 15 of this pamphlet (see also Shanes, *op. cit.*, 1990, pp. 16–21, 347–48).
66 *Yorkshire 4* sketchbook, T. B. CXLVII, pp. 2a–3.
67 Hill, *op. cit.*, 1984, p. 90.
68 For example, Blair's *The Grave*, Young's *Night Thoughts* and Gray's *Elegy*.
69 *Yorkshire 4* sketchbook, T. B. CXLVII, pp. 40a–41.
70 John Ruskin, *The Elements of Drawing*, in *Works*, Vol. XV, pp. 208–09.
71 See Andrew Wilton, *op. cit.*, 1979, watercolour no. 541, Graves Art Gallery,

Sheffield.

72 *Yorkshire 4* sketchbook, T. B. CXLVII, p. 33a.

73 See John Gage, *op. cit.*, 1980, letter 70, p. 71.

74 Butlin and Joll, *op. cit.*, 1884, no. 360. The painting was commissioned by Henry McConnell and is now in the National Gallery of Art, Washington, D.C.

75 See the *Durham, North Shore* sketchbook, T. B. CLVII, pp. 3–5, as well as p. 2 of the *Scotch Antiquities* sketchbook, T. B. CLXVII, upon which the present watercolour was based.

76 See the *Vale of Heathfield* sketchbook, T. B. CXXXVII, pp. 70–1.

77 See the *Brighton and Arundel* sketchbook, T. B. CCX, p. 48.

78 The scene was wrongly identified by David Hill in his *Turner and Yorkshire* catalogue (p. 90, No. 139) as a view of Redcote Bridge, below Gott's Park, Leeds, which is situated about a mile south of the scene depicted by Turner.

79 See the *Brighton and Arundel* sketchbook, T. B. CCX, p. 60a.

80 There is no record of any work taking place on the brewery in 1824–25 but the building was constructed in the 1790s and Turner visited the abbey in 1797, so very possibly he remembered the building work from then.

81 W. G. Rawlinson, *op. cit.*. Vol. II, p. 370, No. 766.

82 See Marcel-Etienne Dupret, 'Turner's "Little Liber" ', *Turner Studies*, Vol. 9, No. 1, Summer 1989, pp. 32–47.

83 The size of the work, which corresponds with that of the other 'Marine Views' series drawings, plus its subject and technical approach, validates this claim.

84 T. B. CCLXIII-357.

85 It has proven impossible to identify the flag flown by this lugger and so to know where it came from. The tinctures of yellow and white are those traditionally associated with the Papacy, which is not renowned for its shipping. The blue saltire on a white field is equally puzzling as it has Russian connotations. The Belgian royal coat of arms after 1830 was a gold shield charged with a black lion but in 1822 it had no significance. Extensive enquiries in Britain, Europe and the U.S.A. lead to the conclusion that this is not a marine flag but a personal or house flag. A similar yellow and white flag appears on a large fishing smack in the 1803 oil painting *Calais Pier*.

86 Butlin and Joll, *op. cit.*, 1884, no. 48.

87 The watercolour was given this title by the Hammer Galleries, New York, in the mid-1960s.

88 For a list of the books in Turner's library, see Andrew Wilton, *Turner in his time*, London, 1987, pp. 246–47.

89 These paintings are Butlin and Joll, *op. cit.*, 1884, nos. 134 and 133 respectively.

90 See Andrew Wilton, *op. cit.*, 1979, watercolour no. 1212.

91 *ibid*, watercolour no. 1055.

92 With the single exception of the watercolour of *Ilfracombe* made around 1813 for the 'Southern Coast' series (233), the last major storm-scene Turner had created was *The Wreck of a Transport Ship*, a large painting now in the Gulbenkian Museum, Lisbon (Butlin and Joll, *op. cit.*, 1884, no. 210), made around 1810.

93 The work had been lost sight of completely by Turner scholarship until it was rediscovered by Edward Yardley – see 'Picture Note', *Turner Studies*, Vol. 2, No. 2, Winter 1983, pp. 55–6.

94 See the *Folkestone* sketchbook, T. B. CXCVIII, p. 57.

95 See Andrew Wilton, *op. cit.*, 1979, watercolours nos. 527 and 528.

96 Ruskin, *The Harbours of England*, London, 1856, reprinted in *Works*, Vol. XIII, pp. 74–5. The 1818 view of Scarborough is no. 529 in Andrew Wilton, *op. cit.*, 1979.

97 Ruskin, *The Harbours of England*, London, 1856, reprinted in *Works*, Vol. XIII, p. 52.

98 Ruskin, *The Harbours of England*, London, 1856, reprinted in *Works*, Vol. XIII, pp. 53–4. Ruskin contends that both designs represent the same scene at a *simultaneous* moment but from different viewpoints. However, a close examination of the two works does not support this contention.

99 *ibid*.

100 Ruskin, *The Harbours of England*, London, 1856, reprinted in *Works*, Vol. XIII, p. 58.

101 In his text for *The Harbours of England* Ruskin drew attention to Turner's incorrect setting of the battleship's sails, noting that the jib (the sail seen edge-on at the bow of the ship) would not be wanted with the wind blowing from behind. Furthermore, a man-of-war would never have her foretop-gallant sail set and her main and mizzen top-gallants furled – 'all the men would be on the yards at once'. Ruskin was told this by 'a naval officer' (Ruskin, *The Harbours of England*, London, 1856, reprinted in *Works*, Vol. XIII, pp. 63–4).

102 The signalling figure seems to be very similar to a waving man in Géricault's *The Raft of the Medusa*, which Turner is sure to have seen when it was exhibited to great acclaim in the Egyptian Hall, Piccadilly, London, between 12 June and 30 December 1820. See Lee Johnson, 'The Raft of the Medusa in Great Britain', *The Burlington Magazine*, XCVI, August 1954; and Lorenz Eitner, *Gericault's Raft of the Medusa*, London, 1972. Turner may have been one of the several Royal Academicians present at the private viewing of the painting on 10 June 1820.

103 There is a reference on p. 42 of the *Finance* sketchbook (T. B. CXXII) to Richard Payne Knight's *An Account of the Remains of the Worship of Priapus lately existing in Isernia*, published by the Dilettanti Society in 1786 (see William Chubb, 'Minerva Medica and the Tall Tree', *Turner Studies*, Vol. 1, No. 2, 1981, Appendix, p. 35).

104 Ruskin, *The Harbours of England*, London, 1856, reprinted in *Works*, Vol. XIII, p. 68.

105 The tower on Mount Batten Point is silhouetted by white clouds although it is easy to read the sharp line of the edge of these clouds in reverse: the blue sky above them is difficult to distinguish from the blue-grey clouds passing in front, and so the open sky also appears as clouded, seen against lighter clouds beyond.

106 Ruskin, *The Harbours of England*, London, 1856, reprinted in *Works*, Vol. XIII, p. 67.

107 When the work was engraved in 1844 Turner wrote to the engraver, J. Cousen, about his concern that the net resembles a sail in the engraving (see Rawlinson, *op. cit.*, Vol. II, No. 643, p. 327).

108 See Wilton, *op. cit.*, 1979, p. 248.

109 W. G. Rawlinson, *op. cit.*, Vol. II, No. 314, p. 219.

110 See Andrew Wilton, *op. cit.*, 1979, watercolour no. 519. Unfortunately Mr Wilton can no longer find the reference that provided this information. However, he did kindly furnish the memory that it may be that only one of the watercolours – for the engraving of the other, see 258 – was made on commission for George IV.

111 *Murray's Handbook to Berkshire*, London, 1882, p. 90.

112 See Gage, *op. cit.*, 1980, Letter 329, p. 231.

113 Turner had used this device – of merely showing us *part* of a form so that it becomes imaginatively enhanced in scale – many times before, perhaps most notably in the watercolour *A First-Rate taking in stores* of 1818 (see Andrew Wilton, *op. cit.*, 1979, watercolour no. 499).

114 John Ruskin, *Modern Painters*, Vol. II, in *Works*, Vol. V, p. 163.

115 A. J. Finberg characterized the timing as late afternoon (*Turner's Sketches and Drawings*, London, 1911, pp. 111–112), a view shared by W. G. Rawlinson (*op. cit.*, Vol. I, p. 122) who also suggests that it may be moonlight, although a comparison with *Alnwick* (165) rather demonstrates that this is not the case.

116 See the *Yorkshire 4* sketchbook, T. B. CXLVII, p. 34.

117 'Picture Note,' *Turner Studies*, Vol. 4, No. 2, Winter 1984, pp. 59–60.

118 See p. 29 of the *North of England* sketchbook, T. B. XXXIV.

119 See the *Yorkshire 4* sketchbook, T. B. CXLVII, p. 32.

120 See pp. 78–77a (upon which this watercolour was based) and pp. 77 and 79–80a of the *Durham, North Shore* sketchbook, T. B. CLVII. Turner sketched the castle from the riverside, and thus from a much lower viewpoint than appears in the final watercolour, which may explain why he elevated Prudhoe Castle.

121 W. G. Rawlinson, *op. cit.*, Vol. I, No. 222, p. 126.

122 *ibid*.

123 See pp. 57a–59 of the *Norfolk, Suffolk and Essex* sketchbook, T. B. CCIX.

124 See p. 13 of the *Tabley No. 1* sketchbook, T. B. CIII.

125 Timothy Clifford, *Turner at Manchester*, Manchester and Rome, 1982, p. 37.

126 See Sam A. Smiles, *art. cit.*, 1987.

127 See pp. 18a–19 of the *Ivy Bridge to Penzance* sketchbook, T. B. CXXV.

128 John Ruskin, *Notes on his drawings by Turner, 1878*, in *Works*, Vol. XIII, p. 443.

129 See p. 56a of the *Yorkshire No. 1* sketchbook, T. B. CXLIV.

130 W. G. Rawlinson, *op. cit.*, Vol. I, No. 229, p. 130.

131 Butlin and Joll, *op. cit.*, 1984, nos. 11, 36 and 37, the first of which (National Trust, on loan to Wordsworth House, Cockermouth) shows the same view as this water-colour.

132 John Ruskin, *Modern Painters*, Vol. V, in *Works*, Vol. VII, pp. 190–91.

133 *ibid.*

134 John Ruskin, *Modern Painters*, Vol. I, in *Works*, Vol. III, p. 413.

135 The engraving of *Salisbury, Wiltshire* was published as Plate 4, Part XIII of the 'England and Wales' series, on 1 June 1830; the *Stonehenge* had been published in 1829 as Plate 3 in Part VII.

136 John Ruskin, *Notes on his drawings by Turner, 1878*, in *Works*, Vol. XIII, p. 439.

137 See p. 25a of the *Isle of Wight* sketchbook, T. B. XXIV, dating from 1795.

138 See p. 44 of the *North of England* sketchbook, T. B. XXXIV.

139 Diary of Thomas Tudor (private collection), entry for 5 July 1847. I am grateful to Selby Whittingham for making a transcript of the entries relevant to Turner available to me.

140 And see the commentary above on *Lulworth Castle* (34) which was owned by Weld.

141 *Landscapes with Walton Bridges*, Private Collection (see Butlin and Joll, *op. cit.*, 1984, no. 511).

142 See p. 61 of the *Hereford Court* sketchbook, T. B. XXXVIII, used on Turners' fourth tour of Wales, in 1798.

143 Sir Walter Armstrong, *Turner*, London, 1902, p. 281.

144 See W. G. Rawlinson, *op. cit.*, Vol. I, No. 251, p. 141.

145 William Finden, *The Ports and Harbours of Great Britain*, London, 1836, p. 1.

146 John Ruskin, *Notes on the Turner Gallery at Marlborough House*, in *Works*, Vol. XIII, p. 155.

147 John Ruskin, *Notes on his drawings by Turner, 1878*, in *Works*, Vol. XIII, pp. 439–40.

148 See Andrew Wilton, *op. cit.*, 1979, watercolours nos. 280 and 281 respectively.

149 Letter of 27 July 1813 from H. Elliott to Robert Finch, quoted in John Gage, *op. cit.*, 1980, p. 294.

150 For a typical example see the watercolour (ill. 24) of *Eton College* by William Daniell, R.A., sold at Christie's on 16 March 1982, lot 115. This shows Eton College and Chapel from nearly the same angle as appears in Turner's view, with Romney Island completely devoid of any flora at all.

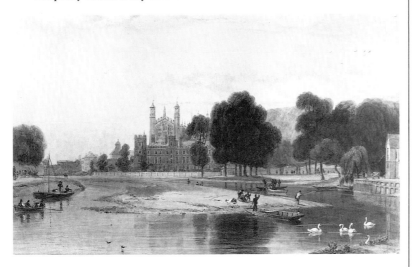

24 William Daniell, R. A., ETON COLLEGE, *signed and dated 1827, pencil and watercolour on paper.*

151 For an examination of Turner's use of trees as metaphors, and his employment of antitheses, see Eric Shanes, *op. cit.*, 1990.

152 See Andrew Wilton, *op. cit.*, 1979, watercolour no. 50.

153 Thomas Hughes, *Tom Brown's School Days by an Old Boy*, London, 1857, pp. 38–9.

154 P. G. Palmer, 'Katern Hill Fair', *The Keep*, Guildford, October 1915, pp. 14–15. The name of the woman is not given but her account, recorded in 1893, is described as 'lucid'.

155 See Craig Hartley, *Turner Watercolours in the Whitworth Art Gallery*, Manchester, 1984, p. 48, where it is stated that an examination of 'the Castle works accounts books show only routine annual expenditure on the bridge [and that] nothing of this scale took place'.

156 John Ruskin, *Præterita*, in *Works*, Vol. XXXVI, pp. 305–06.

157 The sketchbook page is now in the Fogg Art Museum, Cambridge, Massachusetts, probably having been detached from the *Smaller Fonthill* sketchbook, T. B. XLVIII.

158 See pp. 51c, 52 and 55 of the *Kenilworth* sketchbook, T. B. CCXXXVIII.

159 The entry, on p. 19 of the catalogue, is as follows: 'In the time of Charles II the Dutch admiral, De Ruyter, appeared at the mouth of the Thames, and sent Van Ghent up the Medway to destroy the shipping. This he partially effected; but advancing with six men of war and three fire ships to Upnor Castle, Major Scott, commandant of the castle, and Sir Edward Spragge, who directed the batteries on the opposite side, opened so hot a fire, that Van Ghent was obliged to retreat with con-siderable damage, to his ships.'

160 John Ruskin, *Modern Painters*, Vol. I, in *Works*, Vol. III, p. 564.

161 In Vol. I of *Modern Painters* Ruskin characterized the timing and weather conditions depicted by Turner as 'Two o'clock. Clouds gathering for rain, with heat' (see John Ruskin, *Works*, Vol. III, p. 564).

162 For a discussion of Turner's libertarian responses in 1800, see Eric Shanes, *op. cit.*, 1990, pp. 59–72.

163 Turner became friendly with the future French King when Louis Philippe was living in exile in England at Orleans House near the painter's own house, Sandycombe Lodge, in Twickenham. In 1838 Louis Philippe presented Turner with a gold and diamond snuff box. In September-October 1845 Turner stayed with Louis Philippe at Eu.

164 Quoted in Michael Brock, *The Great Reform Act*, London, 1973, p. 98. The news-paper was the *Durham Advertiser*.

165 *ibid.*, p. 101.

166 Eric G. Forrester, *Northamptonshire County Elections and Electioneering 1695-1832*, Oxford, 1941, p. 128.

167 As John Gage has pointed out (*Rain, Steam and Speed*, London, 1972, p. 19), Turner may also have referred to this dance in his 1844 oil painting *Rain, Steam and Speed* where he juxtaposed the railway train (i.e., 'Speed') with a distant ploughman ('speed the plough').

168 This meeting was held at the Crown and Anchor Tavern in the Strand on 25 May 1829. It celebrated the 22nd anniversary of the election to Parliament of Sir Francis Burdett. Those present at the meeting included Henry Hunt, William Cobbett, John Cam Hobhouse and Daniel O'Connell.

169 For example, see the figures in the watercolour (W. 990) and engraving (R. 492) of *Troyes*, made for *Turner's Annual Tour – The Seine* around 1832 and 1835 respectively.

170 John Ruskin, *Modern Painters*, Vol. I, in *Works*, Vol. III, p. 564.

171 John Ruskin, *Modern Painters*, Vol. IV, in *Works*, Vol. VI, pp. 43–4.

172 Elie Halevy, *The Triumph of Reform 1830-41*, 2nd ed., London, 1950, p. 41.

173 John Ruskin, *Modern Painters*, Vol. I, in *Works*, Vol. III, p. 543.

174 See p. 25 of the *South Wales* sketchbook, T. B. XXVI.

175 John Ruskin, *Modern Painters*, Vol. I, in *Works*, Vol. III, p. 491.

176 See p. 1 of the *Kenilworth* sketchbook, T. B. CCXXXVIII.

177 See Butlin and Joll, *op. cit.*, 1984, no. 12.

178 Turner referred to Rembrandt's *The Three Trees* in one of his perspective lectures (British Library, *Add. Ms.* 46151–P, p. 17; the text is published in Jerrold Ziff, 'Back-

grounds, Introduction of Architecture and Landscape: 'A Lecture by J. M. W. Turner', *Journal of the Warburg and Courtauld Institutes*, Vol. XXVI, 1963, pp. 124–47, where the reference cited appears on p. 145).

179 John Ruskin, *Notes on his drawings by Turner, 1878*, in *Works*, Vol. XIII, p. 444.

180 The best-known example occurs in *The Fighting 'Temeraire'*. For an examination of the subject, see Eric Shanes, *op. cit.*, 1990, pp. 38–44, 95–108. This same book also examines Turner's use of river-crossings as metaphors.

181 For the oil sketch, see Butlin and Joll, *op. cit.*, 1984, no. 28; for the watercolour see Andrew Wilton, *op. cit.*, 1979, watercolour no. 254, exhibited at the Royal Academy in 1799.

182 See pp. 81a–82 of the *North of England* sketchbook, T. B. XXXIV.

183 See Andrew Wilton, *op. cit.*, 1979, watercolour no. 551.

184 See p. 61 of the *Hereford Court* sketchbook, T. B. XXXVIII, used on Turner's fourth tour of Wales.

185 See pp. 80–82a of the *Worcester, Shrewsbury, Bridgenorth and Peak 1830* sketchbook, T. B. CCXXXIX.

186 See T. B. XII-F.

187 John Ruskin, *Modern Painters*, Vol. I, in *Works*, Vol. III, p. 557.

188 *ibid.*, p. 557.

189 Turner was one of a group of artists and students from the Royal Academy who witnessed the fire from a boat, according to the shorthand diary of John Green Waller, transcribed by W. J. Carlton, now in London University Library.

190 See Butlin and Joll, *op. cit.*, 1984, Nos. 359 and 364.

191 Letter to Dawson Turner, Library of Trinity College, Cambridge; see Eric Shanes, 'New Light on the England and Wales Series', *Turner Studies*, Vol. 4, No. 1, Summer, 1984, p. 53.

192 See Andrew Wilton, *Turner in Wales*, Llandudno, 1984, p. 51.

193 See W. G. Rawlinson, *op. cit.*, Vol. I, Nos. 11 and 21, pp. 5 and 9 respectively.

194 For the 'Liber Studiorum' plate see W. G. Rawlinson, *Turner's Liber Studiorum*, 2nd edition, London, 1906, pp. 16–7; for the later watercolour see Andrew Wilton, *op. cit.*, 1979, watercolour no. 885. Although I discussed this latter work as a possible 'England and Wales' series drawing in my previous book on the scheme (*Turner's Picturesque Views in England and Wales*, London, 1979, plate 89 and commentary, p. 152), documentary evidence has subsequently come to light to demonstrate that this was not the case. As a result, the watercolour has been excluded from this book.

195 John Ruskin, *Modern Painters*, Vol. I, in *Works*, Vol. III, pp. 534, 573n.

196 In Henry Boswell's *Picturesque Views of the Antiquities of England and Wales*, London, 1786, the view of 'Keswick Lake' occupies the same page as those of 'Winandermere' – the archaic name of Windermere (see 218) – and Broadwater, the title for which also mentions Ullswater (see 204). It seems more than mere coincidence that of Turner's three Lakeland subjects in the 'England and Wales' series, two of them should depict exactly the same lakes as are to be found in Boswell, as well as the same unusual spelling of their names.

197 See p. 57 of the *Hereford Court* sketchbook, T. B. XXXVIII.

198 See T. B. CCLXIII-25 and T. B. CCCLXIV-406.

199 John Ruskin, *Modern Painters*, Vol. I, in *Works*, Vol. III, pp. 586–87.

200 See pp. 52, 54, 55 and 56 of the *Tweed and Lakes* sketchbook, T. B. XXXV.

201 See p. 6a of the *Yorkshire No. 5* sketchbook, T. B. CXLVIII.

202 John Ruskin, *Modern Painters*, Vol. I, in *Works*, Vol. III, p. 557 (for the waterfall), p. 587 (for the foliage).

203 See J. Burnet, *The Progress of a Painter in the Nineteenth Century*, London, 1854, Vol. I, p. 92, which records that the lines from Thomson extolling the view from Richmond Hill were 'written upon a board, and nailed upon one of the trees at the end of the walk' on the hill.

204 For the Milton illustration see Andrew Wilton, *op. cit.*, 1979, watercolour no. 1269,

as well as Eric Shanes, *J. M. W. Turner: The Foundations of Genius*, Cincinatti, 1986, p. 59, where correctly titled as *The Death of Lycidas – 'Vision of the Guarded Mount'*; for the oil see Butlin and Joll, *op. cit.*, 1984, no. 358.

205 For the sketch see p. 1a of the *Kenilworth* sketchbook, T. B. CCXXXVIII; the other 'colour-beginnings' are T. B. CCLXIII nos. 3, 4, 5 and 106.

206 See W. G. Rawlinson, *op. cit.*, Vol. II, No. 651, p. 335.

207 Frederick Goodall, *Reminiscences*, London, 1902, pp. 54–55.

208 Rawlinson (*loc. cit.*) states that the two dons had followed Turner to watch him paint the watercolour but that story is disproved by Goodall's account of the genesis of the drawing.

209 De Loutherbourg's painting of *The Great Fire of London in 1666* (now in the collection of the Yale Center for British Art, Paul Mellon Collection) was exhibited at the British Institution in 1817, and the engraving of it by J. C. Stadler (the engraver of Turner's Sussex drawings made for Jack Fuller in 1810) had been published in 1799; a line-engraving of the work by Anker Smith had also appeared in Vol. 4 of the Bowyer edition of Hume's *History of England*, published in 1806. For Turner's admiration of de Loutherbourg, see *inter alia*, Eric Shanes, *op. cit.*, 1990, pp. 156–59, 327–32.

210 Cyrus Redding, *op. cit.*, 1852, p. 156.

211 See W. G. Rawlinson, *op. cit.*, Vol. I, No. 138, p. 75.

212 *ibid*, Vol. I, No. 90, p. 49.

213 *ibid*, Vol. I, No. 105, p. 56.

214 See p. 170a of the *Devonshire Coast No. 1* sketchbook, T. B. CXXIII.

215 See W. G. Rawlinson, *op. cit.*, Vol. I, No. 103, p. 55. Both the first and second published states of the engraving bear the information that the work had been engraved from the image made for the 'Liber Studiorum'.

216 See Butlin and Joll, *op. cit.*, 1984, no. 136.

217 See Andrew Wilton, *op. cit.*, 1979, watercolour no. 630.

218 On p. 5a of the *Devon Rivers No. 2* sketchbook, T. B. CXXXIII.

219 See Andrew Wilton, *op. cit.*, 1979, watercolour no. 486.

220 A. J. Finberg, *The Life of J. M. W. Turner, R.A.*, 2nd ed., London, 1961, p. 284.

221 See Butlin and Joll, *op. cit.*, 1984, no. 97.

222 See Eric Shanes, 'Turner's Unknown London Series', *Turner Studies*, Vol. 1, No. 2, 1981, pp. 39–42.

223 See pp. 34a–35 of the *River* sketchbook, T. B. CCIV.

224 See pp. 41–12a of the *Yorkshire 5* sketchbook, T. B. CXLVIII.

225 John Ruskin, *Pre-Raphaelitism*, in *Works*, Vol. XII, pp. 371–72.

226 See W. G. Rawlinson, *op. cit.*, Vol. I, No. 221, pp. 125–26.

227 See Alaric Watts, *art. cit.*, 1853, p. *xl*, where Turner is recorded as saying 'What . . . have the Academy done for me? No one has knighted me, Callcott has been knighted, and Allan has been knighted, but no one has knighted me!'. Although Callcott was knighted in 1837 and William Allan in 1842, nonetheless Turner's feelings at being passed over may well have originated much earlier, and especially around 1822–24 after he painted *The Battle of Trafalgar* for George IV who did not like the work.

228 John Ruskin, in *Works*, Vol. III, p. 308.

229 See Butlin and Joll, *op. cit.*, 1984, No. 123.

230 See p. 42a of the *Hereford Court* sketchbook, T. B. XXXVIII.

231 See p. 45 of the *Gravesend and Margate* sketchbook, T. B. CCLXXIX. The final watercolour also incorporates topographical information culled from pp. 42, 44, 45a and 46 of the same sketchbook.

232 See pp. 45a, 46, 47, 50 and the inside back cover of the *Kenilworth* sketchbook, T. B. CCXXXVIII.

233 See W. G. Rawlinson, *op. cit.*, Vol. I, No. 264, pp. 147–48.

234 See Eric Shanes, *op. cit.*, 1990, pp. 24–26.

INDEX OF TITLES AND SUBJECTS

(TURNER'S NAMES OF PLACES ARE USED THROUGHOUT, AND THE NUMBERS REFER TO PAGE NUMBERS)

CREDITS

Photography

Mick Duff: Frontispiece, Plates 4, 5, 6, 9, 14, 19, 28, 46, 74, 105, 124, 125, 127, 128, 137, 139, 145, 147, 151, 153, 156, 157, 158, 162, 166, 168, 169, 170, 171, 174, 178, 180, 189, 197, 208, 212, 222
I. Henderson: Plate 57
Stanley Parker-Ross: Plate 21
Anthony Price: Plate 214
John Webb: Plates 144, 204
West Park Studios, Leeds: Plates 11, 26, 36, 43, 117